From the Wright Brothers to *Top Gun*

B.S

MICHAEL PARIS

From the Wright Brothers to *Top Gun*

Aviation, nationalism and popular cinema

Manchester University Press
MANCHESTER AND NEW YORK

distributed exclusively in the USA and Canada by St. Martin's Press

Copyright © Michael Paris 1995

Published by Manchester University Press
Oxford Road, Manchester M13 9NR, UK
and Room 400, 175 Fifth Avenue, New York, NY 10010, USA

Distributed exclusively in the USA and Canada
by St. Martin's Press, Inc., 175 Fifth Avenue, New York,
NY 10010, USA

British Library Cataloguing-in-Publication Data
A catalogue record for this book is available from the British Library

Library of Congress Cataloging-in-Publication Data
Paris, Michael, 1949–
 From the Wright Brothers to Top Gun: aviation, nationalism and popular
 cinema
/ Michael Paris
 p. cm.
 Includes bibliographical references and index.
 ISBN 0–7190–4073–6. – 0–7190–4074–7 (pbk.)
 1. Flight in motion pictures. 2. War films—United States—
History and criticism. I. Title.
PN1995.9.F53P37 1995
791.43'656—dc20 94–29774

ISBN 0 7190 4073 6 *hardback*
 0 7190 4074 4 *paperback*

Printed in Great Britain
by Redwood Books, Trowbridge

Contents

Illustrations

Acknowledgements

It is impossible to write a book such as this without the support, advice and assistance of a number of individuals and institutions. In particular I would like to thank Jeffrey Richards of Lancaster University for his encouragement and assistance in getting this project underway. My colleagues, Will Kaufman, Dave Russell and Keith Vernon, kindly read and commented upon various chapters, and Christopher Williams generously took time from his own work to translate Russian material. Dr Giovanni Nobili Vitelleschi of Florence provided information on the Italian cinema, and Vladislav Borovkov of Gosfilmofond, Moscow, was helpful on Soviet films.

An award from the Scouloudi Foundation, Institute of Historical Research, London, assisted in meeting the expenses involved in research.

1 Introduction: the credo of the Winged Gospel[1]

> The flight of the birds, so effortless and graceful, has led man since the dawn of time to turn his gaze with longing to the skies. But his dream of soaring above the clouds was not to be realised without weary centuries of experiment and failure . . . Man, because he was himself denied the power of flight, reverenced it as a supernatural quality and could give no higher honour to his gods and goddesses than the endowment of wings in acknowledgement of their superior being. In antiquity are found many examples of this expression of awe at the power of flight.

This opening narration and the subsequent cameos re-enacting the great moments in the history of aviation from Alexander Korda's ill-fated 1935 epic *Conquest of the Air* serve as a useful reminder of the enduring human desire to master the air, whatever the cost.

For centuries, people attempted to fly with a variety of bizarre mechanical contraptions, yet it was only on the eve of the French Revolution that the Montgolfier brothers constructed the first hot-air balloon and made several successful ascents. Over the next hundred years, balloon flights became commonplace – a new and exciting toy for the wealthy. Armies frequently made use of captive balloons for observation purposes and in this way aeronautics developed a military dimension. But the hot-air or gas-filled balloon was hostage to the winds, a means for man to climb to the clouds but never a vessel to navigate the air ways. The first really navigable flying machine was the Renard-Krebs airship *La France* which made a number of well-publicised flights in 1884–85, but even by the turn of the twentieth century, and despite the pioneering work of Alberto Santos-Dumont in France and Ferdinand von Zeppelin in Germany, airships remained fragile, fair-weather vessels. If people were truly to conquer the skies, it would be through the use of powerful, controllable machines and not flimsy airships without reliable steering systems. The point was forcefully made by Hiram Maxim, inventor and entrepreneur, in 1891. Birds, Maxim argued, flew by expending physical force upon the surrounding air, and not by floating in the

manner of kites. Humans must follow this pattern if they were to master the air.[2]

The breakthrough came in December 1903 at Kitty Hawk, North Carolina, when Orville and Wilbur Wright successfully flew a heavier-than-air machine. News of their achievement was at first dismissed as just another hoax in the seemingly impossible quest to fly, and the brothers refusal to demonstrate their machine in public did little to substantiate their claims to have mastered the secret of powered flight. However, in 1906 Santos-Dumont became the first man to fly in Europe, giving a sensational demonstration in Paris. Two years later the Wrights presented their aeroplane to the public in both the United States and Europe, and in 1909 the French aviator Louis Blériot flew the English Channel and revealed something of the future potential of aviation. Between then and the coming of war, aviation developed rapidly and by 1914 aeroplanes could fly at speeds in excess of 100 m.p.h., reach an altitude of 20,000 feet and remain airborne for over 16 hours.[3]

The First World War provided a spur to the development of aviation as the warring nations continually sought the advantage of new and more powerful weapons. The aeroplane was believed by many to be the ultimate weapon: the machine that would break the deadlock of trench warfare and, by passing fortifications and strong points, strike directly at the industrial heart of the enemy nation. Machines became bigger, faster and capable of flying great distances carrying heavy loads. The pilot, already a heroic figure before 1914, took on enhanced status and became the 'knight of the air' a technological warrior according to the propagandists, dismissing his enemies in chivalric combat in the skies over the Western Front. In the years following the Armistice, Richthofen, McCudden, Ball, Fonck, Guynemer and Rickenbacker became national heroes, and the cult of the air fighter, initiated as wartime propaganda, was continually reinforced by novels, pulp magazines and above all by the cinematic image. But the inter-war years were also the age of the great air pioneers, the explorers of the skyways, who took their place alongside the war aviators. By 1939 the pantheon of air heroes included Lindbergh, Wiley Post, Alan Cobham, Amy Johnson, Amelia Earhart and a host of other equally celebrated fliers. In the tracks of the pioneers came the entrepreneurs, the businessmen who developed air transportation and the first airlines. In parallel with this civil development, governments, looking for a cheap and effective means of maintaining national security in an increasingly warlike world, began to develop their military air services and as a result the principles of strategic air warfare came into being. Great air fleets did not deter the aggressor and prevent war as the advocates of air

power hoped, but the Second World War did confirm the importance of the aeroplane as a weapon of war – perhaps the supreme weapon when it was combined with the atomic bomb in 1945. And the conflict, of course, created another generation of air heroes – the 'Flying Tigers' in China, the 'Few' of the Battle of Britain, the aircrews of the strategic bomber offensive and Doolittle's Tokyo raiders.

The years after 1945 introduced new factors into the story of flight: the jet engine, supersonic travel and the possibility of the conquest of space. If some of the rough and ready glamour of the early days of aviation had been lost, there were compensations: faster and higher flying, mass-travel by air and even high-tech war with the jet aces of the Korean and Vietnamese conflicts. The conquest of the air, from the Wright brothers ascent at Kitty Hawk to the first moon landing, was speedily accomplished – a dramatic story that unfolded in a little over fifty years, less than a single lifetime. And here was the raw material of legend: visionary pioneers, romantic air fighters, technological achievement pushed to its very limits and sudden and heroic death in the quest to conquer the elements and allow human beings to break their earthly ties. Little wonder, then, that film makers have found so many themes to exploit in the story of the human conquest of the air.

<div align="center">II</div>

The prophets of flight had, for centuries, speculated on the advantages for humans once they could travel through the air with the freedom of the birds. Those advantages have been well summarised by Michael Sherry, who is worth quoting at length,

> The airplane was the instrument of flight, of a whole new dimension in human activity. Therefore it was uniquely capable of stimulating fantasies of peacetime possibilities for lifting worldly burdens, transforming man's sense of time and space, transcending geography, knitting together nations and peoples, releasing humankind from its biological limits. Flight also resonated with the deepest impulses and symbols of religious and particularly Christian mythology – nothing less than Christ's ascension. Its realization, then, served as a powerful metaphor for heavenly aspirations and even, among the literal-minded, as the palpable vehicle for achieving them[4].

The vision of how the conquest of the air would benefit humankind was established during the late nineteenth century through popular literature: a collection of utopian beliefs that Joseph Corn has aptly labelled the 'Winged Gospel'. Corn was particularly concerned to illustrate America's romance

with aviation, but 'airmindedness' and a belief in the beneficial aspects of the conquest of the air were common to all technologically advanced nations and it seems appropriate to regard them as a world phenomenon.[5] The subsequent developments in aviation before 1914 only strengthened those beliefs that the advent of the aeroplane marked the beginning of a new golden age. And for many visionaries, even the events of the Great War failed to shatter their conviction that through aviation a better, more peaceful and progressive world could be made. However, the gospel operated at two distinct levels. There was what we might term an 'internationalist' gospel, a utopian vision most common before 1914 but still found among a few prophets well into the modern age, and nationalist variations which had surfaced before the Great War but which became increasingly widespread during the inter-war years – a belief that through aviation national ambitions might be advanced, increased security achieved and a dynamic, technological and modernistic image of the state created.

The internationalist gospel was perhaps first most clearly stated by the American poet Edmund Stedman in an essay published in 1879. Pointing out that aerial navigation would obliterate national frontiers and geographical boundaries, Stedman argued that,

> Law and customs must assimilate when races and languages shall be mingled as never before. The fittest, of course, will survive and become dominant types. The great peoples of Christendom soon will arrive at a common understanding: the Congress of Nations no longer will be an ideal scheme, but a necessity, maintaining order among its constituents and exercising supervision over the ruder, less- civilized portions of the globe. Free-trade will become absolute, and everywhere reciprocal: no power on earth could enforce an import tariff, war between enlightened nations soon will be unknown.[6]

Stedman articulated ideas that would soon become commonplace in the gospel of the air: that aeronautics would breakdown national boundaries, improve communications, introduce a universalistic culture and make war too terrible to contemplate. Even a world war could not dampen the fervour of the true believer and in 1917, amidst the carnage of the Great War, we find the English pioneer-airman Claude Grahame-White writing of the eventual destruction of nationalism,

> Instead of widely scattered communities knowing little of each other, and prone in consequence to suspicion and mistrust, humanity will find itself drawn closer and closer together through the speed of aerial transit. Man

will forget his nationalist tendencies and see himself as a citizen of the world.[7]

But the utopians were doomed to disappointment: nationalism was far from dead and aviation, which they had believed would preside over its demise, actually became the new means through which nationalist ideology could be promoted. Aeronautical technology and achievement increasingly became a channel through which national aggrandisement could be promoted, and especially among the defeated and dissatisfied.

Peter Fritzsche, in his study of German aviation and the popular imagination, has convincingly demonstrated how exploits such as the trans-Atlantic crossing of the *Bremen* and the sensational flights of German airships like the *Graf Zeppelin* became a means of restoring pride and national unity for a nation humiliated by the Diktat of Versailles. After 1933, the National Socialist regime prioritised the creation of the *Luftwaffe* and made the revival of German aviation an effective allegory for their own movement. 'We must become a nation of fliers,' asserted Hermann Goering and thus set before German youth a model of the selfless image of the heroic war aviators – Boelcke, Immelmann and Richthofen.[8] In Mussolini's Italy, disillusioned by a peace settlement that failed to give her all that Italians felt had been promised, a powerful air force not only promised a means to recreate a Roman Empire in the Mediterranean, but acted as a powerful metaphor for Fascist achievement – modernism, technical advances, speed, power and elitism. In Soviet Russia, which had suffered long years of revolution and civil war, which remained isolated from other nations by its political ideology and which was labouring to drag itself into the twentieth-century world of technology and industrialism, aviation records appeared to offer a means through which Stalin could win support for his regime at home and abroad, counterbalance the effects of the purges and demonstrate the triumphant spirit of a people under Communism.[9]

Even among the victors of 1918, aviation offered a means of rejuvenation and the promotion of a dynamic national image. In France, perhaps the most demoralised nation among the victorious alliance, the cult of the aviator hero and aeronautical development offered a means to counteract moral decline and assure the French that 'they were a people capable of greater than human achievement'.[10] The British, even before 1914, had perceived air transportation as an important means of bringing far-flung imperial possessions closer to the motherland and as a cheap but effective method of colonial policing. After 1918, with the rumble of nationalism and

self-determination to be heard throughout the Empire, this use of air power became ever more important.[11] In the economically dismal inter-war years, setting aviation records, blazing the new sky routes to Africa and the Far East and winning air competitions all helped Britain to maintain her prestige by showing that those forces which had brought about the first Industrial Revolution were still in existence and that Britain was still a technological state of the first order – even if in popular mythology those forces took the form of such individualistic English eccentrics as Lady Houston, R. J. Mitchell and Barnes Wallis. David Edgerton, in his provocative essay *England and the Aeroplane*, has clearly demonstrated British enthusiasm for aviation and has persuasively argued that in the history of the development of the aeroplane Britain is revealed, 'not as a "welfarist" nation lacking interest in technology, but as a warfare state which gives a remarkably high priority to technological development'.[12]

In America, the conquest of the air appeared to be the logical conclusion to that nation's technological progress coupled with the tradition of rugged individualism – no one is more alone than the pilot when a mile above the earth with only thin metal between her or him and eternity. By the 1920s, the airman had become the final American hero, an image that achieved world recognition with the trans-Atlantic flight of Charles Lindberg in 1927. The skyways were the final frontier, the logical goal of America's perceived 'manifest destiny'.

Aviation, then, in an internationalist sense, was widely believed to be a potent channel for progress and a better world. Yet within individual nations it was also seen as a means of promoting a dynamic self-image and achieving national goals. We might regard these as the positive side of aeronautical development; but there was also the negative side and that focused on the aeroplane as probably the most devastating engine of war yet devised. And it was as a weapon that the aeroplane most exercised the popular imagination.

Even before 1914, a vast literature existed which had explored the military uses of the aeroplane. This ranged from the novels of H. G. Wells and George Griffiths to serious theoretical papers by a host of military commentators, serving officers and air pioneers. There had also been two wars in which airships and aeroplanes had been used in a combat role: by the Italians in North Africa against the forces of the Ottoman Empire and by various nations, most notably Bulgaria, in the Balkan Wars of 1912–13.[13] The War of 1914–18 merely extended their use and further demonstrated the potential of the air weapon. By the end of the Great War, the British had created the Independent Bomber Force to strike at industrial targets inside Germany in the belief that sustained bombardment would weaken the enemy's war

production and demoralise his workers. This hypothesis was never really tested, the war ended too suddenly for that, but during the inter-war years the great advocates of air bombardment – Giulio Douhet in Italy, Billy Mitchell in the United States and Hugh Trenchard in Britain – created the myth that air power alone could win wars.

The fallacy of this belief was only revealed during the strategic bombing campaigns against Germany and Japan from 1941 onwards.[14] Nevertheless, after 1945 the development of the atomic bomb added a new dimension to this theory and the major protagonists of the cold war maintained their atomic bomber fleets at a high level of readiness. Britain, it might be noted, was the only other nation to retain a small nuclear bomber force as an 'independent deterrent'. By the 1960s, the bomber as a major deterrent was virtually redundant, and had been replaced by the more economically viable missile. Nevertheless, there was still an important role for the bomber in modern war and while other nations invested in smaller, more versatile supersonic fighter-bombers, the superpowers retained their heavy bomber fleets; the American Boeing B–52, for example, flew numerous missions during the Vietnam War and even over Iraq during the Gulf conflict in 1991.

III

The 'golden age' of aviation from the beginning of the twentieth century to the 1950s, coincides almost exactly with the 'golden age' of cinema. Moving pictures were first projected in the mid-1890s, usually as part of a vaudeville/ music hall performance. These first films were brief: a minute or two of a prize fight, a busy street, a train pulling into a station or waves rolling onto the beach. However, such mundane scenes soon lost their appeal with audiences. What saved moving pictures and ensured their continual popularity was the introduction of narrative – the story film – and the development of illusion, the film makers' ability to create the fantastic and portray it as reality. December 1903, the month in which the Wright brothers first conquered the air, also saw the New York premiere of what some film historians regard as the first real feature film – Edwin S. Porter's *The Life of an American Fireman*. And film developed just as rapidly, just as dramatically as aviation; complex productions, location shooting, sound and colour were all available to the film maker by the late 1920s. The cinema quickly established itself as the most exciting and most popular form of leisure activity yet devised and, in the process, became a remarkably effective channel for the dissemination of ideas, attitudes and the qualities that a society deemed most worth preserving. But, as Raymond Williams has pointed out, the histories of popular cinema rarely acknowledge any debt to existing theatrical and

literary traditions.[15] To regard film as something completely new is a serious error – only the form of transmission was new, the ideas that film makers portrayed were rooted in older cultural forms.

This is clearly evident from a study of films dealing with the development of the flying machine, which began to appear as early as 1901. Here there was no theatrical tradition upon which to draw – aviation was too new – but there was a literary one, and it was upon the ideas of the early literary prophets that the cinematographers built. Initially, films about flying provided the film makers with ideal scenarios for their developing repertoire of trick photography and for exciting or comic stories, but they soon came to reflect the credo of the 'Winged Gospel', that air transportation would bring about a golden age of progress, that flying was the ultimate technological achievement, and portrayed the airman as a romantic and chivalric figure. During the inter-war period, and in the years of the cold war, popular cinema still paradoxically promoted these established themes, but also exploited current fears about aerial bombardment in the next great war and contributed to a climate of fear in which many people believed appeasement or a bigger and better deterrent was preferable to mass destruction. Simultaneously, cinema used images of the flier and aviation for nationalistic propaganda showing aeronautical achievement as the cutting edge of the nation's technological endeavour. Aviation films continually reinforced, and helped shape, contemporary thinking about the development of aviation.

Considering the number and popularity of aviation films it is surprising that the subject has been so little explored. In 1981, Bertil Skogsberg published his *Wings on the Screen*, an entertaining but idiosyncratic look at the author's favourite films. *When Hollywood Ruled the Skies* by Bruce Orris (1984), chronologically examined American aviation features dealing with World War Two, while Richard Pendo's *Aviation in the Cinema*, published the following year, was a comprehensive chronological listing of virtually every aviation film produced but which provides little detail. A more in-depth study was James Farmer's 1984 book, *Celluloid Wings: The Impact of Movies on Aviation*, an interesting and detailed exploration of Hollywood's involvement with aviation. However, Farmer's main interest is in the stunt pilots and machines featured in various feature films, and although there is a wealth of fascinating detail, the study ends abruptly in 1949. All of these works are now out of print so the time seems appropriate for a new examination of the subject.

Using a basically chronological framework, this book explores the relationship between aviation, nationalism and the cinema from the first aviation films, made at the turn of the century, to those set during the Vietnam War

and beyond. The main focus here are those feature and documentary films made in the English language, but comparative texts from the USSR, Germany, Japan and Italy have been included. The reader will quickly become aware that the majority of films discussed are American. This, however, should not be taken to indicate any bias or preference but simply a reflection of the fact that the American film industry, at least after the First World War, produced more films than any other nation.

NOTES

1 I am indebted to Joseph Corn for this phrase; see *The Winged Gospel - America's Romance With Aviation, 1900–1950* (New York, 1983).

2 Hiram Maxim, 'Aerial Navigation', *Century Magazine*, 42: 6 (Oct. 1891), 831.

3 The history of the conquest of the air has been dealt with in a number of works. Charles Gibbs-Smith, *Aviation, an Historical Summary* (London, 1970) is still useful. On the Wright Brothers see Richard Hallion (ed.), *The Wright Brothers: Heirs of Prometheus* (Washington, 1978). The records cited are to be found in C. C. Turner, *The Old Flying Days* (London, 1922).

4 Michael S. Sherry, *The Rise of American Air Power, The Creation of Armageddon* (New Haven, 1987), 2.

5 On America see Corn, *The Winged Gospel*; for the German experience, Peter Fritzsche, *A Nation of Fliers – German Aviation and the Popular Imagination* (Cambridge, Mass., 1990); for France, Patrick Facon, 'Grandeur through Aviation', paper delivered at the International Aerospace Historians' Conference at the Smithsonian Institution Washington, April 1990: on air enthusiasm in Britain see David Edgerton, *England and the Aeroplane, An Essay on a Militant and Technological State* (London, 1991) and Michael Paris, *Winged Warfare: The Literature and Theory of Aerial Warfare in Britain, 1859-1917* (Manchester, 1992).

6 Edmund Stedman, 'Aerial Navigation' (1879) quoted in H. Bruce Franklin, *War Stars, The Superweapon and the American Imagination* (New York, 1988) 82.

7 Claude Grahame-White and Harry Harper, 'The Dawn of the Air Age', *Contemporary Review*, 112 (July 1917), 78.

8 Fritzsche, *A Nation of Fliers*, 190; and George L.Mosse, 'War and the Appropriation of Nature' in Volker Berghahn and Martin Kitchen (eds), *Germany in the Age of Total War* (London, 1981).

9 K. E. Bailes, 'Technology and Legitimacy: Soviet Aviation and Stalinism in the 1930s', *Technology and Culture*, 5: 17 (1976).

10 Facon, 'Granduer through Aviation'.

11 Michael Paris, 'Air Power and Imperial Defence, 1880–1919', *Journal of Contemporary History*, 24: 2 (Apr. 1989), 209–25, and David Omissi, *Air Power and Colonial Control, The RAF, 1919–1939* (Manchester, 1990).

12 Edgerton, *England and the Aeroplane*, xiii.

13 I. F. Clarke, *Voices Prophesying War, 1789–1984* (Oxford, 1966); Paris, *Winged Warfare*, chap. 2; Michael Paris, 'The First Air Wars – North Africa and the Balkans, 1911–1913', *Journal of Contemporary History*, 26: 1 (Jan. 1991), 97–109.

14 On the development of strategic bombing see Lee Kennett, *A History of Strategic Bombing* (New York, 1988). See also Giulio Douhet, *The Command of the Air* (1921; English trans., New York, 1942) and William Mitchell, *Winged Defense: The Development and Possibilities of Modern Air Power, Economic and Military* (New York, 1925). On the air aspects of the Second World War, see Richard Overy, *The Air War, 1939–1945* (London, 1980).

15 Raymond Williams, 'British Film History: New Perspectives' in James Curran and Vincent Porter, *British Cinema History* (London, 1983), 10–11.

2 The first aviation films, 1901–14

I

By the beginning of the twentieth century, and despite a few visionaries who still continued to predict the eventual conquest of the skies by heavier-than-air machines, popular opinion was beginning to dismiss air travel as an impossible dream. The much-publicised failure of machines built by Hiram Maxim in England and Samuel Langley in the United States merely confirmed the folly of such attempts. The would-be aviator was often portrayed as a figure of fun and his exploits were a source of inspiration for cartoonists and editors looking for amusing copy. In 1895, even H. G. Wells, who would later become a major prophet of air power and forecast so accurately the development of military aviation, mocked Maxim's failure in his first aerial story, 'Argonauts of the Air'. As late as 1903, after witnessing Langley's attempt to fly in Washington, just days before the Wright brothers' triumph at Kitty Hawk, a cynical editor of the *New York Times* noted,

> The ridiculous fiasco which attended the attempt at aerial navigation in the Langley flying machine was not unexpected. The flying machine which will really fly might be evolved by the combined and continuous efforts of mathematicians and mechanicians in from one to 10 million years.[1]

Little wonder, then, that in such a climate of cynicism and hostility even the news of the Wright brothers' achievement in December 1903 was initially dismissed.

The cinema, like any other form of popular culture, reflects the beliefs and attitudes of the society in which it is produced. But early film makers, although not reluctant to use aviators and their fanciful machines as the inspiration for comedy, were often surprisingly positive about the coming conquest of the air; perhaps because they were themselves in the process of exploring a remarkable new technology and attempting to gain public acceptance. The earliest aviation films were little more than a brief opportunity for the film maker to demonstrate his ability to create an illusion through trick photography and focused upon the novelty of the flying

machine. Nevertheless, there were few doubts expressed in these films about the future of aviation. By about 1906, although still influenced by the novelty of flight, the aviation film had become established as either a comedy or drama which took as one of its central concerns the aviator and his machine. From 1909, and given the increasing tensions within European society, a third category began to emerge – films which attempted to predict how the aeroplane might be used as a destructive force in future wars.

Much of the pioneering work on developing moving pictures took place in France and it was there, in 1901, that probably the first film to deal with the flying machine was made; a one-minute novelty by Ferdinand Zecca – *A la Conquête de l'Air*, released in Britain and America as *The Flying Machine*. Zecca, who directed most of Pathé's films at this time, created a miniature airship driven by pedal-power which is seen flying over Paris. Not only had Zecca made the first film to feature a flying machine, but he had also devised split-scene photography to provide realism. The flying machine was suspended from the roof of the studio and filmed against a black backdrop. The film was rewound and the upper half of the lens was covered while filming a panoramic view of the city. When projected, it appeared that the machine was actually flying over the city. The result, although primitive by later standards, proved popular with audiences. When the film was shown in America, Edwin S. Porter of the Edison Company produced his own version – *The Twentieth Century Tramp* or *Happy Hooligan and His Airship* (1902). Porter substituted Fred Opper's popular cartoon strip tramp, 'Happy Hooligan', for the inventor and New York for Paris.[2] Thus began a three-way relationship between aviation, comics and cinema which would mature in the 1930s. The flying bicycle also reappeared in a number of films, most notably in *Sammy's Flying Escapade*, a 1912 production from the French Eclipse Company. The inventor, Sammy, produces a flying bicycle but when he demonstrates it before his neighbours it refuses to work and the inventor becomes a laughing stock.[3]

The twelve-month period beginning in the summer of 1908 proved to be the watershed in the development of aviation. In June 1908 the Wright brothers successfully demonstrated their machines in America and Europe; Count von Zeppelin completed a flight of over 240 miles in his airship, the LZ–4; the first great flying meeting was held at Rheims in France; and the period ended with Bleriot's cross-Channel flight. These events clearly demonstrated to even the most sceptical that the 'air age' had really begun. This acceptance of the flying machine and the reality of flight was reflected within the film industry as novelty shorts featuring flying machines began to give way to narrative films – comedies or dramas – which used the

aeroplane/airship as simply another element within the narrative structure, a development which would seem to suggest that even as early as 1909, the flying machine had become, if not commonplace, at least an accepted cultural artefact. The developments in aviation technology were mirrored by technical improvements in popular cinema and by the rapid growth of the film industry. In Europe, entrepreneurs began to establish theatres exclusively devoted to the projection of film from around 1907. Here, Europe lagged behind America, which had seen the rapid growth of nickleodeons after 1902–3. The development of cinemas generated a greater demand for films and by the end of the first decade of the twentieth century most nations had at least the beginnings of a film industry. This was not confined to North America or Europe: for example, the first films were produced in Japan around 1908, and by 1912 at least one film maker was at work in India. Greater demand and increasing competition among film producers stimulated technical improvement, resulting in a more exciting, more elaborate and more commercial product.

Aviation was new, exciting and clearly offered opportunity for the film maker to explore the effects that could be achieved through photographic trickery and elaborate studio sets. At the same time aviation could provide the basis for an exciting chase or a good joke. *The Man Who Learned to Fly* (1908) from the British Hepworth Company is a typical example. A would-be aviator falls asleep in his study and dreams he is flattened by a garden roller. Attached to a string, he is flown as a kite by the gardener's boy, soaring over rooftops and terrifying passers-by. Of more interest is Charles Urban's 1909 production *Professor Puddenhead's Patents: The Aerocab*. The professor featured in a number of Urban's films and in this one builds an aeroplane reminiscent of the Wright brothers' *Flyer*. This is stolen by his mischievous children who find it easy to operate. The flight over London provides an opportunity for Urban to use an aerial view of the White City Exhibition and to indulge in a number of exciting special effects. *The Airship* or *100 Years Hence* (1908) from American Vitagraph combined novelty and comedy. Advertised as 'A forecast of a probable means of navigation in the coming century', the film was never intended to be taken seriously.[4] Running seven minutes, the story relates how a young couple go for a flight in an airship. They amuse themselves by throwing cabbages at those below until a policeman mounts his aerocycle to investigate, only to collide with another aviator who falls into the sea.

Giving aviation films a topical slant was the French 1909 production, *Bleary-Oh the Village Aviator* from Gaumont. Here we have the inventor whose machine is a variation of the flying bicycle but this time with substantial

wings. The whole village turn out to witness the maiden flight. The aviator, however, is unable to control his machine and it careers through the streets, smashing windows and knocking down lamp posts before it eventually takes to the air. It finally explodes over the village, hurling the inventor to the ground. Given the punning title *Bleary-Oh* on release, the film was an early attempt to profit from a spectatcular flight; in this case the publicity surrounding Blériot's cross-Channel flight of the same year. *Rescued in Mid-Air*, a British film of 1906, was perhaps the first to hint at the beneficial nature of the aeroplane when an inventor uses his flying machine to rescue his daughter trapped on a high church tower. *The Aeroplanist's Secret* (1909) shows us something of the obsessive nature of aviation pioneers. An engineer has built a new and powerful machine but lacks a suitable powerplant. He has no compunction about stealing this from a rival. However, moral conventions ensure that the thief loses his life when his machine crashes on its test flight.

Far more important in the development of public 'airmindedness' were the dramas featuring the aeroplane as a virtually commonplace machine, which were made in increasing numbers from 1908. These films used the flying machine as an integral part of the narrative, while many others included aircraft as an incidental element to add momentary excitement or interest. The 1914 Cricks and Martin detective story, *Paul Sleuth and the Mystic Seven*, had the villains escaping by balloon while the intrepid detective gives chase in an aeroplane. *Through the Clouds* (1913) and *Terror of the Air* (1914), both British productions, also feature an aerial chase at the climax of the narrative. A fight in a balloon between hero and villain provided a thrilling end to the American feature *Drama in the Air* of 1912. In the 1909 French film *Aviation Has its Surprises*, an aeroplane provides an ingenious means of transportation for a young girl to visit her lover. The flying machine was also an effective means of escape. In *An Aerial Elopement*, a 1909 story from Charles Urban, young lovers use an aeroplane to escape an irate father. The film was presumably very successful for it was remade in 1911 by Clarendon under the same title. Thus, by the eve of the First World War, the flying machine had been adopted by film makers as both an exciting central focus around which narrative could be constructed and as just another machine, albeit a novel one, for human convenience in an increasingly technological world. However, theorists had already seen that there were other, less benign uses for the aeroplane and again film began to reflect these pessimistic notions. The French 1909 production of *Burglary by Airship* has the modern burglar using an airship to commit his crimes. Although the burglar is eventually brought down by rifle fire, a reviewer noted: 'When flying

machines become more popular they will not be an unmixed blessing if this film be any criterion'.[5] Such a comment echoed the view held by many who believed that while the conquest of the air might be a positive benefit for humankind, there was also a dark side to the flying machine.

<div align="center">II</div>

Before 1914, films which explored the flying machine's potential as an engine of destruction appear to be a peculiarly British concern. It should not, however, surprise us that while other nations focused upon the benign face of aviation, the British should look to its dark side: to how the flying machine might be employed in future warfare. Britain had long enjoyed immunity from the threat of foreign invasions. Protected by the Channel and the power of the Royal Navy, Britons, despite sending their armies to fight an endless succession of wars across the world, were secure in the knowledge that the homeland was safe. Never having had to come to terms with the possibility of invasion like Continental nations, the British were hyper-sensitive to anything which threatened that security, be it French emperors or German battleships. The aeroplane, once it reached the practical stage, was indeed a major threat. H. G. Wells, commissioned by Lord Northcliffe's *Daily Mail* to consider the significance of Louis Blériot's cross-Channel flight, encapsulated these fears. 'It means', he wrote, 'that England is in mortal danger and has lost the lead in the Darwinian struggle for national supremacy in strength and ingenuity, England has lost its lead'.[6] The flying machine could cross geographical boundaries, bypass strong points, armies and fleets and strike directly at the heart of the homeland. And worse: the British had apparently lost their industrial and technological advantage by allowing a mere Frenchman to construct the machine that had conquered the Channel.

This realisation resulted in a wave of minor panics, which regularly occurred until 1914, that German Zeppelins were flying above docks and arsenals under cover of darkness, mapping invasion routes and likely targets for the coming Anglo-German War. Fear of aerial attack was to haunt the British people from that point on until it climaxed in the 1930s, when even politicians and soldiers succumbed to the belief that the 'bomber will always get through'.[7] In retrospect it is easy to see that these fears were part and parcel of the paranoia about national defence that developed in Britain from the end of the nineteenth century. In view of British insecurity and alarm at what many perceived as the beginnings of a moral and industrial decline, it was inevitable that any new technological development should be almost immediately evaluated for its military potential. Interestingly, during the

inter-war years and after, British aviation films were frequently used to counter the claim that the country had lost its technological 'edge' by showing that Britain was still indeed a major player among the industrialised nations.

The rapid growth of cinema itself and especially its popularity with working-class audiences, for example, persuaded the War Office, as early as 1900, to make use of the medium. Films about the Empire were commissioned to encourage recruiting,[8] a clear example of the manner in which a new technology was quickly adapted for military purposes. Nor was it only the medium that was adopted, the message could also be shaped to serve military needs. The Establishment did not become directly involved in film production until after 1914, but film makers quickly discovered that military and naval themes were popular subjects with audiences. Beginning as early as 1901 with titles such as *The Army Film* and *The Sneaky Boer*, producers kept up a steady output of militaristic titles: both expensive narratives such as *In the Service of the King* (1909) and *Lieutenant Daring RN* (1912), and cheaply produced factual films like *Birth of a Big Gun* (1911) and *A Dreadnought in the Making* (1912).[9] Such films clearly indicate something of the popular militaristic attitudes prevalent in the decades before 1914. The flying machine as a weapon of war had long since found a niche in popular fiction and by 1900 the tale of future war in the air was as common in the popular boys' papers as it was in novel form. Nor were these notions confined to fictional works for they were accompanied by a stream of reasoned predictions from air pioneers, politicians and serving officers. The Establishment, contrary to popular notions, were not hesitant in exploring the future uses of the flying machine. The War Office opened negotiations to purchase a *Flyer* from the Wright brothers in 1904 and, although this came to nothing, a military air service (Royal Flying Corps) was established as early as 1912.[10] Given the widespread ideas that the next war would certainly include the use of flying machines, it is not surprising that the aeroplane should so rapidly have become a suitable subject for a sub-genre of war films in Britain.

The destructive potential of the flying machine was seen at its most basic level in a number of adventure films. In 1910, Kineto released *The Aerial Submarine* — a tale of a marvellous creation, part airship, part submarine, and a concept long popular in novels and boys' papers. The film provides some idea of how modern-day pirates might adapt the new technology to their evil ends. The machine is used to sink passenger vessels by aerial bombardment and then submerges to loot the sunken liner. Even a Royal Navy cruiser is powerless against the aerial pirates and only a fortunate accident destroys this threat to naval supremacy and the freedom of the seas. Closely related

to this film was the Cricks and Martin production *Pirates of 1920*, released the following year: a spectacular feature that was modestly advertised as the 'most startling film ever staged and a wonderful forecast of the wars of the future'.[11] Here the gang of pirates use their giant airship to attack a British liner carrying bullion. Threatening the ship with their guns, the pirates swarm down rope ladders to plunder. Having completed their mission, they bomb and sink the vessel. Only one of the crew survives, Lieutenant Jack Manley. After a series of adventures Manley succeeds in killing the pirate leader and capturing his men. Running for fifteen minutes, *Pirates of 1920* proved immensely popular with audiences and was reissued a number of times, the last being in 1915.

More directly related to future warfare was Charles Urban's 1909 production *Airship Destroyer* (also known as *Battle in the Clouds*), directed by Walter Booth. The story is told in three parts. Part One reveals the anonymous enemy's preparations: the airship being loaded at a secret 'aerocamp' and taking off on a raiding mission. Meanwhile in England, a young inventor fails to persuade his sweetheart's father to allow them to wed. Part Two begins with the enemy indiscriminately bombing the English landscape. A train is derailed and lines destroyed. British aeroplanes take off to intercept the raider but are easily destroyed by the superior enemy. Part Three shows us how the inventor saves the day. His latest invention is an aerial torpedo – an electrically controlled missile which can be guided to its target from the ground. The inventor destroys the raider and, having proved his worth, is allowed to marry his sweetheart. *The Airship Destroyer* brought together two of the primary public concerns about attack from the air: a belief firstly that Germany had been secretly building a huge fleet of giant Zeppelin bombers (the airship of the anonymous raiders bears a remarkable similarity to a Zeppelin) which awaited only the right moment to unleash their deadly cargo on British cities; and secondly that, although the British Army did indeed have its own aeroplanes, they would be inadequate to protect the nation when an air attack came. Booth clearly built upon the fears of aerial bombardment that had been raised in the sensational tale, *War in the Air* by H. G. Wells, published only months before the film's release. Booth's publicity for the film announced 'War In The Air! Possibilities Of The Future! An actual motion picture prediction of the ideas of Rudyard Kipling, H. G. Wells and Jules Verne'.[12] The film was remarkably well made with highly sophisticated models and was popular enough with audiences to be re-released a number of times, the last being in 1915 at a time when the Zeppelin raids on British cities gave it a new relevance.

In 1911, Walter Booth wrote and directed a sequel to the *Airship Destroyer*,

the even more frightening *Aerial Anarchists*. Made at a time when Anglo-German relations were apparently improving, the director was careful not to infer that the raider was German. Instead, it is a group of anarchists who construct a giant aeroplane with the intention of destroying London and bringing about the collapse of the Empire. Once they are airborne, nothing appears capable of halting their mission of destruction. Over London they release their bombs and clever model work shows the destruction of St Paul's Cathedral and other well-known landmarks. Only a sturdy young Briton flying his own technically superior aeroplane damages the raiders and forces them to return to their base. Then, guiding army units to their lair, he watches over the complete destruction of the anarchists. As Phil Hardy has noted, 'Booth uses his film to warn a complacent civilization of the horrors in store if the new power of manned flight falls into the wrong hands'.[13] The realistic sequence where St. Paul's is destroyed must have had a considerable impact upon the relatively unsophisticated audiences of 1911; and while many might take comfort from the official War Office line that civilised nations would never indulge in the indiscriminate bombing of undefended cities, such films began to create a phobia about aerial bombardment that would become so powerful in the late 1930s it would even influence foreign policy decisions. *Aerial Anarchists* and *The Airship Destroyer* should rightly be seen as the precursors of a long line of 'warning' pictures which included 1930s productions like *Things to Come* and *Q Planes* and later cold war features such as *Dr Stangelove*, *Fail Safe* and *Dawn's Early Light*. In striving for realistic special effects, the makers of these films were constantly improving film technology. Thus the production of aviation and other spectaculars was providing a continuing stimulus for the industry.

The Flying Dispatch, an Urban production of 1912, updates a theme common in war literature: the soldier girl who follows her lover to war. Here the story tells of a young military airman who discovers the hideout of a spy ring and who plans to bomb them. Setting out on his mission, he is surprised to find his fiancée, dressed in soldier's uniform, hiding in the aeroplane. However, she proves to be of considerable use for she flies the plane while he carefully aims the bombs. More interesting, perhaps, than the film's updating of an existing literary theme, is the suggestion that women could fly aeroplanes as easily as men. And here, the film was merely reflecting contemporary reality. Women pilots had achieved a measure of success in this period; the first, Baroness Raymonde de la Roche, gaining a licence in 1910, while in 1912, in a blaze of publicity, the American actress turned aviatrix Harriet Quimby flew the English Channel. Even so, *The Flying Dispatch* appears to have been the only film made before the 1920s which featured a woman flier. However, far more

dramatic was Solograph's 1914 film *Flight of Death*. The film relates how a young English sportsman, desperate to stop a foreign aeroplane from bombing the homeland, uses his own flying machine to ram the enemy — thus sacrificing his life for his country — a most appropriate theme for a film released on the eve of the Great War.

Films were not produced in a social vacuum but emerged from a specific cultural context and early twentieth-century culture had already defined a number of widely accepted/expected roles for the flying machine. These definitions had been created through popular literature and it was inevitable that the first aviation films would draw upon the ideas established within the literary tradition of aviation fiction. Novels and stories which took as their theme the coming conquest of the air, and which were frequently related to the future war sub-genre, had become increasingly common in the latter half of the nineteenth century and by 1900 were a standard feature of the popular boys' papers. In papers such as the British *Boys' Friend* and *Dreadnought* or American weeklies like *Brave and Bold* or *The Frank Read Weekly Magazine*, intrepid explorers used the flying machine to discover fabulous lost cities, detectives regularly pursued criminals who used airships to escape, while heroic airmen rescued countless heroines and thwarted the machiavellian plotting of spies and saboteurs.[14] Such fictions virtually defined the manner in which the public thought of the flying machine so it is not surprising that early film makers plundered this literature to create the first aviation films. Perhaps more than any other novelist it was Jules Verne who created many of the basic ideas ideas surrounding the conquest of the air. In his popular novel *Clipper of the Clouds* (1885) and its sequel *Master of the World* (1904), Verne established a model of the great airship of the future which provided inspiration, not only for later writers, but for film makers as well. Verne's novels have frequently been filmed but rarely have film makers done justice to his work. This is certainly true of the 1961 production *Master of the World*, directed by William Witney. Inferior sets, poor direction and a confused story ensure that little of what Verne intended gets through to the audience.

In his novels Verne clearly explored the paradox that while the flying machine could be a powerful agent of civilisation and progress, in the wrong hands it could also be a terrifying engine of destruction which would change the whole nature of warfare. Thus films such as the highly successful *Airship Destroyer*, *Aerial Anarchists* and *Pirates of 1920* can be traced back through novels like H. G. Wells' *War in the Air* (1908), George Griffiths' *Outlaws of the Air* (1895) to Verne and *Clipper of the Clouds*. Other films drew even more directly upon a literary source. The 1910 production *Burglary By Airship*, for example, was taken from the opening of James Blythe's 1906 novel *The Aerial Burglars*;

while *Paul Sleuth and the Mystic Seven* was little more than a reworking of 'Winged Terror', a Sexton Blake tale published in 1909 in the *Boys' Herald*. Clearly, then, the development of aviation films demonstrates a close relationship with established literary traditions. And as cinema continued to develop, this relationship would become ever closer.

The pre-1914 aviation films also reinforced some of the main stereotypical images from the world of aeronautics which had been first created in the literature. The eccentric, single-minded but benign inventor was a stock character of many of these films just as he had been in the novels and stories. Obsessed with finding the secret of flight, his overriding belief was that the conquest of the air would bring great advantages to mankind. This character emerges again and again in the aviation film, and once the skies have been finally conquered, he turns his attention to better machines, safer flying and eventually to the conquest of space. His life's work is undertaken to improve the human condition, and even in later films, as we shall see, the dreamy, obsessive inventors, R. J. Mitchell and Barnes Wallace, in *First of the Few* and *Dam Busters*, develop their new weapons only to ensure the destruction of the Nazi menace and bring about a better world. Occasionally, in these films, the inventor is merged with the most important stereotype of aviation stories and films, the heroic airman – as in *Aerial Anarchists*. But although common in the literature, the pilot hero made few appearances in the pre–1914 films. Certainly Paul Sleuth, in *Paul Sleuth and the Mystic Seven*, is both heroic and a pilot, but his heroic ranking depends upon factors other than his ability to fly. There are certain elements of the heroic in the male leads of *Terror in the Air* and *Through the Clouds*, but again those heroes are not primarily pilots. Only in *Aerial Anarchists*, *Flying Dispatch* and *Flight of Death* do we have early versions of the hero type that will become increasingly familiar after 1914. However, to compensate for this lack in narrative features actuality film dealt with the airman by elevating almost every flight to a major triumph for the hero of the skies.

III

Actuality film – the filming of events as they happened – provided the first raw material for commercial screenings. But it was waning public interest in these short items that paved the way for the development of narrative film. However, actuality shorts or simulations remained a subsidiary part of the cinema programme. These 'topicals' or 'interest' films covered a variety of events from state occasions and news items to sporting events and travelogues of exotic places. By the end of the first decade of this century, the topical short had begun to give way to the news compilation, a weekly newsreel. As

early as 1909, Charles Pathé initiated his Pathé-News in France, and this was soon competing with rival newsreels such as those produced by Warwick Trading or Urban in Britain and American products from the Hearst Corporation and the Fox and Paramount Studios. Aviation events – epic flights, races and meetings – provided exciting footage for newsreel producers and it was through this actuality film that the public were given their first experience of the conquest of the air. Cameramen were present at many of the historic moments in the history of flight, and from around 1908 they covered almost all of the major flying meetings. Thus cinema audiences were presented with a continuing view of the rapid development of aeronautics. Initially, actuality film illustrated rather than commented upon events, but, as Rachel Low has pointed out, it rapidly moved from the merest statement of fact in the early days to the 'systematic presentation of related fact'.[15] By 1909, through carefully chosen captions and by focusing attention on selected images, film makers were able to create certain ideas about flying. For example, by drawing attention to aviation fatalities and spectacular crashes, film accentuated the dramatic and dangerous aspects of flying and, by implication, elevated the airman to heroic status – a man who continuously risked his life as he struggled with nature and attempted to develop this new technology. A useful example is the film coverage of the military funeral of the British pioneer S. F. Cody in August 1913.

Through the popular press but above all through cinematic images, the notion of the heroic airman, first created in late nineteenth-century literature, was disseminated and powerfully reinforced for a mass audience. Claude Grahame-White, perhaps the most important of Britain's pre–1914 airmen, is a useful example. A flamboyant and successful businessman who had done much to promote the motor industry, Grahame-White learned to fly in 1910 – the first Briton to gain an internationally recognised certificate. However, it was his participation in the *Daily Mail's* London–Manchester Air Race that established him as Britain's foremost aviator. Although he failed to win, his brave effort endeared him to the public. The race had exceptional news coverage but, more importantly, much of it was filmed, even Grahame-White's desperate and dangerous attempt to make up lost time by flying at night. Projected at venues throughout the nation, the overriding message is one of supreme heroism: the lone pilot, risking his life in a continual battle against the elements as he masters the new technology.

Grahame-White became established as one of the celebrities of Edwardian Britain, and interestingly, he continually used film in his campaign to make Britain 'airminded'. Having developed the London Aerodrome at Hendon, probably the most popular aviation venue in the country, he had many of his

flying exhibitions filmed and a number of these were shown commercially. In 1911 he took a cameraman aloft and filmed an airman's view of London. Shown commercially, this film clearly emphasised the god-like view of the airman and a visual sense of the feelings Cecil Lewis would put into words some twenty-five years later,

> The earth, so far below! A patchwork of fields, browns and greys, here and there dappled with the green of spring woods, intersecting ribbons of straight roads, minute houses, invisible men . . . Men! Standing, walking, talking, fighting there beneath me! I saw them for the first time with detachment, dispassionately: a strange, pitiable, crawling race, to us who strode the sky. Why God might take the air and come within a mile of earth and never know there were such things as men. Vain the heroic gesture, puny the great thought! Poor little maggoty men![16]

But such sensations were the prerogative of a handful of exceptional men who willingly risked the dangers of flight. How could they not be different from other men; heroes who stood head and shoulders above the humdrum mass? Grahame-White's experience was not unique. In Europe and in the United States film was helping to create the image of the air hero. In Germany, as Peter Fritzsche, has shown 'Zeppelinmania' swept the nation after the successful 1908 flights and elevated the elderly Graf von Zeppelin to national hero status. France had Santos-Dumont and Louis Blériot, and in America Glenn Curtiss, Arch Hoxey and even the staid Wright brothers were the first heroes of the air age. Through newsreel, their every flight became an epic and their names synonymous with bravery.[17]

But newsreel was not the only format through which aviation was promoted in pre–1914 cinema. In January 1909, Pathé released what was probably the first aviation documentary film. Under the title *The Different Aeroplanes*, the French company assembled a fairly comprehensive examination of the world of aviation. Using a selection of old stock and new footage the film included scenes of a flight by Henri Farman in 1907, an attempt by Blériot on the world altitude record and Wilbur Wright's exhibition flight of summer 1908. There was also an impressive line-up of French aviators: Alberto Santos-Dumont, Ernest Archdeacon and Louis Delagrange. A novel aspect was a tour of the Voison factory at Billancourt, then one of the centres of the French aircraft industry, where the audience was given a glimpse of the mechanics of aircraft production.[18] Such films promoted airmindedness as an almost incidental factor in their attempt to capture public interest, but a more deliberate form of air propaganda was being developed in Britain. In 1912, the Aerial League of the British Empire, formed in 1909 to promote British aviation, decided to supplement its lecture

programme with filmed items showing the latest developments in aeronautics. 'If the people cannot come to the aerodromes,' wrote the League Secretary Colonel H. S. Massy, 'the aerodromes must be brought to them through the medium of cinematograph films.' By the following summer a number of film shows had taken place. However, we lack details of what these films were and whether they were specially filmed for the League or standard products leased from commercial distributors.[19] In America, Henry 'Hap' Arnold, a young pilot of the United States Army, appeared in two short commercial films in 1911 to publicise the need to develop military aviation. Arnold eventually became the commander of the US Air Forces in the Second World War and frequently took advantage of the film industry to promote the service.

By 1914, then, the film industry had adopted flying as a suitable subject for narrative, frequently featured flying machines in its products and had considerably helped in promoting a public awareness of the potential of aviation. Narrative and actuality film had begun to create the enduring character stereotypes of aviation, and through the Aerial League of the British Empire, the importance of film as a channel for air propaganda had been established. When war came in August 1914, both the aviation and film industries were poised on the threshold of rapid growth. The Great War acted as a forcing house for both industries: aviation advanced as nations competed for ever more powerful weapons and new ways of striking at the enemy, and film developed as entertainment, a distraction from the horror of war, and as the most dynamic channel yet devised for the dissemination of national propaganda.

NOTES

1 Quoted in Valerie Moolman, *The Road to Kitty Hawk* (London, 1980), 149.
2 Phil Hardy, *Encyclopedia of Science Fiction Movies* (London, 1984), 22–3.
3 The flying bicycle even found its way into the climax of Steven Spielberg's 1982 science fiction classic *ET*.
4 Hardy, *Encyclopedia of Science Fiction Movies*, 30.
5 *Ibid.*, 40.
6 H. G. Wells, 'Of a Cross-Channel Flight', *Daily Mail* (27 July 1909).
7 On the Zeppelin panics in Britain see Alfred Gollin, *No Longer an Island: Britain and the Wright Brothers, 1902–1909* (London, 1984), ch. II; Michael Paris, *Winged Warfare: The Literature and Theory of Aerial Warfare in Britain, 1859–1917* (Manchester, 1992), ch. 4. On the fear of aerial bombardment in the 1930s see Uri Bialer, The Shadow of the Bomber: *The Fear of Air Attack and British Politics, 1932–1939* (London, 1980).
8 Nicholas Pronay, *Propaganda, Politics and Cinema* (London, 1982), 15.
9 Rachael Low, *History of the British Film, 1906–1914* (London, 1949), 162–5.
10 On the negotiations between the War Office and the Wrights see Gollin, *No Longer an Island*; the creation of the Royal Flying Corps is best dealt with in Malcolm Cooper, *The Birth of Independent Air Power* (London, 1986).
11 Hardy, *Encyclopedia of Science Fiction Movies*, 45.

12 *Ibid.*, 34.

13 *Ibid.*, 43.

14 The best survey of future war fictions is I. F. Clarke, *Voices Prophesying War, 1789–1984 (Oxford, 1966)*; on air war fictions see Paris, *Winged Warfare*, ch. 2. On aviation literature generally, Laurence Goldstein's *The Flying Machine and Modern Literature* (New York, 1986) is an excellent survey.

15 Low, *History of British Film*, 151.

16 Cecil Lewis, *Sagittarius Rising* (London, 1936, Penguin edn. 1977), 54–5.

17 On the creation of air heroes in Germany see Peter Fritzsche, *A Nation of Fliers – German Aviation and the Popular Imagination* (Cambridge, Mass., 1990); in the USA see Joseph Corn, *The Winged Gospel – America's Romance with Aviation, 1900–1950* (New York, 1983), and for France, Patrick Facon, 'Grandeur through Aviation', paper delivered at the International Aerospace Historians' Conference at the Smithsonian Institution Washington, April 1990.

18 *Bioscope* (14 Jan. 1909), 22.

19 Paris, *Winged Warfare*, 96–7.

3　The chivalry of the screen: films of the Great War in the air, 1914–18

I

Of the armies that went to war in 1914, most had made at least some preparation to use the aeroplane for military purposes, yet few generals really expected it to play a major role in the conflict. During the initial war of movement, airmen proved useful in locating the enemy, but as the war turned to stalemate and the positions of the rival armies became entrenched, scouting became less important. However, in the endless attempts to break through the enemy lines, aeroplanes began to perform a variety of roles: photographing the trench systems, directing artillery fire and patrolling the front. More important was the introduction of air fighting, as pilots of both sides attempted to deny their rivals information about troop movements and new defences. Although some machines had been armed before 1914, air fighting did not really develop until the appearance of the synchronised machine gun, produced by Anthony Fokker in 1915 for the German Air Service, which allowed automatic weapons to be fired through the propeller arc. This simple innovation meant that the aeroplane became little more than a flying gun. The pilot pointed his machine at the target, pressed the triggers and destroyed the enemy! With this new weaponry, came the cult of the air fighter. The synchronised gun gave German pilots an undeniable initial advantage over their French and British rivals. In particular, two pilots, Oswald Boelcke and Max Immelmann, improved the techniques of fighting in the air and became famous for their prowess in combat. But by 1916, the Allies had developed their own synchronised gun and air combat became less one-sided. In the meantime, both sides began the bombardment of the enemy. In 1915 Germany used Zeppelin airships to bomb England in an attempt to undermine British morale; while at the Battle of Loos in the same year, the Royal Flying Corps (RFC) attempted to disrupt German communications and reinforcements as a prelude to the British offensive. From that point both strategic and tactical bombing became a legitimate part of military operations. The air war developed rapidly as faster and more

deadly fighters were developed and bigger and more powerful bombers attempted to inflict ever greater damage on the enemy.

The conflict also acted as a 'forcing house' for cinema; although as Bardeche and Brasillach have pointed out, the war initially almost ended film production in some European countries. In France, for example, 'most of the actors were called to the colours. Audiences momentarily needed no distractions, the studios were commandeered and it seemed as if movies were the one thing which the army did not want'.[1] And a similar situation prevailed among the other combatants. However, it was soon realised that film could provide an important record of events for audiences on the home front, would encourage recruiting and war production, explain the evil nature of the enemy and, most importantly, justify the war in neutral nations such as America. Propaganda quickly became a vital element of the war effort in all countries. But, as far as propaganda for domestic comsumption was concerned, it soon became evident that there was little about this war to glorify or romanticise.

The war that was fought was clearly not the war that had been expected. The idea of a short, decisive campaign of movement gave way, by the beginning of 1915, to a bitterly contested, drawn-out war of attrition waged in the mud of the North European plain. The traditional romantic images of warfare – dashing cavalry charges, acts of individual heroism, honour and glory – were hard to find in a war of mass death inflicted by high-explosive shells fired from miles behind the lines, poison gas or the anonymous bullet fired by the unseen sniper. This most unglamorous war of mud, blood and squalor offered almost nothing for the propagandist to glorify. Yet, compared to the horrific conflict on the ground, the war in the air appeared very different. Here, freed from the stalemate of the trenches, fliers pursued each other in the clean air, fought individual duels which could be likened to medieval tournaments and behaved, it was generally believed, according to a chivalric code which contrasted dramatically with the grim struggle of the ordinary soldier in his troglodyte world. Some airmen, the successful air fighters, were soon promoted as heroic icons, warriors who embodied the national spirit at war. All nations eventually paid homage in their propaganda to the knights of the air but it was in Germany that the cult of the aviator, propaganda and film were first successfully combined.

The French took the initial step in creating the 'ace' – a pilot who succeeded in shooting down five enemy planes – when Roland Garros brought down several German machines in April 1915 and was hailed as a national hero. But Garros was himself shot down and taken prisoner, which tarnished the image. The cult of the air fighter demanded that the hero fight

endless victorious duels among the clouds, or, failing that, die gloriously. But to be defeated and to survive that defeat as a prisoner was demeaning. By 1916 most nations were beginning to use their top-scoring pilots to enhance national prestige with the full co-operation of the military establishment (except the RFC whose commander, Sir Hugh Trenchard, considered that elevating a handful of pilots to heroic status was unfair to the majority). In the stalemate of war any success was worth exploiting. Thus, as Fritszche points out,

> The army quickly exploited Immelmann's popularity to sell war bonds and to advertise the success of the war. Reenacted in short films, which were distributed to field theatres along the front and metropolitan cinemas at home, his aerial victories served as instantly recognizable demonstrations of German prowess and German superiority.[2]

In newspapers, through morale-boosting tours of the homeland, on post-cards and magazine covers, but above all through the moving picture, the image of the air fighter was promoted. Actuality film could be presented to a vast audience with a degree of reality that was impossible through other cultural forms and which could present a truly dynamic image of the martial spirit of the nation. It was a vindication of the importance to the war effort of film which, ironically, the German government had sought to ban entirely as 'inappropriate to the seriousness of the situation' on the outbreak of war.[3]

When Boelcke and Immelmann were killed, other fliers took their place, a second generation of air heroes. Of these, the most famous was Manfred von Richthofen – the 'Red Baron' – one of the most enduring heroes of air warfare. The mystique of Richthofen was promoted through newsreel and short reconstructions of his more famous victories, but by the end of 1917, in an attempt to raise civilian morale, more substantial compilation films were beginning to emerge. Typical of these was the ten-minute production *War Fliers on the Western Front*. This showed commonplace aspects of the air war: photographing enemy trenches, attacking enemy observation balloons and dropping small bombs. Then the film concentrated on the air heroes, Immelmann, Boelcke and even a young Hermann Goering. However, it is evident that the main subject is Richthofen; indeed the shots of the early aces appear only as a prelude which leads inexorably to the emergence of the Baron, the 'Ace of Aces'. Richthofen is shown in a number of poses: with his dog, smiling and joking with other fliers while putting on his flying suit before a patrol and playing host to a captured British airman. A striking aspect of these scenes is the relaxed assurance of the fliers, often shown

sharing a joke with their comrades. The film ends with scenes of an aerial battle and the destruction of a British machine – the message is obvious. Clearly *War Fliers* revealed something of the everyday activities of the air service but, more importantly, it was rich propaganda for an elite force – the confident young eagles of the Second Reich. Such was the power of the Richthofen legend that when he was finally killed in April 1918, even Allied newsreels gave considerable coverage to his smashed Fokker and the elaborate funeral with full military honours provided by his enemies. Perhaps the most enduring quality of these new heroes was the manner in which they were attributed with a sense of chivalry. In the public imagination, even the most bitterly contested battles in the sky were fought according to knightly rules. Thus, while propaganda from all sides was directed at creating a monstrous image of the enemy soldier, air fighters, all honourable men and worthy opponents, were the single exception. Interestingly, this notion did not apply to the bomber pilot, whose function was believed to be the wholesale murder of women and children. This distinction was clearly expressed in the tribute to Richthofen published in France by *Matin*. He, the newspaper claimed,

> did not belong to that sort of German airmen which goes out like barbarians at night to murder women and children. On the contrary, his deeds gave proof of a certain noblesse and some inkling of gentlemanly feeling. Only the conspicuously gaudy colours of his planes, which were painted blood-red . . . betrayed his barbaric tastes and the height of his ambition.[4]

After his death, the Richthofen Squadron was commanded by Hermann Goering and there is a splendidly contrived film sequence in which we see Goering's plane take off, engage a British scout and dispatch it in flames. Landing beside the burning wreckage, Goering poses for the camera – the hunter and his prey!

Although the British officially frowned upon making heroes of individual airmen, they were not slow to use the exploits of the RFC to sell the war. As early as 1916, the War Office sponsored an eight-minute film showing co-operation between ground and air services. Released in April of that year, *The Eyes of the Army* revealed something of the everyday activities of the Flying Corps. Photographed by Geoffrey Malins, distinguished later for his work on the film *The Battle of the Somme*[5], the film is a straightforward account of how the Corps was employed. Following captions such as 'Going on Reconnaissance', we see a BE2c taking off, then ground receivers taking a gun-laying message from a circling aircraft. Other scenes include the

mandatory German wreck, which we are told was 'brought down by anti-aircraft fire'. Interestingly, the title reflects the army's narrow conception of how the RFC should be employed at this time. But even as the film was released the air war was changing and the film's emphasis on scouting was largely obsolete. More interesting was the 1917 War Office film, *With the Royal Flying Corps (Somewhere in France)*. Running for sixteen minutes, it clearly revealed the changes that had occurred in the air war over the past year. After various shots of machines being repaired and mobile workshops, the film poses a group of pilots from 60 Squadron, including the Canadian ace Billy Bishop, in front of their machines in a scene remarkably similar to German propaganda films. As the young pilots laugh and joke with each other they are apparently untroubled by thoughts of combat. Later scenes demonstrate the offensive activities of the RFC; an FE2 being 'bombed up' before a raid and a Sopwith $1\frac{1}{2}$ Strutter performing various stunts after the caption reading 'Evolutions. Daring but necessary to avoid enemy fire'. April 1917, known as 'Bloody April' was perhaps the point where morale in the RFC hit rock bottom. Superior German machines and tactics, and the insistence that the Corps continually fly predictable offensive patrols over enemy lines resulted in heavy losses. The situation was judged so critical that a government inquiry into the conduct of the air war was set up. Although the full seriousness of the situation was withheld from the public, it was obvious that something was drastically wrong. Hence, *With the Royal Flying Corps*, released in September, was an obvious attempt to promote public confidence in the air war and the RFC.

In April 1918, the RFC became the Royal Air Force, a fully autonomous force of equal rank with the other services. Although most airmen welcomed this freedom, the army and navy had resisted losing control of their air components. Thus, the RAF, facing considerable hostility from its sister services, quickly developed an awareness of the need for a positive public image. *Tails Up France — the Life of an RAF Officer in France*, released in the summer of 1918, was an early attempt to promote such an image. With a running time of fifty-one minutes, this was indeed a major production, well-filmed and edited and designed to show the new service to advantage. The film begins with student pilots completing their combat training on flight simulators, followed by scenes of Camel and SE5 fighters being armed and prepared for action. No caption is required to tell us that these machines will be used by those young pilots who have now completed their training. The camera, mounted in another aircraft, tracks the take-off and there follows an exciting aerial combat sequence. Despite its attempt at reality, this is clearly a

simulated combat, but the scenes of wrecked German aircraft are obviously intended to add to the realism. Back at the airfield, the pilots relax playing baseball and there is the usual line-up of smiling pilots in front of their machines. Unusually, since for most films focused only on officers, there are several sequences showing 'other ranks' repairing machines and relaxing. Overall, *Tails Up France* provides a convincing and comprehensive picture of life in the RAF.

Released just after the end of the war, *With the Eyes of the Navy*, is a fifteen-minute view of co-operation between air force and navy. The film has considerable interest in its scenes of airship and flying boat anti-submarine patrols. One shot shows an airship patrol over the North Sea spotting a hostile submarine. A morse signal is sent which attracts a nearby destroyer and this forces the submarine to dive, a clear statement that the air service plays a major part in the war against the submarine 'menace'. The final compelling shot shows British airships escorting the surrendered German High Seas to their last mooring – a sequence which might be read as suggesting that sea power had finally given way to air power. The short *Life of an Airship Squadron* (1918) deals mainly with life on the airfield; while *Royal Air Force: Per Ardua Ad Astra* shows an inspection of cadets at the School of Military Aeronautics, Oxford. Of far more interest is the fourteen-minute *Training Pilots for the Imperial Royal Flying Corps*, an American or perhaps Canadian film of 1917 filmed at a North American flying school. Here British and American cadets are shown receiving basic military training and then moving on to flying instruction. The final sequence shows the cadets in combat training and here, quite unusually for 1917, one aircraft has a camera mounted to illustrate the difficulties of keeping on an enemy's tail in a dog fight. Although this is intended as a training exercise, what clearly comes across to the audience is the drama and excitement of the high speed chase of aerial combat – a marked contrast for anyone with experience of the static war in the trenches.

The war of 1914–18 is often regarded as the first 'total' war – a war which involved whole populations. This had the effect of creating opportunities for women to work in areas which had previously been closed to them. The military establishment was no exception, and in 1918 a Women's Royal Air Force was created. Although women served mainly in Britain, they were allowed to perform a variety of important roles. In early 1918, the War Office commissioned a short recruiting film for the women's services – WRAF, WAAC and WRNS. *Sisters in Arms* showed little detail of service life, but later that year, *With the Women's Royal Air Force: Life on a British Aerodrome*, provided a comprehensive picture of the duties performed by servicewomen. The

opening shot shows women bringing out an anti-submarine patrol airship, but rapidly cuts to what a caption tells us is 'Mid-Morning Recreation' a cosy scene where the women have tea and relax in a canteen marked 'Women Only'. After a short scene of 'Rigging an Airship', we then see them 'Cleaning Aeroplanes'. Following a lunch break, the women are shown performing 'Clerical Duties', 'Cleaning Engines' and 'Covering Aeroplanes', which appears chiefly to involve sewing new canvas coverings for damaged aircraft. The main aim of the film would seem to be to demonstrate to potential recruits that the work involved was little different from familiar domestic chores. and that in the WRAF they would enjoy companionship and comfortable conditions while supporting the war effort. Such was the apparent contribution women were allowed to make to the war in the air![6]

In Europe, as we have seen, the war initially had an adverse effect upon film production. Shortage of materials became serious and many studio personnel enlisted or took other war work. Although all nations came to realise the importance of film as a vehicle for national propaganda or simply to boost morale, feature films dealing with the war remained exceptionally difficult to make. Technical problems and difficulties in re-creating the images of warfare severely limited the themes that film makers could tackle. By their very nature films dealing with aerial aspects were an even more problematic task. One method open to innovative film makers was animated films. As Clyde Jeavons points out, the war greatly stimulated the production of animated films in Britain in its early stages.[7] Precisely because it was relatively easy to create and could carry effective propaganda combined with entertainment, animation was an easy medium through which producers could explore air war themes.

In Britain, the one aspect of aerial warfare which impinged upon almost everyone was the bombing by German Zeppelins which began in early 1915. Animated films were the first to reflect this development. In the spring of 1915, Ernest Mills produced his *What London Saw*, a short animation which portrayed a Zeppelin attack on the capital. More adventurous was Cherry Kearton's *An Aerial Invasion Frustrated* of the same year. This built upon the pre-1914 British paranoia about invasion and by using primitive animation showed how the Kaiser's Zeppelin-borne army were destroyed as they attempted to land in England. These early animations, together with the reissue of pre-1914 air attack films such as *The Airship Destroyer*, were the film industry's first response to the bombing of Britain. But by 1916, film companies had overcome the initial problems of producing films in wartime and could now create full-scale dramas. An interesting film which reflected

both concern about bombing and the widespread belief that German agents were guiding the Zeppelins to their targets was Criterion's *Tracking the Zeppelin Raiders*, released in the early part of that year. This relates how spies use a curious combination of wireless and homing pigeons to guide the raiders to key military targets. Fortunately, they are discovered by the authorities who, by sending false messages, trick the airships into destroying the spies' head-quarters.

By 1916, despite causing some damage, the Zeppelins had failed to achieve the result of breaking British morale. This, combined with serious losses and the realisation that airships were too fragile for war purpose, led the German military authorities to virtually halt the Zeppelin raids. Reflecting this development was Percy Smith's film *The Strafer Strafed*, which dealt with the destruction of the Schutte-Lanz airship SL.11 on the night of 2 September 1916. The airship was attempting to bomb north London when it was attacked by an RFC machine flown by Lieutenant Leefe-Robinson. The lieutenant fired into the airship and saw it catch fire and crash outside the village of Cuffley. Smith reconstructed the event in his house in Southgate using trick photography, models, 'cotton wool and trails of smoke'[8] The resulting short film appeared the following week. These air bombardment narratives both reflected current concerns and added to the developing anxiety about attack from the air. But although Percy Smith's film was reasonably popular because of its novelty value, the British public had begun to lose interest in war films from the middle of 1915. The appalling human cost of the war and hardships on the home front meant audiences wanted escapist, especially romantic, features. Only in mid-1918, with victory in sight, did the war film regain some of its former popularity.

Although the United States did not enter the war until April 1917, American film makers had begun to reflect the conflict long before that. In 1916, no doubt influenced by the future war genre so popular in Europe before 1914, D. W. Griffiths, probably the most significant film maker at work in America at that time, made his own contribution, *The Flying Torpedo*. This clearly owed a debt to Charles Urban's *Airship Destroyer*, which had been first shown in the United States in December 1909 under the title *Battle in the Clouds*. With little to fear from the German menace, Griffiths added his own nativist twist, for as Franklin points out, the film was calculated to arouse hostility to the 'Oriental', the much-feared 'yellow peril'.[9] Running for over seventy-five minutes and featuring Jack Emerson and Bessie Love, this was clearly a major production. The story concerns a young inventor who develops a radio-controlled flying bomb. However, before it can be put into production he is murdered by spies who steal the invention. His

friend, a novelist (played by Emerson) and his Swedish servant (Love) track down the spies and regain the torpedo. And they are just in time, for at that point an army of 'yellow men from the East' invade California. The flying torpedo is quickly mass-produced and used to drive the invaders out of America. Karl Brown, assistant to Griffiths' cameraman G. W. Bitzer, has left an interesting account of how the special effects were created,[10] but unfortunately, all prints of the film appear to have been lost. Griffiths dealt more explicitly with aerial attack in his 1918 Paramount production, *The Great Love*. With Henry B. Walthall and Lillian Gish, the film appears to be a reworking of the 1915 British film *Tracking the Zeppelin Raiders*. Karl Brown called it a 'nasty little off beat drama' with Walthall playing the 'dirtiest kind of scoundrel possible . . . a respected, honoured Briton by day, but at night he drove his expensive car to the target areas the Germans wanted to destroy and shone his spotlight upward to show the Zeps where to drop their bombs'. Again, Brown was responsible for the special effects and found his inspiration for the model work in an artist's impression in the *Illustrated London News*.[11] The semi-documentary *The Last Raid of Zeppelin L–2*, released in 1918, is a curious compilation of British newsreel footage and studio shots showing a raid on London and the subsequent destruction of the enemy airship at the hands of the RFC.

In the same year, American Pictures released the serial *Secret of the Submarine* starring Juanita Hanssen and Lamar Johnson. Basically a spy story, the final episode does climax with an exciting aerial chase when the foreign agent attempts to escape by aeroplane. Only one other aviation film appears to have been made in the United States before the end of the war: *Berlin via America*, released just before the Armistice. Francis Ford stars as an American aviator turned secret agent; his mission involves him posing as a German pilot and joining Richthofen's flying circus in order to mastermind a devastating Allied air raid on Berlin. *Berlin via America* is exactly the type of convoluted, unbelievable spy drama that would re-emerge time and time again from American studios during the Second World War.

The few narrative films made during the war years by British and American companies reveal little beyond reflecting the growing public concern at the prospect of bombardment from the air. The offical propaganda films, however, are far more important. They are a valuable visual source for the rapidly developing role of air power during the war. *The Eyes of the Army* (1916) clearly illustrates the narrow conception of military aviation as no more than an adjunct of the British Expeditionary Force during the early years. Yet only a year later *With the RFC* shows aircraft taking an

offensive role: being armed with bombs, testing guns and executing the complicated maneouvres required for air combat. But these films are more than simply a visual account of the development of military aviation; for together with popular fiction, newspaper articles and the memoirs of combatants, they significantly contributed to the growing cult of the air fighters: an elite group who were believed to have fought a chivalric and noble war and who upheld the traditional values and skills of the warrior in face of the increasing industrialisation of war. What is obvious in these films is the marked difference in training between infantry and airmen. Certainly aviation cadets undergo basic military training; as a caption in *Training Pilots for the Imperial RFC* tells us, 'the first necessity of an airman is that he must have discipline'. However, this is only a prelude to the real business of technical education and learning to fly and fight in the air, the development of individual skills and abilities and the creation of a military elite. Even a superficial viewing of these films reveals the contrast between the war in the air and the war on the ground. In *With the RFC*, for example, the scene of the pilots of 60 Squadron lined up before their machines shows us exuberant, cleanly dressed young officers laughing and joking. An almost identical scene is to be found in the German *War Fliers on the Western Front*. We are struck by the enthusiasm and high spirits of the young airmen in these films and cannot help but compare them with the grim faces of the trench fighters to be found even in such propagandist films as *The Battle of the Somme* (1916).

The camaraderie of the air war is also evident: the Richthofen Squadron entertaining the captured British pilot, the funeral honours for the fallen Richthofen in Allied newsreels, all contributed to the emerging cult of the air fighter and emphasised his chivalry and honour. Needless to say, all films focused on the successes of the air services. Both British and German films had the mandatory scenes of destroyed enemy aircraft. The *Eyes of the Navy* even has a contrived scene where a Lewis-gunner aboard the British airship NS7, on patrol over the North Sea, spots an enemy aeroplane and immediately shoots it down with only a couple of bursts. Only in the newsreels of Richthofen's funeral and in the scene in *Tails Up France*, where a British Bristol Fighter lands and a wounded pilot is gently lifted from the cockpit and driven away by ambulance, do we get any hint of the grim realities of aerial warfare. The later feature films that dealt with the war in the air developed this mythic cult of the air fighter and carried it to a far wider audience, but it was a myth that had its roots in the official propaganda films made during the war years.

II

The war had considerable impact on the technology of film making: the hand-held camera, telephoto lens and efficient view finders were all wartime developments. In America, as Jeavons points out, the Army Signal Corps (responsible for official military photography) produced a number of talented graduates who would eventually become successful directors and cinematographers of commercial film. Men like Victor Fleming, Josef von Sternberg and George Hill all owed their initial training to the military.[12] More importantly, while European film production had slowed because of the war, American production had been hardly affected. Consequently by the Armistice, the United States was in a position to virtually dominate the world of film. This trend had been noted as early as 1916. The British commentator, W. G. Faulkner, writing in the *Evening News*, claimed, 'The War has given one trade opportunity to America of which she is availing herself to the full. She is fast becoming the universal provider of moving pictures, the world's camera entertainer'[13] By 1920 this domination was complete. Hollywood, the home of the American film industry, was the undisputed leader in film production. Other nations, of course, continued to produce films – many of which are intellectually and artistically satisfying – but it was impossible to compete on equal terms with the expensive, glamorous and technically superior American product. In terms of a popular cinema which appealed to a mass audience, Hollywood set the trends and other nations could only attempt to emulate that success.

Following the Armistice, films dealing with the war almost disappeared from the screen; as one cinema history points out,

> public taste underwent a violent change. Overnight everyone suddenly sickened of the patriotic war pictures which had been turned out wholesale: miles of film had to be scrapped, other pictures taken out of production. There was a general shift from the heroic virtues of wartime to the light fare more suited to a victorious mood.[14]

But it was impossible to forget the war completely. In 1919 the great French director Abel Gance produced his classic anti-war statement, *J'Accuse*, and Hollywood continued to turn out a few cheaply produced war dramas. However, aviation films were technically difficult to make – dependent upon weather conditions and a substantial budget to hire aeroplanes, pilots and special equipment. In a climate where war films were generally unpopular, few producers would risk the financial outlay on expensive flying films. One film, however, was already in production at the war's end and this

was released in 1919: Crest's *A Romance of the Air*, a slight tale of war flying in France and starring Bert Hall and a youthful Brian Donlevy. Bert Hall was an old-time pilot who had flown as a mercenary for the Bulgarians in the Balkan Wars of 1912–13. Later he served in France with the Lafayette Flying Corps – the American volunteers who flew with the French on the Western Front.[15] Using Hall to perform the flying sequences, the film was an obvious attempt by the producers to exploit the romantic image of the Lafayette pilots. *Romance of the Air*, despite a grandiose launch, was only moderately successful. Arcadia Pictures also attempted to profit from the popularity of the air fighter when they persuaded French ace Nungessor to star in *The Sky Raider* in 1925. And Carl Laemmle of Universal Studios hotly pursued American flier Eddie Rickenbacker to star in a feature based on his war experiences.

However, real public interest in war features was revived only with King Vidor's spectacular 1925 production *The Big Parade*, a film dealing with the experience of American soldiers in France. The popularity of Vidor's film led eventually to a number of films which dealt with the air war. However, of the thirty or so American films that explored this theme, only three stand out as major productions: *Wings* (1927), *Hell's Angels* and *Dawn Patrol* (both 1930). The remaining titles are largely derivative in plot and many indeed borrowed aerial footage from one or other of the major productions. However, that so many were made is clear evidence of the popularity of air war films. The major features and many of the derivative productions were the work of a small group of Hollywood aviation enthusiasts: directors like William Wellman, Howard Hawks and Howard Hughes, and writers such as John Monk Saunders and Elliott White Springs. With the exception of Hughes, all had direct experience of war flying, having served with the Lafayette Flying Corps, the American Army Aviation Corps or the British RFC.

The financial returns of *The Big Parade* and *What Price Glory?* (1926) were a powerful argument that war was once again an acceptable subject for films. At this point, John Monk Saunders, an ex-army aviator turned screenwriter, persuaded Jesse Lasky of Paramount that a film about war flying could rival the success of Vidor's spectacular. Lasky took the gamble and Saunders was commissioned to prepare a script. William Wellman, a relatively unproven film maker, was chosen to direct on the basis of his own flying experience with the Lafayette Flying Corps. Both the two stars, Richard Arlen and Charles Rogers, were aviation enthusiasts, and Arlen had served in the Canadian RFC from 1917. Charles Rogers had learned to fly after the war, but later in 1942 would serve as a navy test pilot. To minimise the costs of

what was intended to be a lavish project, Paramount secured the assistance of the Department of War, which agreed to provide manpower, equipment and technical advice. The previous year, Congress had authorised a five-year expansion programme for military aviation and undoubtedly the Air Corps saw the film as positive propaganda which would enhance the reputation of the air service and stimulate recruitment. Lieutenant-Colonel Oscar Estes acted as liaison and technical adviser. Filming began in mid-1926 near San Antonio, Texas, and the production was completed late in the following spring.[16] The film deals with the training and combat experience of two young American pilots (Rogers and Arlen). After training, they qualify as fighter pilots and are sent to France. Unfortunately, they are both in love with the same girl (Jobyna Ralston). Their rivalry causes a rift between them and in an air battle with the German pilot, Kellerman, Rogers deserts his friend who is shot down and captured. Later, Arlen escapes by stealing a German Fokker. Returning across the lines he meets an American machine flown by Rogers who, of course, has no idea that his friend is flying the enemy machine. In the ensuing aerial duel, Arlen is shot down and killed. Rogers is grief-stricken when he finds out that he has killed his best friend and attempts to come to terms with his guilt.

The story, overly melodramatic and quite unbelievable, is clearly of importance only as a device to connect the exciting flying sequences – the air battle with the flying circus, the attack on German observation balloons, the final duel between Rogers and Arlen and a dramatic re-enactment of the Battle of St Mihiel, for which the army created a five-acre facsimile of the battlefield and provided 5,000 infantrymen as extras. To cover these spectacular sequences, Wellman used a number of cameras – twenty-one for the St Mihiel battle scene – and Harry Perry, the cinematographer, pioneered what were to become standard techniques for aerial filming. Perry and Wellman were not content to film the action from another plane, but wanted close-ups of the leading players in action. Perry's technicians welded camera mounts

over the engines and behind the rear cockpits. This allowed the principal actors to be shown, apparently flying their own single-cockpit pursuit planes. In reality, the planes had two cockpits, with the camera shooting over the head of the real pilot in the front seat; or shooting forward over the head of the real pilot in the rear seat, to concentrate on the actor, no matter what the direction of shooting.[17]

Other cameras were mounted on wings and undercarriage. To give the impression of speed and movement Wellman photographed the aerial

sequences against a background of clouds: on one occasion, he waited for four weeks to film one particular sequence. Most of the flying was performed by army pilots, but Arlen and Rogers flew in some of the less dangerous scenes and the spectacular stunts were performed by Dick Grace. Wellman, looking for authenticity, managed to acquire several aircraft of wartime vintage, but most of those used were disguised army machines.

Wings opened at the Criterion Theatre in New York on 12 August 1927. The lobby was decorated with seventeen huge paintings of famous war aviators, forming what was called 'The Aviator's Hall of Fame', and the film was dedicated to 'Those young warriors of the sky whose wings are folded about them forever.' Wellman's carefully constructed epic of air warfare was an instant critical and commercial success. Paramount could not have found a more opportune moment to release the film, coming as it did just three months after the Lindbergh Atlantic flight. Lindbergh had captured the public imagination and focused attention on aviation and the aviator. In such a climate, an epic of war aviation could hardly fail. To exploit the film's popularity, the publisher Grosset and Dunlap put out a hard-backed novelisation of the script illustrated with stills from the picture – surely one of the first occasions when this was done. In 1928, the film's success was acknowledged by the industry when, during the first Academy Award ceremony, it was acclaimed 'Best Picture of the Year'. *Wings* has rightly been called the last of the great silent epics but it was to wield considerable influence over later, more technically advanced films. Within months of its release the first derivative films began to emerge, but it was not until 1930 that the second of the major productions emerged.

Hell's Angels was very much the personal project of millionaire businessman Howard Hughes. An aviation and cinema enthusiast, Hughes had already produced several films when he saw *Wings*. Although impressed with Wellman's work, he believed he could do better and told an acquaintance that he wanted to make a film that would 'glorify and perpetuate the exploits of the Allied and German airmen of the World War'[18] With a script mostly put together by Hughes himself and with Luther Reed as director, production began in October 1927 with actors James Hall and Ben Lyon and the Swedish actress Greta Nissen. With typical fanaticism, Hughes wanted only genuine World War aircraft and had agents scouring Europe. He also wanted to buy two airships but was persuaded by his financial advisers that sixty-foot models would do just as well. Unfortunately, only a third of the eighty-seven aircraft finally assembled were genuine and Hughes had to make do with disguised contemporary machines. Curiously, one machine used in the film, a Pfalz D.XII, which is now on exhibition in the National Air

and Space Museum, was purchased for use in Howard Hawks' production *The Dawn Patrol*, filmed concurrently with *Hell's Angels*. When Hawks had finished with the machine it was sold to Hughes and appeared in his film and several other productions in the 1930s. Ironically it logged more hours flying in movie combats than it did in action on the Western Front.[19] With the interior scenes finished, Hughes took over no less than five airfields and began work on the flying sequences in January 1928. Deciding that he could better direct these himself, Hughes dismissed Reed and took over. Attention was lavished on the aerial combat scenes and Hughes drew up elaborate diagrams of movement and created three-dimensional models to study camera angles. Such was his demand for spectacular flying that three pilots were killed during the filming.[20] In March 1929, the two-million dollar silent epic was first shown to a less than enthusiastic audience in Los Angeles. In 1927, sound had been introduced and the public were no longer interested in silent film. Hughes, however, with an unlimited budget and a horror of failure, decided to completely remake the film with sound. The expensive aerial scenes only needed to have a soundtrack of engine noise, gunfire and other effects added, but the dialogue was a more difficult matter. Greta Nissen, the leading lady, spoke little English and was replaced with the virtually unknown Jean Harlow. With a team of writers and James Whale as director, new interior scenes were created around the existing action sequences.

Hell's Angels was finally released in June 1930. Attracted by the huge pre-launch publicity, a vast crowd assembled outside Grauman's Chinese Theatre for the premiere. Like *Wings*, the film was enormously successful but it was the exciting combat scenes that were the attraction. The final storyline, which most critics seemed to agree was absurd, told of two brothers, the idealistic James Hall and caddish Ben Lyon, who leave Oxford to volunteer for the RFC on the outbreak of war. Both are attracted to the same girl (Harlow). After a number of flying adventures in France, they volunteer for the highly dangerous assignment of bombing a German ammunition dump. On the way, they are jumped by Richthofen's squadron. However, their own squadron come to the rescue and there follows what is probably the most spectacular air battle ever re-created. Originally running for over twenty minutes and involving some Thirty-one aircraft, it is a wheeling, swirling dance of death carefully choreographed by Hughes. Finally the brothers bomb the dump but are shot down and captured. Threatened with death unless they reveal the plan for the Allied offensive, Lyon is about to talk, when Hall shoots him in order to save countless Allied lives. The noble Hall

is thereupon shot himself. Despite the silly story and the wooden acting, the film continued to draw capacity crowds and remained on the theatre circuit for the next twenty years, eventually earning Hughes some ten million dollars.

While *Hell's Angels* was in production, Howard Hawks, a friend of Hughes and another ex-aviator, was at work on *Dawn Patrol*, the final major aviation film to deal with the Great War. Like *Wings*, the story was provided by John Monk Saunders, but unlike the earlier films, Hawks intended to concentrate less on spectacle and more on realism. The film is set at a time when the German air service has superiority over the Western Front. The commander of the RFC's 59 Squadron (Neil Hamilton) grows bitter and disillusioned at having to order constant patrols which lead only to the death of his pilots. Promoted out of the squadron, he hands over command to his friend Courtney (Richard Barthelmess), who has been critical of his leadership. However, under the stress of command, of constantly sending out young pilots to die, Courtney eventually takes on a suicide mission himself. In a duel with the enemy ace 'Von Richter', Courtney is killed and command falls to the last of the squadron's original members, Scott (Douglas Fairbanks Jr.). Hawks' film has little of the ballyhoo of *Wings* or *Hell's Angels*, but appears a restrained and honest attempt to examine the problem of leadership in combat – a theme that would later be explored in films dealing with the Second World War such as *Twelve O Clock High* and *Command Decision* (both 1949). Although the flying sequences are expertly handled (Hawks did some of the stunt flying himself), there is no romantic interest and none of the glamour of the earlier films. First National clearly expected little from the film, especially as it was released just a month after the Hughes spectacular. It was issued quietly without a premiere, but contrary to expectations, it proved extremely popular and achieved considerable critical acclaim. *Dawn Patrol* has often been cited as an anti-war film but Hawks denied this: 'I've never made made a picture to be anti-anything or pro-anything,' he told Joseph McBride, 'I flew. I knew what the air force was up against'.[21] Seemingly, his intention was simply to re-create an accurate picture of air warfare, but what appears on the screen is a damning portrait of the pointlessness of war. In 1938, at the end of the cycle of World War One flying films, *Dawn Patrol* was remade by Edmund Goulding with Errol Flynn, David Niven and Basil Rathbone. It closely followed the original script and used the aerial sequences from Hawks' production. Both Rudy Behlmer and Jeffrey Richards rightly consider the *Dawn Patrol* to be the most satisfying film of the sub-genre.[22] But the success of these major productions ensured that the war flying film rapidly established itself as staple product during the

inter-war years. However, virtually all the later films were merely variations of one or other of the big three and almost all reused the same aerial footage.

Even before the end of 1927, the studios began to exploit the success of *Wings*. First National released *Hard-Boiled Haggarty* with Milton Sills. Based on a story by Elliott White Springs, another ex-aviator and a prolific writer, the film is little more than a romantic comedy about an American ace and his amorous adventures in Paris. Paramount countered with *Now We're In the Air*, another comedy with Wallace Beery that made use of aerial sequences from *Wings*; and Warners released *Dog of the Regiment* with Ross Lederman and Rin Tin Tin. Audiences were no doubt disappointed to discover that the flying ace was played by Lederman and not the dog. But the trusty animal does at least help the hero to escape from behind enemy lines after he is shot down. The last production of the year was Universal's *Lone Eagle* which centres on an American volunteer in the RFC who is accused of cowardice. To regain his reputation, he seeks out the enemy ace and in an aerial duel proves his courage. Paramount, eager to repeat Wellman's success, had him direct two other films in the sub-genre, *Legion of the Condemned* (1928) and *Young Eagles* (1930). The first, written by Saunders, starred Gary Cooper, who had established his reputation with a small part in *Wings*; the second, with Charles Rogers, was written by Springs. Both deal with disillusioned but duty-bound young airmen and both use aerial sequences first used in *Wings*. The same shots were used again in Stuart Walker's *Eagle and the Hawk* (1933) and, for good measure, supplemented by other scenes from *Dawn Patrol* and *Hell's Angels*. With Cary Grant and Frederick March and again written by Saunders, the film explores the gradual loss of nerve of a young British pilot (March) under the constant strain of battle. Eventually driven to suicide, his body is found by the loyal observer (Grant), who puts him into his plane and, once in the air, riddles the body with bullets making it appear his friend has died in combat.

It was, however, the vast footage of film shot by Hughes that provided the richest plunder for film makers. *Cock of the Air* and *Sky Devils* (both 1932) were basically comedies made by Hughes to employ previously unused sequences. Later films merely took the most exciting footage and constructed a thin plot around the scenes of air combat. *Crimson Romance, Hell in the Heavens* (both 1934) and *Suzy* (1936) were all created in this manner. *The White Sister* (1933), an appallingly sentimental romance with Clark Gable as a dashing Italian aviator, made use of the spectacular air battle filmed by Hughes to gain from the popularity of the sub-genre. Even MGM's *Today We Live*, based on a William Faulkner story and made by Howard Hawks in the same year,

included some of Hughes' best shots. *Crimson Romance* is an interesting example of the carelessness of film makers in their rush to get these films made and into the theatres. Desperately looking for a new approach, the film deals with two American pilots (Ben Lyon and James Bush) who volunteer to fly for Germany. However, when America comes into the War, Lyons swaps sides while Bush, a German-American, stays with the Fatherland and is subsequently killed – but not, as might be expected, by Ben Lyon. The aerial sequences were a mixture of new footage and material taken from *Hell's Angels*. This resulted in a bizarre scene where a German bomber with Lyon as the gunner (a sequence taken from the earlier film) is attacked by a fighter piloted by Lyon (a newly filmed shot). It should be noted that Ben Lyon, flying for the Allies, is the victor of the combat.[23]

Only two films from the cycle had completely original aerial sequences: *Lilac Time* (1928) and *Sky Hawk* (1929). The former, starring Gary Cooper and Colleen Moore is little more than an overly sentimental romance with a war background. *Sky Hawk*, however, was Fox's attempt to upstage *Hell's Angels*. Accused of cowardice, a partly crippled British pilot is determined to regain his reputation. Helped by loyal friends, he manages to build a reliable fighter from several wrecks and, when a Zeppelin bombs London, destroys it, thus proving his courage. The final combat between aeroplane and airship lasts for over thirty minutes (almost half the total running time) and is an impressive scene making use of models and live action. Of little interest are *Captain Swagger* (1928) and yet another Monk Saunders script *Ace of Aces* (1933) with Richard Dix trying to live down a charge of cowardice by becoming a ruthless ace. Before he leaves for the Front the pilot reveals his plans to become a hero so that his fiancée will be proud of him. 'You sound like a young squire waiting to receive his spurs,' she tells him. However, he becomes so ruthless and efficient that his fellow pilots dislike him: he 'doesn't give the enemy a chance', we are told.

Body and Soul (1931), taken from a story by Elliott White Springs, has Humphrey Bogart as an American pilot attached to the British RFC; and *Heartbreak* (1931) has yet another American pilot flying with an Italian squadron. In the latter, the pilot falls for an Austrian countess whose brother just happens to be the legendary enemy ace 'Kapitan Wolke'. Needless to say, the climax of the film is the aerial duel between the two. The popularity of such films gradually began to wane after 1934 and ended with the remake of *Dawn Patrol* in 1938. But even with the approach of another major conflict, not all interest was lost in the first great air war. William Wellman's 1938 story of the conquest of the air, *Men With Wings*, has a central sequence set during the World War; and *The Story of Vernon and Irene*

Castle, a 1939 biography of the famous pre-1914 dance team, ends with Vernon (Fred Astaire) joining the RFC in 1914 and flying in combat on the Western Front. January 1940 saw the reissue of an edited version of *Hell's Angels* with colour added to the Zeppelin sequence and a six-minute prologue called 'Wings Over the World', which provided a summary of the history of aviation from the Wright brothers' first powered flight. Even during the Second World War, films dealing with contemporary aviation sometimes referred back to that earlier war. *Army Surgeon* (1942) has a military nurse recalling her experiences in France in 1917 and uses newsreel footage and a few sequences from *Hell's Angels*; while *Captain Eddy* (1945), a weak biography of Eddie Rickenbacker, America's top ace of World War One, has a brief section dealing with his exploits in that war. American productions dominated the market throughout the inter-war years but most of the other major combatant nations did make at least some cinematic reference to the war in the air.

III

At the end of the First World War, Britain had the world's most powerful air fleet and the only autonomous air force in existence. Compared to the dismal showing of the army and navy, the British air effort was hailed as a major success. Official histories, memoirs and reports all emphasised the great contribution of the RFC/RAF to the final victory. Given these circumstances, it seems strange that the air war attracted such little attention from film makers. It would appear that only one film of the inter-war years focused specifically on the war in the air — the excruciatingly bad *Reverse of the Medal* (1923) with Clive Brook. This unconvincing tale of heroism and duty among RFC pilots on the Western Front was poorly made and clearly underfinanced. The British failure to make films comparable to the American epics can partly be explained by the financial limitations of the film industry. Certainly the British made a number of aviation films during the period, but these tended to be documentaries examining contemporary aerial developments — especially the opening of commercial routes linking the empire. These could be filmed cheaply using current machines and funded by major commercial enterprises such as Imperial Airways, Shell Petroleum and so on. As Low points out, British film makers were continually limited by lack of investment in the industry.[24] Aviation films were particularly expensive in terms of aeroplanes, pilots and sophisticated equipment. Location filming, dependent upon the vagaries of the British climate, would significantly add to production costs. And even if the necessary

financing could have been raised, there was little chance of a return on that investment given the limited size of the home market and the general unpopularity of British films with the domestic audience. It should also be noted that many of the American features were very cheaply made but only because expensive aerial sequences could be 'borrowed' from one of the earlier productions. Nor did the British have need to dwell upon the exploits of the RFC as the majority of American productions were stories of 'British' airmen. The old story of the British fighting to the last drop of foreign blood would appear to be true even of cinematic re-creations of the RFC in the Great War.

The situation was little different in France. As Martin points out, the film industry suffered considerably from the effects of war and by 1925 over 70 per cent of all films shown in France were American.[25] Again, lack of investment limited the themes film makers could take on. Although the aviator and his exploits in war had become a national passion, financial constraints limited film as a channel of dissemination. However, one story that was filmed and re-filmed was a version of Joseph Kessel's popular 1924 novel L'Equipage (The Crew). First produced as a silent feature in 1928, it is the story of a young observer who flies with the squadron's most unpopular pilot. By accident, the young man discovers that the woman he loves is, in fact, his pilot's wife. The pilot is aware of the affair but says nothing. On patrol, their aircraft is attacked; the observer is killed and the pilot seriously wounded. As he lies in hospital, close to death, his wife realises that it is him she loves, and with her support, he eventually recovers but never reveals he knew of her infidelity. The film earned considerable praise for its re-creation of the Western Front and scenes of the air war. Enormously popular with audiences, it was remade in 1935 by Anatole Litvak under the same title, with Charles Vanel as the ageing pilot. The aerial sequences were taken from the original and it was eventually released in America in 1938 under the title Flight into Darkness. In the meantime, Litvak had emigrated to the United States, and chose as his first project yet another version of Kessel's novel. Re-titled The Woman I Love, it was released in 1937 with Paul Muni as the pilot and Louis Haywood as the observer. Miriam Hopkins played the wife. Again, the original 1928 flying sequences were used.

It would seem inevitable that when a film of war flying was made in Germany it would focus on the most famous of all the air fighters – the 'Red Baron'. Richthofen (Red Knight of the Air), released in the spring of 1929, was a curious mixture of re-enacted scenes of his career combined with newsreel footage. The film ended with coverage of Richthofen's state funeral in Berlin in 1925 when the hero's body was returned to Germany. Although many American films paid homage to Richthofen's skills, the portrayal of other

Germans was less sympathetic, and most war flying features were not well received by German audiences. *Hell's Angels*, for example, with its robotic airshipmen leaping to their death in order to save the stricken Zeppelin and ruthless general was especially unpopular. In 1931, the Federation of German Cinema Owners demanded that the film be withdrawn because it was 'derogatory to the reputation of the German people'.[26] The film was not withdrawn but the final scene in which James Hall was executed was cut from prints shown in Germany and Austria. The adventures of fliers on the Western Front were widely celebrated in popular literature but there were no other films dealing exclusively with their exploits. However, the many film appearances of Ernst Udet, the highest-scoring survivor of the Richthofen group, remained a powerful reminder of that experience. Other films that touched upon the subject were Johannes Meyer's 1935 production *Hangmen, Women and Soldiers* and Karl Ritter's homage to the new German Air Force *Pour Le Mérite* (1938). Ritter was an ex-fighter pilot and one of Hitler's favourite directors. By drawing connections between the mystique of the air fighters and the *Luftwaffe*, the service legitimised itself as the rightful successor to that chivalrous band of West Front warriors. The same linkages between the old air fighters and the new order were demonstrated in another aviation film of 1938: Otto Maish's *D111 88*. This deals with irresponsible *Luftwaffe* cadets who are taught the meaning of discipline and duty by a veteran pilot of that earlier war.

The Italian film industry produced a number of aviation films in the period but none dealt directly with the experience of World War One. However, *Cavalleria*, directed by Goffredo Alessandrini in 1936, does touch upon that experience. Very much in the tradition of Italian historical epics, *Cavalleria* is the story of the dashing cavalry officer Captain Solaro (played by Italy's most popular star, Amedeo Nazzari) before and during the war. Solaro lives in two worlds — that of home, a world of luxury, indulgence and idleness, and the cavalry school, a world of duty, discipline and sacrifice. Unrequited in love, Solaro chooses the latter and after an accident transfers to the aviation service. The climax of the film comes during the war when Solaro dies nobly in combat. As Landy suggests, the film deals in patriotic ideals of sacrifice and duty to the homeland.[27] But it is also a clear reference to the manner in which war was transformed between 1914 and 1918, becoming modernised through aviation technology, and to the perception of the aviator as the repository of the traditional values of the cavalry elite. The documentary *Da Icaro a de Pinedo*, released in 1927 and directed by Silvio Laurenti Rosa, also deals in historical continuity. This time it is the heroism

of the aviation pioneers who frequently sacrificed themselves that man might conquer the skies. The whole film leads inexorably to the First World War and the sacrifice and noble deeds of Italian air fighters.

In the last troubled years of the 1930s, the need to present a positive image of national strength and positive achievement inevitably meant that the aviation films of most nations concentrated on contemporary air forces rather than past triumphs. The Second World War and its immediate aftermath produced a host of new, heroic aviation icons and thus interest in earlier wars diminished. However, it never entirely disappeared and was revived from time to time from the mid-1950s on. In 1955, William Wellman wrote a script based upon his own flying experiences in the Lafayette Flying corps. Originally to be called *C'est la Guerre*, it was put into production by Warner Brothers. Although William Wellman Jr. plays Wellman Sr., the main focus is the fictional Thad Walker (Tab Hunter), a rebellious young pilot continually in trouble with his seniors. The finished film, retitled *Lafayette Escadrille*, was far more closely related to the 1950s 'youth' movie genre than to air warfare. Wellman claimed that Jack Warner continually interfered in the film's production and insisted on so many changes that he finally quit. Wellman never made another film.[28] It is a pity that the director who had virtually created the sub-genre ended his career with such a dismal production.

In 1965, Twentieth Century Fox decided to produce a spectacular film version of Jack D. Hunter's novel *The Blue Max*. The central character of the film is Bruno Stachel, a glory-hunting ex-infantryman who transfers to the air service. Ignored by the aristocratic fliers of his squadron, the working-class Stachel (George Peppard) is determined to gain the coveted 'Pour le Mérite', the Blue Max, awarded for shooting down twenty enemy aircraft. Facing court martial for his apparently ungentlemanly behaviour, he is saved by the astute Count von Klugerman (Jeremy Kemp), who sees in Stachel a pilot who will earn the admiration of the masses. Stachel is carefully groomed for his role as hero. However, when the dubious circumstances of some of his kills threatens the integrity of the air service, the High Command 'arrange' his death testing a new fighter. In the final analysis, the film remains unconvincing. Director John Guillermin was never able to allow Stachel to become the brutish figure of the novel, a legacy perhaps of almost four decades of heroic, noble air fighters. Nevertheless, the film was the first to comment on the manner in which air fighters were elevated into national heroes to promote the war. Interestingly, although Stachel is killed at the end of the film, in the novel he survives; and indeed flies again, but this time for the *Luftwaffe* in the late 1930s. Stachel's later adventures are dealt

with in a second novel, *The Blood Order* published in 1980. The idea of a working-class pilot in an essentially elitist group was also the theme of the BBC Television series *Wings* (1976-77). Created by Barry Thomas, an ex-RAF navigator, the story focused on Alan Farmer, an ex-blacksmith who serves as a sergeant pilot with the RFC in the early days of the war. The enemy, operating their new Fokker monoplanes are deadly but the class-conscious officers of the RFC are equally deadly to a man of Farmer's background who has to continually defend himself against the insinuations of his comrades. Only when he proves himself as a competent pilot does he gain a grudging acceptance. It is interesting that Farmer was played by Tim Woodward, who reappeared as Squadron Leader Rex, the ultimate elitist fighter pilot in the controversial *Piece of Cake* made in 1988 (see Chapter 6).

De-mythologising the air fighters was also the theme of the British production *Aces High* (1976) — an adaptation of R. C. Sherriff's classic anti-war drama *Journey's End*. A young pilot, Stephen Croft (Peter Firth), is sent to join the squadron commanded by his old house-captain Gresham (Malcolm McDowell). Having idolised Gresham at school and filled with ideas about the nobility of air fighters and the chivalry of the air, Croft is horrified to find his friend almost permanently drunk and the war in the air as barbarous as that in the trenches. Although based on Sherriff's play, the film owes a considerable debt to *Dawn Patrol*. Gresham is clearly modelled on Courtney, once the latter has assumed command of the squadron. Many of the scenes are familiar, as is the squadron's headquarters, and in both films an elderly officer, an ex-observer, is adjutant and father-confessor for the squadron. The film's message might be less ambiguously anti-war than *Dawn Patrol*, but the influence of the 1930s continues to haunt film makers who tackle that first war in the air.

Cult American film maker Roger Corman made his homage to the Red Baron in *Von Richthofen and Brown* (1971), a film which contrasts the characters of the German ace (John Philip Law) and the man who allegedly shot him down, the Canadian Roy Brown (Don Stroud). The film draws an interesting comparison between the aristocratic German who sees air fighting as a sport and the ex-farmer Brown who kills Germans because the more he kills the sooner the war will end. There is one particularly revealing scene where the British squadron toast their enemies. Brown refuses to drink and is condemned by his comrades for being a 'bad sport'. However, when the airfield is attacked by German planes and non-combatants are killed, they begin to see war as less of a game. Like earlier film makers, Corman was carried along with the romantic aspects of the air fighters. Originally his

intention was to make the film focusing on just Richthofen. The studio, however, felt this would be too 'German' and so the contrasting character of Brown was added. Yet in an interview with Philip Strick, Corman claimed that Richthofen was, 'the more glamorous character; for me, he represents the last of the knights, the last of the great heroes. When he was shot down, Sir Lancelot, Sir Galahad was shot down. Roy Brown represents the first of the faceless . . . the beginning of the concept of mass warfare.'[29]

Equally romantic was Blake Edwards' *Darling Lily* (1970) with Rock Hudson as American pilot William Larrabee and Julie Andrews as Lily Smith, a musical star and German spy attempting to romance information out of the stoic air fighter. Alternating between lavish musical numbers and exciting flying sequences, the film is very much in the style of 1930s features. Much the same might be said of *Flying Dutchman* (1957) from the Netherlands, a dull biography of Anthony Fokker, inventor of the synchronised machine gun. The British production *Zeppelin* (1971) was even more an exercise in nostalgia. Michael York, the archetypal British hero, is a British officer who attempts to persuade the Germans that his sympathies lie with them in order to discover the secrets of the latest model Zeppelin. The latest film of the sub-genre is perhaps the strangest of all, the British made *Biggles* (1986), loosely based on the character created by novelist W. E. Johns, and probably the most famous fictional aviator of all. Here, however, we have Biggles (Neil Dickson) and his 'time twin', Manhattan businessman Alex Hyde White trapped in a time warp that alternates between the Western Front of 1917 and New York in the 1980s – a scenario that must have greatly distressed the legion of Biggles fans.

Far more interesting is the Canadian documentary film *The Kid Who Couldn't Miss* (1983). Based upon the controversial stage play *Billy Bishop Goes to War*, the film explores the war career of an actual top-scoring Allied ace by using scenes from the play, documentary footage and sequences from earlier aviation films. The film was subject to considerable criticism because it suggested that the incidents which earned Bishop his Victoria Cross may have been 'manufactured' by the ace himself. The film antagonised World War One aviation enthusiasts so deeply that they scrutinised the text for even the most minor errors. Stephen Pendo, for example, was indignant because the film suggested that Richthofen suffered a head wound after his eightieth victory instead of his fifty-eighth: 'the movie's most glaring historical error comes in its reporting on Richthofen'.[30] Attacking the integrity of the film at this trivial level would appear to be an attempt to discredit the claim that Bishop may have been less than the noble warrior of popular myth. This is typical of the criticism that air war films have received in recent years.

Ignored by mainstream critics and serious commentators, these films have become the province of the air war enthusiasts who are far more concerned that the aeroplanes carry the correct colour schemes and armament than with the distortions of the realities of air warfare and the myths they perpetuate. Even a basically sensible, if somewhat limited, analysis of these films concludes with the comment, 'The sky was knighthood's last backdrop, and World War I the last time the gentleman hero went his highly individualized way'.[31]

The overriding impression gained from viewing these films is of the dramatic differences between the air war and the war fought in the trenches; that the airmen inhabited a noble and chivalric universe, where combat was personalised and fought according to a latter-day chivalric code. The main concern of these films is the fighter pilot — the lone warrior who accepts his duty is to fly and fight whatever the odds. The frailty of his machine only adds another dimension to his courage as he battles not only against the enemy but against the limitations of existing technology. As Solomon points out, since flying demands both courage and fatalism, 'we can only expect that the pilot will be a romantic'. This romanticism, 'manifests itself in his devotion to duty, his tendency to immerse himself in the life of his squadron . . . and his taking upon himself the responsibility for the lives of others. Thus the hero must risk his own life before those of his fellow pilots.'[32] In *Dawn Patrol* for example, the squadron commander hates sending out the young inexperienced pilots to almost certain death, but he continues to send them out; never does he disobey or attempt to find excuses. And the doomed young aviators continue to carry out their orders even though they are well aware of the odds against their survival. Graham Greene, in his review of the 1938 version, took an apt metaphor from an earlier 'heroic' incident: 'day after day the Light Brigade, as it were, rides forth against the guns — "Theirs not to make reply, Theirs but to do and die"'.[33] 'It's a rotten war,' says Courtney when he hears that his friend's young brother has been killed on his first mission, but he accepts that duty demands such sacrifice. When a single pilot of the squadron has to take on a suicidal mission, Courtney ensures that it is he, not his friend, who attempts it. Even the weak Monty in *Hell's Angels*, who has pleaded illness to avoid dangerous patrols, temporarily conquers his nerves and volunteers for the last deadly mission. Romanticism and devotion to duty are characteristics of the screen air fighter, and so is behaving according to a strict warrior code. Constantly referred to as 'knights of the Western Front' or the 'chivalry of the air' in

wartime propaganda, this image became the hallmark of the pilot in popular imagination. As Laurence Goldstein has suggested,

> Pulp and other magazines ran fiction and non-fiction about the air war from its very beginnings. After the war the memoirs of air aces became the closest approximation one can find to the knightly tales in Malory, an association the authors underlined explicitly.[34]

As an example, Goldstein quotes from the memoir of Cecil Lewis, 'It was like the lists of the Middle Ages, the only sphere in modern warfare where a man saw his adversary and faced him in mortal combat, the only sphere where there was still chivalry and honour.[35]

Cinema of the inter-war years reinforced these notions and took them to a far greater audience. One is reminded of the British pilot in *Hell's Angels* who salutes the German pilot who has shot him as he sits dying in his cockpit. In *Hell in the Heavens*, during the final duel, the American pilot finds his guns jammed. Unhesitatingly, he rams the German's machine and both planes crash. Amazingly, both pilots survive and congratulate each other on a gallant fight. The essential nobility of airmen could be equally shown in other ways. For instance, the loyal observer in *The Eagle and the Hawk*, after his pilot has committed suicide, takes his friend's body aloft so that it will appear that he has died in combat and not by his own hand. Enemy airmen could share this nobility as well. The German airshipman in *Hell's Angels*, for example, directs his bombs into Hyde Park rather than on to the homes of helpless women and children. Even the somewhat robotic figures who deliberately sacrifice themselves in an attempt to save the Zeppelin, demonstrate a certain nobility. The camaraderie among air fighters is another demonstration of this. There are the bonds which unite the men of the squadron in a common purpose, but there are also the bonds which unite friend and foe simply because they are brother airmen and face the same dangers and live by the same moral code.

In *Dawn Patrol*, Courtney invites a captured German airman into the squadron mess after shooting him down. They drink together, not as enemies but as brothers in the same fraternity of warriors, even though Courtney believes the German is responsible for the death of his best friend. Even a film as clearly anti-war as Jean Renoir's *The Grand Illusion* (1938) falls into the trap of romanticising the aviator's world. When the French airman (Jean Gabin) is shot down, the man responsible, Von Rauffenstein (Erich von Stroheim), welcomes him into the German mess for lunch. While they are eating an orderly walks through with a wreath, to be dropped on a French aerodrome, for airmen killed by the pilots of Rauffenstein's squadron.

Clearly, although Renoir later emphasises the waste and pointlessness of war, he is unable to avoid the cliché of the chivalry of airmen. Interestingly, both Renoir and Gabin served as pilots in the French air service during the war.

Films of the first war in the air give the impression that the entire conflict was dominated by the aces – the lone eagles who patrolled the skies seeking combat, that their world was one of endless duels fought by champions. On the ground their lives were a constant round of parties, romantic adventures and reckless escapades which continually challenged military discipline and authority. Perhaps most important is the impression that the conflict in the air was the only war that really mattered; that without the air fighters the war on land would somehow have ground to a halt. Certainly, some of the films make reference to the great battles. *Wings*, for example, has a fine reconstruction of the Battle of St Mihiel. But again, the contribution of airmen to that battle is greatly exaggerated. More usual are the sequences in *Dawn Patrol* and *Hell's Angels* where the RFC have to destroy enemy ammunition dumps in order to ensure the success of the ground offensives. *The New York Times* review of *Wings* encapsulates this mythic view:

> This feature gives one an unforgettable idea of the existence of these daring fighters – how they were called upon at all hours of the day and night to soar into the skies and give battle to enemy planes; their lighthearted eagerness to enter the fray and also their reckless conduct once they set foot on earth for a time in the dazzling life of the French capital.[36]

It has to be noted, however, that in reality the contribution of air power to victory was marginal. Air services provided useful information during the initial stages of the war – for the British Expeditionary Force on the Marne and for the Germany army before Tannenberg – but the most significant contribution aircraft made was in reconnaissance, photography, directing artillery fire and, in the later stages of the war, in ground attack. There is no evidence that the constant offensive patrols of the Allies, especially of the RFC, served any really useful purpose. The age of the individual air fighter was also remarkably brief. By 1917, the very success of the 'lone Eagle' led to his demise, as formation tactics and scientific methods were introduced to counter the effectiveness of the ace in combat. Most pilots led a dangerous but routine existence. The 'frenzied gaiety' after combat was rare. As Denis Winter has noted, 'quietness was the norm after an active patrol . . . Few in the mess would talk about their experiences in the face of such an urgent need for rest'.[37] Horseplay and heavy drinking were rare and then usually

instigated by the squadron commander to relieve tension.[38] The reckless, anti-authoritarian escapades of the screen aviators were also at odds with reality. The first aviators were drawn from the ranks of the army officer corps, a disciplined body of professionals. Even the young volunteers who came into the air services direct from school or university later in the war were inducted into a service which had a highly developed sense of discipline and professionalism – perhaps even more rigid than other branches of the army because in the air even a minor error or infringement of the rules could prove fatal.

It is possible to find real incidents of chivalric behaviour among air fighters: the RFC, for example, dropped a laurel wreath on Boelcke's aerodrome after learning of his death. Likewise, German pilots sometimes informed British squadrons of the fate of downed pilots. But these incidents were marginal. Combat was bitterly fought and rarely was mercy shown to the pilot who was out of ammunition or whose guns had jammed. It is difficult to find chivalry and romance in a war where most of Richthofen's victories were against slow, clumsy reconnaissance machines; where British ace Mick Mannock was motivated by an intense hatred of all things German and enjoyed watching his victims go down in flames; and where the Allies' top-scoring ace, the ambitious Billy Bishop, may well have invented the incident which earned him his VC. The death of a comrade was an occasion for bitterness and a desire for revenge, hardly one where fliers wanted to congratulate the man responsible.[39] Thus cinematic reconstructions of the first war in the air bear only slight resemblance to reality. Why this should be so is an interesting question. Clearly it might be thought that the film industry's particularised view of the war was due to ignorance – a state of affairs not entirely unknown when Hollywood went historical. However, in this instance it is important to remember that these films were, to a great extent, created by the aviators themselves. As we have seen, Hawks, Wellman and Hughes had an aviation background as did Monk Saunders and White Springs, who between them were responsible for the writing of the majority of these features. The same can be said for European directors such as Karl Ritter and Jean Renoir. Although their experience of the air war may have been limited, they must have been well aware of the realities.

At a basic level, the images of air warfare created by Hollywood were good cinema: exciting, dramatic and drawing upon established cinematic notions of the romantic hero. These images sold films, and it would be foolish to forget that film makers were primarily concerned with creating a commercial product and not with reconstructing accurate history. During the inter-war years, a time singularly lacking in real heroes, the screen air fighter, like

the Hollywood swashbuckler, was a viable substitute. In the 1930s, a time of depression, disillusionment and cynicism, the war flier of popular culture reflected the cynicism of the age but ultimately also demonstrated the finer qualities of self-sacrifice, duty and patriotism. Nor should we forget that film was not the only channel through which this distorted image was being disseminated: novels, pulps, comics and even the memoirs of aviators themselves were all equally guilty. But the particularised view of air warfare in these films goes beyond simplistic explanations.

Until the creation of the atomic bomb, the aeroplane was the most terrifying weapon yet devised – able to strike at cities and civilians virtually without warning and, it was commonly believed, almost impossible to defend against. The bomber cast a long shadow over the popular imagination during the inter-war years. The indiscriminate bombing of cities began during the First World War and, although limited in scale, pointed to the future of warfare where whole populations were at risk from anonymous machines with a potential for 'scientific murder'.[40] Yet none of these films deal with the bombing of cities. Certainly, *Hell's Angels* and *Dawn Patrol* contain bombing sequences but these are against ammunition dumps, legitimate military targets, and never against civilians. In these films, the new, and very frightening, technology of modern war has been located in a pre-industrial structure of knightly combats between professionals bound by a strict warrior code. This is a powerful means of diffusing fears raised by the spectre of future aerial warfare. The camaraderie in combat squadrons was no doubt a reality of 1914–18, but the focus on this aspect of the air fighter's character, together with his nobility was, in cinematic terms, a useful emphasis through which to show his basic decency. It is almost impossible to visualise the screen aviators bombing helpless women and children and laying waste the great cities of Europe.

In his analysis of how the memory of the World Wars has been shaped, George L. Mosse has invoked what he calls the 'myth of the war experience' – a means of constructing a memory designed to 'legitimise war by displacing its reality'.[41] A romantic, chivalric view of the air fighters masked the terrifying realities of the potential of the aviator as the destroyer of cities. This myth became the reality for the airmen themselves, for as Thelen has pointed out, 'memory, private and individual, as much as collective and cultural is constructed, not reproduced', and this construction is not made in isolation but in 'conversations with others that occur in the contexts of community, broader politics and social dynamics'.[42] Thus the aviator-film makers constructed their memories of the war in less frightening terms to

make their experience less painful. Their films simply reflected that 'constructed' reality. But this 'masking' of reality did not just occur in the years following the Armistice; the roots lay in the manner in which the air war had been portrayed to participants at the time: a portrayal through propaganda images – the reality films, newspapers, magazines, the speeches of politicians and even posters.[43] These films were more than just a particularised view of the first air war, providing a few hours' escapist entertainment for a depression-haunted audience; they had significant influence on later generations, both in the manner in which the public thought about air warfare and in the manner in which later films dealt with the subject.

In the early twentieth century, the distinction between reality and what appeared on the screen was often blurred. Unsophisticated audiences accepted screen images for what they purported to be.[44] Even more 'real' were the official films made during the war itself, for they were backed by impeccable institutions such as the British War Office. The later feature films gained from this legitimacy, for they showed much the same images; and there is little reason to suppose that audiences of the 1920s and 1930s were less trusting of what they saw on the screen. The combined weight of documentary and feature films, together with similar images disseminated through other cultural forms, defined the way in which the public thought of air warfare during 1914–18, and they created a stereotypical model of the airman for future generations. Thus in real life many of the young airmen of later wars modelled their behaviour on the screen images of the heroes of *Wings* and *Dawn Patrol*, while in cinematic terms these early films provided the models for films dealing with subsequent wars. It is not difficult to identify the linkages between the films of the 1930s and films dealing with the Second World War, Korea and even contemporary events.

NOTES

1 Maurice Bardeche and Robert Brasillach, *History of the Film* (London, 1938), 93.
2 Peter Fritzsche, *A Nation of Fliers – German Aviation and the Popular Imagination* (Cambridge, Mass., 1990), 74.
3 George L. Mosse, *Fallen Soldiers: Reshaping the Memory of the World Wars* (New York, 1990), 144.
4 *Matin* (23 Apr. 1918).
5 Production details from the film archive of the Imperial War Museum.
6 This message was resurrected during the Second World War. In America, during the campaign to persuade women to take up war work in the aircraft factories, one propaganda short shows female machine operatives at work with the patronising comment that, 'Instead of cutting out dresses, this woman stamps out airplane parts . . . After a short apprenticeship, women can operate this press as easily as the juice extractor in their own kitchens'.
7 Clyde Jeavons, *A Pictorial History of War Films* (London, 1974), 25.
8 Marie Seton, 'War', *Sight and Sound*, 6:24 (1937), 185.

9 Bruce Franklin, *War Stars: The Superweapon and the American Imagination* (New York, 1988), 101.
10 A description of the film is in Phil Hardy, *Encyclopedia of Science Fiction Movies* (London, 1984), 53–4; Karl Brown, *Adventures with D. W. Griffith* (London, 1973), 105–9.
11 *Ibid.*, 201.
12 Jeavons, *War Films*, 35.
13 W. G. Faulkner, quoted in Seton, 'War', 183.
14 Bardeche and Brasillach, *History of the Film* 199–200.
15 See Bert Hall and J. J. Niles, *One Man's War* (London, 1929).
16 Rudy Behlmer, 'World War One Aviation Films', *Films in Review* (Aug.–Oct. 1967), 413–14.
17 *Ibid.*, 416.
18 *Ibid.*, 420.
19 Dominick Pisano (ed.), *Legend, Memory and the Great War in the Air* (Washington, 1992), 21.
20 Stephen Pendo, *Aviation in the Cinema* (NJ, 1985), 91–2.
21 Joseph McBride, *Hawks on Hawks* (Berkeley, 1982), 27.
22 Behlmer, 'World War One Aviation Films', 430; Jeffrey Richards, *Visions of Yesterday* (London, 1973), 186.
23 Pendo, *Aviation in the Cinema*, 105.
24 Rachael Low, *History of the British Film, 1918–1929* (London, 1971), 276.
25 John W. Martin, *The Golden Age of French Cinema* (London, 1987), 20.
26 *New York Times* (19 June 1931).
27 Marcia Landy, *Fascism in Film: The Italian Commercial Cinema, 1931–43* (Princeton, NJ, 1986), 14–49.
28 Behlmer 'World War One Aviation Films', 430.
29 '"Ma Barker to Von Richthofen", an Interview with Roger Corman', *Sight and Sound*, 39:4 (Autumn 1970), 183.
30 Pendo, *Aviation in the Cinema*, 117.
31 Behlmer, 'World War One Aviation Films', 432.
32 Stanley Solomon, *Beyond Formula: American Film Genres* (NY, 1978), 255.
33 Graham Greene, *Spectator* (3 Mar. 1939).
34 Laurence Goldstein, *The Flying Machine and Modern Literature* (New York, 1986), 89.
35 Cecil Lewis, *Sagittarius Rising* (London, 1977), 45.
36 *New York Times*, quoted in Pisano, *Legend, Memory and the Great War in the Air*, 12.
37 Denis Winter, *First of the Few* (London, 1982), 109.
38 Peter Liddell, *The Airman's War, 1914–1918* (Poole, 1987), 117–19.
39 *Ibid.*, 182.
40 Michael Sherry, *The Rise of American Air Power* (New Haven, 1987), 39.
41 Mosse, *Fallen Sildiers*, 217.
42 David Thelen (ed.), *Memory and American History* (Bloomington, 1990), vii.
43 David Lloyd George's extravagant tribute to the RFC, 'The Cavalry of the Clouds, the Chivalry of the Air', was made to the House of Commons in Oct. 1917. See also Lord Northcliffe's *At the War* (London, 1916), or the March 1918 issue of *Mayfair*.
44 David Mould and Charles Berg, 'Fact and Fantasy in the Films of World War One', *Film and History*, 14:3 (Sep. 1984), 50.

4 Barnstormers and airlines

As we have seen, the cycle of World War One flying pictures began with *Wings* in 1927, but Hollywood's enduring relationship with aviation really started at the end of the First World War. Many of those working in the industry saw the potential of the aeroplane as an exciting ingredient for fiction films, while others became interested in aviation as a revolutionary form of transportation. Thomas Ince, the respected film pioneer, for example, set up his own flying field outside Los Angeles in 1915, while Cecil B. De Mille, a qualified aviator, owned two airfields and in 1918 created the Mercury Aviation Company which operated California's first scheduled air line. The following year, Syd Chaplin established the Chaplin Air Line and ran regular services from Los Angeles to Catalina Island. At the end of the war, the government cut back on military expenditure, selling surplus machines and releasing hundreds of young aviators anxious to continue flying. Commercial opportunities were rare and the only hope for these young men was to buy a cheap ex-service machine and try to make a living as an exhibition flier: a 'barnstormer', performing dangerous stunts and selling rides to the public. Some of these young pilots gravitated to Hollywood to fly for the movies, since the industry was rapidly beginning to exploit public interest in aviation.

For the studios in the early 1920s, aviation was a means to rejuvenate old themes, and producers often included an aeroplane sequence, a chase or a stunt, for novelty or added excitement – a modern replacement for the horse or automobile. In the years following the Armistice, the industry produced a considerable number of cheap aerial adventures; little more than up-dated crime thrillers or westerns. Typical of these features were *Bootleggers* (1922), where a naval pilot saves his girlfriend from gangsters; *Cloud Rider* (1925), involving a flying secret agent fighting drug smugglers; *Shield of Honor* (1927), the adventures of a policeman/aviator, and *Air Patrol* (1928), where a young aviator battles diamond smugglers. The alternative to the air thriller was the aerial western. As Pendo has pointed out,

> these films substituted planes for horses but retained the traditional
> western elements. Instead of jumping from horse to horse, the hero

jumped from plane to plane. Bandits who once lay in wait for the stage, now lurked in the clouds, waiting to pounce on a valuable air mail shipment . . . The western clichés remained the same, and little, if any, attempt was made to use aviation as anything but a gimmick to bring the audience into the theatre.[1]

Pendo has identified a considerable number of these features made between 1921 and 1929. Among them are, *A Cowboy Ace* (1921), *Sky High* (1922) and *Silver Valley* (1927), the last two both starring Tom Mix; *The Flying Buckaroo* (1928) and *Winged Horseman* (1928). Unless the film was a vehicle for an established cowboy star, like Tom Mix for example, the studios often cut costs on these cheaply made films by using the stunt pilot as the leading man. After all, little acting skill was required in silent action features, but the most flamboyant and daring of these aviator-actors was Ormer Locklear.

Locklear, an ex-army pilot quickly developed a reputation as a daredevil stunt flier after leaving the service. In July 1919 he was signed by Universal to appear in the lead of a six-reel feature, *The Great Air Robbery*, released in 1920. Locklear plays an air mail pilot who takes on a gang of air pirates known as the 'Death's Head Squadron'. The film features a number of Locklear stunts, including transferring from one aeroplane to another in flight, and was a financial success. Despite this, Carl Laemmle at Universal decided not to take up his option for a second film. Fortunately, in April 1920, Fox offered Locklear the lead in *The Skywayman*, a complicated tale of an ex-war aviator pursuing jewel thieves. The film involved several highly dangerous stunts including one at night. With the film virtually finished, Locklear was asked to perform a tailspin at night but failed to recover and dived into the ground at high speed. Fox capitalised on the fatal crash and had the film completed and in the theatres in just over a month. The advertising for the film proclaimed, 'Every Inch Of Film Showing Locklear's Spectacular (And Fatal) Crash Is Shown. The only Picture Showing Locklear's Last Flight, His Death-Defying Feats And A Close Up Of His Spectacular Crash To Earth'.[2] The feature attracted considerable attention but it would appear that no print of *The Skywayman* has survived.

Many film makers were anxious to profit from the reflected glory of the surviving war heroes and when French ace Charles Nungessor arrived in America in 1924 to form an air circus, he was quickly signed by Arcadia Pictures to star in *The Sky Raider* (1925). The opening sequences dealt with Nungessor's war experiences in France but the remainder of the film had the ace tracking air mail robbers in America. Universal's Carl Laemmle was anxious that his studio should make a biographical picture of Eddie

Rickenbacker, the top scoring American war ace. Rickenbacker reportedly turned down an offer of $100,000 but Laemmle found it difficult to accept the aviator's refusal. After his agents had pursued Rickenbacker for several weeks the aviator finally threatened to sue the studio for personal harrassment. In his autobiography, Rickenbacker wrote,

> I was fully aware of my potential influence on the youth of America, and I intended to continue to do my best to inspire them by both deeds and words. Depicting myself in the movies, I felt, would degrade both my own stature and the uniform I so proudly wore.[3]

In the years immediately following the end of the war, then, the film industry's response to aviation was exploitative: the mass production of cheap aerial action pictures which capitalised on the novelty and excitement of the flying machine and an attempt to take advantage of the surviving heroes of the war. However, the attitude of the industry to aviation began to change during 1927.

In that year the young ex-air mail pilot Charles Lindbergh conquered the Atlantic in a solo flight that captured the public imagination and focused attention firmly on aviation and the airman. The commercial and critical success of *Wings* demonstrated that expensive flying epics could be economically viable; and finally the development of sound added a new dimension to popular cinema and allowed film makers greater depth with which to explore their subject matter. The Lindbergh phenomenon was aided in no small measure by extensive newsreel coverage of his departure from New York and triumphant return from Europe. Only a month before the flight, William Fox introduced sound in his 'Movietone News', and this enabled Lindbergh not only to be seen but also to address his admirers. In the Roxy Theatre, New York, the audience stood and cheered Movietone's Lindbergh report for over ten minutes. Lindbergh was the man of the hour and Hollywood was quick to pounce, making lavish offers for him to star in a screen biography. William Randolph Hearst offered him a contract which guaranteed him a minimum return of half a million dollars for a film to be made with 'dignity' and 'taste' which would contribute to 'public interest in aviation'. Lindbergh, however, was not impressed with the Hearst offer and later wrote of the Hearst newspapers, '(they) seemed to me sensational and excessively occupied with the troubles and vices of mankind. I disliked most of the men I met who represented him [Hearst]'.[4] The aviator refused the offer and all subsequent ones until his tragic personal life made him too controversial a figure for a screen biography. Not until 1957 did director Billy Wilder retell the story of the Lindbergh flight in *Spirit of St Louis* (see below).

But if film makers couldn't get Lindbergh, they could at least gain some profit from his name and achievement and the studios rapidly embarked on a short cycle of Lindbergh related features.

Publicity Madness (1927) was a comic story of a businessman who, for publicity, puts up a prize of $10,000 for the first Pacific flight to Australia. However, when Lindbergh conquers the Atlantic, proving that such long-distance flights are possible, the businessman realises his money is at risk and makes the flight himself to save his investment. *Hero For A Night*, released the same year by Warners Brothers, dealt with a taxi driver who yearns to complete a trans-Atlantic flight. *Flying Romeos* (1928), from Universal, was a Sydney and Murray comedy about barbers who accidentally fly the Atlantic after becoming involved with a famous pilot. Perhaps the most curious film influenced by Lindbergh was Walt Disney's cartoon *Plane Crazy*, released in 1928. This, the first appearance of Mickey and Minnie Mouse, has Mickey hearing about Lindbergh's flight and building his own aeroplane from items lying around the farmyard. After a number of disasters, he finally takes Minnie for a flight in his machine and is cheered by the other animals. According to Richard Schickel, Disney gave Mickey a number of the hero's characteristics, including a 'Lindberghian ruffle' in his hair.[5] Lindbergh's achievement and popularity clearly directed Hollywood's attention to the possibilities of more serious studies of aviation and thus, alongside the cycle of air war films, developed a series of films which explored the world of civil aviation.

The ex-war aviators who continued flying after the war did so for many reasons and several features examined their motivations. Many of the young veterans knew only flying and war. After that experience, the routine of civilian life appeared dull indeed and a considerable number continued flying for the challenge and excitement. A useful example of a film which explored this area was First National's *The Last Flight* (1931). The film began life as a short story by the prolific John Monk Saunders, *Nikki and Her Men*, and was then transformed into a novel (*Single Lady*) and a play, *Nikki*. William Dieterle, directing his first feature in America, worked from Saunders' screenplay. The film was not an outstanding success but its interest is in the exploration of the four veterans and their friend Nikki. The fliers have all been scarred in some way by the war and drift without purpose. They become barnstormers, air racers and eventually, when his friends have all been killed, the survivor founds an airline.

More substantial was RKO's *The Lost Squadron* (1932), based upon a short story by Hollywood stunt pilot Dick Grace. Starring Richard Dix, Joel McCrea and Robert Armstrong, the story deals with veterans unable to

find regular employment and who use their flying skills for economic reasons. The film opens on 11 November 1918, a few minutes before the Armistice comes into effect. A bitterly fought air battle is taking place over the Western Front. One of the pilots looks at his watch, it is eleven a.m. The airmen salute each other and return to their base. The three American survivors of what they now call the 'lost squadron' decide to stay together and return to America where they are welcomed with open arms: 'your services to your country will never be forgotten', a politician tells them. Yet none can adjust to a peacetime existence or find a regular job. Woody (Armstrong) gravitates to Hollywood where he become a stunt pilot and the others, Gibby (Richard Dix) and Red (Joel McCrea), soon follow. They are reunited at the premiere of director Arnold von Furst's (Erich von Stroheim) aviation epic *Sky Heroes*, for which Woody has performed the stunts. Woody persuades his friends to sign on for the next von Furst aviation epic, 'Fifty bucks a flight and it's easy money,' he tells them, 'all you have to do is a couple of outside loops, tear off a wing and land upside down.' They agree, but the insanely jealous von Furst has married Gibby's old girlfriend and is afraid their romance will be rekindled. He sabotages Gibby's plane, but it is Woody who flies it and who is killed. Red shoots the director when he discovers what has happened but Gibby puts the body into his plane and dives at high speed into the ground, killing himself but ensuring that the murder of von Furst will never be revealed.

The Lost Squadron is one of the more interesting features of the period and operates on a number of levels. The opening sequences reveal much of the chivalric qualities attributed to the war aviator, as does Gibby's final romantic gesture to save his young friend. The film also reveals something of the cynicism of veterans who were hailed as heroes by the nation in 1918 but often received a raw deal when it came to being helped to adjust back into civilian life. At another level, the film is a valuable insight into the filming of an air war epic, with the dictatorial von Furst bullying his pilots and crew while shooting and betraying his desire for sensationalism when, during a particularly dangerous stunt, he tells his cameramen 'be sure to keep them in camera, we might catch a nice crack-up'. The battle sequence that follows, where the American airmen attack a German ground position, is a revealing example of how film makers create the illusion of war, and provides an interesting counterpoint to the hyperbole of the premiere of von Furst's film *Sky Heroes* where the pilots are first reunited. A remarkably similar scene re-emerged in the 1978 production *The Stunt Man*, directed by Richard Rush and with Peter O'Toole as the fanatical director. But the success of *The Lost Squadron* naturally inspired imitations. RKO's *Lucky Devils*, released the following year,

was again based on a Dick Grace story and covered much the same ground: war veterans flying for a murderous director. Monogram's 1938 feature, *Stunt Pilot*, one of the 'Tailspin Tommy' series based on the Hal Forest strip cartoon character, has Tommy working on a Hollywood war epic. Here the mystery to be solved is who substituted live ammunition for the dummy rounds in the plane's machine guns? The answer, of course, is the director who would stop at nothing to achieve a realistic battle scene! A number of plot elements from these films re-emerged in *The Great Waldo Pepper* (1975), a product of post–1945 nostalgia for the early days of aviation (see below).

Most of the ex-war aviators, or the young men who took up flying after the war, never made it into the highly paid, glamorous world of the film stunt pilot. With restrictive cuts in the armed forces and virtually no opportunities in civil aviation, the only way to continue flying in the immediate post-war period was to set up as an exhibition flier, a 'barnstormer', putting on a show for the public, offering five dollar rides and competing in aerial races which were rapidly becoming a popular attraction at air shows and carnivals. As Hallion points out, barnstorming began with the development of the flying machine and by 1909 such exhibitions were common in America and Europe, But the heyday of the exhibition pilot was the decade after 1918.[6] Films dealing with barnstormers were ideal aerial exploitation vehicles: little was required by way of a plot and the whole film was built around dangerous aerial stunts. As with the cheap air thrillers, many of these barnstormer movies featured the stunt pilot in the leading role. The most successful of the actor/stuntmen was Al Wilson. In *Flying Thru'* (1925), he played a war veteran turned aerial showman; *Wide Open*, released the same year, included stunt sequences, air racing and air mail flying, while *Won in the Clouds* (1928) merely repeated the formula. Wilson wrote many of the films in which he appeared but his acting career did not survive the coming of sound. He did, however, continue his career as a stunt pilot until he was killed in an air crash in 1932.[7]

More interesting than these cheaply made, silent barnstorming films was Howard Hawks' 1928 production *Air Circus*. Originally intended as a silent feature, the production was overtaken by events and was completed with synchronised sound and dialogue scenes. The film was basically the story of two friends, 'Speed' Doolittle (Arthur Lake) and 'Buddy' Blake (David Rollins), who have to learn the discipline and control needed to become successful pilots. *Air Circus* introduces several of what later became the major concerns of Hawks' work; male camaraderie and loyalty to the group. It also introduces a woman stunt pilot Sue Manning (Sue Carroll) who is an instructor at the flying school where Speed and Buddy train: a tough,

independent woman very much in the mould of Hawks' later female characters. Although all prints of the *Air Circus* seem to have disappeared, it would appear to be one of the first films to attempt a serious exploration of the world of the barnstormer. Unfortunately, the majority of films that followed reverted to simplistic stories built around exciting aerial sequences.

Air Eagles (1932) had former enemies, an American and a German, flying against each other in an air circus, while Paramount's *Sky Bride* of the same year featured Richard Arlen as 'Speed' Condon, a barnstormer who loses his nerve after a crash. However, when a child's life is in danger, Speed conquers his fear and flies to the rescue. Leo Nomis, the main stunt pilot on the film was killed during filming when attempting to recover from a spin. RKO produced *Flying Devils* in 1933. This featured Ralph Bellamy as 'Speed' Hardy, an aerial circus proprietor, who plots the death of his wife's lover, 'Ace' Murray (Bruce Cabot). *Parachute Jumper* (1934) from Warners was perhaps the silliest of these films. Douglas Fairbanks Jr. and Frank McHugh play ex-marines who become jumpers in an air circus until they are recruited by gangsters to assist in a prison escape. As an alternative to the air circus, some film makers explored the world of air racing which became increasingly popular during the inter-war period. *Daring Deeds* (1928) was probably the first to concentrate on this aspect of aviation. But even MGM's major production about American defence preparations, *Test Pilot* (1938), includes a scene where Clark Gable competes in the 1937 Thompson Trophy Race at Cleveland's National Air Meeting. With the possible exception of *Air Circus*, these films dealt exclusively with the glamorous and romantic characteristics of the stunt pilot/air racer. For Hollywood, the barnstormer was a stereotypical heroic figure with little depth or character exploration. It was not until after World War Two that the industry really attempted to explore the dark and tragic world of these flying showmen.

In 1957 Universal produced *Tarnished Angels*, based on the William Faulkner short story 'Pylon'. Directed by Douglas Sirk and starring Rock Hudson, Robert Stack and Dorothy Malone, it tells the story of Robert Schumann (Stack), an ex-Lafayette Escadrille ace turned stunt flier; of his wife Laverne (Malone) and the faithful mechanic Jiggs (Jack Carson). Appearing in a small town air show, they meet the alcoholic reporter Burke Devlin (Hudson). Devlin is fascinated by the lifestyle of these aerial gypsies and strongly attracted to Laverne. He tries to persuade his editor to let him do a feature on the aviators, but the latter is not interested in what he calls a 'cheap, crummy carnival of death'. Devlin, however, carried away with the apparently romantic and heroic aspects of their life ('winged knights jousting with death', as he first describes them), continues to court their

friendship. But after getting to know them, seeing Schumann virtually sell his wife for a chance to compete in the pylon race, and the death of the pilot when he crashes into the lake, Devlin loses his romantic illusions and sees Schumann for what he is, a man driven by his love affair with flying. 'Do you know who's lying dead on the bottom of the lake?' he asks his editor, in a eulogy to the dead aviator (but which could stand for all the dead barnstormers driven by their obsession),

> the son of an Ohio country doctor, a child who refused to follow in his father's footsteps because he was also a child of the twentieth century. He was a boy who stole away to a foreign war only because he had outgrown the motor bikes and the motor cars and because he had a hunger for the flying machine. He knew no flags and no enemy but one, death! And when the war ended he found himself a hero. He hadn't asked for the confetti and the flags and he ran from them. He was lost until he found those pylons; those three bony fingers of death sticking out of the earth waiting to bring him crashing down. And he'd chase those pylons from coast to coast; Canada in the Summmer, Mexico in the Winter . . . It wasn't the money he was after anymore than it was the glory; because the glory only lasted until the next race. He was a man conquered by the flying machine.

Tarnished Angels revealed another, often sordid, aspect of the stunt pilot's life – a life driven by the obsession to fly and usually ending in sudden death. Faulkner's unromantic view of the world of the air circus was not well received by critics or public; perhaps because it didn't conform to audience expectations about 'heroic' airmen? Admittedly, the acting is often leaden and the direction uninspired: even the aerial sequences lack excitement, but nevertheless, the film is probably closer to the truth than the heavily romanticised and exciting features that Hollywood usually produced. There were few other films exploring the subject. Burt Lancaster starred in the 1969 MGM film *Gypsy Moths*, a weak story of a trio of barnstorming sky divers, while *Cloud Dancer* (1977) looked at the world of modern-day acrobatic fliers. Although the flying sequences were impressive in the latter film, it was less than enthusiastically received and was given only limited distribution.

Barnstormers made a precarious living and most died violently. Respectable aviators deplored their antics and felt that they brought aviation into disrepute. This tendency had been noted even in the very early days of aviation, as George van Deurs has pointed out,

> Most of the professional pilots knew little about the 'why' of their machines. They had been parachute jumpers, balloonists . . . or circus

stunt men. Few of them ever formally learned how to fly. They took off by luck, superstition, and rule of thumb, and then landed by sheer audacity and agility. They would try anything for publicity and big money. These men were the mainstays of the exhibition teams, but they bored thoughtful men like the Wrights[8]

And such dangerous stunting became even more common in the 1920s, the heyday of the barnstormers. Their dangerous manœuvres and frequent accidents held back the development of commercial aviation, convincing many people that aeroplanes were inherently dangerous. Their one contribution was to inspire a second generation of fliers; young men who first experienced the thrill of flying through a five-dollar ride in a barnstormer's 'Jenny'. However, the real development of civil aviation came with the growth of the air mail service.

II

More than anything else, it was the creation of the US Air Mail Service that paved the way for the development of comercial aviation in America. This complex organisation of routes, airfields, ground support services and aircraft maintenance systems pioneered the techniques upon which successful air lines would later be built. Flying the mail also acted as a training school for pilots who later pioneered the long-distance air routes, such as Lindbergh, or who became the first commercial pilots. The use of aeroplanes and airships to deliver mail was not a new departure and airmail flights had been made as early as 1911 in Britain, Germany, America and even in South Africa. However, these early attempts had been short-lived and despite the persistence of some pioneers to maintain a regular service, the outbreak of war in 1914 cut short their endeavours. A nation as vast as the United States would obviously benefit from the rapid transit of mail and as early as 1916, the Post Office began to lay plans for a scheduled service. This was inaugurated in May 1918 with the Washington–New York route. Despite criticism that the service was uneconomical and of the growing number of fatalities among pilots, the Post Office, and in particular Second-Assistant Postmaster-General Otto Praeger, never lost their faith. As Richard Hallion has noted, in the immediate post–1918 world, while Europeans were taking their first tentative steps in civil aeronautical development, it was the airmail service that kept American air transport alive.[9] In 1925 the Kelly Act transferred the airmail service to private operators and opened the door to the growth of commercial aviation.

By the early 1920s, the epic adventures of the young pilots who flew the

mail had already captured the public imagination. In 1921, for example, *the New York Times* paid tribute to the Postmaster-General and his pilots: 'Aviation owes a great deal to Otto Praeger . . . But American aviation owes far more to the brave youngsters . . . who have attempted what has often seemed to be impossible in flying according to schedule in all weather.'[10] The danger and excitement of mail flying was, for many young pilots, a substitute for the experience of war. Even Howard Hughes, carried away with the romanticism of 'flying the mail', attempted to enlist in the service under an assumed name. But given the dangers, the excitement and its obvious appeal as a modern version of the legendary Pony Express, where daring pilots carried their mail into the new frontiers of the sky, the film industry quickly saw the commercial potential of the subject as a background for aerial adventure.

The Great Air Robbery of 1919, the Ormer Locklear extravaganza, was probably the first film to feature mail pilots, but by 1922 with the service established in the public mind, the studios began to thoroughly exploit the subject. *Trapped in the Sky* (1922), for example, was a loose reworking of the Locklear film, but without its appeal. *Fast Mail*, made the same year, established a trend for action thrillers which merely used the air-mail as a background for daring robberies and spectacular stunt flying by the mail pilot hero. Paramount's *Air Mail* (1925), written by ex-flier Byron Johnson, was a superior production but critics referred to it as an 'up-to-date western adventure'.[11] Typical of the sub-genre were Pathe's ten-episode serial *Snowed In* (1926), *Flying High* and *Pirates of the Sky* (both 1927) and *Air Mail Pilot* (1928). Slight variations were to be found in *Wolves of the Air* (1927), where two young pilots are in competition with villainous rivals to secure an air-mail contract, and *Flying Mail* (made the same year), with its young pilot the victim of a blackmail plot to force him to deliver his shipment of government gold into their hands. More interesting was the 1928 feature *The Air Legion*, directed by Bert Glennon and starring Ben Lyon and Antonio Moreno. Lyon plays a pilot who, in a moment of panic during a storm, bails out and thus loses the mail. However, with the help of the experienced chief pilot (Moreno), he regains his nerve and exonerates himself. *Air Legion* well details the natural hazards of flying the mail. The *New York Times* referred to the film as providing an 'unusually good idea of the duties of the fearless pilots who dart through the air with Uncle Sam's mail'. It praised Glennon for creating a realistic and believable film and for resisting the temptation to introduce crooks, air pirates and other such melodramatic elements but relying instead on the natural dangers pilots faced.[12] *Air Legion* was virtually the last silent air-mail movie and although the coming of sound enabled film makers to explore

their subject with greater detail and sophistication, it also created considerable technical difficulties.

As Farmer has pointed out, the introduction of sound brought about many changes in the specifics of film production. Sound recording equipment was heavy and highly sensitive, making location shooting difficult. Directors preferred to remain in the studio where recording could be carefully controlled and recreate the outside world on the sound stage. One response was the development of back projection, having the action background projected onto a screen in front of which the actors performed. Location filming began to be handled by a second-unit team, and editor and director then intercut location and studio shots into a continuous narrative. Another response in the early 1930s was the increasing use of sophisticated miniatures – models to simulate reality for difficult action scenes. This not only cut expense (clearly important in the the climate of worsening depression), but gave the director a greater degree of control over action scenes.[13] In 1931 Universal spent over $50,000 on the building of a sound stage devoted exclusively to special effects. John Ford's 1932 production *Air Mail* was probably the first aviation film to make extensive use of the stage.

The film was in many ways a typical Fordian project dealing with group loyalty and survival against external dangers. Mike Miller (Ralph Bellamy), an experienced pilot, runs an airmail station in the Rocky Mountains. One of his pilots is the reckless Duke Talbot (Pat O'Brien), who is romancing the wife of a fellow aviator. When the husband is killed, Duke and his lady friend go on a spree leaving the airmail run to Mike, who is suffering eye trouble. Mike crashes in the mountains and rescue seems impossible. Duke, however, realising how weak and selfish he has been, manages a daring rescue and regains the respect of his fellow pilots. *Air Mail*, like the earlier *Air Legion*, takes a serious look at the day-to-day workings of the airmail service and relies for its dramatic tensions on natural hazards. Although the *New York Times* critic found the plot had scenes of 'incredible fiction', he noted it was 'ably-photographed' and 'in its more sober scenes there are striking conceptions of the risks and hazards of airmail pilots, particularly in heavy rains and wild snowstorms'.[14] The film was co-written by Frank 'Spig' Wead, a naval aviator until a flying accident forced his retirement. Wead then turned to writing and became a prolific author of film scripts and plays dealing with aviation topics. Ford and Wead became close friends and worked on a number of projects, and that friendship resulted in the 1957 film *Wings of Eagles*, Ford's screen biography of Wead in which the character John Dodge is a thinly disguised portrait of Ford.

Despite the less far-fetched images of *Air Legion* and *Air Mail*, most studios

continued to produce the 'cops and robbers' style of airmail movies. *Flying the Mail* (1932) from MGM and Universal's twelve-episode serial *Air Mail Mystery* (made the same year) were typical of these cheaply made action films. The latter was notable for its wonderful villain, 'Black Hawk', and his revolutionary aerial catapult used to bring down the unsuspecting mail planes. In an attempt to capture audiences for these routine features, studios used a variety of publicity ploys. In 1935, Columbia's answer to declining audiences was to hire veteran aviator Wiley Post to appear in a film as himself. Advance publicity for the film, *Air Hawks*, made much of Post's appearance, but it was merely a walk-on part lasting for little more than a minute of screen time.

The film was just another variation on a well-worked theme, where two companies compete for a mail contract and one resorts to sabotage and other underhand methods to gain the advantage. The film gained from a certain morbid curiosity when Post was killed in August of that year when flying the humorist Will Rogers to Alaska. *Flight From Glory* (1937) from RKO was original only in its location, the Andes, where a group of American airmen supply the local mines and operate a mail service. Republic's *Flight at Midnight* (1939) concerned a brash, daredevil mail pilot who achieves maturity and discipline only after the death of his best friend. Of all the features made after Ford's *Air Mail*, only three made any determined effort to explore the real world of the airmail pilot: *Night Flight* (1933), *Ceiling Zero* (1935) and *Only Angels Have Wings* (1939).

MGM's *Night Flight* was adapted from the novel *Vol de Nuit* (1931) by aviator-poet Antoine de Saint-Exupéry. Laurence Goldstein has suggested that Saint-Exupéry's work is 'certainly the most sophisticated literature of aviation that appeared between the time of Lindbergh's flight . . . and the outbreak of World War ll'.[15] Saint-Exupéry sought to end the idealisation of the solo pilot-hero and *Vol de Nuit* was based upon his own experiences flying for the Latecoere Airline in South America. Pierre Latecoere, the founder, was a man driven by a vision of a vast network of air routes joining the continents, rapidly transporting mail and passengers and bringing nations closer together in mutual harmony. The novel was an instant success and MGM acquired the film rights. The screen version featured John Barrymore as Riviere, the airline's operations manager, and a character closely modelled on Latecoere. Riviere is driven by his belief that whatever the risk to machines and men, the mail must always get through. Even the death of the young pilot, Fabian (Clarke Gable), does not shake this belief. When the dead pilot's widow protests that men are being killed so that someone in Paris can get his mail on Tuesday instead of Thursday, Riviere is unmoved: scheduling flights, sending out pilots, delivering the mail on time, that is his

function. The manager and his pilots are part of something much bigger than one small South American airline, and indeed as one watches him sitting in front of his huge control board on which lights indicate the positions of his aircraft, something of the growth and purpose of civil aviation is conveyed. Although the film fails to do justice to the original text, *Night Flight* was nevertheless a superior production when compared with the majority of aviation dramas of the period.

James Farmer has noted that by 1933 the very popular on-going cycle of war flying pictures began to have a considerable effect on the features dealing with civil aviation; and that the latter began to borrow heavily from the former in terms of plot and characterisation.[16] *Night Flight* is a useful example of this borrowing. The dedicated Riviere is similar in many respects to the squadron commander of *Dawn Patrol*, the officer who sends out his men day after day to face great danger because that is his duty and only by such actions can the enemy eventually be hounded out of the skies. Riviere orders out his men knowing that only by their efforts can the air lanes be pioneered and made safe for those that follow. Riviere's young pilots are just as eager to test themselves against the challenge of weather and technical limitation as that earlier generation were to test themselves against the guns of Immelmann and Boelcke. The airline, like the fighter squadron, must function as a team with every man playing his part and taking responsibility for his comrades. It was this emphasis on team work, initially raised in *Night Flight*, that was at the centre of two Howard Hawks features, *Ceiling Zero* and *Only Angels Have Wings*.

Based upon a Broadway play by Frank Wead, *Ceiling Zero* clearly betrays its stage origins in its static location – the operations office of 'Federal Air Lines'. Into the office comes 'Dizzy' Davis (James Cagney), an outstanding pilot but a loner, a 'hot-shot' with little sense of duty or loyalty. Because of his long-standing friendship with manager Jake Lee (Pat O'Brien), Dizzy is taken on but continually clowns around and evades his responsibilities to the air line and to his fellow pilots. A date with a new girlfriend is more important than his scheduled flight and he pretends to be too ill to fly. The run is taken by a fellow pilot, a man who lacks Dizzy's experience and ability. When he runs into heavy fog, 'ceiling zero', he cannot cope and crashes to his death. Dizzy, becomes a pariah, distrusted and shunned by his colleagues. Forced to face his irresponsibility, he volunteers to fly in almost impossible conditions and is killed in the attempt. Clearly, Dizzy finally learned the meaning of duty to the team. Someone had to take the mail and he was the pilot with the best chance. Although there are few flying sequences in the film, the critic Frank Nugent called it a 'constantly absorbing chronicle of life in and around a

commercial airport'.[17] There are obvious similarities between this film and Wead's earlier screenplay for the 1932 feature *Air Mail*, but *Ceiling Zero* is a far more considered piece of work and gained greatly from Hawks' controlled direction. Hawks intended the film to be a tribute to civil aviators but airline executives were less than happy with yet another film depicting the dangers of flying. Representatives of the industry approached Warners requesting the film to be withdrawn as they considered it would convince would-be passengers that flying was unsafe. The studio could not comply without suffering financial loss but they did agree to a preface which read, 'This picture depicts the pioneer days in air travel. As a result of these heroic events, we have arrived at today's safety'.[18] And with that the airlines had to be content. With *Ceiling Zero*, writer and director added distinction to what was rapidly becoming a routine and clichéd format. Three years later, Hawks again explored the theme in *Only Angels Have Wings*, virtually the last film of the 1930s air mail cycle.

Considering that critics have suggested that *Only Angels* is the quintessential airmail film,[19] it contains, like *Ceiling Zero*, remarkably little flying, and most aerial scenes make extensive use of models. Yet continuous action is implied through the recurring radio transmissions between pilots and the control room (a device Hawks first used in *Ceiling Zero*). Like *Night Flight*, *Only Angels* is set in South America, in the fictional town of Barranca. Here, Geoff Carter (Cary Grant), a tough, dedicated pilot runs an air mail/cargo operation for the 'Dutchman' (Sig Ruman). Most of the film takes place in the Dutchman's claustrophobic saloon which also doubles as the airlines control room and pilot mess. Hawks uses this contained and isolated group to explore the psychological make-up of the fliers: men whose worth is measured by their loyalty to each other and to their duty and by their personal conduct. Carter is the man who sends them out on their dangerous assignments, but flies himself when it is too dangerous to send anyone else (a parallel with the romanticised squadron commander of *Dawn Patrol*). His loyalties are to his pilots and to the Dutchman who, in order to gain a government contract, must maintain a regular service. The Dutchman, a sentimental uncle to the aviators, contrasts strongly with Carter. Left to the saloon keeper, no one would ever fly in anything less than perfect conditions but, of course, the contract would soon be lost. Only the efficient and apparently ruthless Carter can establish the line and push along the development of air transportation.

Into this enclosed world come Bonnie Lee (Jean Arthur), a singer on her way back to New York, and replacement pilot Bat McPherson (Richard Barthelmess), a man living down a reputation for cowardice. McPherson is

given every dirty, dangerous job until he proves himself to his fellow fliers. Bonnie is attracted to Carter but cannot come to terms with his apparently callous attitude to the death of his friends. What she cannot understand is that death is so commonplace among the pilots that public demonstrations of grief have no meaning: ensuring the next flight gets through is tribute enough to a dead comrade. Only once does Carter reveal his feelings, after the death of Kid (Thomas Mitchell) his close friend. But this is the world the fliers have chosen and they know the risks. In one scene, Bonnie asks Kid, the ageing pilot, 'Why do men fly'? 'I've been in it for twenty-two years, Miss Lee,' the veteran replies, 'and I couldn't give you any answer that makes sense.' Here again, then, we meet men who have been 'conquered' by the aeroplane like Roger Schumann in *Tarnished Angels*, men who risk everything to go on flying . Kid himself is slowly going blind, yet he will resort to any trick to continue flying even though he is well aware of the consequences. As Robin Wood has suggested, an element of darkness and death is necessary to establish the background but 'no one who has seen (the film) will regard it as gloomy. Buoyant, vital, exhilarating, are more likely to be epithets to spring to mind'.[20] In fact, by the end of *Only Angels* almost every character has undergone a process of improvement. Hawks' film was virtually the last of the airmail cycle.

By 1939 the studios increasingly began to reflect an interest in defence preparations and military flying and, after December 1941, with air war films. However, in 1947 Paramount returned to the the air mail theme with *Blaze of Noon*, again scripted by Frank Wead and based on a novel by veteran pilot Ernest Gann. The *New York Times* reviewer suggested that the Paramount production had 'blueprinted an old aviation romance complete with standard situations',[21] and certainly *Blaze of Noon* added little to what had gone before. Advertised as 'the screen's tribute to the men of aviation . . . the first to fly the mail', this tale of men who 'flew egg crates by the seat of their pants to blaze a trail beyond new horizons',[22] was little more than a pastiche from earlier films. Set in the early 1920s, it is the story of the four McDonald brothers, all pilots and all obsessed with aviation. After a brief career barnstorming they join 'Mercury Air Lines' to fly the mail. But one by one they succumb to the dangers of flying: two are killed, one crippled and one grounded. Even the air line manager (Howard da Silva) is the tough, dedicated professional first seen in *Night Flight*. To publicise the film, the stunt pilot Paul Mantz, who had worked on the film, flew coast to coast in record time in a blood-red P51 called 'Blaze of Noon'. But despite such gimmicks, the film was not overly successful. The great days of the airmail pilot had long gone and audiences wanted films more relevant to the times; in aviation

terms that meant the war and new developments such as jets, rockets and breaking the sound barrier. Following the poor reception of *Blaze of Noon*, the cycle came to an end. It was revived in 1980 with *The Aviator*, again based on a story by Ernest Gann and starring Christopher Reeve, better known for his role as 'Superman'. The *Aviator* was an uninspired romance that had little to do with airmail flying. Outside America, only one feature film dealing with air mail flying was produced. This was the Soviet-made *Air Mail* (1935) from Soyuzderfilm. Unusually this focused on the bravery of women pilots flying the mail and cargo in the Arctic regions. The main story concerned a pilot who manages, despite the appalling weather, to deliver vital medical supplies to an isolated community in Siberia.

The cycle of airmail films began in the early 1920s and lasted until the outbreak of the Second World War. The airmail service was instrumental in pioneering the routes and systems which led to the development of air transportation and passenger-carrying air lines. Something of this debt is revealed in the better feature films dealing with the subject, but airlines themselves also provided the subject matter for another major cycle of films which ran parallel to airmail dramas.

III

The desire to establish regular air transport routes for passengers predated the First World War. In Britain, France and the United States at least several attempts were made; but only in Germany, making use of Zeppelin airships, did a regular service begin. The war called a halt to such initiatives but, following the Armistice, surplus machines and unemployed ex-war aviators provided the raw materials for a nascent civil aviation. A regular London–Paris route was established in 1919, and even in defeated Germany, Berlin and Leipzig were linked by an air route in February of the same year. Local services were also established in the United States, the Cecil B. De Mille line in California, for example. Most of these ventures were short lived; technical limitations, insufficient investment and lack of consumer demand were the main factors that prevented the initial growth of civil aviation. It was not until the mid-1920s, when the development of more suitable aircraft types and increased public interest in air travel coincided, that the major airlines were established. Clearly, the Lindbergh flight drew public attention to aviation and this coincided with safe, comfortable and economically viable commercial machines such as the Fokker and Ford Tri-Motors and the Boeing 80A and 247. Many nations recognised the need to fund airlines from state resources to promote the image of an advanced industrial state, and thus were the great airlines established – British Imperial Airways (1924)

or Lufthansa (1925), for example. The American government, committed to free enterprise, refused to provide state resources and it was only through a Guggenheim Fund award that the first major airline was established in the United States – Western Air Express in 1927. The film industry, however, with its interest in aviation subjects immediately saw the commercial potential in the growth of the airlines as suitable subject matter for screenplays.

Films dealing wih air transportation usually took one of two directions: films which explored the creation and work of the airlines and, far more commonly, those which used commercial flights as a background for dramatic action – engine failure, hijacking, forced landings and so on. There is often considerable overlap between these categories because many features dealing with the workings of airlines make use of dramatic episodes aboard the aircraft to increase interest and tension. Several of the early civil aviation films saw air transport as a modern equivalent of the exciting world of Wells Fargo, the aeroplane a *Stagecoach* with wings. Indeed, many of the first air transport features, like airmail dramas, were merely variations of the western and even made use of a cowboy background. Typical of this type of film was Mascot's twelve-episode serial *Hurricane Express* of 1932, with John Wayne as a Fokker Trimotor pilot working for an air transport company which uses the sky as an alternative to the railroad, which is being sabotaged by outlaws. These 'western' style features remained common throughout the period and even as late as 1938 Wayne returned to flying with *Overland Stage Raiders*, which deals with a mining company turning to air transport when its trucks are continually hijacked by gunmen.

Probably the first feature to look seriously at civil aviation was William Wellman's 1933 film *Central Airport*. The story centres around Jim Blane, an airline pilot dismissed after a crash. He joins an air circus but when he loses his girl to his brother he becomes a mercenary flying for air forces in China and South America. His brother, however, settles for the routine of airline flying. Although a great deal of the film is concerned with the romantic entanglement it does show something of the background of the development of air transport and the workings of a busy commercial airport. Much of the location work was filmed at United Airport, Burbank, California. Commercial flying also provided the background for *Bright Eyes* (1934) from Fox. While basically a Shirley Temple vehicle (soft-hearted pilots adopt the appealing orphan), the film does act as a showcase for American Airlines and their new Douglas DC2 aircraft. Like *Central Airport*, it made considerable use of location shots and again provided some insight into the work of a modern airline. However, it was the following year, 1936, that the airline

movie really came of age with the release of three important features: *Sky Parade* and *Thirteen Hours By Air* from Paramount and *China Clipper* from Warners.

Sky Parade, based upon the popular radio show *Jimmie Allen*, created by ex-RFC pilot Bill Moore, dealt with the adventures of a brave and daring air cadet. An inconsequential production in many respects, *Sky Parade* was pure aviation adventure in which hijackers take over an airliner and kill the pilot. Young Jimmie, travelling as a passenger, defeats the hijackers and manages to land the plane safely. Significantly, however, it would appear to be the first film to use a number of incidents which would later become common within the sub-genre: the attempted hijack, for example. It was also the first film where an unqualified pilot is 'talked down' by radio from the airport control tower. More substantial was *Thirteen Hours By Air* released in April, and the first major production dealing with airlines. United Airlines, established in 1928, had previously provided Paramount with aircraft and facilities for a number of films and, in return, the studio assigned writers Bogart Rogers and Frank Mitchell to develop a screenplay which would show the profes- sionalism of the line's new transcontinental service. The final script is the story of one such flight from Newark to San Francisco and of senior pilot, Captain Jack Gordon (Fred MacMurray), and a curious collection of passen- gers. Over Nevada, the plane runs into a severe storm and is forced to land. Once on the ground, the film degenerates into a typical thriller. One passenger is a wanted killer, another an FBI agent on his trail. After several shootings, the killer is overpowered, the storm clears, Gordon manages to get the plane off and the journey continues. *Thirteen Hours* established a formula for the future and introduced the stock characters for such dra- mas: the dedicated crew, quirky passengers including the 'mystery' woman, the doctor, the criminal, the passenger terrified of flying and the humorous salesman who makes the best of any situation. It was a scenario that would be endlessly repeated until only the final parody of *Airplane* (1980) remained. The first half of *Thirteen Hours* is the most interesting, for here we have a detailed and realistic study of the workings of a modern airline. The irony was that United Airlines had helped create the film to promote the safety and comfort of its flights. Yet, as one critic pointed out, the film 'contributes nothing at all to the benign theory that air travel is safe and comfortable'.[23] But the film was extremely popular with audiences and United were apparently satisfied with the finished product. At the initial preview they asked for only one scene to be cut – an in-flight brawl, which United felt would threaten passenger safety!

Just as exciting but without the melodrama was *China Clipper*, released in

August, written by Frank Wead and made in co-operation with Pan-American Airways. Pan-Am had already received considerable publicity for its Sikorski flying boat service to South America (established in 1932) in the RKO musical spectacular *Flying Down To Rio* (1933). This Astaire–Rogers vehicle has what has now become a classic sequence; the chorus line dancing on the wings of the S 40 as it circles Rio de Janeiro Bay. Interestingly, the producer, Merian C. Cooper, perhaps better known for his later association with John Ford, had been an aviator in World War One and served on Pan-Am's board of directors. Three years later, Warner Brothers explored the airline's story in an almost documentary styled feature. Taking as its main theme the vision and drive of the fictional 'Dave Logan' (Pat O'Brien), we see how this ex-war aviator creates 'Trans-Ocean Airways' in the Caribbean, his struggle to convince the public to travel by air and his efforts to overcome technical limitations. But Logan is the dedicated professional and driven by a belief in the future of civil aviation. With a team of like-minded professionals, he forges ahead whatever the cost to his private life and creates both a trans-Pacific line and a new flying boat to operate it. The climax of the film comes with the first America–China flight. Making use of considerable documentary and newsreel footage, we see the huge Martin flying boat lifting off from Alameda, California and refuelling at Honolulu and Midway Island; the adverse weather and in-flight problems as the aircraft drives her way across the Pacific. The scene alternates between the flying boat's cockpit and the airline control room in California, interspersed with beautifully filmed flying sequences.

Logan is the typically tough but visionary airline boss, driving himself and his employees to the very limits of ability and endurance. Humphrey Bogart is 'Hap' Stuart, the chief pilot and captain of the clipper on the first China run, but a third star is the streamlined Martin aeroplane around which the film is constructed – the 'clipper' of the title – an impressive symbol of the power and grace of American flying boat technology. However, as Pendo has noted, the major struggles of Pan-American took place in Washington, not in the skies. The US government discouraged airline competition for international routes believing that a single strong, overseas airline had the best chance of competing with the state-subsidised lines of Britain, France and Germany. Pan-Am, through its powerful lobby, and presumably its impressive representation in popular cinema, invariably received contracts for international routes even though it was not always the most economical bidder.[24] Of course, nothing of this is shown in the film: but it remains one of the best reconstructions of airline development of the period. Its strength is in its reliance on real events and Warners' refreshing approach of not

resorting to cheap melodramatic episodes to enliven the script. As Nick Roddick has rightly pointed out, at the height of the Depression, *China Clipper* 'reaffirmed a belief in American technology, know-how and the spirit of innovative adventure'.[25]

After 1936, airline features frequently reworked themes which had appeared in these earlier films. *Sky Giant* (1938), from RKO, was set in a flight training school operated by Trans-World Airways, but the story was borrowed from military training pictures. Harry Carey, the dedicated professional, and Richard Dix, the veteran pilot assigned to training, between them teach the young airline pilots the meaning of discipline. The first part of the film is an interesting and detailed portrait of the operations of such a flight school but it soon degenerates into an action spectacular when the line attempts to inaugurate a trans-Arctic flight to Russia. This opens the way to storms, near-crashes and heroics. The training of pilots also featured in the 1939 production from Fox, *20,000 Men A Year*, again based on a story by Wead. This explored the newly formed Civilian Pilot Training Programme, with Randolph Scott as the veteran instructor responsible for the training of tomorrow's airmen. While it includes some useful documentary material on the programme, it suffers from over-long adventure sequences – looking for lost cadets, dangerous landings and so on. While many of the pilots trained through the CPTP did go into civil aviation, the real intention was to double the number of qualified pilots as part of an increasing national defence programme. By the end of the decade, film makers were beginning to run out of ideas for the airline movie (the 1939 production *Fugitive In The Sky*, for example, was virtually a remake of *Thirteen Hours By Air*) and, in an attempt to revitalise the format, began to make use of exotic settings. RKO's 1937 *Flight From Glory* established a precedent for South American locations. In this feature a group of American pilots attempt to fly supplies to the isolated mining communities of the interior. *Flight Into Nowhere* (1938) from Columbia had Jack Holt as the chief pilot of an American airline trying to establish a new route to South America and spending a great deal of time searching for a fellow pilot forced down in the jungle. As we have seen, South America was the scene for *Only Angels Have Wings* and also for the archetypal air crash movie, the splendid *Five Came Back* (see Chapter 8) both released in 1939.

The expansion of civil aviation also provided limited opportunities for women – not, of course, as pilots but as flight hostesses. Following the introduction of the 'hostess' by United Airlines in 1930, the convention quickly spread and by the middle of the decade the stewardess was an essential member of the crew on most airlines. Since applicants were selected on the basis of appearance, personality and intelligence, the job

rapidly developed glamorous and romantic connotations and the air hostess became a stock character in popular romantic fiction.[26] Nor was the film industry slow to exploit the subject. As early as 1933 Columbia released *Air Hostess*, a sentimental adventure about a pilot's wife who was a hostess before their marriage. The film is really about their relationship but it did establish one important convention for hostess movies, the belief that all hostesses were intent on marrying a pilot. *Flying Hostess* (1936), was far more relevant and explored the selection, training and work of three stewardesses. Unable to resist melodrama, Universal introduced an attempted hijacking on the aeroplane on which the three young women are flying. The gunman is overpowered but in the struggle the pilot is injured and unable to fly the plane. However, all is not lost for the senior hostess takes over the controls and lands safely (an idea resurrected in 1974 for the second *Airport* movie). As a patronising critic noted of *Flying Hostess*, the film 'pins a decorative laurel or two on the young registered nurses who provide the nation's airline passengers with bouillon, chewing gum, small talk and encouragement'.[27] *Love Takes Flight* (1937) concerned a stewardess who wants to become a pilot. She attempts a dangerous long-distance flight to the Philippines but just when all seems lost during a great storm, her fiancé (a dashing pilot) is revealed to have stowed away and he naturally takes over the controls and saves the aircraft. The year 1939 saw the release of *Flight At Midnight* from Republic, where a rule-breaking, irresponsible pilot is taught the meaning of duty by his stewardess girl friend. *Flight Angels* (1940) ended the short cycle of hostess movies. Filmed with the co-operation of American Airlines, it was mainly concerned with the romantic affairs of the 'angels'.

Outside America there were few films dealing with civil aviation; European studios could rarely compete on equal terms with Hollywood's financial and technical resources. The French, for example, even in partnership with Warner Brothers could produce only a modest effort – the 1931 production *L'Aviator*, with Douglas Fairbanks Jr. heading a French cast. The film was a basic aerial adventure and all the flying sequences were taken from earlier American films. The following year, a Hungarian production *Flying Gold* (*A Repulo Arany*) was released, dealing with the robbery of a shipment of gold being transported by air from Paris to Budapest. A French-language version (*Rouletabille Aviateur*) was also issued. The British were indeed an 'air-minded' nation as a vast literature of flying stories, memoirs and other ephemera testify, yet this was hardly reflected by the film industry. Few aviation pictures were made and those that were demonstrate the constant problem of underfinancing. The silent feature *Land of Hope and Glory* (1927) from Glory Films was an air adventure where the pilot/inventor's girlfriend

save his new machine from foreign agents. The imaginative *Last Hour* (1930), directed by Walter Forde, owed a great deal to earlier American features, including some of its flying sequences. The story concerns a gang of crooks using a radio beam to force down passenger airships so that they can rob them. BIP released *Flying Fool* in 1931, a crime thriller with a few flying sequences, and the Jack Buchanan musical comedy, *The Sky's The Limit* (1937) had only marginal aviation interest despite its title. Other than those features which demonstrated Britain's air defence preparations or dire warnings about the consequences of future aerial warfare (*Q Planes* or *Things To Come*), only three features really dealt with aspects of civil aviation: *FPI* (1933), *Flying Doctor* and *Non-Stop, New York* (both 1937).

FPI (Floating Platform One), based on a story by Kurt Siodmak, was a Gaumont-British/Ufa co-production starring Conrad Veidt and Leslie Fenton. Directed by Karl Hartl, the film deals with the creation of floating platforms anchored to the seabed and intended to be used as refuelling stations for long-distance flights by a German airline. However, rival interests are at work in the form of a shipping company which fears it will lose its passengers to the airline once a trans-Atlantic air service is available. The shipping magnate places a saboteur aboard the platform to destroy it. A veteran flier, Major Ellisen (Conrad Veidt), is responsible for tracking him down. Lufthansa actually considered using such platforms and, according to Farmer, an operational prototype was anchored in the North Sea and used for filming[28] *FPI* was well received by audience and critics and established Veidt as a major talent in the British cinema. However, the film was made in Germany and cannot really be classed as a 'British' production.

The year 1937 saw the release of the British-Australian production *Flying Doctor* — the adventures of the flying medics of the Australian outback. Although exploring an interesting use of air transportation, the film's major claim to significance was as the first sound film made in Australia rather than for its content or production values. The idea of using aeroplanes as rapid transportation for doctors or as ambulances had already been explored in the first Swedish aviation film *Vagabond Of The Air (Ungdom Av I Dag)* (1933), from Europa Films. The film opens with a girl hiker being injured. An air ambulance is summoned. One of the pilots (Albin Ahrenberg) recognises her as an old flame but she falls for his friend (Ake Ohberg). Interestingly, Ahrenberg was a well-known flier in Sweden, who attempted a number of long-distance flights and toured Sweden by air in an attempt to promote interest in aviation.[29]

Non-Stop, New York was a Gaumont-British attempt to break into the popular airline sub-genre established by American studios and which made

use of many of the conventions and stock characters created in such films as *Thirteen Hours By Air*. However, there are some interesting variations in this major production. Starring Anna Lee, John Loder and Francis Sullivan, *Non-Stop* is set in the immediate future where luxurious airliners operate scheduled trans-Atlantic flights. On one such London–New York flight is the young witness to a murder (Anna Lee). She must reach New York in time to save an innocent man convicted of the killing and sentenced to death. By strange coincidence, the real murderer (Francis Sullivan) just happens to be aboard and is unmasked during the flight! Despite the melodramatic storyline the film was well made: the interior of the airliner of the future was particularly convincing and owed a considerable debt to the giant passenger airships of the 1930s. But despite this and above average production values, it remains just another skyborne thriller. Although there may have been shortcomings in the British feature films of the period, other film makers did achieve considerable praise for their appro h to documentary film, and a number of their productions focused on aviation topics.

The mid-1920s in Britain saw the emergence of an innovative group of documentarists including John Grierson, Paul Rotha, Basil Wright and others. Given the financial straits of the film industry they were fortunate enough to find initial sponsorship through the Empire Marketing Board and later with the General Post Office Film Unit and various commercial concerns.[30] Much of their work promoted positive images of the nation, and aeronautical development was an important propagandist element in this context. In the 1930s a number of short films were produced extolling British achievements in the air, beginning in 1933 with Grierson's *Aero Engine* and Rotha's *Contact* (see Chapter 5). In 1934 came the release of *Air Post*, which promoted both the GPO airmail service and Imperial Airways. It is a fascinating account of how mail is collected, sorted and sent from Croydon Airport to destinations across the Empire. Croydon, England's main terminal for overseas air travel, also featured in Edgar Anstey's study *Air Port*, released the same year. Made by the newly formed Shell Film Unit, it was a short study of the workings of a busy modern terminal.

At Imperial, the publicity director was C. F. Snowden Gamble, an ex-RNAS pilot with a deep interest in the history of aviation.[31] Snowden Gamble also believed in film as an important channel for prestige publicity and used film makers to promote the airline: *Wings Over Africa* (1933) and *Air Ways To Cape Town* (1934) were two early examples. In late 1936, a unit from the independent Strand Films were commissioned to produce a film dealing with imperial air routes. After three months filming they had over 50,000 feet of

film. This was eventually used for a number of shorts but the chief production was *The Future's In The Air*, released in 1937 and again produced by Paul Rotha. This celebrated the inauguration of the Empire air mail carried on Imperial Airways aircraft. With a commentary written by novelist and critic Graham Greene, the film shows how a letter from the Australian outback is carried by air until it eventually reaches Southampton: a device around which Rotha built a splendidly photographed travelogue of exotic imperial locations touched by the airmail liners. *Air Outpost*, released the same year, a short study of Sharjah airport on the Persian Gulf, a refuelling stop for Imperial, was also produced from the original film shot by Strand. The GPO celebrated the Empire Air Mail Service in an early colour animation, *Love On The Wing* (1939), by Norman McLaren. The training of flying boat pilots for the Imperial air routes was the subject of Ralph Keene's *Watch And Ward In The Air*, made for Imperial Airways by Strand Films and released in 1939. Even as late as 1940, Strand released *African Airways*, a study of the flying boat service from Southampton to Cape Town. Much of this was comprised of routine shots – flying boats, passengers and exotic locations – intended to convince the public of the airline's high standards of safety and comfort. However, director Donald Taylor used the final sequences to make a political statement as he contrasts the luxury by which the imperial traveller is surrounded with the conditions of South Africa's black population. It becomes a searing critique of discrimination and apartheid, and as Graham Greene noted in his review, the film is a 'horrifying vision of the Rand and the awful squalor of the mining compounds of Johannesbug'.[32]

Film was also used to promote a Swiss-African airline which in 1935 produced *Wings Over Ethiopia*, a visual record of a flight over that troubled country. The film owed a great deal to Rotha's *Contact*, but the Italian invasion of Ethiopia in October of that year gave the film topical interest. Lufthansa used the cinema to publicise its long-distance airship flights. *Across The World By Zeppelin* (1924) was a record of the trans-Atlantic flight of the ZR3 but the film included documentary footage of the development of the Zeppelin airships. The 1929 production *Around The World Via Graf Zeppelin* was a compilation of newsreel footage taken during the world flight of the great airship. The film is a persuasive advertisement for the comfort and safety of airship travel and includes a spectacular scene where the airship flies through an electrical storm over the Pacific. However, the serenity and safety of the airship was completely undermined by the crash of the British R101 and, more spectacularly, by the destruction of the *Hindenburg* at Lakehurst, New Jersey, on 6 May 1937.

The moment was captured on newsfilm and live broadcast by Herb

Morrison of Radio WLS, Chicago. Both the film and Morrison's commentary were used in Universal's 1975 production *Hindenburg*, a film which suggested that the airship's destruction was the consequence of an anti-Nazi plot.

Only one other nation appears to have used film to explore air transportation in the period and that was the Soviet Union. As part of the propaganda drive to create a dynamic image of a rapidly modernising state, a number of films were made extolling Soviet aviation. While most of these concentrated on military subjects, some did focus on civil aviation. *The Winged Painter*, a comedy of 1936, was set in a flying school and dealt wih the training of young pilots. More interesting was the 1937 production from Ukrainfilm, *Short Stories About Heroic Pilots*. Filmed in documentary style, the feature related several stories about brave Russian airmen — Arctic rescue crews and the transport pilots who carry mail and supplies to inaccessible towns and villages in Siberia. The only other civil aviation film to be made before 1945 was *Workdays* (1940) from Mosfilm, a detailed examination of the working life of Aeroflot pilots.

<center>IV</center>

From the late 1930s, aviation films began increasingly to deal with military aspects: air defence, the training and preparation of air force personnel and the new machines developed for offensive warfare. And war remained the main focus for sometime after 1945. However, for some film makers, the early days of flying still had considerable appeal and in the age of space travel, several films were made which nostalgically looked back to the 'golden age' of aviation after the First World War.

High Road To China (1980), set in 1920, starred Tom Selleck as O'Malley, an ex-war aviator, hired to lead an air expedition to find an archeologist lost in China. Based on Jon Cleary's novel, the film fails to do justice to the original story but it does reinforce many of the commonplace assumptions about war fliers in cinematic representations. The cynical O'Malley, disillusioned by the war and the death of his comrades, is concerned with only two things, flying and good whiskey. He undertakes the expedition because he has become addicted to danger and the continual testing of his skill as a pilot. *Ace Eli and Rodger of the Skies* (1973), based on a story by Steven Spielberg, also deals with a veteran of World War One. 'Ace' Eli (Cliff Robertson) is another who cannot settle to a routine peacetime existence and so becomes a barnstormer touring the country with his young son Rodger. Robertson, an aviation enthusiast, was responsible for setting up the project. However, the most revealing of

the modern features was George Roy Hill's *The Great Waldo Pepper* (1975), with Robert Redford in the title role.

Set in the mid-1920s, it is the story of Waldo Pepper, a gifted pilot, but a warrior who arrived in France just too late to take part in the great air battles of the Western Front. It is this fact which drives Pepper to take continual risks as he barnstorms around the Midwest. He is searching for an experience which will test his flying skill as severely as combat would have done. He teams up with another pilot, Axel Olsson (Bo Svenson), and together they join 'Dillhoefer's Air Circus'. In an attempt to find a crowd-pulling stunt, Axel's girlfriend is talked into wing walking. However, when she falls to her death, the pilots are temporarily grounded by the regional Civil Aviation Authority inspector, Pepper's old squadron commander. Unable to fly, Pepper cannot use the new plane his friend has built to perform the 'last great stunt' – the outside loop. The inventor flies the plane himself, and when it crashes and catches fire the crowd flock around the wreck preventing the rescue of the pilot. Waldo, furious at their ghoulish behaviour, takes off in another machine and buzzes the crowd until he too crashes. Permanently grounded by the CAA, he goes to Hollywood, where Axel is already employed as a stunt man. Under an assumed name, Pepper becomes a stunt pilot and gets the opportunity to fly against the great German ace Ernst Kessler (Bo Brundin) in a film being made about the air war on the Western Front. Kessler, one of the few surviving German war fliers is acting as technical adviser and stunt flier for the movie. During the staged air combat, Kessler and Pepper test their flying skills by trying to ram each other. Pepper wins by disabling the German's machine and receives Kessler's salutation – his ability has finally been tested in 'combat' and he now knows that he was among the best. A postscript tells us that Pepper was killed in 1931; he was 36 years old. Beautifully photographed and acted, *Waldo Pepper* is probably the most realistic examination of the age of the barnstormer and the changes wrought by the development of civil aviation.

The opening sequences are light in tone, played almost as comedy, but with the death of the wing walker a darker note enters the film. Some critics found this change of mood disconcerting: too abrupt and unrealistic.[33] However, the point is that with her death, Pepper realises that flying isn't just fun but can be a deadly business, as subsequent events prove. The death of his friend reinforces the point. When Pepper is grounded, unable to prove himself in the air, the story is played out in tragedy until his final triumphant duel with Kessler in front of the cameras. The film deals with the ending of the barnstorming era; and when Waldo and Axel are first grounded, the CAA inspector makes this clear. 'Your air circus is operating in direct

violation of CAA code', he tells them, 'The fun and games are over . . . you guys have scared hell out of the people for too long. Flying is getting to be big business and people have to figure it's safe.' The future is regulations, controls, airlines, airmail and corporate structures. Significantly, Axel, after a brief spell as a Hollywood pilot, applies to an airline for a permanent job. Pepper, however, lacks the discipline and still needs to prove himself – a war flier who was never allowed his chance in war. Kessler, the German ace, is an equally tragic figure, a man who has outlived his age. He is the victim of the romantic myth of the war flier. 'In the sky it is clear,' he tells Pepper. 'Even in my enemies I found honour, courage, chivalry,' On the ground life is complicated and nobility is not to be found. And we have seen the proof of this in the vulture-like behaviour of the crowds who flock to the air circus only to see a spectacular crash and the drama of death. Kessler is clearly based on Ernst Udet who toured the USA on several occasions and featured in a number of films before joining the *Luftwaffe* in 1935.

Commenting later about the film, screenwriter William Goldman suggested that barnstormers were just 'adolescents, nourishing a heroic fantasy that World War One had taken away' and he intended to illustrate this in an opening sequence. The scene, however, was cut by director George Roy Hill, an ex-Marine pilot and veteran of World War Two and Korea.[34] The film had its origins in Hill's passion for flying and interest in the early days of aviation. But it is more than an empty tribute to the barnstormers and is raised to a meaningful exploration of the early aviators through Goldman's perceptive script. In the opening sequence, the camera pans slowly over the pages of a photograph album showing pictures of the great stunt fliers, including Ormer Locklear and Ernst Udet – men who were only at home in the air – and the film ends with a return to that album and the photograph of Pepper.

The Rocketeer, released in 1990, is the most recent nostalgic exploration of the early days of flying; an entertaining adventure which tips its hat to a host of aviation film conventions and Hollywood myths. Set in 1938 in Los Angeles, it is the story of a young racing pilot, Cliff Secord (Bill Campbell), and his faithful mechanic Peev (Alan Arkin). Into Cliff's possession comes a rocket motor which, strapped to a man's back, gives him the power of flight. The blueprints have been destroyed and both Nazi agents and the FBI are desperately searching for the sole prototype. Cliff uses the motor to rescue a fellow pilot and the press dub the mysterious young flier the 'Rocketeer'. The leader of the Nazi agents is the swashbuckling film star St Clair. He has been ordered by Berlin to steal the motor so that it can be used to equip an army of storm troopers. The Nazi plans are revealed in an

animated film which St Clair shows his followers, and this reveals how the rocket-equipped troopers will conquer the world. Cliff use the rocket to wreck St Clair's plans and destroy the Nazis as they attempt to escape in a huge airship. The rocket motor is destroyed, but its grateful inventor, 'Mr Hughes', gives Cliff a new racing plane from his aircraft factory for defeating the Nazi plan. Adapted from a graphic novel by Dave Stevens, the film version of the *Rocketeer* entertainingly exploits all the clichés of the 1930s aviation movie: heroic young pilot, devoted mechanic and so on. The animation showing how the Nazis will conquer the world parodies Walt Disney's 1943 explanation of the importance of strategic bombing, *Victory Through Air Power*. The destruction of the German airship owes more than a little to the *Hindenberg* and St Clair is based on Errol Flynn, with the scriptwriter picking up on the silly rumours that Flynn was really a Nazi sympathiser.

The mythic world of civil aviation on film was just as much a creation of the American film industry as were the war films. Plots, characterisations and conventions were established by the Hollywood studios and other nations could only follow where American film makers led. But the widespread popularity of such films and the number in which they were produced meant that after the mid-1930s the theme had been almost fully explored, and the sub-genre began to feed upon itself as studios continually reworked old themes and reintroduced the stock characterisations; and the formula has persisted – *Airplane II: The Sequel*, made in 1982, for example, may be set aboard a space shuttle of the near future, but its passengers and the situations they face are merely a replay of the passengers and situations first seen in films such as *Sky Parade* and *Thirteen Hours By Air*. In turn, the civil aviation film fed upon the successful war film formula. Hollywood portrayed the development of civil avaition in exactly the same heroic terms as it had portrayed war flying. Instead of battles with enemy airmen, the civil pilots fought the wind and rain and fog, while the men who managed the airlines and sent up the young fliers to battle the elements were simply a variation on the dedicated, hard-bitten squadron commanders of the war films. Partly this was due to the fact that many of the writers and directors responsible for civil flying films were the same men who made the war films: Wellman, Hawks and Wead, for example. And partly it was because, having found a successful formula, no one wanted to abandon it.

NOTES

1 Stephen Pendo, *Aviation in the Cinema* (NJ, 1985), 10.
2 James Farmer, *Celluloid Wings* (Blue Ridge Summit, Pa., 1984), 24: Locklear's story is told in Art Ronnie, *Locklear: The Man Who Walked on Wings* (NJ, 1967).
3 Edward V. Rickenbacker, *Rickenbacker – An Autobiography* (NY, 1967), 137–8.

4 Brendan Gill, *Lindbergh Alone* (NY, 1977), 175.
5 Richard Schickel, *The Disney Version: The Life, Times and Commerce of Walt Disney* (NY. 1968), 128–9.
6 Richard Hallion, *Test Pilots: The Frontiersmen of Flight* (Washington, 1981), 35.
7 Farmer, *Celluloid Wings*, 25.
8 George Van Deurs, *Wings for the Fleet: A Narrative of Naval Aviation's Early Development, 1910–16* (Annapolis, 1966), 15.
9 Hallion, *Test Pilots*, 71. See also William M. Leary, *Aerial Pioneers: the US Air Mail Service, 1918–1927* (Washington, 1985).
10 *New York Times*, 25 Feb. 1921.
11 *Ibid.*
12 *Ibid.* 13 Nov. 1928.
13 Farmer, *Celluloid Wings*, 77–9.
14 *New York Times*, 7 Nov. 1932.
15 Lawrence Goldstein, *The Flying Machine and Modern Literature* (New York, 1986), 139.
16 Farmer, *Celluloid Wings*, 76.
17 *New York Times*, 20 Jan. 1936.
18 Jim Greenwood, *Stunt Flying in the Movies* (San Diego, 1978), 181.
19 Farmer, *Celluloid Wings*, 68; Robin Wood, *Howard Hawks* (London, 1968), 17.
20 Wood, *Howard Hawks*, 24.
21 *New York Times*, 5 Mar. 1947.
22 Advertising poster, 1947.
23 *New York Times*, 30 Apr. 1936.
24 Pendo, *Aviaition in the Cinema*, 122.
25 Nick Roddick, *A New Deal in Entertainment: Warner Brothers in the 1930s* (London, 1983), 65–6.
26 On the fiction of the air hostess, see Mary Cadogan, *Women With Wings* (London, 1992), 212–16.
27 *New York Times*, 14 Dec. 1936.
28 Farmer, *Celluloid Wings*, 87.
29 Bertil Skogsberg, *Wings on the Screen* (London, 1981), 89–90.
30 For the British documentary school, see Rachael Low, *History of British Film: Documentary and Educational Films of the 1930s*, vol. 5 (London, 1979).
31 See, for example, his still valuable study of the origins of military aviation in Britain, C. F. Snowden Gamble, *The Air Weapon* (Oxford, 1931).
32 *Spectator*, 9 Feb. 1940.
33 Pendo, *Aviation in the Cinema*, 57.
34 William Goldman, *Adventures in the Screen Trade* (London 1984), 115.

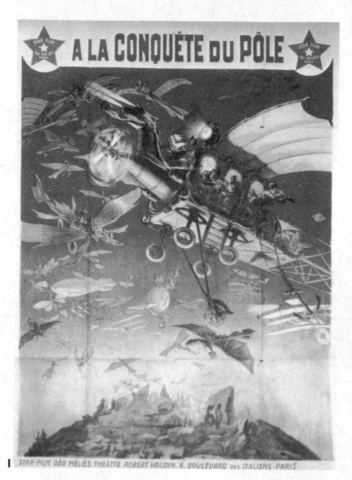

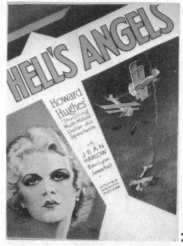

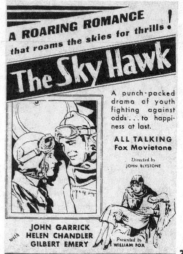

1 *The Conquest of the Pole* (Melies, 1910) demonstrates the fantastic flying machines envisioned by film makers of the early period.

2 Howard Hughes' spectacular production of 1930 featured Jean Harlow prominently in its advertising.

3 *The Sky Hawk* (1929), one of the cheaply produced 'epics' inspired by *Wings*.

4 Richard Barthlemess in the 1933 production *Central Airport*.

5 Even films which had little to do with war used the romantic images of the aviator created in World War One features. Christopher Reeve in the 1985 film version of Ernest Gann's novel *The Aviator*.

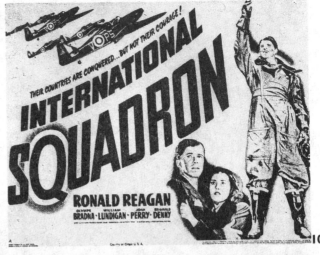

6 The new Boeing 247 featured in *Thirteen Hours By Air*.

7 Constance Bennet, one of the new breed of women pilots in *Tail Spin* (1938).

8 Lars Hansen shows his determination to maintain Swedish neutrality in *The First Squadron* (1941).

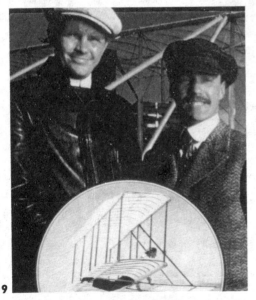

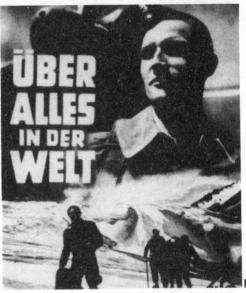

9 *The Winds of the Kitty Hawk*, the worthy but dull 1979 retelling of the Wright Brothers' great American epic of flight. 10 Hollywood's 1941 homage to the American volunteers flying with the RAF.
11 *Flying Tigers* the 1942 RKO production that initiated a cycle of features dealing with American volunteers in China. 12 Camaraderie was an essential element of films about the Luftwaffe: young dive-bomber pilots in *The Stukas* (1941). 13 *Above All In The World* (1941).

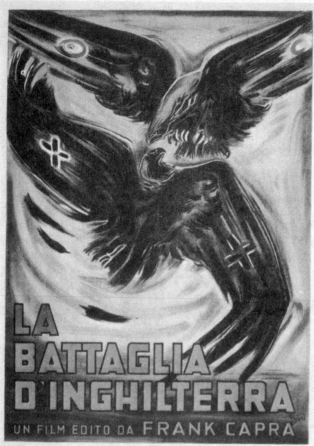

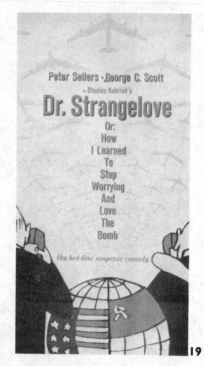

14 This poster for Capra's *Battle of Britain*, shown in Italy after the Liberation, used the familiar imagery of a duel of eagles.
15 Richard Todd as Wing Commander Guy Gibson (*The Dam Busters*, 1954).
16 Lt-Colonel Fuchida (Takahiro Tamura) leads the Japanese bombers into the attack on Pearl Harbour (*Tora! Tora! Tora!*, 1970).
17 The 1958 West German feature *Star of Africa* told the story of Luftwaffe ace Hans Joachim Marseille.
18 Nigel Patrick, the dedicated test pilot in David Lean's *The Sound Barrier*.
19 Stanley Kubrick's 1964 black comedy of the nuclear holocaust.

20 *Blue Thunder*, the ultimate means of urban social control.
21 *Flight of the Intruder*, so far the only war feature made dealing with Vietnam.
22 *The Right Stuff*, the ultimate tribute to American test pilots.
23 *Flight of the Phoenix* probably the most interesting of the post-1945 air disaster movies.

5 Nationalism and the shadow of war

The development of an aviation industry, the creation of an airmail service and the founding of national airlines all played their part in promoting a positive and technologically dynamic image of the state: an important means of enhancing national prestige and status. During the inter-war decades – a time of disillusionment, economic uncertainty and increasing international tensions – most governments were concerned to counter accusations of incompetence and drift. Aeronautical progress was one means by which the state could demonstrate progress and achievement, a way of fostering and maintaining national pride. Thus, throughout the period, most of the technically advanced nations focused at least some attention on aviation: on the 'heroes of the air', on technical achievement, on epic and record-breaking flights or on the general excellence of their aero industry. Popular cinema provided the most effective channel through which nationalist progaganda for these achievements could be carried to the largest possible audience in a simple, entertaining but influential manner. As Kevin Brownlow has argued, World War One put an end to the internationalism of the early cinema. The development of propaganda during the war years led to a nationalistic mood among film makers which persisted long after 1918[1] and few were reluctant to show the flag and to produce features which glorified national achievements.

Cinematic demonstrations of aeronautical progress generally followed one of two basic forms. The state revealed itself as technically advanced, firstly through a focus on the heroic qualities of the aviators, on epic or record-breaking flights or on the superiority of new machines, and secondly through imposing images of the nation's military air power and preparations for defence against aerial bombardment. Given the widespread public concern about attack from the air, and the increasingly dangerous international situation from the mid-1930s, this latter type of film became more important towards the end of the decade. Propagandist films were common to all countries, but they were nowhere more important than among the states where national prestige had been adversely affected by the outcome of the First World War: among the defeated or resentful.

Germany, humiliated by defeat and struggling under the shackles of the Treaty of Versailles, was clearly a nation seeking to regain her former status and restore national pride. One avenue to this goal was through techno-logical advance which, as Neufeld has pointed out, was taken as 'evidence of national recovery or superiority' – as for example the 'rocket craze', begin-ning in 1923 and reaching its climax in 1929. Through books, articles and spectacular stunts, public attention was focused clearly on rocketry and the possibilities of space-flight.[2] Despite some minor successes (Fritz von Opel's flight in a rocket-powered aircraft, for example), there were few real achievements. Through the 1920s, however, aviation offered a more positive indication of national recovery. The 'heroic' status awarded to airmen, the rapid spread of gliding clubs and sport flying, the growth of commercial aviation, the success of the national airline 'Lufthansa' and the almost fanatical interest in the long-distance flights of the new Zeppelin airships, all testify to the popularity of, and public support for, aviation. As Fritzsche has suggested, air achievements 'redescribed German nationalism in compel-ling ways. Aviation forecast a new, more powerful, and disciplined German Reich that would be able to meet the hard industrial demands and join the revived imperial contests of the twentieth-century'.[3] And German cinema both reflected and reinforced this interest in aviation.

After 1918, the German film industry rapidly established itself as a major enterprise, and within five years, production was second only to that of the United States. However, as Bardeche and Brasillach have noted, the films reflected little of the democratic spirit of Weimar. Indeed, most productions were 'strenuously nationalistic works of propaganda'.[4] Under the guise of lavish spectacle they attacked Germany's former enemies and glorified national achievement. The aviation film was one channel for this self-glorification. According to Mosse, the 'struggle of the airplane against the hazards of nature was not only dependent upon technical superiority but upon the moral qualities of the man in the cockpit, the 'new man' symbolic of all that was best in the nation',[5] as for example in the film *Flight into Death* (1921] – a feature dealing with competition flying. Another early attempt to glorify the 'new man' was the 1929 Richthofen biography. Far more success-ful were the first screen appearances of Ernst Udet in Arnold Fanck's popular mountaineering pictures *White Hell of Pitz Palu* (1929) and *Storm Over Mont Blanc* (1930).

As Mosse has pointed out, mountain films were surrogate war films: an appeal to manliness and purity, in which 'conquering the mountains and glaciers symbolised individual strength in a world gone wrong'.[6] Such films provided an illustration of man's domination of the natural world. After the

introduction of the aeroplane into the genre, especially when it was flown by Udet, it became a highly significant feature and linked war, the conquest of nature and aviation in a symbolic relationship. Udet was the most famous war aviator after Richthofen; an international figure, well-known for his stunt flying in Europe and the United States. His cameo role in *White Hell* was reprised the following year in *Mont Blanc*. Here, a young climber, trapped on the mountain and slowly freezing to death, manages to tap out an SOS on his radio transmitter. The rescuers, however, are delayed by a storm, but his friend, the aviator, braves the weather and flies to the rescue. Something of the power of the machine and the 'will' of the aviator can be gleaned from the *New York Times* review, 'The steely rocks cutting through the snow, the clouds lying massed below . . . the glaciers laced with rifts. An aeroplane fighting its way above the mountains through a driving storm'.[7] The success of these films persuaded Deutsche-Universal to film a Fanck story in 1933, but made in Hollywood and directed by Tay Garnett. *SOS Iceberg* starred Rod La Rocque but the cast included Leni Riefenstahl and another cameo performance from Udet as the airborne rescuer.

Udet also appeared in *Flying Shadows* in 1932, a documentary-style feature dealing with an air expedition to Central Africa. To enliven the scenes of stunting over the pyramids and chasing wild animals from the air, the producers added a romantic element whereby a young woman pilot follows the flier's route. Udet's last commercial film, just months before he joined the *Luftwaffe* in 1935, was *The Miracle of Flight* [see below). These cinematic appearances by Udet were a continuing reminder to audiences of the romantic heroism of the war aviator and a method of exploiting the pilot who, through his 'will', masters the world of nature and technology. The flying machine was glorified as the means through which the aviator's will is manifested – a salute to technological achievement and a theme central to the Anglo-German co-production *FP1*. Technical achievement was also the subject of the Tobis feature *Gloria*. The narrative is structured around the disintegrating marriage of a stunt flier. But, in order to regain his wife's love, the pilot undertakes a dangerous Berlin–New York flight. *Gloria* was the last aviation film made in Germany before the Nazi seizure of power in January 1933.

The Nazis did not implement total control over the film industry until 1942, yet film makers who remained in Germany, either because of an allegiance to National Socialism or a desire not to offend their political masters, invariably reflected Nazi ideology in thier work.[8] However, in aviation feature films at least, there was an obvious continuity of themes in productions made during the Weimar period and those made after 1933.

Rivals of the Air (1933) from Ufa, was the story of a young female glider pilot. Her lover, a fellow pilot, builds his own machine and enters a major competition. Interestingly, Hanna Reitsch, the well-known gliding champion and test pilot, performed the stunts. *Rivals of the Air* promoted the camaraderie and dedication of fliers and exploited the enormously popular gliding movement of the time. Udet's final commercial film was *The Miracle of Flight*, directed by Heinz Paul. The film was built around the flier and featured most of his popular stunts, including flying through a hanger. Romantic interest was provided by the actress Kathe Haack, but the film was really an attempt to promote airmindedness and persuade young Germans to take up flying by showing something of the excitement of aviation. Terra's 1938 production *Love in Stunt Flying* was more romantic escapism concerning a famous woman pilot whose marriage fails because of her dedication to aviation. However, the film deals with themes that are explicitly propagandist, such as dedication and duty.

'Both Hitler and Mussolini'. Mosse tells us, 'had a passion for speed – aircraft and powerful cars provided one outlet for their activism'.[9] But more than that, in Germany, aviation provided a potent visible example of the 'New Order' in action – the conquest of nature and technology and a powerful symbol of military power.

> Aviation described Germany's future. Accordingly, the Nazis set out to make the Third Reich 'airminded' and thus fully able to meet the challenges of the twentieth century. When Hermann Goering . . . asserted 'we must become a nation of fliers', he announced the Nazi commitment not simply to train a reserve of military pilots but also to inculcate the moral values of aviation, which were self-sacrifice and service to the volk community.[10]

Through the new Air Ministry, the Nazis reorganised aviation clubs into the 'German Airsport League', took direct control of civil air activities, and began planning the creation of the *Luftwaffe* – the new air force.

Hitler created a dynamic personal image through his personal use of the aeroplane – in 1932, for example, he hired a Lufthansa machine for his election campaign – one of the first politicians to campaign by air. The tour was filmed and a short documentary, *Hitler Flies Over Germany*, was released by the NSDAP (the National Socialist German Workers Party) for viewing by the faithful. After the seizure of power, this dynamic image was reinforced by the impressive opening sequences of Leni Riefenstahl's record of the 1934 party rally, *The Triumph of the Will*. From the cockpit of an aeroplane we see a panoramic view of the clouds. Suddenly they open and below is Nuremberg.

The plane descends, its shadow falling upon the ancient spires and towers of the city. The machine lands and from its interior emerges the Führer: a sequence heavy with the obvious symbolism of a descent from Olympus and Hitler's commitment to modern technology. At a more subtle level, the juxtaposition of aeroplane and medieval city is an allusion to the German past and the National Socialist future. This linkage between past and present was a favourite one for Nazi propagandists and was used to considerable effect in the aviation films of the late 1930s. But Nazi air propaganda on film began in earnest with the 1935 Nuremberg Rally film *Day of Freedom — Our Armed Forces*.

Filmed again by Leni Riefenstahl, and released in December 1935, *Day of Freedom* was a celebration of the Nazi rearmament programme announced in March 1935. The film deals with the political rally and the climactic military pageant which demonstrated the newly mechanised army and its concept of *Blitzkrieg* — a return to mobility in war after the stalemate of 1914—18. The air sequences show an attack on a village, its defence by anti-aircraft batteries and a battle between bombers and fighters. Reviewers made much of the appearance of Udet in an attack on a power station. The graphic description from the trade paper *Licht-Bild Buhne* is worth quoting. During the battle between bombers and ground defence a 'sensational' act of bravado by a pilot takes place:

> There appears in the sky, a tiny dot, then disappears into the clouds. A moment later, however, the plane plunges down like an arrow — the spectator holds his breath — just a few metres above the ground the plane suddenly regains its equilibrium; at the same time the whole plant disappears in flames. The pilot has successfully dive-bombed the plant. The audacious fighter pilot . . . is Ernst Udet.[11]

This was an early demonstration of the devasting dive bombing techniques developed by the *Luftwaffe* and used to such effect in the Polish and French campaigns in 1939—40. What emerges from *Day of Freedom* is a frightening picture of the capacity of the German Air Force to deliver a crippling first strike against their enemies.

This propaganda was reinforced in newsreels of the period. A *Deutsche Wochenshau* report from 1936 hailed the new air service: 'We are indebted to our Führer for giving Germany back their air force,' the commentary tells us, as the report reveals the different types of aircraft employed. The most interesting footage deals with the bombers. Here the background music becomes ominous as we see Dornier 23s being loaded with their deadly cargo. A formation of bombers take part in manoeuvres and all hit their

targets in an attack. The report ends with a mass flypast while the commentary states, 'Germany's air force stands firm and proud, ready to defend Germany's peace and protect our Fatherland'.[12] Most of the machines shown (Dornier 23 bombers and Heinkel He51 fighters) were already obsolete when the film was released, but audiences would not be aware of this fact, and what is projected on the screen is a powerful image of the air potential of the Third Reich: an image which proved effective enough to create widespread fear among other nations and enabled Hitler to use the threat posed by the *Luftwaffe* as a political weapon in his foreign policy dealings in the late 1930s.[13] Air operations during the Spanish Civil War, especially the air attack on Guernica (which received considerable newsreel attention), appeared to confirm the power of the *Luftwaffe* and the threat posed by the German bomber.

Feature films played a major part in helping to create these anxieties. As Welch has pointed out, by the mid-1930s, it was important for economic reasons that Germany have exportable products. Hence there was a playing down of the overt National Socialist propaganda that had marked such early feature films as *Hitler Youth Quex* and *Hans Westmar*.[14] In aviation features there was a return to the popular theme of the early days of aviation and especially the First World War. But even here a number of propaganda themes could be introduced. *Hangmen, Women and Soldiers* (1935), from Baveria Films, explored the experiences of a war ace uncomfortable in decadent post-war Germany (a theme that would later re-emerge far more forcefully in *Pour le Mérite*). The 1938 production from Terra, *Target in the Clouds*, told the story of aviation pioneer Walter von Suhr (played by Albert Matterstock). Von Suhr, a young cavalry officer in the Kaiser's army attends a flying meeting at Johannistal in 1909. After a meeting with the aviators Latham and Blériot, he is struck by the potential of aviation for military purposes and becomes a pilot himself. Despite the disapproval of his family, von Suhr continues to campaign for a military air service. The climax comes when the aviator is invited to take part in a military ceremony in Berlin which signifies the acceptance of aviation by the military. Directed by Walter Liebeneiner, who had played a young pilot in *Rivals in the Air, Target* was a widely-shown and popular feature.

Some films, in keeping with Hitler's dictum of guiding audiences towards specific issues, were commissioned by the state (*Staatsauftragsfilme'*) and included in this category were the last two aviation features made before the outbreak of war: *Pour le Mérite* (1938) from Ufa and *D111 88* from Tobis the following year. The first, directed by Karl Ritter, was based on his experiences as an aviator in World War One and after. The film opens in the last months of 1918 and features some exciting combat sequences by the Richthofen

squadron. However, at the Armistice, some squadron members (all holders of the coveted 'Pour le Mérite') refuse to surrender their aircraft to the Allies and fly instead to Darmstadt. The nation is in ruins, the political situation chaotic, and after an attack by communists, the pilots burn their machines and pledge themselves to overthrow the government that has brought such shame upon the Fatherland. The group continue to meet throughout the Weimar period and the old squadron camaraderie is maintained; of course, they all become members of the NSDAP. Finally, in a street battle with the *Roter Frontkampferbunde* (the military arm of the KPD), several communists are killed. The pilots are arrested and at his trial, Squadron Commander Prank (Paul Hartmann), tells the court, 'I will have nothing to do with this State because I hate democracy like the plague. Whatever you would like to do I will disturb and disrupt whenever I can. We must get Germany on its feet – a Germany that will meet the demands of the fighting soldier.' Prank escapes from prison and flees abroad, only to return after the Nazis have taken control. The finale has the airmen reform the old Richthofen squadron in the new *Luftwaffe* under the benign gaze of Reichsmarshall Goering while the voice of Goebbels reads Hitler's rearmament proclamation. In the background is heard the airmen's song 'We are the Black Hussars of the Air'.

Pour Le Mérite reflected a number of propagandist themes: it glorified the *Luftwaffe* by showing it as the legitimate successor of the Imperial German Air Service, and drew upon the heroic status of the airmen of 1914—18 by featuring Goering and A. E. Bohme (another Western Front ace), and by invoking the spirit of Richthofen. The film also took a sideswipe at Communists and Jews who, the Nazis claimed, had betrayed the nation in 1918. The director, Karl Ritter, was a personal favourite of Hitler and at the premiere in December 1938, the Führer publicly congratulated him, referring to the film as a 'a great success, the best film of contemporary history up to now'.[15] Even when shown abroad, *Pour Le Mérite* was regarded as a major success. An American critic noted that although 'non-Nazi' audiences would be more interested in the first half of the film, it was 'remarkably well made'.[16]

D111 88, the last aviation film made before the outbreak of war, was commissioned by Hermann Goering to promote the 'brotherhood of the air' and their spirit of sacrifice for the nation. Directed by Herbert Maisch and scripted by former ace Hans Bertram, the film starred Heinz Wetzel and Otto Wernicke. Released in October 1939, *D111 88* was one of the most financially successful of all Nazi films. The main story deals with two young *Luftwaffe* pilots, rivals in the air and rivals for the same girl. Desperately trying to outdo each other, they disobey orders and fly into a severe storm which damages

their machines. Grounded for this breach of discipline, they are saved by their squadron commander, a veteran of 1914—18, who tells them,

> Personal differences are everywhere, but in the Service you must give your whole self. Frictionless co-operation, unconditional obedience, only in this way can our armed forces become an instrument on which our Leader can rely unconditionally in an emergency.

Thus the pilots learn that individualism constitutes danger and of the need for discipline and devotion to duty. The film, like *Pour Le Mérite*, again demonstrated how the *Luftwaffe* had inherited the spirit of the air fighters of World War One. Interestingly, the poster promoting the film showed modern fighters of the *Luftwaffe* being led through the sky by a ghostly Fokker DR111. *D111 88*, (the title refers to the serial number of the last flyable Fokker Triplane) was praised by Goebbels as an 'irreproachable film of national destiny',[17] and was shown in the United States in the spring of 1940 with the subtitle 'The New German Air Force Attacks'. Aviation film propaganda served its purpose well by contributing to the legend of the might of German air power. As a New York reviewer of *D111* noted, while American audiences might not be seriously impressed, 'Germans, witnessing this striking display of efficiency during storms and manoeuvres may well believe that Hitler can bomb his enemies to pieces whenever he feels like it.[18] But America was a long way beyond the range of German bombers – it was a different matter in Europe where, in 1940, many nations had direct experience of the deadly realities of German air power.

II

Other nations – Italy, the USSR, Japan and Britain, for example – also made use of aeronautical achievement in national propaganda albeit, perhaps, with less success than Germany. The Fascist regime in Italy regarded aeronautics as the hallmark of a technically advanced state but, like the National Socialists in Germany, considered the machine as only part of the equation, for a vital quality was the 'will' of Fascist Man to control it. Mussolini, himself an aviator, claimed in a propagandist biography of 1935,

> No machine requires so much human concentration of soul to make it work properly. The pilot understands the fullest meaning of the word 'control'. Thus it seems there is an intimate spiritual link between Fascism and flying. Every airman is a born Fascist.[19]

Given this interest in aviation and Fascist control of the Italian film industry, it is surprising that so few aviation films were made. The Fascists did,

however, make considerable propaganda from the long-distance flights by the 'Atlantic' Squadron of the Italian Air Force commanded by General Italo Balbo. The mass flight of twelve Italian flying boats across the Atlantic was made at the end of 1930 and the cinematic record of that flight was released the following spring. *Atlantic Flight* was filmed by Air Force cameramen and showed the elaborate planning for the expedition. While it contains some remarkable visual sequences, it was unfortunately made as a silent feature and suffers from inadequate captions which fail to explain the various stages of the expedition. Although the flight itself was hailed in Italy as a 'modern epic',[20] the cinematic version lacks drama and a proper sense of the achievement; a mistake corrected in the Fascist's next film, *Army in Blue*, released in 1932. Directed by Gennaro Righelli, this expensive and prestigious production was made to promote Italian air power. Most of the aerial sequences were shot during the 1931 army manœuvres and involved vast formations of aircraft. However, somewhat artificially, a narrative theme was introduced involving the friendship of two young pilots, a daring rescue and other melodramatic incidents. The film's editor, Giorgio Simonelli, went on to direct several short documentaries for the Air Force. Curiously, an English version of *Army in Blue* was made at Teddington by Warner-First National. *The Blue Squadron*, directed by George King and starring Esmond Knight and John Stuart, was intended to be a spectacular production and used aerial footage from the original Italian feature. It was, however, refused a British quota registration and apparently never shown.

Cavalleria of 1936 has already been discussed, but it clearly revealed Fascist ideals of sacrifice and duty. The only other aviation film made before the Second World War was Goffredo Alessandrini's *Luciano Serra -Pilot*. Here the basic theme is a love of flying that is passed from father to son. It deals with Luciano Serra, a pilot in the Great War who, unable to settle for a peacetime existence, becomes a drifter looking for adventure. He disappears on an Atlantic flight and is presumed dead. His son Aldo eventually becomes a pilot and takes part in the invasion of Ethiopia. When he is shot down and badly wounded, his life is saved by a group of soldiers, one of whom is his father, and Luciano dies saving the young pilot. The script was supervised by Mussolini's son, Vittorio a serving air force officer and a combat flier during the war in Africa.

The war was covered by a special film unit under the direction of Luciano de Feo. The vast footage shot of all aspects of the war was edited into a seventy-minute documentary, *The Path of the Heroes*, released in 1937. The film covers both ground and air operations but those sequences dealing with the air force are particularly interesting, especially where ground forces, operating

in difficult mountain terrain, are resupplied by an air drop. *The Last Roll Call*, a feature film of 1938, was also set during the war and filmed on location in Ethiopia. While basically the story of an Italian gun-runner who only belatedly comes to understand the call of duty, it did include air war footage shot by de Feo's unit. However, what was intended as a glorification of Italian arms back-fired; as an American critic pointed out,

> The scenes of battles between Italian invaders and natives are hardly likely to be good propaganda for Fascism . . . The sight of airplanes, tanks and all sorts of modern implements of death being used against the poorly armed Ethiopians makes one wonder that the latter held out as long as they did.[21]

Although these films attempted to promote Italian aviation they had little of the impact of their German counterparts. There were too few films and those that were made failed to convince audiences that Italian air power was a major force or a serious threat to European security.

In the USSR, as K. E. Bailes has demonstrated, Stalin used achievements in aviation to win support for his regime and, perhaps, to counterbalance the deleterious effects of the purges of the 1930s.[22] It was thought that, in a nation believed to be technologically backward at the beginning of the Soviet regime, Stalinisation should be seen as addressing this problem. Among the various schemes to modernise was the attempt to make the nation air-minded and to demonstrate the potential of the aviation industry. According to Bailes, Stalin's personal interest in aviation dated from 1933 when he decided to make 18 August 'National Aviation Day' and inaugurate a series of record-breaking flights by Russian aviators – 'Stalin's Falcons', as they became known.[23] From the mid-1930s, a series of long-distance flights were undertaken, new records were attempted and mass flights by the military became a part of every holiday – aviators even toured the remote rural areas in an attempt to promote interest in flying, and cinema was enlisted to disseminate aviation propaganda. Beginning in 1935 with Alexander Dovzhenko's *Air City*, a substantial number of feature films focused on aviation.

Air City deals with the building of an aviation centre in Siberia, both as an economic capital for the region and as a stronghold against Japanese aggression. Of the origins of the film, Dovzhenko wrote,

> After studying the region, I became convinced that the existing administrative and economic centres in the Far East are inadequate . . . that a Socialist, Bolshevik city should be built on the shores of the Pacific Ocean.

That city should be called 'Aerograd' and I regard the title of my film as a forecast of the future.[24]

In the early stages of production, the director had difficulties with Mosfilm officials over the script. Having written direct to Stalin to complain, Dovzhenko was called to the Kremlin the following day. When he had explained his problems, Stalin showed considerable interest in the project and ensured that there were no more 'difficulties' with Mosfilm. The year 1935 also saw the release of *Air Mail* (discussed above) and *In the Footsteps of Heroes*, a childrens' film directed by Vladimir Nemolyaev about the aviation hero Vasily Molokov.

In 1938 Mosfilm produced *Victory*, concerning the dedication and courage of pilots carrying out high-altitude research, and in 1940 Lenfilm released a major film biography of the USSR's most famous aviator *Valerii Chkalov* (retitled *Wings of Victory* in the USA). Chkalov was an internationally known figure and the first flier to use the transpolar route from Moscow to Vancouver in June 1937, a triumph which earned for Chkalov and his crew the title 'Bolshevik Knights of Culture and Progress'. The film reveals the young Chkalov as irresponsible and lacking any sense of purpose. However, drawn to aviation, the young pilot soon develops a sense of duty to his comrades and through a chance meeting with Stalin, dedicates himself to progress and the Bolshevik cause. Significantly, the film ends before his death, testing a new machine in 1939. The project was initiated by Georgi Baidukov, co-pilot on the polar flight, and was personally approved by Stalin. *Valerii Chkalov* was one of the few Soviet films shown in America at this time and was remarkably well received there.

Chkalov was the final saga in a short cycle of films extolling the daring exploits of Soviet airmen in the Arctic. The series began with the 1934 documentary *Heroes of the Arctic* by A. Shafron. This retold the story of the rescue of the crew of the research ship *Chelyuskin* by Soviet aviators. *Conquerors of the Arctic*, directed by Mark Troyanovsky, was a film record of the first aeroplane landing at the North Pole, in May 1939, by explorer Otto Schmidt and three aviators. As well as *Chkalov*, 1940 also saw the release of *The Heavens*, a comedy about Soviet youth and their passion for gliding, directed by Yuri Tarich; and *Workdays*, which looked at the training of Aeroflot pilots.

As Bailes has suggested, major flights were often initiated by Stalin and may well have been used to distract public attention away from the effects of the purges which were moving into high gear in the late 1930s.[25] Be that as it may, these films did clearly emphasise the rapid development of soviet aviation under Stalin's leadership and helped to create a positive image of

technological progress. But a second aspect of aviation films was to direct public attention towards defence issues by demonstrating the effectiveness of Soviet air power. Despite a number of achievements in civil aviation, the Spanish Civil War, in which Russia had provided virtually all the Republican air element, had revealed the inferiority of front line Soviet machines when compared with new German and Italian aircraft. The series of air defence features were intended to counter these negative images by focusing on the dedication and skill of Soviet pilots.

The cycle began with Yuli Raizman's *Flyers* (US title *Men With Wings*) in 1935, which as Peter Kenez has claimed was probably the most successful Russian aviation film of the decade.[26] Set in a military aviation training school, the story bears a striking familiarity to numerous Hollywood films of the period. Two cadets, in love with the same girl, take their rivalry into the air and attempt to out do each other with daring aerobatics – one cadet wrecks his machine and is grounded. However, unlike American features of this type, the cadet is not reinstated after performing some heroic act, but simply dismissed from flight school. The Soviet Air Force, apparently, allowed no second chances! The need for discipline in the air was an appropriate theme for 1935, as the prestigious giant aeroplane built by Sikorski, the 'Maxim Gorky', had crashed killing its crew after colliding with a stunting escort fighter.

The Motherland Calls (1936) from Mosfilm, dealt with the duties of military pilots and emphasised their readiness to defend the homeland against Fascist invaders. The film was remade in 1939 by Avram Room as *Number Five Squadron*. In that year Eduard Pentshin made *Fighters*, which again dealt with the training of military pilots. More interesting was the 1940 release *The Fifth Ocean*, directed by Isidor Annenski. This told the story of a young Siberian hunter. Captivated by the flying machine, he joins the air force and becomes a fighter pilot. When Japanese aircraft cross into Soviet air space during one of the numerous border incidents, the pilot uses his hunter's skill to stalk and destroy the enemy. It is interesting that even Soviet realism could not completely escape the romantic iconography of the air fighter. A Japanese attack on a Russian border settlement was also the theme for A. G. Ivanov's 1939 production *Soviet Border*. Although this was a propagandist showcase for the efficiency of the armed forces, considerable attention was focused on the heroes of the air force.

In the same period, Soviet newsreel continually emphasised aeronautical achievements. A number of reports concentrated on the popularity of youth gliding clubs, even in rural areas. The polar flights of 1936–37 received considerable attention as did other epic air adventures. Nor was military

From the Wright Brothers to *Top Gun*

aviation ignored and air force exercises were often covered in detail. Particularly impressive were the film reports of the September 1936 manœuvres in Byelorussia where huge TB 3 transport aircraft dropped several thousand paratroopers in less than eight minutes and then landed to disgorge a cargo of tanks and field guns.

During the 1930s, Soviet feature films and documentaries created a powerful image of a nation forging ahead in the development of aviation. Cinema emphasised the need for discipline in the air, the dedication of Russian pilots, the strength of the Red Air Force and, above all, hailed Josef Stalin as the leader who had almost single-handedly dragged a backward nation into the air age.

In Japan, the 1920s witnessed the rise of military domination leading to a national policy of territorial expansion and aggressive nationalism. However, overt nationalist sentiment did not begin to appear in films until the late 1930s. The first aviation film to reflect this new mood was Tomataka Tasaki's *Airplane Drone* of 1939, which dealt with the public subscription to buy aircraft for the Imperial Air Force. The story is set in a small rural town where the mayor's son is a military aviator. When he comes home on leave the citizens warmly welcome him and present him with their collection. Although the feature presents the aviator in heroic terms and attempts to promote public interest in aviation, it appears to have been as much propaganda for the home front as for the military. *Flaming Sky* (1940), directed by Yutaka Abe, dealt with aviators in the war against China and, according to Richie, was the first film to use actual combat footage.[27] *Soaring Passion* (1941) told the story of a young farm boy and his training as a military pilot, while *Nippon's Young Eagles*, of the same year, dealt with the training and dedication of fliers. Made in documentary style, the feature also used combat footage. Only one film appears to have been made about civil aviation: the 1935 feature *Daughter of Japan*. This Japanese-Burmese co-production tells of the first non-stop Tokyo–Rangoon flight by a Japanese woman pilot.

Given the strength of the warrior tradition, the lingering belief in the samurai code in Japanese culture and the manner in which many of these qualities had been ascribed to the airman, it seems surprising that so few aviation films were made by the pre-Second World War Japanese film industry.

For the British, aviation provided a means through which the nation could reassert its position in the world after the destructive consequences of the First World War. Faced with social problems, the loss of traditional markets for manufactured goods and a rising tide of nationalist feeling throughout the Empire, the aeroplane became both a visible demonstration of technical

excellence and a means of rapid communication, binding Empire and Motherland closer together. Even before 1914 aviation had been seen as an important means of promoting imperial unity, but the dramatic development of aviation during World War One made this possible. The growth of cinema in the 1920s enabled these ideas to be presented to a mass audience. Although few features were made, British documentary makers produced a substantial number of films which presented aviation in these terms. As we have seen, some of these films dealt with the growth of civil aviation by focusing on Imperial Airways and the creation of the air mail service, but the cycle really began in the 1920s by demonstrating the importance of aviation to the Empire.

Blazing the Airways to India (1923), a short film about a UK–India route, emphasised aviation as a rapid means of imperial communications. It was reinforced by a series of films featuring the well-known aviator Sir Alan Cobham. From the mid-1920s, Cobham appeared in no less than eight documentaries dealing with his flights in Africa. The first, *With Cobham to the Cape*, a film record of his flight from Cairo to South Africa, appeared in 1926, and the series ran until 1932 when the last, *With Cobham to Kivu*, was released. *Kivu* was the story of an air expedition over the Nile Valley to locate a suitable site for a seaplane base for the Imperial air route to Australia. The history of aviation, with a strong emphasis on the part played by British pioneers, was the subject for British Instructional's *Conquest of the Air* (1931). This told the story of humanity's determination to fly and used newsreel footage and reconstructions. It ended with the British triumph in the 1931 Schneider Cup Race. It was presumably this little-known documentary that inspired Alexander Korda to produce his own version a few years later. However, the most interesting of these documentaries was *Dual Control* (1932) from BIP, directed by Walter Summers, and featuring Amy Johnson and Jim Mollison. Made just after their record-breaking flight to Cape Town, the film shows them stunting and Amy taking a young schoolboy for his first flight. But even Britain's most famous aviator wasn't allowed to forget that she was only a woman: 'I say, Amy,' says the boy after his flight, 'do you mind if I tell the chaps at school it was a man I went up with?'

The economic slump at the beginning of the 1930s and the subsequent loss of confidence in the future provided the stimulus for Stephen Tallents' influential text *The Projection of England*, published in 1932. Tallents, then Secretary of the Empire Marketing Board (EMB), advocated a positive portrayal of the nation and empire in the media, and especially in film: 'If we are to play our part in the new world order, we need to muster every means and every art by which we can communicate with other peoples. The

need is especially urgent between ourselves and other parts of the Empire.'[28] Besides improved communications and closer imperial ties, Tallents went on to argue that potential customers for British goods had to be convinced that the nation could still supply quality material, 'we need continuous and sustained presentation of our industrial ability and industrial ambitions'.[29] The documentary film makers that had emerged from the film unit at the EMB were, despite their 'Leftist' sympathies and concern for realism, eager to follow the lead established by Tallents and much of their work was concerned with promoting positive images of the nation. A number of their films were concerned with technological achievement through aviation.

One group of films promoted technical progress and perhaps the best example here is Arthur Elton's *Aero Engine*, made for the EMB in 1933. This was a silent visual explanation of the workings of a modern engine, intended for instructional purposes. An edited version, however, appears to have been put on general release as a testament to British precision engineering. Elton also directed Strand Films' *Air Flow* in 1937, another technical short. Other films which explored the British contribution to aviation technology were *Aircraft Design* (1935) and *Propeller Making* (1936), both made by Gaumont-British; and the Shell sponsored *Prelude to Flight* (1938) – which focused on gliding. A second group of films dealt with achievements in the air. Some, like Paul Rotha's *Contact*, acted as a showcase for British Imperial Airways routes to India and the Pacific, while others concentrated on a single spectacular flight. *Wings Over Everest* (1934) is a useful example of the latter. This was a cinematic record of Lady Houston's Mount Everest expedition to demonstrate the use of aerial photography in map-making. With its impressive photography, it was hailed as a triumph for the fliers and perhaps the only way in which the mountain would be conquered. But the climax of the cinema of technology and imperialism came under the pressure of war – in the 1941 feature *They Flew Alone*, a tribute to Amy Johnson.

In this rousing story of the 'girl from Yorkshire', Anna Neagle, already established as the leading interpreter of imperial womanhood (Queen Victoria, Florence Nightingale and Edith Cavell), played Amy and Robert Newton her husband Jim Mollison. The film opens with her last flight, ferrying an RAF machine in 1940. In thick fog and out of fuel on a flight over the Thames Estuary, she takes to her parachute. As she descends a flashback of her life and achievements form the substance of the film. The early sequences establish Amy as a rebellious schoolgirl and student, then as a bored solicitor's clerk, unable to settle and unsure about her future. Then comes the discovery of flying and aviation rapidly becomes her life – a liberating force against the confines of middle-class convention. First

qualifying as a pilot, she goes on to become a certificated mechanic and rigger while working as a volunteer for the British Empire Aerial League. Deciding that she must promote aviation, she undertakes a solo flight to Australia and persuades Lord Wakefield to back her. In a tiny 'Gypsy Moth', she sets out in May 1930. The flight is portrayed as an almost spontaneous adventure, in exactly the same way that Lindbergh's Atlantic flight would later be shown in *Spirit of St Louis*. We see nothing of the elaborate preparations for the journey, the detailed planning that such a flight would require. These, of course, would make dull viewing, but the purpose here seems to be a decision by the film maker to heighten the sense of spontaneity and adventure of the aviator. Amy reaches Australia in record time, becoming the most famous woman of the decade and creating a new, dynamic image, the 'aviatrix'. As Lord Wakefield comments to a companion, 'She's driving . . . an aeroplane through centuries of custom and convention.' The friend agrees, 'Yes, in a few short hours she's broken a great gap in the fence that's been surrounding our young women for generations.' Meanwhile, in Australia, Amy modestly tells Jim Mollison on their first meeting that she must 'learn to fly properly' when she gets back to England, indicating that she is still by no means certain of her skills.

However, it is her speech at the official reception in Melbourne that completely sums up the manner in which aviation was used by Britain to promote national pride and the imperialist world view. It is worth quoting at length. Having thanked Australia for her wonderful welcome, Amy goes on,

> I want to try to do something for England so that out of my flight to Australia I can get the youth of our country to become air-minded.
>
> My message to youth is to abandon the slogan 'safety first' – there are lots of things to come before safety. Our country must come first. We must dream dreams and see great visions. We've got to breed a race of airmen comparable to Drake's seadogs, who'll go out to the skyways of the air and help bind still closer the British Empire.
>
> And I want to appeal to the youth of the Empire to join with me in furthering the great cause of aviation . . . Our great sailors won the freedom of the seas, it's up to us to win the freedom of the skies.

On her return to England, she lives her life in the public gaze: lecture tours, charity work, more record-breaking flights and marriage to Jim Molllison. However, their partnership is fraught with difficulties and their dual flights all fail – as Amy points out, they only really succeed when 'they fly alone'. The marriage breaks down, and when war comes Amy joins the Air Transport Auxiliary ferrying RAF machines – the closest she can get to

military aviation. *They Flew Alone* is a remarkably honest reconstruction of Amy's life and her stormy relationship with Mollison — who incidentally acted as adviser for the film. Directed by Neagle's husband, Herbert Wilcox, and written by Viscount Castleross, it stands as a fitting tribute to an outstanding airwoman. However, as a propagandist work promoting aviation, English fliers, patriotism, imperialism and the liberating consequences of aviation, it is a film without rival.

Other films explored the history of aviation and particularly the British contribution to its development. Vickers-Armstrong, for example, which had operated its own film unit since 1914, produced a number of short films. Among them was *Historic Flights* (1932), a silent compilation of British triumphs. Much of the same material was featured in Strand's *Aerial Milestones*, sponsored by Imperial Airways in 1939. However, the most elaborate of these film histories should have been Alexander Korda's semi-documentary *The Conquest of the Air*.

In 1935, Korda began work on an epic film that would tell the whole story of flight using re-enacted historical episodes and documentary sequences. He signed the young Laurence Olivier for his first screen role (a cameo performance as the balloonist Vincent Lunardi) and a host of familiar faces from British cinema. A script was commissioned from the American John Monk Saunders, author of *Wings*, and filming began at the end of the year. The film was apparently almost complete when for some reason Korda shelved the project. Resurrected and completed in 1938 it was given a limited release before being withdrawn. Finally, re-cut, with several new sequences added (one showing Winston Churchill as Prime Minister), it was released in 1940 in a truncated form. Despite its chequered production history and the rather silly enacted sequences at the beginning, it is a comprehensive and well-made survey of the subject, and covers most of the landmarks of aviation history — the Montgolfier brothers, Cayley, Lilienthal, the Wrights, Blériot and so on. However, while the coverage of the period up to 1920 is international, from that point it becomes predominantly a tribute to the British: the R34 Atlantic crossing, record-breaking flights by Alan Cobham and Amy Johnson and, of course, an emphasis on the manner in which air transport was linking Britain's far-flung Empire. It also praised the decision to rearm but pointed out that Britain was 'reluctantly compelled to divert the genius of her designers and the resources of her industry to modernising and expanding her small but efficient Air Force'. Following scenes of the 'latest' warplanes — 'Blenheim' bombers and 'Spitfire' fighters — the commentator adds that 'England is ready for the time when action will follow mere words'. As the film was released in 1940, it was presumably an

indication to the public that the RAF would soon be taking the war to Germany in the form of a bomber offensive.

The military context of aviation was hardly touched upon until the late 1930s. *The Eyes of the Army* (c. 1922) was a rare exception. This RAF promotional film was created to show how the air force contributed to military operations and was made at a time when the future of an independent RAF was in doubt. Most sequences appear to have been filmed during manœuvres but some footage from 1914–18 was included. *Flight Commander*, a little known feature from 1927 and directed by Maurice Elvey, was an attempt to profit from Cobham's 1926 world flight. The film, starring Cobham, John Stuart and Estelle Brody, dealt with a rebellion in China and an attack on a British mission by an unpleasant war lord. Only the intervention of Cobham, who bombs the Chinese into submission, saves the Europeans. The climax of the film, the bombing of the village, was filmed during the RAF Hendon Pageant where it was staged with considerable publicity. A minor film by any standard, it is nevertheless interesting as a reflection of the manner in which the RAF were actually using the concept of 'air control' to police vast areas of the Middle East. After *Flight Commander* British film makers did not return to the subject of air warfare until the mid 1930s, when the increasingly tense international situation made another conflict a distinct possibility.

Things to Come (1936), Korda's splendidly visual but somewhat pompous version of H. G. Wells' prophecies, was a plea for sanity in an increasingly dangerous world. The film clearly reflects many contemporary ideas about the use of air power and the role of the aviator in modern society. It begins in the year 1940 in 'Everytown' (London) as the people celebrate Christmas, but the war clouds are looming. Tensions increase and finally an enemy air fleet crosses the English coast. There follows an effectively filmed sequence of the air raid on Everytown. As the city is gradually destroyed and its inhabitants subjected to high explosive and poison gas, we are forcibly reminded of Prime Minister Baldwin's much quoted phrase of 1932, 'There is no power on earth that can protect him (the man in the street) from being bombed . . . the bomber will always get through'.[30] Wells, however, goes beyond repeating current fears and reinforces his earlier ideas that the bomber can only destroy, not conquer.[31] Thus as England retaliates and other nations are dragged into the war, civilisation crumbles. But even the realist Wells cannot resist the romantic notions of the chivalry of the air. After an aerial battle, an enemy plane is forced down; the victor lands beside it and the English pilot, John Cabal (Raymond Massey), helps the heavily-accented enemy pilot from the wreck. 'God! Why do we have to murder each other,' Cabal explodes.

Then a cloud of poison gas drifts across the landscape and the pilots put on their masks. A little girl, terror-stricken, runs before the gas cloud. The enemy airman gallantly takes off his mask and gives it to her. Silently Cabal hands the European pilot his revolver before he takes off. Even in a world gone mad, the nobility of the air fighter remains.

Following years of conflict, the world reverts to barbarism and primitive warlords struggle for control of the devastated lands. Into this chaos flies the airman Cabal, a representative of an organisation called 'Wings Over The World': a brotherhood of the air, scientists and technologists who are establishing a new order from their headquarters at Basra. After destroying the petty warlords with 'peace gas', the world is rebuilt under the control of a benign 'air dictatorship'. The notion of airmen forming a dictatorship was not new and had been first suggested in popular fiction at the beginning of the twentieth century. Flying appeared to offer unlimited power to a chosen few; as they were heroic, noble and masters of the ultimate technology, it was suggested they would be ideal leaders. The idea was most clearly explained in Rudyard Kipling's stories, 'With the Night Mail' (1904) and 'As Easy As ABC' (1907). The theme was resurrected by Mussolini and other European Fascists in the 1930s who saw the airman as the archetypal hero of the New Order. Nor, as we have seen, was the idea neglected in 1930s' Britain; and it also provided the basis for Rex Warner's neglected novel *The Aerodrome*, published in 1941 and filmed by the BBC in 1985.

Things to Come was a tremendously effective movie. The young Leslie Halliwell later remembered, 'from the opening titles we were awed, gripped and frightened'.[32] Graham Greene, writing in the *Spectator*, claimed that the first third was 'magnificent', the air raid scene in particular was created in 'horribly convincing detail', but the idea of 'Wings Over the World' was 'childish, uncontrolled fantasy'.[33] But while the optimistic might dismiss *Things to Come* as pure invention, it was less easy to dismiss the newsreel coverage of the bombing of Guernica the following year, which appeared to vindicate Wells' dire predictions about attack from the air. The Basque town was raided on 26 April 1937 by aircraft of the German Condor Legion flying for the Spanish Nationalists. Gaumont-British newsreel Number 350 issued a brilliantly edited story showing an aerial view of the ruins while an emotive commentary noted,

First pictures from the Basque Republic of the city of Guernica, scene of the most horrible air raid our modern history yet can boast. Hundreds were killed here, men, women and children. Four thousand bombs were

dropped out of a clear blue sky . . . This was a city and these were homes, like yours!

As Aldgate point out, the report brought forcibly home to 'British audiences the full implications of aerial bombardment' and persuaded newsreels to give greater attention to air matters.[34] In an attempt to allay public fears concerning air attack, the government sponsored a number of reassuring documentary films.

Military aviation had already received attention in John Betts, *RAF*, a crudely made recruiting film of 1935; but two years later, in line with the rearmament programme, Donald Carter was engaged by the Army and Air Councils to produce *The Gap*, intended to enlist volunteers for London's air defences. The film's climax is a simulated air raid on the capital when, without warning, a fleet of enemy bombers appear out of the evening mist. However, the raiders are driven off by the expertise and dedication of the defenders. *The Warning* (1939) was remarkably similar. Made by Maurice Baring for British National, it again featured a simulated air raid but this time the raiders are driven off by RAF biplane fighters. While one of these antiquated machines accounts for an equally antiquated bomber the com- mentator claims, 'Let us be glad there is still time for us to train' – and presumably fully re-equip with the new fighters that had been hailed in the newsreels since 1936.

British-Movietone's coverage of the 1936 Hendon Pageant, for example, was an attempt to reassure the public that the RAF was being given the means to defend the nation. Revealing the service's new Whitley bombers and an early Hurricane, the commentator tells us these are the 'wonderful new machines' of the RAF: 'They're going to bring back to Britain her former supremacy in the air.' The Spitfire was introduced to the public in 1938. A Movietone newsreel story showed the new fighter performing various stunts while the commentary claims,

> Deliveries of Britain's new super machine are soon to be made to the RAF, and new pilots will soon be flying the type. The 'Spitfire' is very hush hush, of course. Though you can see from these pictures it can perform aerobatics with ease, you can only guess its speed – for that's one of the Air Ministry's secrets. It would be used if necessary to intercept and destroy raiding bombers.

These films clearly reflected public concern over the probability of aerial attack as the devastating prelude to the next war. They added to the general paranoia and, to a great extent, help to explain why, until late 1938,

appeasement was such a popular policy and why, when war did come in September 1939, it was such an anticlimax. Reassurance that Britain was prepared for war was also the theme of the last aviation feature of the peace, *Q Planes*, released in February 1939.

A comedy-thriller starring Laurence Olivier and Ralph Richardson, *Q Planes* (*Clouds Over Europe* in the USA), was directed by the American Tim Whelan. It concerns an experimental device which dramatically increases the speed of aircraft developed by an English manufacturer. Unfortunately, the test aircraft disappears and pilot Tony McVane (Olivier) and intelligence officer Major Hammond (Richardson) set out to solve the mystery. An unnamed European Power has perfected a ray which, when directed at an aircraft, causes total electrical failure and forces it down. The device is used aboard a salvage ship so that aircraft forced down over the sea can be picked up and their secrets explored. McVane and Hammond unravel the mystery and unmask the spies. Made in the autumn of 1938 while most of the nation basked in the misplaced euphoria of the Munich settlement, the film took an unfashionable line in criticising the government for failing to rearm sooner and by making the enemy so obviously German. Well-made and thoroughly entertaining, the film was well received by critics and public alike. However, it is difficult to believe that the film's antiquated Airspeed 'Oxford' aircraft could seriously interest a nation capable of making an anti-electrical ray, even if it does have increased speed. Ian Dalrymple's script, although allowing the device to fall into British hands, offers no clues as to how the RAF would counter this device should it ever become necessary to attack the anonymous European nation. Nevertheless, it did create a convincing scenario that British aviation was rapidly advancing and that the debonair products of English public schools would always prove more than a match for scheming foreigners.

III

Aviation was enormously popular in the United States between the wars: a 'love affair between millions of Americans and the flying machine'.[35] This affection for the aeroplane was manifested through a variety of cultural artefacts – magazines, novels, comic books – through attendance at aero shows and above all through popular cinema. After 1919 Hollywood produced more aviation features than all other nations together. The explanation for this popular interest in flying is perhaps best explained by reference to Wilbur Zelinsky's influential model of American culture. Zelinsky identified four central themes in American culture: individualism; mobility and change; a mechanistic world view and love of technology; and a belief in

'messianic perfectionism' – the idea of the United States as a nation with a world mission.[36] America's romance with aviation is a clear demonstration of Zelinsky's argument and of the interrelationship of those themes. Aeroplanes were at first novelties. Indeed it might be argued that even by the 1930s aviation had not lost its novelty value. Flying was certainly the ultimate exercise of rugged individualism – no one could possibly be more alone than a pilot when a mile above the earth and with only thin canvas or metal between him or her and eternity. The creation of the flying machine was a major conquest of nature – a marvel of technological achievement that freed mankind from earthly ties and opened the way to the heavens. After the development of the theory of strategic bombing came the promise of the aeroplane as a weapon that would prevent war or at least ensure that hostilities could be ended swiftly by striking at the enemy's homeland. Bombardment aviation, it appeared, would not only defend the nation, but might also provide the means through which Teddy Roosevelt's vision of America as the 'world's policeman' might be made a reality. The aeroplane, in short, was widely believed to be the means through which America could achieve her world mission.

By the 1920s, the airman had become the ultimate modern hero, an image which achieved its final form with Lindbergh in 1927. The cultural significance of Lindbergh's flight cannot be overestimated for, as John Ward has pointed out, it combined two vital ingredients of popular culture: the promise of the triumph of the machine age and the continuation of the virtues of frontier individualism.[37] Lindbergh linked a gloriously heroic past with an even more heroic future. After 1929, as the Depression bit deeply into the American psyche, it became even more necessary to reassert the inherent wonder of American achievement and re-establish the hero as the go-getter, the achiever. The aviator was the perfect choice as a symbol that, deep down, all was well with society. Lindbergh, of course, should have provided the ideal subject for a film but, as we have seen, his troubled personal life made this impossible until the 1950s. Nevertheless, ideas which the aviator symbolised became even more important as Japanese expansion in the Pacific began to threaten the security of the United States. Superior air technology, an Anglo-Saxon technology, was believed to be the key to defence against these encroachments. As Lindbergh himself wrote in 1939,

It is time to turn from our quarrels and build on white ramparts again . . .
It is our turn to guard our heritage from mongol and Persian and Moor
. . . Aviation is a tool specially adapted for western hands . . . another

barrier between the teeming millions of Asia and the Grecian 'inheritance of Europe'.[38]

Most cultural forms glorified aviation in the 1930s but cinema was the most effective channel and, because of Hollywood's domination, carried this propaganda to an international audience. The themes of individualism, change, and technical progress are to be found, in some measure, in most American aviation films. Virtually all refer at some point to the aviator as hero, while films such as *Air Mail*, *Nightflight* and *China Clipper* illustrate American 'manifest destiny' as national airlines spread out first across the American continent and then to the Far East. But there were other films of the 1930's which emphasised technological achievement.

The cycle of Arctic exploration features is a useful example of how cinema portrayed national achievement in the air. The series began in 1926, *With Commander Byrd in America's Polar Triumph*, which acted as a showcase for both technical excellence and the US Navy's belief in the future of aviation. Commander Byrd and pilot Floyd Bennett became the first men to fly over the North Pole in the Ford trimotor *Josephine Ford*. Byrd filmed much of the flight himself and the footage was released by Pathé less than two months after their return. In 1929, Byrd mounted another aerial expedition, this time to the South Pole. More elaborate preparations were made for this flight and it was filmed by two professionals, Joseph Rucher and Willard Van der Veer, for Paramount. The subsequent film, *With Byrd at the South Pole*, narrated by aviation historian Floyd Gibbons, was released in 1930. This is simply an illustrated record of the flight yet it is far more than a narrative of a successful journey over the world's most dangerous continent. It is a triumph of the enterprise, daring and technical achievement which made such a flight possible. Mordaunt Hall expressed some of the audience reaction in his review, 'Even in the theatre one feels like throwing one's hat in the air. The gallant Admiral once again has met with success, and one enjoys knowing of the glory to which he is entitled.'[39] The cinematographers earned Academy Awards for their work at the 1930 ceremony. Interestingly, Byrd made his last expedition to the North Pole in 1947 and a film of this exploit, *The Secret Land*, photographed by a navy film unit succeeded in winning the best documentary award in 1948.

Polar exploration was also the subject of three feature films: *Conquest* (1929), *The Lost Zeppelin* (1930) and *Dirigible* (1933), all of which deal with what might be termed glorious failures – gallant attempts which subsequently fail. The first, from Warner Brothers, told of the exploits of two aerial explorers and their love for the same girl. By far the most spectacular scene

in this early talkie is the crash of a trimotor on the polar ice. *The Lost Zeppelin* was a shoddy production from Tiffany, which has a navy airship crash in an Antarctic blizzard and the commander's friend attempting a daring air rescue, The film was no doubt based upon the crash of the Italian airship *Italia* over the North Pole in 1928 (an incident which inspired *The Red Tent* in 1970). Frank Capra's *Dirigible*, however, although inspired by the same incident, was a different matter. Based on a story by Frank Wead, the film explored the whole debate about whether the navy should develop airships or aeroplanes. The two protagonists, Lt. Commander Jack Brandon (Jack Holt), an airship commander, and Lieutenant 'Frisky' Pearce (Ralph Graves), a airplane fanatic, pursue a friendly rivalry until Brandon attempts to take an explorer to the South Pole. The airship is wrecked in a spectacular sequence and the party are rescued by Pearce in his aeroplane. The explorer then uses the machine to reach the Pole. But when that crashes, Brandon uses another airship to come to the rescue.

Dirigible was Columbia's most expensive feature to date and Capra made full use of the Navy Bureau of Aeronautics. Much of the filming took place at Lakehurst Naval Air Station and the dirigible *Los Angeles* was made available to the film crew. Capra used Elmer Dyer to record the aerial sequences, including the exciting scene where US Navy fighters 'hooked' onto the underside of the airship then later 'unhooked' and flew on to their destinations. The idea of an airship as an aircraft 'carrier' had often been suggested but it was the USN which put the idea into practice and were happy to demonstrate it for Capra's film unit. The same footage was used again in *Above the Clouds* (1934), Columbia's story of a news photographer who scoops his rivals with the story. *Dirigible* was well received by critics and public alike. It highlights technological achievement and the navy's interest in lighter-than-air aviation, an interest that was all but extinguished by the destruction of the *Macon* in 1935 and the *Hindenberg* two years later. The cycle of polar exploration films featured a number of dramatic air disasters which, it might be argued, could hardly be positive propaganda for aviation, However, the real point is that these only serve to heighten the determination and dedication of the airmen and make the final achievement, the conquering of new frontiers, even more glorious.

Other cinematic demonstrations of aeronautical triumph were Monogram's 1934 feature *Lost in the Stratosphere*, based on the army balloon experiments which established a new altitude record on July 1934. The film was released just three months after the event. Several real fliers were also persuaded to play themselves in feature films: Dick Merrill starred in Monogram's *Atlantic Flight* in 1937, and Doug Corrigan in RKO's *Flying Irishman* in 1939 — a film which retold

the story of his Atlantic flight. But the most ambitious feature to glorify the story of American aviation was William Wellman's elaborate 1938 production *Men With Wings*, the first aviation film to be made in technicolor.

Wellman wanted to make a spectacular feature that would chronicle the first decades of flight, starting with the death of 'Nick Ransome' (Walter Abel) at the turn of the century. Ransome stands for that host of would-be aviators who lost their lives attempting to fly. His death is witnessed by two boys, Pat Falconer (Fred MacMurray) and Scott Barnes (Ray Milland), who both become obsessed with flying. The story of aviation is told through their experiences – learning to fly on primitive machines, the First World War and service on the Western Front, the restless 1920s and the rapid development of civil aviation. Scott eventually becomes more interested in the technology of aviation and building aeroplanes but Pat, an instinctive flier, is the restless pilot constantly seeking a new challenge. He flies the Atlantic, serves with the Republicans in Spain and is killed flying for the Chinese in the war with Japan. Scott, meanwhile, has been developing a new machine for the military, 'the world's most formidable bomber'. Paramount launched the film with a $20,000 newspaper campaign, but *Men With Wings* was not overly successful with the public. The critic Frank Nugent suggested that this was because Wellman had focused more on Scott, the sober technician, than on the flamboyant soldier of fortune Pat Falconer: 'Wellman's conscience impels him to favour the scientist. But his sympathies are always on the sider of the rover'.[40] Thus the central focus was ambiguous. It would appear that the public had been so conditioned to expect airmen to be romantic, dashing and adventurous that they could not empathise with one who was unheroic and dedicated to producing better machines.

However, the most complete statement of national endeavour in the air was a relatively minor 1944 production from Twentieth Century-Fox, *Captain Eddie*, a biography of Eddie Rickenbacker, again starring MacMurray in the title role. This intensely patriotic film was, according to producer Winfield Sheehan, the 'story of an American who, through the showing of his own experiences, wishes to drive home to the youth of the land the opportunities the Country offers those willing to work for them'.[41] Those opportunities, of course, are in the sky, for the film is completely committed to notions of technical advance, individualism and American destiny in the air. The story is told in flashback, while Rickenbacker drifts in the Pacific following a plane crash and after a chance remark from one of the crew about machines sets the aviator realising that his whole life has been one long interrelationship with the machine. In flashback we see the young Rickenbacker tinkering

with engines, a boy fascinated with anything mechanical. 'Lucky boy, Eddie', his father tells him on one occasion,

> To be born at this time, this new age of marvels. Machines and engines are going to bring changes, changes in everything. Some for the bad, some for the good. But you hitch your waggon to the machine, pin your hopes and dreams on them, and work to make your dreams come true.

The young man goes on to work with automobiles, becoming a racing driver and then, during World War One, a pilot and America's 'Ace of Aces'. After the war, Rickenbacker becomes involved with civil aviation and again serves his country after Pearl Harbor. But this is more than the biography of a self-made man, it is an almost complete exposition of America's romance with the machine and with aviation. Cinematic interest in the triumph of the machine and nationalism of the air became commonplace themes during the war years and continued into the age of superpower rivalry. Yet on several occasions after 1945, film makers returned to the early days of aviation to demonstrate the achievements of American pioneers.

In 1946, Wellman produced *Gallant Journey* for Columbia – the story of the Californian John J. Montgomery, who claimed to be the first man to make a controlled, heavier-than-air flight in 1883. Although Wellman managed to create some impressive scenes using reconstructions of Montgomery's gliders, the film attracted little attention. Curiously, it was not until 1978 that a feature film about America's greatest aviation triumph was made – the story of the Wright brothers.

The Winds of Kitty Hawk, an NBC television film, starred Michael Moriarty as Wilbur and David Huffman as Orville. The film was a worthy but dull attempt to reconstruct something of the excitement of the first powered flight. Covering the period 1897–1908, it details the almost fanatical attempts by the brothers to create a successful flying machine. Accurate replicas of the Wright *Flyers* were created for the film and some of the photography is impressive, but even the 'dramatisation' of events failed to enliven the script and only succeeded in irritating experts. The first half of the film, leading to the historic flight, is more interesting; but the story soon becomes bogged down with the Wrights' attempts to patent their discoveries and profit from their invention and the running feud with Glenn Curtiss who, they believed, had stolen their secrets. The voice of Orville claiming that, 'Once our patent has been granted, we will sell it to the United States government so that our country will be the first in the world to own such a valuable invention. We will have done for the United States what Langley could not do,' is strangely at odds with scenes of their obsessive

attempts to profit from the *Flyer*. The overriding impression is of the Wrights as unsuccessful men of business embittered by their failure to gain the rewards they felt should be theirs. As Orville bitterly complains, 'For all our years of work we have achieved some fame and no money!'

Perhaps the most successful of the post–1945 features was the 1957 reconstruction of the Lindbergh flight, Billy Wilder's *Spirit of St Louis*, with James Stewart as the aviator. The film opens the night before his epic flight and, as he lies unable to sleep waiting for the dawn, Lindbergh recollects his earlier experiences and the sequence of events that have led to this undertaking. The flashbacks continue as he sets out across the ocean, creating a revealing portrait of the airman. *The Spirit of St Louis* is beautifully filmed and Stewart is ideal as the shy, introspective Lindbergh. The film is a fascinating exploration of how man and machine become a single entity to battle the elements, the conquerors of the Atlantic, the pathfinders who pioneered the way for the development of civil aviation.

We have seen how the cult of the hero of the air emerged during the First World War with the air fighter and how this image was reinforced by later versions, the barnstormer, airmail flier and civil pilot. However, a new departure of the 1930s was the heroine of the air – the aviatrix, the woman with wings. As early as 1911, one of the first women aviators, the American actress Harriet Quimby, associated aeronautics with sexual equality. Quimby turned to flying because she believed there could be no discrimination in the air; that aviation would come to symbolise the freedom most women lacked and enable them to compete on equal terms with men.[42] Several women became successful fliers before 1914 but the challenge was really taken up during the inter-war years when a number of women pilots became international figures – Ruth Law, Katherine Stimson, Florence Barnes and Amelia Earhart. But despite their considerable successes in the air, women were denied equality.[43]

As Farmer points out, California became a centre for airwomen; actress/ pilots such as Ruth Chatterton, Andre Peyre and Ruth Elder became well known for their flying exploits and created a climate in which women fliers were, if not common, at least not unknown. From the early 1920s the studios began to produce romantic comedies exploiting the idea of women fliers, *Flying Pat* (1920), for example, where a husband advises his wife to find a career but becomes jealous when she qualifies as a pilot, or *Speed Girl* (1921) where Bebe Daniels plays a movie stunt woman who is also a daring pilot. *Stranger than Fiction* (1921), *One Week of Love* (1922) and *A Dollar Down* (1925) were other examples which featured women in the air, but it was not until Hawks' *Air Circus* in 1928 that the idea of a woman aviator began to be taken seriously by

film makers. The turning point came in the period 1929–30 with, firstly, the establishment of a women's air race (patronisingly known as the 'Powder-Puff Derby') at the Cleveland National Air races in August 1929; and secondly, the record-breaking flights by Amy Johnson and Amelia Earhart. The first serious examination of the subject on film came in 1933 with Dorothy Arzner's *Christopher Strong*, starring Katherine Hepburn.

Arzner was one of the few women to enjoy a long-term career as a Hollywood director and was responsible for several successful features including *The Bride Wore Red* (1937) and *Dance, Girl, Dance* (1940). *Christopher Strong* is still probably the most revealing cinematic exploration of a woman pilot yet made. It told the story of aviator Lady Cynthia Darrington (Hepburn), a woman closely modelled on Earhart, who loves flying but who also uses it to defy the conventions which imprison women. Arriving at a smart cocktail party dressed in a leather coat, jodhpurs and a 'beanie' hat, she shocks the male guests by telling them of her plans to fly around the world. However, her life becomes complicated when she falls in love with Christopher Strong, a married politician. During their passionate affair, Strong continually begs her to give up flying so that they can be married. She is thus forced to choose between a career or marriage, and Arzner uses this dilemma to condemn the system which makes it impossible for women to have both. That the film is named after Cynthia's lover is a typically cynical gesture from Arzner and writer Zoe Akins. When Darrington discovers she is pregnant she deliberately crashes her plane rather than give up flying and a way of life that allows her to be an individual rather than just someone's wife or mother. While some of the later films about women fliers were interesting, they failed to develop the ideas raised in *Christopher Strong*.

Wings in the Dark (1935) from Paramount starred Myrna Loy and Cary Grant. Loy is a famous aviator and Grant a crippled pilot working to perfect blind-flying instruments. Their stormy relationship is interrupted when Loy embarks on a long-distance flight. On her return she is unable to land at Boston because of thick fog. However, Grant is able to talk her down using the instruments he has developed. Loy again played a flier in the 1938 comedy *Too Hot to Handle*. Here she plays Alma Harding, a character closely modelled on Amelia Earhart. Clark Gable is the cynical reporter Chris Hunter. On a mercy flight to China (delivering cholera serum) she meets Gable, who is not impressed: 'She's a comic little dame who thinks she's a man flying round the world with grease on her face'. But Hunter and Harding combine their talents to find Alma's brother, another pilot, missing in the South American rain forest. An entertaining and well-made feature,

Too Hot to Handle takes a remarkably cynical view of the press and the public appetite for sensation and disaster (see below).

Tail Spin (1939) from Twentieth Century-Fox focused on three women racing pilots in the Womens' Air Derby. Written by Frank Wead, the film was promoted by an air circus hired by the studio to tour twenty-five major cities. Warner Brothers also featured the Derby in *Women in the Wind*, again released in 1939 and featuring Frances Kay. The story deals with a flier trying to raise money to help her pilot brother injured in a crash, but the plot was subordinate to the exciting air race sequences. Amelia Earhart, America's most famous airwoman, provided the model for Rosalind Russell's 'Tonie Carter' in *Flight to Freedom* (1943). Although this does explore some of the prejudice that women aviators faced, it is really an exercise in patriotism and suggests that Carter (Earhart) met her death while spying on Japanese defences in the Pacific. Earhart also rated a TV film biography, *Amelia Earhart* in 1976, with Susan Clerk as the heroine and John Forsythe as her husband, the publisher George Putnam. The film was a fairly accurate reconstruction of her life but again speculated wildly about her mysterious disappearance. Earhart was also the subject for Lauren Cardillo's short 1982 documentary, *On a Wing and a Prayer*, which featured interviews with those who had known the flier.

Women aviators were treated with considerable ambiguity in American cinema. Initially they were regarded as a joke, a novelty and the subject for comedy and romantic involvements. Yet by the end of the 1930s they were being taken seriously, and most films did make at least some reference to the difficulties they faced in a male-dominated profession. On the one hand they were extolled as pioneers, breaking down conventions and demonstrating the pluck and determination of American womanhood – another dimension of the expertise of American aviators. On the other, there was always a strong male to support them and on whom they came to rely, and marriage was the usual resolution for these films. The war curtailed the activities of women in aviation by ending civil flying while military aviation remained a closed door. Harriet Quimby was clearly over-optimistic in her belief that there would be no discrimination in the air.

In the immediate post-Armistice period, military aviation in America languished. However, under the impetus of Billy Mitchell and other air power enthusiasts, President Coolidge appointed the Morrow Board to study the whole question of the aeroplane and national defence. The Board's recommendations, published in 1926, resulted in increased expenditure and a growth of the air service. But in the economic climate of the early 1930s, it was essential that if military aviation was to continue to develop, it must

have public support. Sympathetic feature films, demonstrating the crucial role of aviation in national security and the dedication of airmen, were a useful propaganda element in the battle for continued funding.

Military aviation was shared between the navy and army, there was no independent air force. This led to considerable inter-service rivalry, and in popular cinema the navy probably had the advantage until the late 1930s. Naval aviation was novel, carrier operations and exotic locations adding a new dimension to the aviation film. But, more importantly, the Navy had its own 'representative' in Hollywood; the ex-naval aviator Frank Wead – one of the most prolific writers of the period. Farmer has rightly referred to Wead as the navy's 'unofficial public lobby' for naval aeronautics.[44] These factors resulted in a number of quality films promoting the navy and beginning in 1926 with *Non-Stop Flight*, a silent feature about navy fliers attempting to fly from San Francisco to Hawaii. Over a Pacific island, the aircraft runs out of fuel, the crew land and become involved in a series of adventures. More serious was *Wings of the Fleet* (1928), a twenty-minute promotion film made by the navy but distributed by Paramount, and detailing the recent advances in carrier aviation.

The Flying Fleet of 1929 was a major production from MGM. This ambitious feature, written by Wead, starred Raymond Novarro and Ralph Graves. It was the first film to use location shots taken aboard a carrier – the USS *Langley*. The story follows the careers of two pilots as they pass through flight school and are assigned to the carrier. One pilot (Graves) takes part in a long-distance flight but is forced down in the sea, and this provides the opportunity for a daring rescue by Novarro. The cinematographer on *Flying Fleet* was Charles Marshall, an ex-air service flight instructor. His aerial photography was particularly praised and his original footage was used in a number of later films. MGM followed this with *Hell Divers* (1931), again based on a Wead story and filmed by Marshall. The plot follows the exploits of a squadron of F8C–2 'Hell Divers' aboard USS *Saratoga* and at Naval Air Station North Island. It focuses on the rivalry between two air gunners, Wallace Beery and Clark Gable. The film had little real story but is a glorification of naval technology, the world's largest aircraft carrier, new techniques in dive bombing and even naval airships. While some reviewers criticised its pro-war attitudes, the *Motion Picture Herald* praised it for showing, 'the efficient preparedness of a great nation in times of peace', and suggested it should be shown in schools as an educational film.[45] Dedicated to 'those great fliers of the United States Navy who daily face death in peace time', the film was unusual in that the central characters are enlisted men and not officer pilots, although Gable is selected for officer school at the end of the

feature. Interestingly, Wallace Beery was a Lieutenant-Commander in the Navy Reserve and a qualified naval pilot himself, while Gable became an air gunner in the USAAF during the Second World War.

Released in Germany, the film was retitled *Wolkensturmer* (*Storming the Clouds*) and shown in schools as part of an educational package justifying rearmament and the need for a powerful German air force.[46] Before its commercial release, however, the US Navy insisted that all sequences showing arrester hook action be cut from the film. Naval Intelligence apparently felt that such a technique would be useful to foreign governments. *Hell Divers* was perhaps the most blatant example of naval propaganda made in the early 1930s and was followed by a number of less interesting films: *Navy Born* (1936) from Republic, dealt with the two sons of an admiral who become fliers; *Wings Over Honolulu* (1937) was the story of a flying boat patrol, and *Air Devils* (1938) a comedy about building a naval airstrip on a Pacific island. Only *Wings of the Navy*, a Warner Brothers production of 1939, offered anything new – the Navy's new long-range PBY flying boats and Olivia de Havilland! The Aviation Section of the US Coast Guard was also promoted in two features, *Border Patrol* (1936) and *Coast Guard* (1939). The first dealt with the capture of smugglers and the second with the rivalry of two patrol pilots. More substantial was *Devil Dogs of the Air* (1935) from Warner Brothers and written by John Monk Saunders. This film of the training of navy pilots follows the career of 'Tommy O'Toole' (James Cagney). O'Toole is a familiar character – the irresponsible natural pilot who is continually in trouble with the authorities. Only during the cadets' final manœuvres, when his best friend is nearly killed, does O'Toole discover the need for teamwork. Most of the filming for *Devil Dogs* took place at San Diego's North Island Air Station and included a number of interesting scenes of the navy's front line aircraft.

However, the most impressive Navy features made before the outbreak of war were *Flight Command* (1940) and *Dive Bomber* (1941). The former was a major production from MGM, written by Wells Root and Commander Harvey Haislip USN. It tells the story of a newly qualified pilot, Alan Drake (Robert Taylor), posted to the crack 'Fighting Eight' squadron (VF8). Through over-enthusiasm and a misunderstanding with his commander's wife, Drake is shunned by his colleagues. Only when he daringly saves the life of a fellow pilot is he accepted as a full member of the squadron. Despite the trite story line, the film is important as a detailed portrayal of naval aviation on the eve of war. It contains a great deal of documentary material but, as Farmer points out, audiences must have been troubled by the rather antiquated biplanes used in the film and the newsreel coverage of the sleek monoplanes

employed in the war in Europe.[47] However, the film does offer reassurane here when the commander of VF8 tells his wife the squadron will soon have new aircraft, 'There's a new plane . . . that makes these [F3Fs] look like turtles'. The film was well received, the *Hollywood Reporter* noting that it was important because it was 'educational. Pulling back the curtain on a most vital branch of our fighting forces – Naval Aeronautics'.[48] The propaganda was successful in at least one case: Robert Taylor, the film's leading man, was so impressed that he learned to fly and later joined the Service. The navy gave MGM considerable assistance during the making of the film but in return requested that the studio make a short documentary about the training of carrier pilots. The result, *Cloud Hoppers*, was released in late 1940.

Even more prestigious was Warner Brothers' salute to the navy, *Dive Bomber*, premiered in 1941. Written by Wead, directed by Michael Curtiz and starring Errol Flynn and Fred MacMurray, *Dive Bomber* was a lavish production. It is concerned with the dedication of flight surgeons, the doctors who pioneered the development of aviation medicine, but focuses a great deal of attention of the USS *Enterprise* and the new *Vindicator* dive bomber. The main story concerns the antagonism between Dr Douglas Lee (Errol Flynn) and Joe Blake (MacMurray), a veteran pilot who believes science has little to offer the experienced flier. Lee is looking for a solution to the problem of pilot 'black-out' when pulling out of a high speed dive. He becomes a researcher at North Island and even learns to fly in order to test his theories. Blake is assigned as his instructor and this increases the antagonism between the two men. Dedication and assistance from Senior Flight-Surgeon Rogers (Ralph Bellamy) resolve the problem of black-outs by the development of a 'pneumatic' belt worn by pilots and dive flaps on all aircraft to reduce the speed of a dive. Interestingly, a belt similar to the one in the film was used by dive bomber pilots in the later stages of the war. Eventually, Blake realises the benefits of medical research and becomes a test pilot for the programme.

Dive Bomber explores the way in which flight surgeons dealt with a number of serious problems in high-speed aviation, and creates a dynamic image of the service: a variety of powerful machines, the dedication of personnel and their preparations to defend the United States. The film adopts an interventionist attitude – as Lee tells Rogers after the successful test of the 'G' belt, 'Before I put her [the aeroplane] into that dive I kept thinking to myself there's two kinds of blackout this belt might whip; our kind and the sort they're having over London right now.' The film ends with Rogers telling a group of pilots about their experiments, which have helped to ensure that

'the planes and pilots of this nation can more safely fly, fight and defend their country in the stratosphere'.

There were few major productions dealing with army aviation before 1938. Major Hap Arnold (later Commander-in-Chief US Air Forces), commandant at March Field, the Air Corps base near Hollywood, had from the early 1930s made it clear to the studios that he was more than willing to help in film production. Arnold's son later recalled his father's attitude, 'I know my father had a great concern to further the utilization of film to place the Air Corps on the map!' To that end, Arnold got to know all the major film producers and indeed provided machines and facilities for a number of aviation films.[49] However, army aircraft were usually disguised as World War fighters or civil machines and the Air Corps itself got little publicity other than a mention in the credits. The Corps, then, was more than pleased to assist in the production of the two service pictures made in the mid-1930s – *West Point of the Air* (1935) and *Devil's Squadron*, made the following year.

West Point of the Air from MGM utilised a John Monk Saunders script about the training of army pilots at the Central Air Training facility in Texas, known as the Air Corps' 'West Point'. Filmed on location, it is a detailed view of contemporary training methods. *Devil's Squadron* was a confused tale about testing new army machines. No other army aviation features were made until 1938, but the first film of that year was another cheaply made and confused story of flight testing; *Clipped Wings* brought little credit to anyone involved. However, the second production clearly detailed defence preparations and the latest technology of aerial warfare and became one of MGM's most successful features. *Test Pilot* featured Clark Gable, Myrna Loy and Spencer Tracey and was directed by Victor Fleming. Scripted by Wead, the production had the full co-operation of the Air Corps who were quick to realise the value of such splendid propaganda.

The film is really the story of pilot Jim Lane (Gable) and his loyal mechanic 'Gunner' (Tracey). The opening sequence has Lane attempting to break the transcontinental speed record. Over Kansas, he is forced down and meets Ann Barton (Loy), a farmer's daughter whom he later marries. Sacked by his company, Drake Aviation, for wasting time romancing Loy, he enters the Thompson Trophy Race in Cleveland and despite several setbacks wins. Drake rehires him for a special assignment – testing new machines for the Army. The climax of *Test Pilot* is the test flight of Drake's 'superweapon', the B 17 'Flying Fortress', and all twelve of the Army's Second Bomb Group were used in the film. Lane and Gunner attempt a new altitude record in the 'Fortress' while carrying 20,000 lb of ballast. At 30,000 feet the cargo slips, pinning Gunner behind the control column. The plane spins down but Lane

just manages to crash land. However, Gunner is killed in the crash and, sobered by his friend's death, the adventurous Lane rejoins the Air Corps to train pilots – much to the relief of his long-suffering wife. The last scene shows Lane holding his baby son in his arms as the sky overhead fills with Air Corps bombers.

Despite the commonplace script, *Test Pilot* skillfully weaves together many of the threads of air nationalism into a tightly controlled and enjoyable package. Lane is the romantic daredevil pilot, the rugged individualist; his friendship with Gunner reinforces notions about the camaraderie of the air. American technological achievement is continually reinforced by the machines flown by Lane – the Drake *Bullet* (a Seversky S2 and forerunner of the Republic *Thunderbolt*), the Northrop A17 dive bomber and of course the 'superweapon', the B17. Confidence in national defence is promoted by these new machines and through the emphasis on the Air Corps programme of 'bigger, better, faster'. Add to this the excitement of air racing and the work of the test pilot and it would seem that *Test Pilot* could hardly fail to please audiences and promote a positive image of aeronautical progress.

National defence and the 'Flying Fortress' were also the subjects for a *March of Time* report in 1939 called 'Soldiers with Wings'. The episode opens with scenes of air raid precautions in London and Paris and film of formations of German bombers, while the commentary informs us that air power has made every great city a 'front line objective'. Then, on screen, B17s are wheeled from their hangars while the narrator reassures the audience, 'Today, as all the world knows, the most powerful weapon of air armament is the long-range, high-speed heavy bombardment airplane. By far the most effective US bomber is the four-engined B17 – the "Flying Fortress"' The audience are then told of its tons of bombs, its machine guns and 'top secret' bombsight. As the screen fills with a fleet of aircraft, the commentator tells us that with such armament the 'Fortress' is the 'most powerful air weapon in the world today'. And with its impressive photography and confident narration, *Soldiers with Wings* does indeed convey a powerful image of the aerial might of the United States.

As Europe was engulfed in war, the American studios increased their output of defence-orientated pictures. Some concentrated on American volunteers for the British Royal Air Force, while others reiterated the message that America, guarded by dedicated men and the latest technology, had little to fear. In February 1941, President Roosevelt made an unprecedented radio address to the Academy Awards banquet. He reminded the industry of their great potential for 'solidifying the nation's resolve in support of a strong national defence'. The members of the Academy took

him at his word, and in the months before Pearl Harbor a considerable number of defence films were made and three focused attention on the Army Air Corps.

I Wanted Wings, from Paramount, was inspired by the 1937 book of the same title by Lieutenant Beirne Lay, a reserve Air Corps pilot, and intended to promote recruiting for the Air Corps. Lay had seen *Wings* while a student at Yale and had decided on a career in aviation. *I Wanted Wings* was the story of his experiences at the 'West Point' of the Air at Randolph Field, Texas. Qualifying as a pilot in 1933, Lay spent his spare time writing flying articles and stories and the book of his own experiences. In 1939, Paramount bought the rights to the story and hired him to write the film version, which realistically tells the stories of three cadets (William Holden, Ray Milland and Wayne Morris) as they pass through flying training and of their need to learn discipline and teamwork. The film is only marred by a silly sub-plot involving Veronica Lake and some gangsters added by the studio. Beirne Lay, interestingly, went on to write a number of aviation features after 1945 including *Twelve O' Clock High* and *Above and Beyond*. Wayne Morris, one of the young cadets in the film became a naval pilot in 1942 and a Pacific fighter ace.

Universal produced both the other two Air Corps features of 1941, *Keep 'Em Flying* and *Flying Cadets*. The first had Abbott and Costello joining the Air Corps as mechanics and spreading confusion throughout the Cal Aero Academy at Chino California, while the second was a cheaply produced 'B' film dealing with a veteran pilot who founds a flying school to train military pilots.

IV

The First World War provided the background for many of the aviation films made between the the wars, but there was a number of others (virtually all American) which dealt with other, 'small' wars, some fictional, some based on real incidents. From the mid-1930s, with conflict in Ethiopia, Spain and China, war increasingly came to provide a background for film makers — films which we might regard as a prelude to the main event, the Second World War. As we have seen, the aeroplane as an instrument of social and political control had been demonstrated by the British RAF in Iraq and India in the early 1920s, and the idea became commonplace among the imperial powers. The United States had no formal empire but banditry and revolutions in South America provided a constant challenge for the United States as 'peace keeper' of the Americas. Beginning in 1922, a number of films

explored the use of air power as an instrument to maintain order in America's 'back yard'.

With Wings Outspread (1922) was probably the first to use the background of a small war for aerial adventure. The story dealt with a squadron of American fliers sent to Cuba to help put down a rebellion. Columbia's *Flight* (1929), directed by Frank Capra and written by Wead, had Jack Holt as an American mercenary flying for Bolivia in a fictional war with one of her neighbours. The film was considered successful enough to be remade in Spanish ten years later. Now called *Wings Over the Chaco*, it used all the original flying sequences. *Marine's Fly High*, an RKO production of 1940, was based on a story by Lt.-Commander A. J. Folton USN and starred Richard Dix and Lucille Ball. The story, concerning Marine pilots flying against insurgents in a fictional Central American Republic, is depressingly familiar today, for the film set the tone for later features which have used aviation in the battle against communist rebels, bandits or drug barons – *Wings of the Apache* (1990), for example, which pits the pilots of the Drugs Enforcement Agency against a Columbian heroin dealer.

But America was not the only nation to make films which reflected this use of air power. The British, as we have seen, produced *Flight Commander* in 1927 and some ten years later the French released *L'Escaudrilla De La Chance*, a 1938 feature which glorified an *Armée d' l'air* squadron in North Africa and its operations against nationalist rebels. Using aeroplanes, bombs and gas against the primitive Rif tribesmen was, thought *Variety's* critic, a 'distasteful subject'.[50] As we have seen, the most blatant glorification of air power in small wars came during the Italian conquest of Ethiopia and was reflected in films such as *Luciano Serra, Pilot* and *The Path of Heroes*.

The aviation aspects of the Spanish Civil War were also of interest to film makers beginning with the French production *L'Espoir (Hope)*, written and directed by André Malraux in 1938. Malraux had fought in Spain for the Republicans and had written a novel based on his experiences. His film, based on an incident from the novel, dealt with an attack on a Fascist-held airfield. With a minute budget and an enthusiastic but inexperienced crew, Malraux began filming in Barcelona in early 1938. The finale of the film is the attack on the airfield by Republican machines. The leader (Julio Pena) crashes into the mountains after his aircraft is damaged by enemy fire and he has to be rescued. The picture was finished in France, where the director added aerial sequences from newsreel footage of Japanese aircraft over China.

The film was completed in late 1938 but the government, sensitive to the international situation, refused to allow it to be shown. Only in 1944, after the liberation, was it publicly seen.[51] Two American films were set in Spain:

William Wellman's *Men With Wings*, which had a Civil War sequence and, more substantially, *Arise My Love*, a 1940 propagandist feature from Paramount starring Ray Milland and Claudette Colbert. Milland plays an American pilot, a Republican volunteer, captured by the Fascists. Rescued from prison by an aggressive newspaperwoman (Colbert), they steal a plane and escape to France. The aviator joins the *Armée d' l'air* to continue the fight against Fascism. After the fall of France in 1940, they return to the United States so that Milland can use his combat experience training American pilots.

The Spanish Civil War offered a useful opportunity for the German and Italian air forces to gain combat experience and both nations sent air units to fight for the Nationalists. In 1939, Hermann Goering arranged for director Karl Ritter to make an epic film of the exploits of the *Luftwaffe* volunteers — the 'Condor Legion'. The intention was to use documentary footage built around an adventure story. Filming apparently began in August, but the outbreak of war caused the project to be shelved.[52] However, at the end of the year, Fritz Hippler, an official at Goebbels' Ministry of Propaganda, produced a short documentary of newsreel material shot in Spain. *Condor Legion* was released at the end of 1939. Air warfare, particularly sensational reports of the bombing of cities, was a common feature of most newsreels of the late 1930s. In Germany, Italy and Japan, film of air attacks in Spain, Ethiopia and China was seen as a symbol of national will and military power, while in the democracies, it was shown as propaganda to support appeasement and later to justify rearmament.

In Spain, few films about the conflict were made once the war ended. However two focused on aviation. In 1941 Antonio Roman produced *Squadron* with Alfredo Mayo and Jose Nieto. This concerned two of Franco's fighter pilots, in love with the same girl. However, patriotism is more important and in combat with the Republicans one pilot sacrifices himself to save his friend. The film made use of some documentary footage. Alfredo Mayo reprised his part in *Squadron* in the 1957 production *Heroes of the Air*. The film is set in 1950 when Mayo, a Civil War veteran now in command of a Spanish Air Force rescue unit, meets a wartime comrade. Their reminiscences lead to a flashback of their combat experiences and particularly the incident when Mayo was shot down and captured. However, he escapes by stealing an enemy fighter. On his return to base he encounters his friend who, taking him for a Republican, shoots him down. Unlike the episode in *Wings*, which clearly provided the inspiration for the story, Mayo survives the crash.

The summer of 1937 saw the resumption of the Sino-Japanese War and the bombing of Shanghai — an episode dealt with in two American feature films of 1938. *Shadows Over Shanghai* was an inconsequential thriller involving an

American newsman and stolen jade. The Japanese attack on the city merely provided a dramatic background. The Clark Gable/Myrna Loy feature, *Too Hot to Handle*, however, was a far more interesting proposition. Although basically a romance between a newsreel reporter and a woman flier, *Too Hot to Handle* makes some valid points. The film opens in Shanghai, where Gable has been sent by his editor to get shots of 'bombing and assorted outrages'. Unable to procure sensational material, he is reduced to faking shots using model aeroplanes – an incident based on the 'March of Time' documentary *War in China* where dramatic footage of the Japanese bombing raids was actually filmed at a New York airfield.[53] *Too Hot to Handle* reveals something of the public's morbid fear of aerial bombardment and, at the same time, the vicarious thrill which such attacks afforded cinema audiences. It also details the callous desire of newsreel makers to provide sensational and gory items. As Gable's editor cheerfully comments when he receives what he believes is film of the bombing attack: 'I've been waiting two weeks for this – civilians being bombed from the air, enemy planes diving over the rooftops straffing the streets.'

The aviation films of the inter-war years provided a channel for the dissemination of propaganda extolling national achievement, heroism and military effectiveness. They both reflected and reinforced public fears about attack from the air and, in the case of Germany at least, enabled the National Socialists to achieve foreign policy objectives by creating a climate of fear.

NOTES

1 Kevin Brownlow, 'Out of the Shadows' (BBC Radio Three, 23 Aug. 1993).
2 Michael J. Neufeld, 'Weimar Culture and Futuristic Technology: The Rocketry and Spaceflight Fad in Germany, 1923–1933', *Technology and Culture*, 31:4 (Oct. 1990), 751.
3 Peter Fritzsche, *A Nation of Fliers – German Aviation and the Popular Imagination* (Cambridge, Mass., 1990), 134.
4 Maurice Bardeche and Robert Brasillach, *History of the Film* (London, 1938), 189.
5 Mosse, *Fallen Soldiers: Reshaping the Memory of the World Wars*, (New York, 1990) 120–1.
6 *Ibid.*, 151.
7 *New York Times*, 1 Mar. 1931.
8 M. S. Phillips, 'The Nazi Control of the German Film Industry', *Journal of European Studies*, 1 (1971), 37.
9 George L. Mosse, *Masses and Man: Nationalist and Fascist Perceptions of Reality* (New York, 1980), 182.
10 Fritzsche, *A Nation of Fliers*, 190.
11 David Culbert and Martin Loiperdinger, 'Leni Riefenstahl's "Tag der Freiheit": the 1935 Nazi Party Rally Film', *Historical Journal of Film, Radio and Television*, 12:1 (1992), 40.
12 This item is included on vol. 2 of the video release *A Newsreel History of the Third Reich* (Pedigree Films, 1993).
13 See Bialer and Eugene M. Emme, 'Emergence of Nazi Luftpolitik as a Weapon in International Affairs, 1933–35', *Air Power Historian*, 12 (1965).

14 David Welch, *Propaganda and the German Cinema, 1933–1945* (Oxford, 1983), 90.
15 *Ibid.*, 191.
16 *New York Times*, 8 Apr 1939.
17 Quoted in Welch, *Propaganda and German Cinema*, 205.
18 *New York Times*, 17 Febr. 1940.
19 *Mussolini, Aviator, And His Work for Aviation* (1935), quoted in Laurence Goldstein, *The Flying Machine and Modern Literature* (New York, 1986), 139.
20 Italo Balbo, *My Air Armada* (London, 1934), 277.
21 *New York Times*, 11 Apr. 1939.
22 E. Bailes, 'Technology and Legitimacy: Soviet Aviation and Stalinism in the 1930s', *Technology and Culture*, 5:17 (1976).
23 *Ibid.*, 58.
24 The report of this 1935 interview is in Jay Leyda, *Kino* (London, 1960), 335.
25 Bailes, 'Technology and Legitimacy', 63.
26 Peter Kenez, *Cinema and Soviet Society, 1917–1953* (Cambridge, 1992), 162–3.
27 J. L.Anderson and D. Richie, *The Japanese Film: Art and Industry* (New York, 1960), 130.
28 S. G. Tallents, *The Projection of England* (London, 1932), 17.
29 *Ibid.*, 18.
30 Quoted in Tim Travers, '"The Shape of Things to Come": H. G. Wells and Radical Culture in the 1930's', *Film and History*, 6:2 (1976), 32.
31 See H. G. Wells, *The War in the Air* (London, 1908).
32 Leslie Halliwell, *Seats in all Parts* (London, 1986), 128.
33 *Spectator*, 28 Feb. 1936; and see *New York Times*, 18 Apr. 1936.
34 On newsreels and the Spanish Civil War, see Anthony Aldgate, *Cinema and History* (London, 1979).
35 Joseph Corn, *The Winged Gospel – America's Romance with Aviation, 1900–1950* (New York, 1983), vii.
36 Wilbur Zelinsky, *The Cultural Geography of the United States* (New Jersey, 1973), 40.
37 John Ward, 'The Meaning of Lindbergh's Flight', *American Quarterly* 10 (Spring, 1958), 3–16.
38 Charles Lindbergh, 'Aviation, Geography and Race', *Readers Digest*, Nov. 1939), 107.
39 *New York Times*, 20 June 1930.
40 *Ibid.*, 24 Oct. 1938.
41 Quoted in Stephen Pendo, *Aviation in the Cinema* (NJ, 1985), 130.
42 Corn, *The Winged Gospel*, 35, 71–3.
43 African-Americans similarly believed that aviation might might be a route to equality. Like women, they were doomed to disappointment; and despite several outstanding aviation successes, they were denied access to civil and military aviation until the Second World War (see Ch. 6).
44 James Farmer, *Celluloid Wings* (Blue Ridge Summit, Pa., 1984), 105.
45 *Motion Picture Herald*, 16 Jan. 1932.
46 Culbert and Loiperdinger, 'Levi Riefenstahl's "Tag der Freiheit"', 15.
47 Farmer, *Celluloid Wings*, 142.
48 *Hollywood Reporter*, 17 Jan. 1941.
49 Quoted in Farmer, *Celluloid Wings*, 102.
50 *Variety*, 20 July 1938.
51 John W. Martin, *The Golden Age of French Cinema, 1929–1939* (London, 1987), 77–80.
52 David Stewart Hull, *Film in the Third Reich*, (Berkeley, 1969), 150.
53 John O'Connor, *Image as Artifact – The Historical Analysis of Film and Television* (Malabar, Fla., 1990), 53.

6 The age of the bomber: images of the Second World War

I

The German Army invaded Poland on 1 September 1939 and Britain declared war two days later, but initially very little appeared to happen. As the days went by, the British felt only a sense of anticlimax; the great enemy air attacks, so long expected to accompany the outbreak of war, failed to materialise, cities were not devastated by high explosive and poison gas and some believed, like Harold Nicolson, that 'boredom and bewilderment' might become the main elements of the war.[1] Yet clearly, the *Luftwaffe* could appear at any moment and, given the savagery of the onslaught on Warsaw, it was necessary to convince the public that all possible precautions had been taken and that the enemy would find Britain a difficult target. Having been told with monotonous regularity throughout the 1930s that 'the bomber will always get through', the public now had to be convinced that this was a miscalculation – that only some bombers would get through and that defence against air attack was indeed possible. A novel and highly visible form of defence was the barrage balloon, the 'blimp', flown over a potential target to deter enemy aircraft, particularly the Stuka dive bomber which had developed such a fearsome reputation during the Polish campaign.

In early 1940, Air Vice-Marshall Boyd, Commander of the balloon barrage, suggested a film about the barrage to improve morale among his men and to demonstrate to the public the value of such defence. The documentary was undertaken by the GPO Film Unit and Harry Watt's *Squadron 992* was the result. This twenty-five-minute film shows the training of an airship squadron and reconstructs the German air attack on shipping in the Firth of Forth in the autumn of 1939. The raid damaged several ships, although some raiders were destroyed by British fighters. Nevertheless, realising that the raid could be repeated, Squadron 992 are dispatched to Scotland to protect the area. The final sequence shows the Forth bridge and its balloon guardians, 'the sentinels of the sky, silent and deadly'. The propagandists' view of the effectiveness of the blimps had already been demonstrated in the first feature film of the war, Alexander Korda's *The Lion Has Wings* (1939), which

shows an attacking squadron of German bombers turning back from their target when they see the balloon barrage. However, *Squadron 992* was released in June 1940 and by that time the war had started in earnest and the film was out of date. It received only a limited showing, although a shortened version was shown in America as *Flying Elephants.*[2] In 1942, *Balloon Site 568* explained how women of the WAAF had taken over the operation of balloons from their male colleagues. The film was primarily intended to demonstrate how women were performing an important duty, but it nevertheless reinforced ideas about the defensive qualities of the balloon. Even as late as 1943, the RAF Film Unit produced *Operational Height*, a short film which demonstrated how balloons were operated from the deck of a ship to protect convoys from air attack. Although the subject of numerous jokes, balloons did have some effect in preventing low-level attacks and often inspired a quite irrational sense of security among civilians. Other films which dealt with aspects of defence against the bomber were Peter Baylis' *Ack Ack* (1941) and *Night Watch*, made the same year by Strand films, which looked at the important work of the ARP. However, following the fall of France and the German bomber offensive against Britain it quickly became obvious that the most effective element of air defence was the fighter, the sleek Spitfire or Hurricane, meeting the enemy raiders head on as they crossed the Channel.

Films dealing with fighter defence built upon the cult of the air fighter developed during the inter-war years: the young warriors who represented the 'spirit' of the nation at war became, during the Battle of Britain, the 'Few' who, although heavily outnumbered, fought the mighty *Luftwaffe* to a standstill. But these young men were not the lone eagles of 1914–18, for they were now organised into highly trained units, attacking in formation, directed from the 'control room' and guided to their targets by radar. Nevertheless, the fighter pilot rapidly became a heroic stereotype — romantic, boyish, given to high jinks, addicted to a peculiar 'slang' and inured to sudden death. And their battle, the Battle of Britain fought in the late summer of 1940, rapidly became a legendary struggle which has provided the subject for virtually every British feature film dealing with fighter pilots (the single exception was the 1953 *Malta Story*). However, the enduring screen images of the battle and the 'Few' were established in a handful of official documentaries produced during the early years of the War.

It was difficult for film makers not to be influenced by traditional images of the air fighter. In *Squadron 992*, for example, when Harry Watt reconstructed the German air raid, it ended with a sequence where a Spitfire pursued an enemy bomber and the director intercut this film with one

showing a gamekeeper hunting rabbits. However, in mid-1940, Movietone produced an eight-minute film for the Ministry of Information, *Fighter Pilot*, intended to highlight the extensive training of RAF pilots and their new fighter planes. Although pre-dating the Battle of Britain, *Fighter Pilot*, established a number of images which would become the enduring visual symbols of the summer of 1940: the boyish fighter pilot at one with his machine and the streamlined Spitfire, roaring at high speed over the gentle countryside of southern England. The first hint of what was to come was featured in a 'March of Time ' report that summer. *Britain's RAF* showed scenes of air combat near Dover during the initial stages of battle, but this short film tried to cover too many aspects of the work of the RAF to be effective. The Battle really began in August when, after a series of raids against Channel convoys, the *Luftwaffe* commenced its attack on the mainland. Although the RAF was outnumbered five to one, Air Ministry figures indicated that German losses were far heavier, and on some days quite remarkable. The short documentary, *Story of an Air Communiqué* (1940), was intended to demonstrate the accuracy of those figures by showing how carefully they were authenticated.

The film concentrates on a single day, 15 September, a day when, it was claimed, 185 German aircraft were destroyed. We see pilots landing after an attack, debriefed by squadron intelligence officers who, it is pointed out, only submit claims of a 'kill' where there is corroborating evidence. The figures are then collated at Group HQ and sent on to the Air Ministry for final checking. Having been authenticated they are presented to the air commodore on duty, who comments, 'My God! that's damn good: best we've done yet.' He then issues a communiqué to the press: 'the biggest bag yet, 185 enemy aircraft shot down'. The film, however, did more than attempt to authenticate the claims of Fighter Command, for the early sequences show us something of the nature of these young fliers, their good humour, ability and dedication – a theme pursued in *An Airman's Letter To His Mother* (1941). Produced by Michael Powell, the film had John Gielgud reading the last letter written by a young pilot to his mother. The letter had originally appeared in *The Times* on 18 June 1940 and was a testament to the courage and sacrifice of Britain's fighter pilots.

The First of the Few (1942), directed by Leslie Howard, was the first feature film to refer directly to the Battle of Britain – although its main concern was the heroic struggle by aircraft designer R. J. Mitchell to develop a modern fighter plane capable of defending Britain. The film begins on 15 September 1940, German raids are in progress and a Spitfire squadron lands after combat. A wounded squadron leader is bundled into a waiting ambulance. The squadron are put on standby and the station commander, Wing

Commander Crisp (David Niven), an old friend of Mitchell's, hears the young pilots discussing the fighter and its designer. Crisp then tells them how this 'miracle' came to life. In flashback, we see how Mitchell (Leslie Howard) came to design the aircraft and his struggle to get it accepted. The flashback sequence ends with the designer's death in 1937, but by then the Spitfire has been accepted by the Air Ministry. We then come forward to 1940 again. The squadron scramble and Crisp flies instead of the wounded squadron commander. After a dog fight over the Channel, Crisp pulls back his cockpit hood and looking up to the sky, quietly pays tribute to the aircraft's designer, 'Mitch, they can't take the Spitfire Mitch, they can't take 'em.' The film is really the story of one man's struggle to create technological excellence, a tribute to a great designer and to the British aero industry, but the sequences relating to the Battle of Britain again reinforce those popular images already established: the eagerness of the pilots, summed up by the wounded squadron leader who, driven off to the sick bay, irritably tells Crisp, 'I want an aeroplane, not an ambulance'; their youth and public school humour in the scene where they discuss the fighter; the constant references to how outnumbered they are – 'Six to one, piece of cake!' And, of course, their success in combat.

Curiously, the first detailed account of the battle came from America, *The Battle of Britain*, the fourth film in Frank Capra's 'Why We Fight' documentary series. This was written and directed by Captain Anthony Veiller and released in 1943. Not surprisingly, the film closely followed the Air Ministry's published account of the battle.[3] The film explains how, after the fall of France, Hitler planned the invasion of Britain and how essential it was that Germany should have command of the air before mounting the invasion. The film takes us through the various stages of the battle, the coastal attacks, the raids on RAF airfields and the daylight bombing of industrial centres. But as the commentator (Walter Huston) tells us, 'The workers kept on working and the RAF kept on flying. These few men with wings, alone in the sky behind their motors and machine guns, were shooting down more than the '*Luftwaffe*' – they were smashing the whole Nazi plan of world conquest.' Having failed in daylight, the Germans switched to night raids on the cities – indiscriminate attacks aimed at civilian morale. Finally we see RAF Bomber Command going onto the offensive and, using an extract from *Target For Tonight*, successfully attacking a military target; and the emphasis is on 'military' for, unlike the *Luftwaffe*, the RAF does not make war on civilians. To reinforce the point, the film ends with the German raid on Coventry. There is the eulogy to the Spitfire – 'one of the deadliest weapons put into the hands of man'- and to RAF pilots – 'this was a new kind of war, and the

RAF were the men who could fight it'. The commentary claims that during the battle the enemy lost 2,375 aircraft but, more importantly, suffered their first defeat. The film ends with Churchill's tribute to the RAF, 'Never in the field of human conflict was so much owed by so many to so few.'

Compared to the gritty, apparent realism being developed by British film makers at this time, some American features appeared strangely contrived. Universal's tribute to the American volunteers serving in the RAF is a useful example. *Eagle Squadron*, based on a short story by C. S. Forester and released in 1942, tells the story of the American pilots of 71 'Eagle' Squadron. Starring Robert Stack and Leif Erikson, the film opens in documentary style and introduces some of the real pilots who flew with 71. It also uses actuality film of Eagle Squadron operations filmed by the second unit director, Ernest Schoedsack in late 1941. However, the main plot, focusing on Robert Stack, involves him in a number of melodramatic episodes including a commando raid to steal the latest Messerschmitt fighter for the Air Ministry. Other aspects of the Battle of Britain were dealt with in several short films made in 1941. *Ferry Pilot* concentrated on the work of the Air Transport Auxiliary, the volunteers who ferried desperately needed aircraft from the manufacturer to the fighter station, and *The Pilot Is Safe* demonstrated the effectiveness of the RAF air sea rescue service in picking up pilots forced down over the Channel.

These wartime films established a stereotypical image of the fighter pilot which remained virtually unchanged until the late 1980s and which became one of the most enduring heroic episodes in the history of the air fighter. It has been suggested that the Battle of Britain became a legend at once, as soon as Churchill uttered his famous judgement,[4] but it was far more than that. It was generally regarded as the first decisive victory against an enemy who for over a year had met with unrivalled success. The battle was won, at considerable cost, by a handful of young men, and only in the contemporary documentary films do we get a real sense of just how young they were. More importantly, the action took place not in some distant arena but in the skies over southern England. Ordinary men and women could chart the progress of the battle in the sky overhead and its consequences in the burnt-out wrecks which littered the English countryside. These physical remains were a living testament to the skill, daring and sacrifice of the air fighter. Little wonder, then, that in the post-war years British film makers have returned again and again to the subject.

Angels One Five (1952) was the first post-war film to deal with the Battle of Britain. Written by Derek Twist, a World War pilot, and directed by George More O'Ferrall, it starred Jack Hawkins, John Gregson and Michael

Dennison. The story opens in June 1940 at a Fighter Command airfield in Kent commanded by 'Tiger' Small (Hawkins). Small is preparing his squadrons for the coming battle. A replacement pilot, 'Septic' Baird (Gregson), crashes on landing and 'writes off' the new 'kite' (almost everyone has a nickname and no one speaks without using a slang expression in every sentence. It was this which presumably prompted one American critic to complain the 'film is difficult to follow').[5] Baird is detailed to serve in the operations room until he finds his feet but resents this – 'I'm a pilot,' he angrily tells another flier. Interestingly, the operations controller is played by Cyril Raymond, re-enacting the part he played in *First of the Few* ten years earlier. As the Battle approaches, Tiger tells his pilots that although outnumbered the RAF have 'better aircraft, better pilots and perhaps most important of all, we've got radio location and ground control.' During an attack on the airfield, Baird manages to get into the air and, although he shoots down an enemy plane, he leaves his transmitter on and jams the squadron radios. This leads to Small telling him that war is a team effort, that 'discipline and procedure are just as important as skill and courage'. Chastened, Baird joins Pimpernel Squadron and eventually becomes a valued member of the unit until his death in combat. *Angels One Five* was the first British feature film to deal with the Battle of Britain, a belated cinematic tribute to the 'Few'. But it is also about squadron loyalty, duty and team work; and how the stubborn, introverted and individualistic Baird comes to understand what it means to belong to a group. Finally, it reinforces all the stereotypical images associated with the 'Spitfire summer' of 1940.

This year 1956 saw the release of the film version of Paul Brickhill's hagiographical book about Douglas Bader, *Reach For the Sky*. Bader (Kenneth More), a young RAF pilot, lost both legs in a crash in 1931 after attempting stunting too close to the ground. Retired from the service, he learned to walk again with artificial limbs. In 1939 he badgered the Air Ministry until he was finally reinstated to operational flying, fought through the Battle of Britain and ended the war as a POW in Colditz. Whilst there is no doubting Bader's courage and the power of More's performance, the pilot's barely suppressed aggression and constant need to prove himself are tedious. The thirtieth anniversary of the war in 1969 resulted in the epic *Battle of Britain* from United Artists, which was intended to reconstruct the whole story from 10 August to 15 September from both a British and German perspective.

Producer Bejamin Fisz conceived the project in 1965 and engaged Terence Rattigan to produce a screenplay. However, difficulties between writer and producer resulted in Rattigan being replaced by James Kennaway. Despite considerable financial problems, production finally began in 1967. *Luftwaffe*

General Adolf Galland and Wing Commander Stanford Tuck were engaged as technical advisers and the cast included Laurence Olivier (Dowding), Michael Caine, Trevor Howard and Christopher Plummer. The filming was plagued with technical and political problems: the recurrence of wartime squabbles involving RAF commanders Dowding and Keith Park, and Galland taking offence when *Luftwaffe* aircrew were asked to give the Nazi salute.[6] Finally completed, the film was premiered on 15 September 1969 but, despite general praise for the battle sequences, it was poorly received. The introduction of fictional characters adds little to the story, while the serious disagreements between Park and Leigh Mallory, which did affect the battle, and the shabby treatment of Dowding afterwards are hardly mentioned. The film also attempts to cover all aspects and briefly introduces so many characters it is surely bewildering to anyone not familiar with the events of 1940. Visually, the film is excellent and a great deal of trouble was taken to re-create the images of 1940. However, overall the film was an artistic and financial failure.

The Battle of Britain simply repeated the conventional wisdom about the battle and the 'Few', an interpretation that remained unchallenged on the screen until 1988, when Derek Robinson's irreverent *Piece of Cake* was filmed for television. Robinson tells the story of Fighter Command's 'Hornet' Squadron from September 1939, through the campaign in France, to the climax of the battle in September 1940. But the picture created here is of an RAF dedicated to a 'gentlemanly' existence, more concerned with the mess menu than flying, trained in tactics more relevant to 1918 than 1939, and incompetently led by the aristocratic Squadron Leader Rex (Tim Woodward). In France, Hornet Squadron are shot out of the sky by the professional fliers of the *Luftwaffe*. Robinson's Fighter Command is rather like a second-rate public school complete with out-moded rituals, riddled with snobbery, bullying prefects and unpleasant masters – the senior officers more concerned with their own careers than the lives of their men. War and the single-minded ruthlessness of the enemy come as a shock to men who have been taught to believe themselves an invincible warrior elite. The events of 1940 show them warfare is not a 'piece of cake' and under the pressure of battle they begin to learn. By then, of course, it is too late for most of Hornet Squadron. *Piece of Cake* is an indictment of the class-bound arrogance of the pre-war Royal Air Force rather than a critique of the Few. Nevertheless, it drew the venom of professional airmen and veterans of the battle.[7]

The only film about Spitfire pilots that was not set during the Battle of Britain was the 1953 production *Malta Story*, which takes place in 1942 when the island was under siege by the Axis powers. The story concerns Peter Ross, a photo-reconnaissance pilot attached to the Malta garrison almost by

accident. A scholarly, romantic figure, Ross is no professional warrior but a man caught up in war and doing his job in the best way he can. The film is a tribute to the fortitude of the Maltese and the British garrison, but it is more a study in duty and the manner in which war can sometimes ennoble man. By the 1950s even the 'enemy' could sometimes be treated sympathetically. The 1957 British-made *The One That Got Away* told the story of Franz von Werra, a *Luftwaffe* pilot shot down in 1940 and the only German POW to escape and return home. Von Werra is not portrayed as a fanatic but as an aviator, a man addicted to flying, a soldier doing his duty; and the film awards him the same qualities as British fliers – boyish exuberance, dislike of authority and a sense of adventure. After a number of false starts, von Werra finally escaped from a Canadian POW camp and returned to Germany via South America. In June 1941 he resumed operational flying and was killed in action the following October. *The One That Got Away* reveals just how quickly ideas about the international brotherhood of the air fighter were re-established in popular cinema after 1945.

In Germany, few films about the *Luftwaffe* were made after the initial successes of the war and none about fighter pilots. The air arm was largely discredited by its defeat over Britain in 1940 and the subsequent failure to prevent the Allied bomber offensive – an unjust verdict for in 1940 it wasted its strength attempting to perform a role for which it had never been designed. However, in 1955 Helmut Kautner succeeded in filming Carl Zuckmeyer's anti-Nazi play *The Devil's General*, based on the story of Ernst Udet. The film was part of the attempt to re-establish the German military by emphasising their resistance to Hitler. The film deals with *Luftwaffe* General Harras (Curt Jurgens), a World War One fighter pilot persuaded to help create the new German Air Force in 1935. However, after initial admiration for the NSDAP, Harras realises it is a brutal and destructive regime and this realisation leads to his suicide. Very different was *Star of Africa* (1958), a biography of the military career of fighter ace Hans Joachim Marseille, killed serving with the Afrika Korps. Presumably the film was intended as an action spectacular, but Marseille had been an ardent Nazi and the film was banned in West Germany and received only limited showings elsewhere.

Russian film makers, however, produced a substantial number of films dealing with their fighter arm, beginning in the first months of war. Most glorified the achievements or sacrifice of Soviet pilots in defending the Motherland and a number of these features were based on well-known air fighters such as Igor Kozhukharov (*Highway to the Stars*, 1942) or Alexsei Maresev, a pilot who, like Douglas Bader, lost both legs in a crash but

learned to fly and fight again (*The Story of a Real Man*, 1948). Other films, such as *The Last Turn* (1941), *The Skies Over Moscow* (1944) or *Baltic Skies* (1960), used fictional characters to tell the story of the air defence of the Soviet Union. Although a few of these films were shown in Britain and America, most remained unseen in the West. It was the American film industry which picked up on images established by British film makers during the first years of war and reinforced ideas about the heroism and sacrifice of the air fighter.

In January 1939, the Japanese launched a major air offensive against south-west China, beginning with air attacks on Chungking. Claire Chennault, an American Air Force adviser to the Chinese government, was delegated to raise and organise a force of American volunteers to counteract the Japanese. International volunteer airmen had been fighting with the Chinese Air Force since 1937, but Chennault's unit was intended to be exclusively American and drawn from service pilots on secondment for duty in China. In November 1940, Chennault succeeded in gaining Roosevelt's support and the American Volunteer Group (AVG), later more romantically known as the 'Flying Tigers', came into existence. From autumn 1941, one hundred pilots equipped with P40 Hawk fighters were operating over China. From then until they were incorporated into the US Tenth Air Force in April 1942, the Flying Tigers waged their own war against the Japanese.[8] It was the story of the AVG that Republic Studios chose for their first aviation feature of the war dealing with air fighters.

Flying Tigers, released in October 1942, starred John Wayne, John Carroll and Anna Lee. The film opens with a tribute from Generalissimo Chiang Kai-Shek,

> Since the Flying Tigers first spread their wings in the skies above China, the enemy has learned to fear the intrepid spirit they have displayed in the face of superior numbers. They have become the symbol of the invincible strength of the forces now upholding the cause of justice and humanity.

In the first scene we see an AVG squadron being scrambled to deal with approaching Japanese bombers. As the planes take off, Chinese peasants look on, admiration in their eyes. The scene changes to a busy city, American Red Cross workers are feeding refugees. The enemy appear overhead, bombs fall causing death and destruction. And as the smoke finally clears we see a small child sitting crying among the ruins. The scene changes to the cockpit of a Japanese bomber. The crew look down and smile at the devastation they have wrought, but their pleasure quickly turns to fear as they spot the fighters of the Flying Tigers approaching. In the ensuing dog fight, a number

of Japanese aircraft are destroyed. These opening sequences are a highly effective piece of propagandist cinema, establishing several important points within the space of a few minutes. The Tigers are always alert and ready for combat; they are repected by their Allies, the industrious Chinese. America cares about the sick, hungry and homeless (the scene of the Red Cross workers) and helps as much as it can. The Japanese make war on defenceless women and children, they bomb indiscriminately. The Japanese enjoy creating devastation but they are frightened when faced with real warriors. Finally, the Japanese Air Force cannot compete with American pilots, even when the Americans are heavily outnumbered.

Having established the basic points, the film then relates the experiences of one AVG squadron commanded by the hard-bitten veteran Jim Gordon (Wayne). Most of the episodes are familiar from earlier aviation films: the ageing pilot desperate to keep on flying; the cocky mercenary interested only in the 500-dollar bonus for each Japanese aircraft shot down, but who eventually learns the meaning of team work; but above all, the dedication and sacrifice of the air fighters. *Flying Tigers* is a well-made and exciting war adventure remarkably well-received by the public and nominated for three awards by the Academy of Motion Picture Arts. Seriously underrated by later writers, the film created a model for American studios when dealing with the air fighters genre for World War Two. More importantly it created an enduring cinematic image of the AVG.

The Flying Tigers quickly became established as an American counterpart of the 'Few' – a legendary and romantic fighter elite. Although their exploits were marginal to the course of the war, there were a number of reasons for the award of such status. They were the first American combat pilots to take on the Japanese, even before the 'Day of Infamy'. Heavily outnumbered, they defended a helpless people against a tyrannical and barbarous enemy and were the only combat unit to achieve some success against the Japanese in the early months of the war. Consequently, AVG pilots rapidly became a romantic symbol for the nation at war and film makers frequently returned to the theme.

For example, in 1943, when RKO wanted to establish the Fred Astaire character as a romantic hero in the musical *The Sky's the Limit*, they made him a Flying Tiger home on leave. In the same year, *The Lady From Chungking* had two Flying Tigers shot down behind enemy lines and helped by Chinese guerrillas. In 1945, Warner Brothers produced a film version of Flying Tiger Colonel Robert Scott's autobiography, *God Is My Co-Pilot*. Scott was one of Chennault's top scoring aces. The film, although containing some effective aerial sequences, was more notable for its piety and 'mindless' anti-Japanese

dialogue, which recalled some of the worst propaganda elements of the early war years.[9] The same year saw the release of Monogram's *China's Little Devils* with Harry Carey. The film, like the others that deal with the AVG, uses a number of sequences from the original *Flying Tigers*, but the story really concerns a group of refugee children adopted by a sentimental AVG squadron. Flying Tigers again featured in the NBC television series *Black Sheep Squadron* (1976–78), based on the reminiscences of Gregory 'Pappy' Boyington. Boyington flew with the AVG before gaining command of Marine squadron VMF214 during the Pacific campaign. The pilot film for the series was released as *The Flying Misfits* in 1976. It opens with Boyington (Robert Conrad) in China. After Pearl Harbor Boyington decides to return to the Marine Corps. However, at 35 years, he is judged too old for combat. Following some highly unofficial 'operations' and a great deal of political manoeuvring, he finally gains command of a squadron mostly comprised of 'misfits' – pilots who have little respect for authority and military discipline. Yet, under Boyington's leadership, VMF214 became one of the most effective combat units in the Pacific.

Aside from the AVG films, only two other features were made during the war which focused on fighter pilots: *A Guy Named Joe* and *Pilot Number Five*, both released by MGM in 1943 and both dealing with the nobility of sacrifice. The first starred Spencer Tracey as Pete Sandidage, a B25 pilot who, when his aircraft is badly damaged, deliberately dives into a German warship ensuring its destruction. Sandidage is killed but his spirit returns to earth as 'guardian angel' to Ted Randall (Van Johnson), a trainee fighter pilot. When Ted is sent to a P38 squadron in the Pacific, Sandidage goes too, and with the help of his unseen guardian, Randall becomes an ace. The film was surprisingly popular and the idea was resurrected in 1992 for *Always*, an up-dated version with Richard Dreyfus as the guardian angel. *Pilot Number Five* was a cheaply produced curiosity with Franchot Tone and Gene Kelly. On a Pacific island, threatened with attack from a Japanese carrier, the last five Army fighter pilots decide who will take their one surviving aircraft into the attack. Braynor Collins (Tone) gets the mission and while he heads towards the enemy, the others discuss what they know about Collins. In flashback, we see him as an ambitious lawyer involved with corruption and crooked politicans. The war, however, has given him an opportunity to redeem himself, a last chance to do something worthwhile. Over the enemy warship, Collins realises that he must make sure the enemy is destroyed and dives his aircraft straight into the target. He thus gives his life to save his comrades. Interestingly, both these films deal with sacrifice, a suicide attack by the central character, a fine and noble gesture to die for one's country and

friends. Yet in the last year of the war, when the Japanese did exactly the same thing, they were portrayed as mindless robots, brainwashed into sacrificing their lives for nothing!

Although the USAAF produced a considerable number of documentary films during the war years, most were concerned with training and therefore not shown commercially. The director William Wyler, however, produced several films which explored the nature of aerial warfare and which were released for public exhibition. Probably the most famous was *The Memphis Belle* (1943), a record of one Eighth Air Force Mission over Germany (see below), but equally impressive was his film of the 57th Fighter Group in action over Italy in 1944. The group were transferred to a base in Corsica to take part in Operation 'Strangle', an offensive intended to cut the supply routes to the German armies holding up the Allied advance on Rome. Wyler's forty-five-minute film covers missions flown by 65th Fighter Squadron flying P47 Thunderbolt fighter-bombers. We are introduced to the men of the squadron commanded by a 24 year old veteran, Lt.-Colonel Wymond, and follow a particular mission – an attack on bridges on the road to Cassino. Then there are aspects of other missions flown by the squadron – sometimes as many as eight a day. Wyler obtained some remarkable combat footage by placing automatic cameras in the cockpits, wings, fuselage and tailplanes of the aircraft, and then judiciously edited the results with film taken from his own B25 camera plane. There is little overtly heroic about *Thunderbolt* and the director is concerned to show us ordinary men doing a dangerous job day after day because it has to be done. Nor does he shrink from reality, as for example when we see the charred remains of a young pilot being dragged from his burning aircraft. The film is simply a record of young men at war carrying out yet another successful operation. But it does emphasise the vital importance of tactical air power. *Thunderbolt* had a limited showing in late 1945, but was put on general release in 1947 through Monogram.

The realism of *Thunderbolt* was undermined by the last feature film to be made about American fighter aircraft in the Second World War, Warner Brothers, 1948 colour spectacular *Fighter Squadron*. Written by Seton Miller, the film owes a great deal to his 1930 script for *The Dawn Patrol*. The story concerns Ed Hardin, an ex-Flying Tiger ace, now serving with a Thunderbolt squadron in Europe in 1944. Hardin is forced to take command of the unit and the film shows how this individualistic pilot learns to take responsibility for the men under him. A second theme explores his struggle to persuade senior officers to adopt new fighter tactics. Not surprisingly, *Fighter Squadron* made use of considerable footage shot by Wyler for *Thunderbolt*. Directed in swashbuckling style by Raoul Walsh, the film nevertheless said little that was

new. As Bosley Crowther noted in his review, 'All (or most all) of the cliches that one has ever heard (or seen in the movies) about the brave fellows who zoomed and strafed in the boundless blue and then spent their evenings drinking are in this rowdy film'.[10] *Fighter Squadron* was the last major production about air fighters made by American Studios. However, there was one other little-known documentary that is worth noting.

As we have seen, during the pioneer days of flight, African-Americans had believed that aviation might prove to be an area of opportunity free from discrimination. Yet, throughout the inter-war years and despite a few isolated successes, civil and military aviation remained closed to the African-American; civil airlines would not consider Black aircrew and the Air Corps, like other elite forces, was for Whites only. From 1939, increasing pressure from Black organisations eventually forced change. In the summer of 1941, the air service established a training programme for African-American pilots at Tuskegee, Alabama, Booker T. Washington's famous college. Senior officers expected little from these cadets, believing that the Negro was inherently inferior, lacked the ability to pilot a plane and would certainly not have the discipline for combat.[11] To their surprise, the Tuskegee airmen learned well and the Army eventually formed an all Black fighter squadron (an integrated unit would have been unthinkable at this time). The 99th Pursuit Squadron performed with great credit when it went into combat in June 1943 over North Africa and other units were organised.[12] However, 1943 was the year that racial tensions exploded with riots in Detroit and other major cities and serious incidents on military bases even as far away as Lancashire, England. Although the Tuskegee airmen had received attention in the Black press, their achievements were little known and even most white airmen were were unaware of their existence. In 1944, Truman Gibson, Assistant for Black Affairs at the War Department, suggested that a documentary film about the Tuskegee experiment would have considerably more impact and help defuse racial tensions.

Later that year, the Air Force began production of two films *Red Tails* (the 99th Squadron's nickname) and *Wings For This Man*. The first was never completed but the second was released in early 1945 for distribution to 'Negro theatres', a strange decision for not only was the film a demonstration of African-American achievement, it was, as Cripps has pointed out, an effective plea for racial integration.[13] The film opens with American fighters in action over Italy, wing cameras recording the actions that send German aircraft crashing down in flames. The fighters land and the pilots assemble on the runway to discuss the mission — every pilot and every member of the ground crew is an African-American for this is the 99th. Over this scene the

voice of the narrator (Ronald Reagan) tells us, 'You can't judge a man by the colour of his eyes or the shape of his nose'. In this coy commentary not once is any reference made to the fact that these pilots are black, the first African-Americans ever allowed to serve their country in the air! A later sequence shows a Tuskegee passing out parade with pilots being awarded their wings; it cuts to a formation of P51 Mustangs, then a final close up of an African-American pilot in his cockpit. During these scenes the commentator explains,

> Here's the answer to Adolf and Hirohito.
> Here's the answer to the propaganda of the Japs and Nazis.
> Here's the answer – wings for this man.
> Here's the answer – wings for these Americans.

Certainly, it had been pointed out in Japanese propaganda that while America denied political and civil rights to some seven million African-Americans, it was sheer hypocrisy for the government to pose as the champion of oppressed nations and claim to be fighting for freedom from tyranny. But clearly this ambiguous little film would do little to help America's cause. Although the escort missions flown by the squadron did have some influence on the attitudes of white bomber crews, the film had no effect at all on race relations at home for it was not shown to white audiences. Nevertheless, it remains an interesting record and shows something of Black achievement in the air. The armed forces were finally desegregated in the late 1940s but not until 1954, in a film dealing with the Korean War, do we actually see an African-American air force pilot (*Battle Hymn*); as far as World War Two was concerned, the American air fighter was drawn exclusively from a white elite.

II

However glorious and heroic the exploits of the 'Few' or the Flying Tigers, they could not win the war, but the heavy bomber might. The fighter's role was defensive: to prevent enemy bombers reaching their target or to protect Allied bombers against Axis fighter defence and ensure that they completed their mission. It was the bomber that was believed to be the central element in aerial warfare during the Second World War. Far more feature films were made, both during the conflict and after, about bomber operations than were made about fighters. Partly this reflected the rhetoric of air power enthusiasts who, since the First World War, had stressed the war-winning capabilities of the heavy bomber; partly because the bomber alone could hit back at the enemy in 1941–42, and partly because the bomber crew – often

from diverse social and political backgrounds – metaphorically symbolised the ideological consensus of the War. It might also be suggested that the crew, highly trained specialists, reflected something of the technological dimension of modern war, a war of 'experts'.

In Britain and America, air power enthusiasts had long claimed that the bomber had the ability to win wars almost without the assistance of other arms. This belief was enshrined in RAF doctrine by successive Chiefs of the Air Staff, and most forcefully by Sir Hugh Trenchard (CAS, 1919–29), 'Father of the Royal Air Force'. In America, the theory of strategic bombing was argued by General Billy Mitchell and his successors. Throughout the inter-war years emphasis was laid on the role of the strategic bomber, its ability to strike directly at the enemy heartland, create destruction and panic and undermine the enemy's will to continue the war. The RAF, in its passion for the bomber, almost entirely ignored the tactical and defence roles which had been developed at great cost in the last years of the First World War. And when the fighter defence of the United Kingdom was reorganised in the late 1930s it was mainly to allay public fears. The best possible defence, the RAF argued, was attack on the enemy's capacity to wage war. But by 1939, senior officers were beginning to experience doubts for there was a distinct lack of heavy bombers in the Service and the standard of navigation was remarkably low. On the outbreak of war, the RAF was forced to pursue a basically defensive strategy. The much vaunted air offensive against the enemy was not unleashed.

The German attack on France in 1940 came as a revelation to the Air Force. Despite having had the lion's share of the rearmament budget, the RAF were outclassed and outmanoeuvred by the '*Luftwaffe*'. British machines were obsolete and tactics and training were inadequate. Antiquated bombers like the Fairey Battle and Bristol Blenheim attacking tactical targets to slow the enemy offensive were simply shot out of the skies by the enemy. In late 1939, Bomber Command had instituted raids against enemy warships and the German North Sea ports. However, RAF chiefs were appalled at the losses incurred during these raids and it was clear that bomber formations could not protect themselves against fighter and anti-aircraft defences. In May 1940, partly in hope of drawing away German air strength from the campaign in France, the Cabinet made the decision to commence night attacks against specified targets in the Ruhr. The first raid took place on 15 May when 100 Wellingtons, Whitleys and Hampdens attacked marshalling yards and oil storage depots. RAF losses in night raids were appreciably lessened. It was clear from these experiences that daylight bombing raids, against tactical battlefield targets or strategic targets in Germany, were doomed to failure. By

summer 1940, public opinion began to regard the RAF as almost irrelevant; there was an inevitable anticlimax following the realisation that the bomber was not the decisive weapon that air enthusiasts had claimed. The prestige of Fighter Command was restored by the Battle of Britain, but although the Few appeared to have saved the nation from invasion, they could not prevent the bombing of British cities, and the complacency of the 'Phoney War' gave way to anger and a desire for revenge. For this the bomber was needed. Thus the strategic bombing offensive was not only believed to be a means of disrupting German capacity to wage war, it was also a method of restoring British morale – the only direct method by which Britain could strike at the enemy in the dark days of 1941–42. It was against this background that British studios produced a number of features and documentaries which reflected the strategic bombing of Germany by Bomber Command.

The first feature film of the War, *The Lion Has Wings* (1939), Korda's propagandist explanation of why Britain was at war and how the war would be fought, contained one sequence where RAF bombers attack the Kiel Canal – based upon the first offensive action of the war in September 1939. In the film, the raid is a success, targets are hit and considerable damage is done. In reality, however, these early attacks achieved little (when 'Blenheims' attacked the *Admiral Scheer* on 4 September, their bombs failed to explode) and were costly in terms of aircraft and aircrew lost. The public, of course, knew nothing of these failures and saw only the propagandist images of a successful strike against the enemy.[14] The German air attack on British cities in late 1940 led Churchill and Beaverbrook (Minister of Aircraft Production) to claim that there was a growing public desire for revenge. However, far more important was the need to restore morale after the disasters of May and June; for the public to know that Britain was hitting back. Typically overstating the case, the Prime Minister told his Cabinet in early September, 'Bombers alone provide the means of victory'.[15] While it was highly debatable whether the bomber could win the war, the long arm of Bomber Command was, at that time, the only means of striking directly at the enemy. The first film to focus on the bomber offensive was the enormously influential *Target for Tonight*.

Made in the spring of 1941 and released in August, *Target for Tonight* was written and directed by Harry Watt for the Ministry of Information and produced by the Crown Film Unit (as the GPO Film Unit was renamed in April). With such a pedigree, the film had an apparent official status denied to other features. It was also the first 'faction film', a strange but frequently successful hybrid, scripted as a traditional feature but employing real service-men and women in situations which were commonplace in wartime. *Target*

was acted by RAF personnel and the story concerns one Wellington bomber, F for Freddie, operating from the pseudonymous 'Millerton' airfield, and the planning and execution of a single night bombing raid on Germany. A study of aerial photographs at the Air Ministry reveals an important rail junction, oil storage tanks and barges at 'Freihausen' in the Black Forest region. Bomber Command call for a 'maximum effort' attack that night, and an experienced squadron are detailed to make a low-level raid. *Target* makes considerable play of the team effort required for a successful operation; from the intelligence officers who gather the information, to meteorologists and the ground crews who maintain the aircraft. At the briefing, the military importance of the target is emphasised and aircrews are told that there will be plenty of 'flak' but that the facility can be easily located because it is bounded by railways and a river-canal network.

Taking off at dusk, F for Freddie has little trouble in locating the target and despite the heavy anti-aircraft fire, drops at least one bomb on the storage tanks: 'I got a bulls-eye with that one', shouts the bomb aimer. However, the bomber is hit by flak and the radio operator wounded. With a dead radio and damaged engine, F for Freddie begins the lonely return flight to base. The first planes of the squadron return to Millerton at 3a.m. but as F for Freddie remains silent, the operations room gradually give up hope. Meanwhile, nearing base, the pilot of the Wellington offers his crew the choice: bale out or attempt a dangerous landing in thick fog? Unanimously the crew elect to remain in the aircraft and a safe landing is made. At the de-briefing the crew explain the first bombs were short of the target but the last one started a major fire – 'Black smoke, dullish red flames', says the pilot. 'Sounds like oil all right,' confirms the intelligence officer, and the raid is judged a success.

Documentary films were not always popular with audiences but *Target for Tonight* proved an exception. As Dilys Powell, the distinguished critic, noted,

> The actors were serving airmen, the dialogue was simple, realistic, ironic in the English manner – but somehow imagination had eradicated a plain story of everyday experience. Here was a new genre in the cinema, a fact, a fragment of actual life, which still had the emotional tremor of fiction.[16]

Considerable advance publicity ensured that the film was eagerly awaited. The *Daily Express* serialised the story and then issued it, illustrated with stills from the film, as a 6d. booklet. *Target for Tonight* was a successful rival to straight feature films and even did well in America where it was favourably compared with current Hollywood products. Among British audiences,

disheartened by continuing enemy success, the film fulfilled a particular need – it provided visual evidence that a counter-attack was being made. Director Harry Watt later attempted to explain this popularity,

> I can say that while the film was honest and well-made, it was no cinematic revolution, but an understated and unemotional account of an average air raid . . . I believe, away back in many people's minds, there had arisen the doubt that we could ever win . . . Then came this film, actually showing how we were taking the war into the heart of the enemy, and doing it in a very British, casual, brave way. It was a glimmer of hope, and the public rose to it.[17]

Target for Tonight was carefully packaged propaganda designed to convey the message that Bomber Command was striking at the heart of the Third Reich and severely damaging the German capacity to wage war. Made by the Crown Film Unit and featuring real RAF personnel, it smacked of authenticity and succeeded far more than ever anticipated and in so doing created a particular and enduring view of the RAF's bombing campaign.

These ideas were reinforced in the equally successful Powell and Pressburger feature *One Of Our Aircraft Is Missing*, released the following year. This tells the story of the crew of Wellington B for Bertie, damaged by flak on a raid over Stuttgart. The pilot keeps the aircraft airborne until, over Holland, the engines fail and the crew bale out. The major part of the film deals with the escape of the crew from occupied territory assisted by the Dutch underground – indeed the film was intended as a tribute to the Resistance. Nevertheless, there are a number of points which reinforce the idea of a successful bomber offensive. The crew are the usual diverse social mix – an actor, a farmer, a sportsman and an over-age veteran of World War One who has 'wangled' a posting as an air gunner – but they all share the same commitment and dedication. B for Bertie has no trouble locating the target at night nor bombing it accurately. An epilogue, set three months after their escape sees the crew back on operations but now assigned to the new Short Stirling heavy bomber. Naturally they still demonstrate the same enthusiasm for operations. The message here seems to be that eager and resilient aircrew will continue to hurt German capacity to wage war, and if that capacity could be damaged by obsolete Wellingtons, it will be even more severely damaged by the new generation of four-engined heavy bombers. *One Of Our Aircraft Is Missing* proved enormously successful in America, receiving a place in the *New York Times'* list of the ten best films of 1942 and inspiring several American imitations including *Desperate Journey* (1942) and *Bomber's Moon* (1943), both of

which dealt with Americans serving with RAF Bomber Command. In Britain, two other films of 1942 (*The Big Blockade* and *Flying Fortress*) demonstrated how Germany was being successfully bombed. *The Big Blockade*, from Ealing, dealt with a number of ways in which Britain was waging war but the RAF sequence has Hampden T for Tommy (flown by Michael Rennie and John Mills) making a number of runs over its target before accurately bombing a military installation. Walter Ford's *Flying Fortress*, dealing with American volunteers flying with Bomber Command, repeated the story.

The most detailed wartime exploration of Bomber Command was made by the RAF itself, by the RAF Film Production Unit (created in July 1941). *Journey Together* (1944) was made with actors then serving in the RAF and directed by John Boulting. The story concerns a young wireless mechanic, David Wilton (Richard Attemborough), who is keen to become a flier. Transferring to aircrew, he joins a draft sent to Arizona for pilot training. But despite the help of a sympathetic American instructor (Edward G. Robinson), Wilton lacks depth perception and will never make a pilot. Resentful and angry, he becomes a navigator but continually shirks his duty. Only after a near disastrous training exercise does he begin to realise that the navigator is just as important as a pilot to a successful bomber operation. Back in England, he joins the crew of an old friend (Jack Watling) for a raid on Berlin. Wilton proves himself by guiding the Lancaster to the target and, when the bomber is forced down in the North Sea, by sending an accurate 'fix' to the air sea rescue service, allowing the crew to be quickly rescued. The film is really concerned to demonstrate the high degree of training given to aircrew and the importance of teamwork in bomber operations. But it does reinforce the positive images of *Target For Tonight*

The same was true of *Coastal Command* (1942), a Crown Film Unit production dealing with the RAF's part in the Battle of the Atlantic – and another 'faction' film acted by RAF personnel. The film's central concern is T for Tommy, a Sunderland flying boat of Coastal Command, operating from a Scottish island base. It begins with Tommy being sent to escort an Atlantic convoy because of the suspected presence of a U-boat. This entails a ten-hour patrol during which the Sunderland drives off a long-range German bomber. A Catalina flying boat, on its way to relieve T for Tommy, sights a U-boat on the surface and destroys it. Meanwhile a German surface raider, the *Dusseldorf*, has been sighted south of Iceland and Tommy's next job is to shadow the vessel until a strike force of Coastal Command bombers are ready to attack. In an episode clearly based on the sinking of the *Bismarck* the previous year, the raider is attacked by torpedo bombers and damaged. T for Tommy is hit when trying to assess the damage to the enemy ship and returns to base.

Another Sunderland, crewed by Australians, escorts Tommy home. Despite an attack by enemy fighters the flying boats arrive safely, just as the sinking of the *Dusseldorf* is announced. Made and released at a time when the Battle of the Atlantic was at its most serious, the film was an attempt to show the varied duties of Coastal Command (long range convoy escort, anti-submarine and anti-shipping strikes and close co-operation with the Admiralty), and the successful way in which they were performed. These images were reinforced by the 1949 feature *Landfall*, based on a story by Nevile Shute, and dealing with anti-submarine operations.

Bomber Command's contribution to the Second Front was dealt with in a series of documentaries made by the RAF. *Towards the Offensive* (1944) focused on the Allied build-up for the Normandy invasion while *The Air Plan* (1945), narrated by Eric Portman, showed the contribution of British and Commonwealth aircrew. The latter emphasised how the RAF's attack on German communications systems in Northern France had paved the way for a successful invasion. Interestingly, Sir Arthur Harris, Commander-in-Chief, Bomber Command, resented his aircrews being used to attack railways, bridges and communication centres in France and thus being drawn away from what he considered to be the more vital industrial targets in Germany. The importance of the ground crews who kept the aircraft operational was the subject for *The Big Pack* (1945). The contribution of the RAF to clandestine operations in occupied Europe was dealt with in another film made by the RAF Film Unit. Unfortunately, the film was still unfinished when the war ended and a commercial company was called in to complete it. Released under the title *School for Danger* in 1946, the topicality of the film had been undermined by similar American productions.

These features and documentaries created a particular and enduring popular view of the effectiveness of the RAF's bomber offensive. But just how accurate were these cinematic reconstructions? From June 1940, the RAF was directed to attack specific targets in Germany, particularly oil storage facilities, aircraft factories and certain industrial concerns, targets which were considered vital to the German war effort. *Target for Tonight* and its successors fostered the view that bomber crews were capable of locating these military targets deep inside Germany at night, and often in poor weather; furthermore, that once the target had been located, it could then be accurately bombed. In reality, during the first years of war it was difficult for bombers to find the right city, let alone a specific target. Quite simply, the crews did not possess the navigational aids, bombsights or training to make such precision bombing possible. On 19 March 1940, for example, during the first night raid of the war, fifty bombers were detailed to

attack the German seaplane base at Hornum on the Isle of Sylt. On their return, the crews reported that they had located the target and caused considerable damage to hangars, living quarters and other buildings. A photo-reconnaissance mission over the base the following day revealed little evidence of this, while German reports noted only several aircraft suffering minor damage. Clearly, whatever the RAF had destroyed, it was not Hornum.

Even as late as August 1941, a Cabinet Secretariat survey (the Butt Report) revealed that one third of bombers did not attack the right target, and of those that did, only one third bombed within five miles of the aiming point. But as intelligence sources demonstrated the ineffectiveness of 'precision' bombing, the RAF was forced to consider alternative strategies. It fell back on the doctrine first stated by Trenchard at the end of the First World War that the most effective target for the bomber was the enemy civilian population and their will to continue the war. On 30 October 1940, the Cabinet agreed with this assessment; but it was not until after the German blitz on Coventry (14 November 1940), that Bomber Command aircraft were directed to aim at the centre of enemy cities. The first such raid was against Mannheim on 16 December 1940, but again it was relatively unsuccessful owing to so many crews bombing wide. However, as the offensive gained momentum, new navigational aids, heavier bombers and new techniques such as marker bombs and the creation of Pathfinder Force ensured that destruction became enormous. In May 1942, for example, during the first 'Thousand Bomber raid' against Cologne, over 600 acres of the city were destroyed.[18] Thus while *Target for Tonight* was in production and later demonstrating to audiences the effectiveness of RAF 'precision' bombing against specific military targets, the RAF was in fact using indiscriminate 'carpet bombing' to crush German industrial capacity and to destroy civilian morale. Moreover, in the course of this offensive, some 55,000 RAF personnel were lost.

Much the same was true of Coastal Command operations. Here the most serious weakness in the early years of the war was that the RAF were not prepared for a naval-air operations. As the struggle grew in intensity, the Admiralty insisted that the key to success was increased use of land-based aircraft. The Air Ministry, and particularly Arthur Harris, unwilling to divert machines from the main offensive against Germany, argued that the challenge of the U-boats could only be met by destroying centres of production. The situation was not resolved until the Prime Minister diverted extra resources to anti-submarine operations in the form of long-range land-based aircraft. Despite an increasing number of anti-submarine

strikes, the RAF did not sink its first U-boat until 1941; and between September 1940 and March 1941, only 21 enemy ships were sunk at a cost of 101 aircraft. In anti-submarine warfare the main problem was detection and the chance meeting of aircraft and surfaced submarine, as in *Coastal Command*, was remote. Not until the advent of radar, and such developments as very long-range aircraft and the assistance of the United States Navy, could the RAF successfully help deal with the submarine menace. The exploits of Sunderland T for Tommy should perhaps not be seen so much as a distortion of reality, but rather as an idealised prediction of what would happen within a year or so of the film's release.

Questions concerning effectiveness and doubts about its morality have been at the centre of the historical debate about the strategic bombing campaign since the last years of the war. But in terms of popular cinema, little attention has been focused on these issues – although the post-war paucity of films dealing with bombing operations might seem to suggest that it is a subject film makers would rather avoid. Nevertheless, in the last years of the war, a few films did begin to look at issues raised by the bomber offensive. As Coultass points out, one documentary, *The Biter Bit*, came close to admitting the indiscriminate nature of British bombing operations.[19] Churchill apparently suggested to Alexander Korda that a film documentary should be made which justified the Allied bombing of Germany. Korda took up the suggestion and the film was released in 1943. It opens with a reminder of how the *Luftwaffe* had struck at Warsaw, Rotterdam, London and Belgrade, but now that German cities were the target for Allied bombers the Germans had changed their propaganda to a plea for humanity in warfare – 'Think of historical monuments and the sanctity of human life'. They have adopted this whining tone, the narrator (Ralph Richardson) points out, because the 'biter' has now been bitten. It is obvious from the aerial photography of Dusseldorf and Cologne that the target was the city itself rather than some specific military objective. But satisfaction rather than moral doubt was probably the most common reaction of audiences to these scenes of the destruction of Germany. More typical of contemporary opinion were the view expressed in issue 43 of the *War Work News* (1944), produced by the Ministry of Supply, which described the new 'Bigger and More Beautiful' 4,000, 8,000 and 12,000 pound bombs then being rained upon the enemy, and the almost gleeful commentary that accompanied pictures of a raid in progress, 'We can keep it up for as long as they want'.

While the morality of area bombing was virtually ignored, in the last years of the war cinematic reconstructions did begin to look at the cost of such operations on the men who carried them out. The effect of danger and stress

on aircrew was the subject of the 1944 documentary *There's A Future In It* from Strand. This had the pilot of a Stirling bomber telling his girlfriend that he hates going on operations, hates being shot at but hates even more what 'they' are doing 'over there'. While not an effective film, it was refreshing to see a bomber pilot admitting that operations were not some sort of boy scout jamboree. *Target Germany* (1945), from the RAF Film Unit, was a detailed examination of the preparations and execution of a typical night raid on a German city, in this case Mannheim. However, unlike earlier documentaries, *Target Germany* did show something of the appalling devastation caused by such a raid and, more importantly, admitted that the offensive had cost the lives of over 55,000 airmen. The human cost was also a central theme in Anthony Asquith's 1945 feature *The Way To the Stars* (US title, *Johnny In the Clouds*). Written by Terence Rattigan and Anatole de Grunwald, the film opens to show a derelict airfield, suggesting it is after the war. We then move back to 1940 when a young pilot, Peter Penrose (John Mills), joins a Blenheim squadron for daylight bombing operations. Through his experiences we see the losses incurred on daylight raids. Penrose survives, and having completed his tour of duty, stays on at the airfield as controller when it is taken over by US Eighth Air Force B17s which, in turn, suffer heavy casualties. *Way To the Stars* was intended as a tribute to Anglo-American co-operation, but its most telling aspect is the human cost of operational flying. The early sequences also suggest something of the failure of Bomber Command daylight operations during the first years of war.[20]

Since 1945, British film makers have virtually ignored the bomber offensive. Of eighty-three war features made between 1945 and 1960, listed by Nicholas Pronay, only two deal with the subject.[21] Since 1960 only the BBC television film *Bomber Harris* can be added. Of the two that were made, both have avoided the contentious issues of morality and effectiveness. *Appointment In London* (1952) with Dirk Bogarde focused on the stress on aircrew of continual operational flying, while *The Dam Busters* examined the preparations for a raid against specific targets – the Eder, Mohne and Sorpe dams. The raid was portrayed as a triumph of technical ingenuity and improvisation and of the dedication of 617 Squadron in pressing home the attack. Both films deal with precision attacks on industrial targets and both, of course, suggest that the considerable losses incurred by the RAF in these operations were justified in view of the damage caused to the enemy war effort. This is, however, somewhat contentious in the case of *The Dam Busters*, where losses were remarkably heavy and, despite the impression given in the film, damage to German industrial production was slight. Nevertheless, in the gloomy climate of 1943, the moral-boosting effect of the dams raid was incalcul-

able. The two Anglo-American co-productions, *633 Squadron* (1964) and *Mosquito Squadron* (1968), both deal with low-level precision bombing of military targets – a German 'heavy water' factory in the first film and a Gestapo prison in the second.

The 1989 television film *Bomber Harris*, written by Don Shaw, begins in February 1942 when Air Marshall Sir Arthur Harris (sympathetically played by John Thaw) takes over Bomber Command. Harris brings a new mood to the offensive, telling his senior officers, 'We're not playing games anymore. We're going to consign the Third Reich to oblivion . . . The Boche have sown the wind; they will reap the whirlwind.' Recorded by the newsreels repeating the famous phrase, Harris inspired confidence and his relentless attitude was exactly what most people wanted in the dark days of early 1942. The film details Harris' struggle to get sufficient heavy bombers and to employ them effectively in destroying the enemy's industrial cities. Opposition to the area bombing plan is raised by Bomber Command's Chaplain, Canon John Collins, who enlists Sir Stafford Cripps in his moral campaign, but it has little effect in the face of the determined Harris. The controversial bombing of Dresden, in February 1945, is explained by the suggestion that the prime mover behind the attack was Stalin, who specifically requested the city to be included among Bomber Command targets. *Bomber Harris* is an interesting but defensive study, which justifies area bombing on the grounds that it appeared to offer the only road to victory at that time. Subsequent events demonstrated that bombing alone could not win the war, but it is unfortunate that Harris was so shabbily treated after the war for carrying out a policy which the vast majority of the British population wholeheartedly supported.

Anyone suffering moral doubts over the bombing of Germany might well have been advised to see the 1940 German documentary *Baptism of Fire* (*Feuertaufe*), Hans Bertram's hymn of praise to the *Luftwaffe*'s role in the conquest of Poland. Bertram's elaborate justification for the attack does little to conceal the blatantly aggressive tone of this production, which basks in the *Luftwaffe*'s destructive capability. The film shows exactly how German air power devastated Polish communications before the attack, destroyed their air force on the ground and provided constant air support for the German ground offensive. Bertram gloats over the damage caused by the *Luftwaffe* and constantly reinforces the eagerness of the 'young eagles' of the Reich for battle. Without any trace of irony, the commentary tells us, 'Our young *Luftwaffe* is poised like a sword in the sky, ready to give battle, determined to fight and annihilate those who attempt to destroy the peace in Europe'. The film ends with a tribute from Goering,

These highly impressive pictures bring home to the German people the great impact made by the Polish campaign and in particular the part played by our *Luftwaffe* which has performed feats in this battle which will go down in posterity. It is mainly to the contribution made by the *Luftwaffe* that we owe the defeat and annihilation of the enemy . . .

And while the fliers sing, 'Now the winged host reaches out to sea . . . Forward against the British Lion for the last, decisive blow', on screen is a map of England, the sound of a diving Stuka and a bomb exploding.

Baptism of Fire, released in April 1940, was remarkably effective propaganda and was shown at German consulates throughout Europe to invited local audiences in order to demonstrate the destructive potential of German air power. The British feature film *The Day Will Dawn* (1942) made reference to this. In Oslo, just before the German invasion of Norway, a British reporter (Hugh Williams) phones his editor telling him that at the German Embassy the previous evening 'they showed a film called *Baptism of Fire*, the Polish campaign in pictures . . . That film was horrifying. It's the same old Nazi game, terrifying your victim first, then hitting him hard.' The depressing scenes of havoc caused by aerial attack undoubtedly convinced some members of those audiences that resistance to Germany was futile and so helped to undermine their will to resist.

The success of the film led Goering to arrange for Bertram to produce an aviation feature film based on incidents in the Polish campaign and using much of the footage shot for the documentary. *Bomber Wing Lutzow* (*Kampfgeschwader Lutzow*) was a sequel to *D111 88* using the same principal actors. While the story of heroism and camaraderie is predictable, Hull suggests that it was one of the best directed and photographed and most effective propaganda films of the Third Reich.[22] Several other aviation films were made but were far less successful. *Stukas* (1941), directed by Karl Ritter, told the story of a squadron of Ju 87 dive bombers during the conquest of France and stressed the high morale of the crews and the effectiveness of the aircraft. However, Howard K. Smith, an American who saw the film in Berlin, noted, 'It was a monotonous film about a bunch of obstreperous adolescents who dive bombed things and people. They bombed everything and everybody. That was all the film was – one bombing after another';[23] and, Smith might have added, singing for there are a number of occasions when the pilots spontaneously burst into the 'Stukaslieder' – the Song of the Stukas:

Always prepared and ready to attack,
We the Stukas, Stukas, Stukas,

From the Wright Brothers to *Top Gun*

> We dive from the sky,
> We advance to defeat England
> We the Stukas, Stukas, Stukas.

The credibility of the *Luftwaffe* had really been undermined by the events of 1940 and *Stukas* was the last major aviation film. Even though Ritter was the Party's favourite director, such status did not help his 1943 production *The Crew of the Dora (Besatzung Dora)*. This apparently told the story of the crew of a Junkers 88 bomber on the Eastern Front. The pilot longs for the day when the war will be won and he can settle down to farm in the new eastern territories. However, the film was never shown: by 1943, even the most ardent National Socialists had difficulty believing that the war against Russia could ever be won.

American films dealing with bombardment aviation borrowed a number of elements from the earlier British features – the diverse socal mix of the crew, the aeroplane elevated to almost human status, the B17 *Mary Ann* in *Air Force* or the *Memphis Belle* in the documentary of the same name, and the documentary style of approach, usually through an authoritative narration and the inclusion of actual combat footage. Unfortunately, the excessive anti-Japanese propaganda and Hollywood's tendency to melodrama marred many of these aviation films. Warner Brothers' first major production after Pearl Harbor was *Air Force*, directed by Howard Hawks and written by Dudley Nichols.

According to Hawks, General Hap Arnold actually instigated the project and supplied combat reports and testimony which Nichols worked into a script.[24] Yet the film really deals more with Japanese treachery than with bomber operations. The early days of the war are told through the experiences of the crew of the bomber *Mary Ann*, on route to Pearl Harbor when the Japanese attack. Landing in Hawaii, they are attacked by 'local Japs' – agents infiltrated years before to sabotage the American defences. As the crew are sent on to Wake Island, and later to the Philippines, the full extent of enemy treachery becomes apparent. When the *Mary Ann* encounters the Japanese Air Force, the enemy are revealed as bloodthirsty savages who defy the accepted rules of war and machine-gun an American pilot as he parachutes from a burning aircraft. Escaping from the Philippines, the bomber crew sight an enemy invasion fleet and then guide a force of American bombers into the attack. With the Japanese fleet destroyed, the damaged *Mary Ann* manages to reach Australia and crash-lands on the beach. Most of the crew survive and we know that they will fly and fight another *Mary Ann* until Japan is defeated. A second theme explores how the initially antagonistic crew are forged into a

close-knit, mutually dependent group. Released in February 1943, it proved enormously successful and is considered one of Hawks' finest films.[25]

Five months later, RKO released their tribute to the bombers, *Bombardier*, with Pat O'Brien and Randolph Scott. The film was built around the establishment of the first training school for Air Force bombardiers (bomb aimers). The story concerns the rivalry between two officers, 'Chick' Davis (O'Brien), an enthusiast for high-altitude precision bombing, and Buck Oliver (Scott), a dive-bombing specialist. Beginning just before the war, the film shows Davis persuading his superiors to establish a training school for bombardiers where they will learn to use the secret Norden bomb sight for precision bombing. When Pearl Harbour is attacked the first class are ready and Davis leads a squadron to attack a Japanese aircraft factory near Nagoya. Oliver agrees to lead the mission and mark the target. Shot down over the city, he is captured, but manages to escape in time to sacrifice himself setting fire to some buildings, thus marking the target for the squadron. While the film contains some interesting (if melodramatic) scenes of training, *Bombardier* is pure Hollywood hokum. The Japanese mainland was beyond striking distance of American land-based bombers, and not until General James Doolittle organised a Navy carrier to transport his B25 Mitchell bombers to within range of Tokyo was Japan bombed. The story of Doolittle's raid was recounted in almost documentary style by MGM in *Thirty Seconds Over Tokyo* in 1944.

The most curious aviation film made during the early years of war was Walt Disney's 1943 production *Victory Through Air Power*, a sixty-five-minute animation which attempted to explain Alexander de Seversky's theory of strategic bombing. Seversky's book of the same title had been published in 1942 and Disney had been enormously impressed. As Schickel has noted, for Disney, 'Air power was . . . efficient power'. Seversky argued that war fought by aircraft would be far more economical and efficient than huge traditional armies and would, almost certainly, save life in the long term.[26] Disney used a combination of live action and animation to explain how strategic bombing would be used. Seversky introduced the film and appeared at various points to elaborate his argument, which was illustrated by Disney artists through animated sequences. The picture starts with a brief survey of the history of aerial warfare, beginning in 1914 and finishing with the idea of the long range 'super bomber' that would completely destroy the enemy's industrial complex and thus deny him the means to wage war. A second strand of his argument was that the air force must be independent and not simply an appendage of the army which had failed to understand the implications of strategic air warfare. Intended for the layman, the film presented Seversky's

theories in a simplistic but effective manner. However, some critics found the lack of humanity in the film disconcerting and felt Disney's vision of a war fought by machines gave no idea of the massive loss of life involved in a bombing offensive. As James Agee commented, 'I noticed, uneasily, that there are no suffering and dying enemy civilians under all those proud promises of bombs; no civilians at all, in fact'.[27] Despite Roosevelt's endorsement for the film, *Victory Through Air Power* was never popular with audiences. Nevertheless, it remains an interesting example of the propagandist's attempt to sell the strategic bomber to a mass audience.

Most feature films dealing with aviation remained firmly wedded to the Hollywood tradition of melodrama and high adventure but the realities of the bomber offensive were demonstrated in two powerful documentaries, *Report From the Aleutians* (1943) and *The Memphis Belle*, released in early 1944. In June 1942 a Japanese attack on Dutch Harbour in the Aleutian Islands had been repulsed by an air force counter-attack. However, the enemy did succeed in landing troops on several other islands and *Report From the Aleutians*, filmed by John Huston, then serving with the Army Signal Corps, was a record of the air operations against the Japanese positions. The film focuses mainly on the bombing operations carried out by B24 Liberators from their makeshift, waterlogged and highly dangerous airfields. Beautifully photographed, Huston's film shows something of the appalling conditions under which the Air Force operated during this little-known campaign. William Wyler's *The Memphis Belle* examined the Eighth Air Force's bomber offensive over Europe. Although Wyler had filmed a number of operations carried out by the 91 Bomb Group in 1943, he decided to concentrate his film on the last mission flown by the crew of the B17 *Memphis Belle*. The crew had completed twenty-four missions and needed only one more before being rotated home for training duties. Wyler filmed the mission, to Wilhelmshaven, and produced one of the most dramatic air war documentaries ever made. Bosley Crowther referred to it as a 'thorough and vivid comprehension of what a daylight bombing raid is actually like for the young men who wing our heavy bombers from English bases into the heart of Germany'.[28] The splendid colour footage taken by Wyler and his team is probably among the best air combat film ever shot and has reappeared in numerous features and documentaries.

By 1944, the effectiveness of the daylight bombing campaign in Europe was beginning to be questioned. In June, the invasion of Normandy and the opening of the Second Front appeared to suggest that the war could only be won by a massive land offensive. If that was true, then what had the air force been doing for the past two years? It was against this background that the

'March of Time' was invited to report on the achievements of the Eighth Air Force which, it was claimed, had paved the way for the successful invasion of Europe. 'The March of Time', using footage supplied by the Air Force's First Motion Picture Unit, produced *The Unknown Battle*, first shown in December 1944. After a survey of operations from early 1942, the film explained that, together with the RAF, the Eighth Air Force had been involved in a battle for the 'command of the air' which had enabled a successful invasion of Europe to take place. On 20 February 1944, the 'week long battle' to destroy the *Luftwaffe* began. In the reconstruction that follows, remarkably similiar to the scenes in *Target For Tonight*, we see the planning for massive raids against German aircraft factories, the long flight into enemy territory, B17 formations fighting off German fighters and the successful bombing of the targets. After the returning crews have been de-briefed, the commentary reports that intelligence has gathered 'confirmation of victory. A victory which destroyed a major part of Germany's aircraft production. The Allies had won decisive control of the air over Europe'. The film ends with General Arnold addressing the camera, 'In one week in our intensive air action we not only broke the back of the German "*Luftwaffe*", but also justified our ideas and methods of high-altitude, precision bombing and prepared the way for the invasion of the Continent.' The reality was that German aircraft production was only marginally affected by bombing. The decisive factor that broke the *Luftwaffe* was the massed formations of long-range escort fighters that destroyed German aircraft when they attempted to attack the bomber formations. In a sense, the bombers were the bait, luring the *Luftwaffe* into the sky where it could be destroyed by American fighters. *The Unknown Battle* makes no reference at all to escort fighters.

In 1944 there was also an attempt by Twentieth Century-Fox to emulate the realism of British air war features in their production *Winged Victory*. The script was based on the very successful Moss Hart Broadway musical of the same name. But clearly the film version owed a great deal to the RAF Film Unit's *Journey Together*. The story relates the experiences of six young pilots from basic training to graduation and assignment to combat squadrons. Fox used only actors who were serving in the USAAF, and filmed entirely on location at a number of training centres. The film ends with two of the newly commissioned pilots assigned to a B24, which they christen 'Winged Victory', and setting off for a tour of duty in the South Pacific. While not a major production, *Winged Victory* was a carefully made film which showed the detailed training of bomber pilots without the excessive melodrama so common in other features. Released in December 1944, it was the last film of the war years to deal with bombardment aviation.

MGM's *Command Decision* (1948), examined the problem of leadership during the bomber offensive. The story concerns Brigadier-General K. C. Dennis (Clark Gable), commander of an Eighth Air Force bomb group in 1943. Dennis orders the group to attack a German aircraft factory producing a new jet fighter but the heavy losses bring him into conlict with his superior, Major-General Kane (Walter Pigeon) – a man with political ambitions concerned about his own reputation. Dennis argues that heavy casualties are justified because once the new fighter is operational it could affect the outcome of the war. He fails to persuade Kane and is relieved of his command, but his successor orders the final strike against the factory that Dennis had wanted. Based on a play by ex-bomber pilot William Wister Haines, the story is loosely built around the Eighth Air Force operations against the ball-bearing factories at Schweinfurt in 1943, which resulted in heavy losses to the bomber force. In a similar vein was Fox's *Twelve O'Clock High*, released the following year. Set in 1942, it deals with the fictional 918 Bomb Group, a group suffering from low morale and weak leadership. The authoritarian General Savage (Gregory Peck) is appointed to rebuild their confidence and turn them into an effective combat unit. Savage succeeds, but only through a regime of ruthless efficiency, driving his men and himself to the very edge. *Twelve O'Clock High*, with its intelligent script, fine acting and tight direction by Henry King, is rightly considered a classic of the war film genre. However, in the increasingly tense atmosphere of the Cold War when these films were made, it is tempting to see them as precursors of the Strategic Air Command movies of the 1950s (see Chapter 7), essentially conservative, justifying military leadership and designed to show that war cannot be won without sacrifice.

Republic's *Wild Blue Yonder* (1952) told the story of the B29 Superfortress, the successor to the B17 designed for the long-range bombing of Japan. The plot revolves around the training and first mission of a crew led by Wendell Corey. Despite some impressive documentary film of the air war over Japan, the film merely repeats most of the clichés and situations from earlier films. In 1962, Columbia adapted John Hersey's novel *The War Lover* for the screen. The novel is a psychological study of B17 pilot Buzz Rickson, a man who finds total fulfilment in war. The film version, with Steve McQueen as Rickson, unfortunately loses the depth of character exploration and portrays the flier as just another doomed hero. Boris Sagal's *Thousand Plane Raid* (1969) from United Artists was a confused story of an Eighth Air Force bombing mission against a German aircraft factory in 1943. Cheaply made and poorly acted, the picture is a mish-mash of familiar situations. The film version of Joseph Heller's *Catch 22*, made by

Mike Nichols in 1970, had Alan Arkin as the anarchic bombardier Yossarian. Although set in the Mediterranean in 1943–44, the film was really far more relevant to America's on-going experience in South-East Asia than to World War Two. *Hanover Street* (1979) was essentially a vehicle for Harrison Ford. Filmed in England, Ford is a B25 pilot who becomes involved with Red Cross nurse Lesley-Anne Down. Aviation and the bomber offensive are simply incidental to the plot, which revolves around the doomed affair. Vincent Canby's review really summed up the whole exercise, 'Every now and then a film comes along of such painstaking, overripe foolishness that it breaks through the garbage barrier to become one of those rare movies you rush to see for laughs'.[29]

III

The war confirmed the predictions of the advocates of naval aviation, especially in the Pacific, where enemy targets were frequently beyond the range of land-based aircraft and where carriers became a decisive factor. The majority of films which focused on these aspects of aviation were made by American studios, a fact reflecting that nation's dominance of naval aviation. But, in the early years of the war, the British did produce one major feature, *Ships With Wings* (1941), and two later documentaries.

Ships With Wings, directed by Sergei Nolbandov, was produced by Michael Balcon's Ealing Studio. In August 1940, Balcon planned a tribute to the Fleet Air Arm and arranged for cinematographer Roy Kellino to film aboard the carrier *Ark Royal*. This material was integrated into a script in 1941 which examined the recent German intervention in the Mediterranean. The film, starring John Clements, Michael Wilding and Michael Rennie, was released in January 1942. *Ships With Wings* begins in the late 1930s and tells the story of Stacey (Clements), a naval pilot assigned to the *Ark Royal*. Stacey, a talented flier, is reckless and undisciplined and causes the death of a fellow pilot. Disgraced, he leaves the Service and becomes a charter pilot in the Mediterranean. When war comes he foils a German plot and heroically sacrifices himself in a suicide attack on an Italian-held dam, thus atoning for his earlier misdeeds. Although favourably received by the public, *Ships with Wings* was at odds with the democratic mood of the time, with its pilots drawn exclusively from the upper classes, its false heroics and caricatured enemy. Winston Churchill felt that the film would do little for the prestige of the Fleet Air Arm and wanted it withdrawn. However, the First Sea Lord, Admiral Sir Dudley Pound, approved its release. Churchill's criticisms, which were repeated by the high brow press, did force Balcon to rethink Ealing's policy and, according to Richards, *Ships With Wings* became the 'pivotal film in

effecting the transition at Ealing from "out-dated and class-bound" melo-drama to the new democratic docu-drama'.[30] Later the same year Ealing used some of Kellino's *Ark Royal* footage for a short documentary directed by Compton Bennett, *Find, Fix and Strike*, which dealt with the training of FAA pilots. In 1943, Michael Powell and Emeric Pressburger produced *The Volunteer*, a semi-documentary narrated by Ralph Richardson. The actor plays himself, then serving as a pilot in the Fleet Air Arm, and meets a former dresser, Fred (Pat McGrath), now an aircraft mechanic aboard the *Ark Royal*. Powell took his cameras aboard the Mediterranean fleet and the film clearly shows how far the FAA has developed since 1939 in terms of new carriers and advanced aircraft like the Supermarine Seafire.

The involvement of the American film industry with naval and marine aviation during the war began with the release of a 'March of Time' report, *Sailors With Wings*, released just after the Japanese attack on Pearl Harbor in December 1941. This focused on the work of American carriers in the Atlantic protecting Allied convoys during the uneasy peace before America officially entered the war. However, the dramatic events in the Pacific rapidly concentrated the attention of film makers on that area of conflict. The first feature, *Wake Island*, released in the autumn of 1942, told the story of the heroic but doomed defence of the island by Marines and a squadron of Grumman F4Fs of VMF 211. Although the film is mainly concerned with ground operations, we do see the first Japanese air raid on 8 December 1941, which destroyed eight of the squadron's twelve Wildcats, and the desperate attempts by ground crews to keep the remaining planes battleworthy. One pilot goes after a Japanese cruiser bombarding the island in what is virtually a suicide mission and does manage to seriously damage the enemy warship. On the final day of the siege, the last aircraft takes off to intercept Japanese bombers. In the ensuing dog fight, the pilot succeeds in destroying several enemy machines but he is forced to bale out when his aircraft is crippled. In a scene which became almost *de rigueur* for Pacific war films, he is machine-gunned by a smiling Japanese pilot as he floats helplessly down in his parachute. As Wake falls to the enemy a final narration tells us that, 'this is not the end . . . there are other . . . fighting Americans . . . whose blood and sweat and fury will exact a just and terrible vengeance'. That revenge began with the Doolittle bombing raid on Tokyo on 16 April 1942: an air force operation but one in which the Navy played a vitally important role.

The film industry's first reference to this mission was in the 1943 Warner Brothers production *Destination Tokyo* with Cary Grant as the captain of the submarine *Copperfin*. His mission is to penetrate Tokyo Bay and land an air force officer to gather vital information for the bombers. The air attack is

reconstructed by using a montage of documentary footage and studio model work. The raid itself received detailed treatment in the documentary-style feature *Thirty Seconds Over Tokyo*, MGM's 1944 production based on Ted Lawson's best-selling book of the same title. The film recounts how General James Doolittle (Spencer Tracey) developed the idea that it would be possible to bomb Tokyo by transporting bombers on an aircraft carrier to within striking distance of the mainland of Japan and shows the elaborate training the pilots were given to enable them to fly a B25 Mitchell bomber off a carrier deck. Once the bombers were launched, the carrier task force would have to retire to safer waters leaving the attackers to fly on to China and land at Nationalist bases. The raid actually caused little damage and all sixteen aircraft were lost, although many crews did eventually get back to the United States. However, the operation was a major blow to Japanese morale and, more importantly, demonstrated America's ability to strike back. The film made use of documentary footage shot aboard the carrier USS *Hornet* and MGM recreated a sixty-foot replica of the flight deck for other sequences. Bosley Crowther referred to the production as a 'true and tremendous story . . . told with magnificent integrity and dramatic eloquence . . . handled with restraint'.[31] Clearly, the major focus is on Doolittle and his army pilots, but the film does show the importance of the navy in getting the aircraft to the jump-off point. Interestingly, *The Purple Heart*, released the same year, a powerful propaganda vehicle intended to strengthen anti-Japanese feeling, told the fictional story of eight airmen from Doolittle's force, shot down in enemy territory and executed by the Japanese Army as war criminals.

Less than two months after that first raid on Tokyo came the first real Allied success in the Pacific, the decisive Battle of Midway, a major naval engagement fought almost exclusively by carrier-based aircraft and considered by many to be the 'turning point that spelt the ultimate doom of Japan'.[32] Before the end of the year, John Ford's highly acclaimed documentary *The Battle of Midway* was on general release. The narration tells us that Midway was 'the greatest naval victory of the world to date', but the film shows little of that action. Ford, serving in the Navy's Field Photographic Unit, was actually on Midway Island when the Japanese launched their attack. We see a bombing raid and the air battles over the island, but when the commentator announces 'the trap is sprung', it is Army B17s that we see taking off to attack the Japanese fleet – an attack most historians regard as ineffective. Ford later cut in scenes of carrier planes, and there are some interesting close-ups of pilots who actually took part in the attacks on the enemy warships, but there is remarkably little in the film to explain how the victory was won or of the decisive nature of naval air power in the Battle.

Nevertheless, Ford's film was given the Oscar for the best documentary of 1942 and certainly its message of triumph, its magnificent, if somewhat overly-sentimental images and the 'folksy' narration (by Henry Fonda and Jane Darwell) ensured its popularity with audiences. But however well received these films were by public and critics, and however positive their images of the navy's contribution to combined operations, they only skirted the fringes of the central focus of naval aviation - the aircraft carrier; and it was not until mid-1944 that a film dealing specfically with carrier operations was released: *A Wing and a Prayer, the Story of Carrier X* from Twentieth Century-Fox.

The film begins in March 1941 with a newspaper headline screaming '*where is our navy?*' and an editorial that reads 'Three months have passed since the tragedy at Pearl Harbor and people are at a loss to understand why our Navy does not strike back'. The film is an explanation of why it appeared that in the early months of the war, the navy was reluctant to commit its forces to battle. Having established this public criticism, the scene switches to a conference room where a senior officer explains to his fellow admirals that the service must not be drawn by public accusations of 'failing to fight' for the navy has now regrouped and is going on the offensive. The Japanese, it is explained, are supremely self-confident after their successes and will almost certainly launch an invasion of Hawaii, but first they must take Midway Island. American strategy, therefore, will be to persuade the enemy to split his forces and bring him to battle when and where the United States has the advantage. This task will be carried out by 'carrier *X*', whose mission will be to convince the enemy that American naval strength is scattered and morale destroyed. Having set the scene, the film then shifts its focus to the carrier.

The story really concentrates on the men of the carrier's squadron 'VT5', a newly formed unit of TBFs. The pilots are hungry for combat and not pleased when their commander tells them, 'when enemy planes are encountered do not engage them. Return to the carrier at once.' It is difficult for these young and eager pilots to run from combat and thus make the Japanese believe that they lack the stomach for a fight. Gradually, however, they learn discipline and the squadron becomes a cohesive fighting unit. Finally the Japanese are lured into the trap at Midway and the air groups are launched for the attack on the enemy fleet. Apart from the initial attack by VT5 on a Japanese carrier, little is seen of the battle. It is presented through a series of radio transmissions relayed throughout carrier X. This dramatic device is an effective solution to the film makers' difficulties in recreating scenes of battle but still allows the audience to gain an understanding of the excitement and confusion of modern warfare.

Twentieth Century-Fox followed *Wing and a Prayer* with a feature-length documentary about carriers, *Fighting Lady*, released in January 1945. This is the story of an Essex class carrier from launching, through the most dramatic episodes of the Pacific War, including the battles of Kwajalein, Truk and Saipan, to the decisive victory in the Battle of the Philippine Sea – the 'Great Marianas Turkey Shoot' – in June 1944, when Japanese losses were estimated at 346 aircraft and two carriers. The film contains some impressive footage of aerial combat but it emphasises that it is the dedicated work of all the departments aboard the ship that makes it an effective fighting unit. Everyone is essential from mess hands to fighter pilots. Narrated by actor Robert Taylor, then serving in the navy, the film took over fourteen months to complete. Documentaries were never as popular with audiences as feature films, but despite this and the fact that many people were bored with the war by 1945, *Fighting Lady* proved remarkably successful.

Both *Wing and a Prayer* and *Fighting Lady* can be termed 'semi-official' films; although made by a commercial studio, the Department of the Navy had a considerable degree of control over their making and what they revealed about air operations. In early 1943 the navy agreed to assist Fox in the production of a major feature but insisted on a realistic script. To achieve an accurate portrayal of events leading up to Midway, writer Jerome Cady was provided with combat records of the air and sea units involved, while director Henry Hathaway was allowed to film aboard the newly commissioned carrier *Yorktown II* during her shakedown cruise. 'For seven weeks', Hathaway later recalled, 'we captured everything on film: take-offs, landings, crashes, pilots getting in and out of their planes, everything.'[33] This film was added to scenes shot in the studio and fleshed out with combat footage supplied by the navy. Lieutenant Robert Middleton, a Pacific veteran, acted as technical adviser and commented on the impressive degree of realism achieved by the studio.[34] And this was reflected in Thomas Pryor's review of the film,

> Director Henry Hathaway has so skillfully woven documentary film footage into the story that it is difficult at times to spot the ending of an incident out of history and the beginning of an episode fashioned on the typewriter of scenarist Jerome Cady.[35]

The origins of *Fighting Lady* were somewhat different. Towards the end of 1943, and no doubt influenced by the many films that paid tribute to the other fighting services, Captain H. B. Miller of the Naval Bureau of Aeronautics conceived the idea of a film which would give the public a detailed view of life aboard an aircraft carrier. The film was shot by Naval cinematographers

under the direction of Edward Steichen and Lt.-Commander Dwight Long. However, an arrangement was made with Twentieth Century-Fox by which the latter would produce and release the film for theatrical performance. Most filming took place aboard the *Yorktown II*, and indeed, the film was intended as a cinematic biography of that ship, but additional filming took place aboard the *Essex*, *Lexington* and *Hornet*. The result was, as one reviewer wrote, 'a picture every American should see that he may better know and appreciate what our Navy is doing in the Pacific'.[36] Admiral Chester Nimitz was reported to have said, 'a real picture of real men and real fighting'. He was later quoted as suggesting that 'the Japanese should see this picture someday with our bombs and our compliments'.[37] The navy, then, shared in an active partnership with commercial studios in the production of these pictures and were apparently satisfied that they showed naval aviation in a positive and realistic way.

Released at the same time as *Fighting Lady*, MGM's *This Man's Navy* dealt with the airship units – perhaps the least-known branch of the service. The film concerns a braggart veteran airshipman (Wallace Beery) and a young recruit thrown together on active service. Most of the film deals with the training programme for airship crews at Lakehurst, but eventually Beery's crew see action and sink a U-boat off the New England coast. Transferred to the Burma theatre of operations, they heroically rescue the passengers of a transport aircraft which has crashed in the jungle. Aside from the obvious false heroics, the film is an interesting look at a branch of air operations virtually ignored by film makers since the early 1930s. *This Man's Navy*, however, is something of a throwback to the melodramatic style of the pre-war years and is strangely at odds with the realistic and sombre mood of *Wing and a Prayer*. One other wartime feature dealt with naval air operations, the nonsensical 1943 feature from Universal, *We've Never Been Licked*. This is the story of a young American pilot, an apparent Japanese sympathiser working for the enemy. However, during the Battle for the Solomons, he steals a Japanese dive bomber and reveals the enemy's position to the American fleet. Not content with that, he then sacrifices himself in a suicide attack on a Japanese carrier. *We've Never Been Licked* is an example of the worst kind of Hollywood propaganda of the early war years: cheaply made with shoddy production values and minimal characterisation.

Comparatively few films were made during the war years which examined naval aviation but they conveyed enduring images of the carrier war in the Pacific. The overriding impression is that naval and marine fliers were tough, dedicated and professional. Younger men, the fledglings, were eager for combat; indeed their one initial weakness is a tendency to attack without

regard for the consequences. If we take *Wing and a Prayer* as our example, we find the hardest lesson the young aviators have to learn is discipline – accepting that they are part of a team and that senior officers actually know what they are doing. However, once that lesson is learned, teamwork and mutual dependence become the hallmark of the squadrons. Senior officers are invariably 'crusty', wearing an mask of cold, detached professionalism. However, the mask conceals a streak of sentimentality and a desperate concern for the lives and well-being of their men, qualities which eventually earn them great respect. Of naval air operations the films provide a convincing picture, and in spite of their propagandist function, there is surprisingly little of the exaggerated heroics familiar from some other types of war feature. We see the navy playing its part in combined operations and, despite the hard knocks of Pearl Harbor, quickly recovering and going on to the offensive. Clearly, the Battle of Midway becomes a central focus for film makers dealing with the subject, but no film, not even the 1976 spectacular really demonstrates just how decisive air power was to the war in the Pacific. However, what is perhaps surprising is that the ideas and images conveyed in these wartime productions remain so unchanging in the post-war era.

The first major post-war production came in 1949: *Task Force*, from Warner Brothers. This told almost the whole story of naval aviation through the biography of the fictional flier Jonathon Scott (Gary Cooper). Scott begins his career in the 1920s, aboard the first carrier USS *Langley*, but the main focus of the film is his appointment as commander of the *Franklin* as she takes part in the invasion of Okinawa. *Task Force* is probably the most detailed and revealing film about naval aviation and employs a vast amount of documentary material. The Howard Hughes/John Wayne production about Marine fighter pilots, *Flying Leathernecks* (1951), is ostensibly about a Marine squadron at Tarawa, Iwo Jima and Okinawa, but despite some extremely effective aerial sequences, it is probably more relevant to the Korean War and reflects something of the anti-Asiatic/anti-communist position of the Hollywood right. Much the same might be said of *Flat Top*, released the following year. Set during the Korean conflict, a carrier group commander reminisces about his earlier experiences in World War Two. *Battle Stations* (1956) was a fictionalised biography of the carrier *Franklin* at Okinawa and clearly took its inspiration from the 1945 documentary *Fighting Lady*. Despite the financial success of these films, for twenty years after *Battle Stations* naval aviation in the Pacific was virtually ignored by film makers.

Not until 1970 was another feature made which even touched upon the subject. However, *Tora! Tora! Tora!*, which dramatically reconstructed the attack on Pearl Harbor, demonstrated that there was still a market for this

type of war spectacular, albeit not as profitable as film makers had anticipated. Even so, it was 1976 before a film concentrating on naval aviation appeared. This was the Universal production *Midway*, a highly detailed documentary-style feature reconstructing the story and based on Donald Stamford's book. The film was perhaps marred by the introduction of fictional characters whose peculiar domestic arrangements add little to what is already an intensely exciting and dramatic story. The producers of *Midway* plundered the film archives as well as using a vast amount of documentary material, and the viewer will recognise sequences from *Leathernecks*, *Dive Bomber*, John Ford's *Battle of Midway* and a number of other well-known films. While most of *Midway* is remarkably familiar from the wartime features, there is one crucial difference – the image of the enemy. No longer is he the 'Beast from the East', but a fully drawn character often portrayed with sympathy; this is particularly true of Admiral Yamamoto, the isolated intellectual of *Midway*, or Commander Genda, the air commander of the Japanese units which attacked Pearl Harbor in *Tora! Tora! Tora!*. This new version of the enemy was perhaps most artificially portrayed in John Boorman's *Hell In the Pacific* (1969), in which an American Navy pilot (Lee Marvin) crash-lands on a Pacific island where the only other inhabitant is a Japanese officer. In the struggle for survival against a hostile environment, the two men forget their differences and learn mutual respect and toleration.

The attack on Pearl Harbor by aircraft of the Imperial Japanese Navy, which drew America into war, was the subject of John Ford's 1942 documentary reconstruction *December 7th*. But the attack has also provided the background or climax for a number of feature films, most notably *From Here to Eternity* in 1953. The subject was also of considerable interest to Japanese film makers both during and after the war. In the summer of 1942, Kajiro Yamamoto produced a documentary-style feature using film taken by official cameramen. *The War At Sea From Hawaii To Pearl Harbour* is a celebration of the detailed planning and of the dedication of the aviators that made possible Japan's early victories. *Navy* (1943), directed by Tomotaka Tasaka, and the 1961 documentary *Storm From the Sea* both dealt with the attack on Pearl Harbor in detail. The training of Navy aviators was the subject of *Towards a Decisive Battle In the Sky* (1943), while the 1944 feature from Kajiro Yamamoto, *Torpedo Squadrons Move Out*, told the story of three young aviators who sacrifice themselves in order to sink an American battleship. Of all the Axis powers only Japan has demonstrated a nostalgia for the war years. Beginning in the 1950s, studios began to produce a considerable number of features and documentaries. These films usually criticised the aims and ambitions of the militarists but nevertheless glorified

the devotion and sacrifice of the nation's young warriors.[38] Many of these films focused on the exploits of naval aviators.

Weep People of Japan: The Last Pursuit Plane (1956), directed by Hiroshi Noguchi, told the story of naval pilots who took part in the 'Kamikaze' operations, the suicide attacks on American warships in the final stages of the war. The same theme was explored in *Wings Of the Sea* (1962), and the 1963 feature *Attack Squadron* was based on the exploits of the elite navy fighter group led by Minoru Genda (the architect of the attack on Pearl Harbour) to defend Japan from the Allied invasion. The Mitsubishi A6M Zero, the most famous carrier-based fighter aircraft of the Japanese Navy, would appear to have developed a mythology of its own. As William Green has pointed out,

> To the Japanese, the 'Zero-Sen' was everything that the 'Spitfire' was to the British nation. It symbolized Japan's conduct of the war, for as it fared, so fared the Japanese nation . . . It created a myth – the myth of Japanese invincibility in the air, and one to which the Japanese people themselves fell as a result of the almost total destruction of Allied air power in the early days of the Pacific war . . . Its successive appearances seemed to indicate that Japan had unlimited supplies of this remarkable fighter, and its almost mystical powers of maneuver and ability to traverse vast stretches water fostered acceptance of its invincibility in Allied minds.[39]

It is not surprising, then, that the Zero became the visual symbol for a number of Japanese films. *Zero Fighter* (1961), a documentary by Shue Matsubagashi, recounted the story of the famous fighter from the first prototypes, through the heady period where it dominated the Pacific skies, to the later days of the war where it was outclassed by a new generation of Allied fighters. *Zero Pilot* (1976) was based on the autobiography of Saburo Sakai – an almost legendary fighter ace with sixty-four confirmed kills. *Zero* (1984) again told the story of the 'Zero' fighter through the experiences of two young pilots, beginning with their training in the late 1930s, and passing through the years of combat to 1945 when the fliers came to regard the aircraft as a 'flying coffin'. These features are marked by attention to detail and excellent combat sequences which give them a high degree of realism.[40] However, all these features have a somewhat ambiguous quality, condemning the generals who led the nation into war but praising the considerable sacrifice of the young men. As Sakai's final lamentation in *Zero Pilot* explains,

> This story reflects the bitter realities of war. It is a salutary reminder that we must never forget its terrible toll. Too many young men died believing

in their country's God-given right to victory. The prosperous post-war years grew out of the soil of their countless graves. What can they tell us? They remain silent. And in that vast and humble silence speaks an infinite grief.

IV

In cinematic reconstructions of aerial warfare, the scientific-industrial dimensions rarely receive attention; film makers have invariably concentrated on the actions of the air fighters. The Second World War, however, was a notable exception. The 'total' nature of the war meant that the attempts to develop new weapons systems and to counter enemy technological advance were of the first importance. It was also essential that the industrial complex should be capable of mass-producing the new weapons needed for the war in the air. Thus, for the first time, popular cinema focused attention on these areas: a demonstration that the scientific community were developing new weapons that would bring victory one step closer and that every sector of the nation was playing its part.

A number of films were devoted to new types of aircraft and their equipment. As we have seen, even in the late 1930s, the American Army Air Corps were more than willing to allow film makers access to the new B17 Flying Fortress for features such as *Test Pilot* or news documentaries like *Soldiers With Wings*. Equally important was the top secret Norden bombsight, the tool which would allow the bombers to 'drop a bomb into a barrel from 20,000 feet', as Chick Davis claimed in *Bombardier*. In fact, so successful was this bombsight, that film makers made great play about the enemy's attempts to steal it. In *Joe Smith — American* (1942), Joe is a patriotic aircraft factory worker chosen to install the bombsight on new aircraft. Having been told that this is the one 'secret weapon in the world that . . . may make the difference between defeat or victory', Joe isn't surprised to be kidnapped by Nazi agents and tortured to reveal the secret. The same year saw the release of *Sherlock Holmes and the Secret Weapon*. This suggested that enemy agents had stolen the sight but Washington hires the famous detective to recover it — which he does. Enemy agents, of course, were always at work, setting fire to aircraft factories (*Saboteur*, 1942) or attempting to steal the latest American bomber (*Batman*, 1943). The British didn't have the Norden but the Germans were eager to get the new RAF equivalent. *Cottage to Let* (1941), directed by Anthony Asquith, detailed how an enemy agent, disguised as an RAF fighter pilot, tries to steal the instrument from its eccentric inventor.

The scientist who develops this bombsight is typical of the way in which technologists were (and still are) portrayed in popular film. Leslie Howard's interpretation of Spitfire designer R. J. Mitchell, in *First of the Few*, is of a

dreamy idealist who forgets to eat, goes without sleep for days on end and is generally considered rather 'odd' by the hearty RAF types he deals with. Even in the 1954 film *The Dam Busters*, aircraft engineer and inventor of the 'bouncing bomb', Barnes Wallis (Michael Redgrave) is first seen with his children shooting golf balls into a bath of water and measuring the 'bounce'.

Redgrave's Wallis has all of Mitchell's eccentricities as well as excessive modesty. This ineffectual, bumbling appearance, of course, masks the real talent and dogged determination of the inventor. In British films, the scientist-technologist, the 'Boffin', was a curious hybrid of far-sighted genius and childlike selfishness. As one of these strange creatures (John Laurie) observes in *School for Secrets* (1946), 'There's a large element of childishness in every scientific worker'. *School for Secrets*, written and directed by Peter Ustinov, told the story of how a small team of scientists, working for the Air Ministry, had used radar to develop navigational aids for the bomber offensive. But the Boffins also produced a number of aircraft types which were eulogised in film and which have became part of the mythology of the war.

The Supermarine Spitfire fighter came to symbolise the spirit of British resistance in 1940, particularly through its constant exposure in newsreel reports, Battle of Britain documentaries and in the fictionalised and very popular story of its creation, *The First of the Few*. Equally important, and a powerful symbol of Britain's determination to go on to the offensive, was the Avro Lancaster, the 'Lanc', the most successful of the four-engined heavy bombers. The Lancaster became operational in early 1942 and rapidly became the mainstay of the bomber offensive. Like the Spitfire, the Lancaster was regularly featured in newsreels, and in 1943, Movietone, for the Ministry of Aircraft Production, released *Sky Giant* – a documentary showing how the bomber was built and its effectiveness in night bombing operations. But the most elaborate film tribute to a single aeroplane was perhaps *Mosquito*, produced by the De Havilland Company Film Unit and released in 1946. After a brief history of the company, the film shows how, in early 1940, designers developed the revolutionary concept of a cheaply produced bomber as fast as any fighter – the 'Mosquito'. There follows a detailed review of how factories were retooled to produce the aircraft and the many roles which it performed in its wartime career, from low-level precison bomber to night fighter and high-altitude photo-reconnaissance. The film ends with a tribute to the scientific community who 'serve the needs of the hour. When the need was destruction, British engineers accomplished this with unequalled efficiency and economy'. However, De Havilland also had their eye on the future re-emergence of civil aviation when they added, 'Happier chapters will

be written when the same skill is directed once again to the constructive purposes of aviation'. Such successful aircraft types, however, were of little use unless they could be manufactured in vast numbers. Consequently, a whole series of documentary and feature films were produced that showed British industry doing just that.

The dramatised documentary *Jane Brown Changes Her Job* (1942) has Jane working in an office when she sees an advertisement for industrial workers – an RAF pilot asking for 'planes and bombs'. She retrains and becomes one of the work force producing parts for the Spitfire. The film ends with Jane and her fellow workers watching a completed fighter being wheeled out of the hangar and test flown: 'As it flew off I felt that I was answering that pilot in the advertisement: helping to give him and the rest the planes they need.' Edgar Anstey's *Speed Up On Stirlings*, made the same year, showed the complexities of assembling a heavy bomber; again work largely performed by female labour.

One of the most interesting of this type of film was the 1943 Ralph Elton production, *Workers' Weekend*. This tells the story of a group of workers who give up their weekend to build a bomber, a Wellington, in record time. Starting early on Saturday morning the aircraft is finished and test flown in 24 hours 48 minutes. The same determination was explicit in feature films which explored the subject. *Millions Like Us*, made in 1943 by Gainsborough, had Patricia Roc as Celia Crowson, called up for industrial work and sent to an aircraft factory. Initially resentful, Celia soon realises the importance of her work and becomes one of the 'millions' doing her part for the war effort. American studios produced several features on the same lines. *Wings For the Eagle* (1942) was the story of a group of workers in the Lockheed factory at Burbank, California. The film was made in documentary style in the plant, and Lockheed were anxious to show that the presence of a film crew had not interrupted production and placed an advertisement in the September 1942 issue of *Flying* magazine to point this out. *Swing Shift Maisie* from MGM the following year was another chapter in the adventures of showgirl Maisie (Ann Sothern). This episode had her working on the assembly line producing P38 fighters and falling for the company's test pilot. These films, of course, were primarily made to encourage women into the war industries. Nevertheless, they do also reveal something of the enormous industrial base required to wage a major air offensive.

Perhaps the most dramatic German technological advance was the development of the rocket engine adapted for the V1 'flying bomb'. Flying bomb attacks on England began in June 1944 but by August most of the primary launch sites had fallen into Allied hands. The V1 was, nevertheless, a

terrifying weapon and its deployment constituted virtually another 'Blitz'. In late 1944 Humphrey Jennings produced *Eighty Days*, a short film which revealed how the British had coped with this attack. However, the films which demonstrated the Allied counter-offensive to Hitler's V weapons came later. *Battle of the V1* (1958) was a cheaply made but effective feature showing how Polish workers employed to build the launch sites had smuggled information about the new weapon to London and their attempts to sabotage the rockets. Far more spectacular was *Operation Crossbow* (1965) with George Peppard, Jeremy Kemp and Sophia Loren. This tells the story of both the V1 and V2 and of the fictional Allied agents who infiltrated the German work force to sabotage the German effort. Almost total nonsense, the film is interesting for Trevor Howard's portrayal of Professor Lindemann, Churchill's scientific adviser, and the reconstruction of Hannah Reitsch's test flight of the V1.

However, the most far-reaching development in aerial warfare during the Second World War was the creation of the atomic bomb, the weapon which finally fulfilled the fantasies of the air power theorists: the means of delivering the massive strike against an enemy that would shock them into surrender.[41] The atomic bomb was first used against the Japanese city of Hiroshima on 6 August 1945, yet despite its unprecedented destructive capability a second city, Nagasaki, had to be destroyed before Japan finally surrendered. Hollywood began to exploit the dramatic potential of the bomb almost immediately. *The First Yank into Tokyo* (1945) had Tom Neal as an American officer who undergoes plastic surgery in order to penetrate a Japanese prison.

His mission is to rescue a captured scientist who has knowledge vital to the completion of the bomb. The film was originally intended to be about a newgun, but was re-shot to take advantage of the events leading to the Japanese surrender. The following year, Fritz Lang's *Cloak and Dagger* had Gary Cooper infiltrated into Nazi Germany to contact an atomic scientist sympathetic to the Allies. However, the first film to tell the story of the bomb's development and the attack on Hiroshima came in 1947 with the release of MGM's documentary-style feature *The Beginning or the End*.

Producer Samuel Marx went to considerable lengths to ensure accuracy, even arranging a meeting with President Harry Truman in order to achieve an authentic portrayal of the final conference where the decision to use the bomb was taken. Yet despite this attention to detail, the film still includes two fictional romantic entanglements which were entirely inappropriate and which reduce to story to the level of 'soap opera'. In 1952, MGM tried again. *Above and Beyond* focused on Colonel Paul Tibbets, the pilot of the B29 *Enola Gay*

which dropped the Hiroshima bomb. Tibbets was commander of the 509 Bomb Group and the film concentrates on his efforts to select and train the crews for the mission.

The year 1980 saw yet another version, *The Enola Gay*, again focusing on Tibbets (Patrick Duffy). However, where *Above and Beyond* had unquestionably accepted America's development and deployment of the bomb as a military necessity, *Enola Gay* goes to some length to justify those decisions.

The film opens with an interesting prologue designed to absolve the men who dropped the bomb from any possible guilt: 'This is the true story of a group of young men who went to war, bravely did their duty, and, in their innocence, changed all of human history'. Perhaps the most striking aspect of this version of the story is the inclusion of a Japanese 'presence' (ignored in the earlier films) with several scenes set in Hiroshima. These focus on General Abehata (James Shigeta), military governor of the city, and are designed to show that it was indeed a legitimate military target and that without the use of the bomb the Japanese military would have fought to the bitter end, thus causing far more casualties, both American and Japanese, than did the bombs. The first point is established early in the film when Abehata addresses his officers, pointing out that the Americans have not yet bombed Hiroshima but that 'it is only a question of time before the Americans recognize that we are a city of millions, a gigantic munitions factory dedicated to the Imperial war effort . . . Every woman and child is a warrior'. The second argument is suggested when Abehata is visited by another general who makes it clear that the military will never surrender, and that 'the army will fight on even when there is no hope'. Interestingly, the film also absolves Emperor Hirohito from involvement in the war, for the same fanatical general tells Abehata that Hirohito never understood the military or politics and wanted only to study marine biology. Clearly, then, he was a tool of the generals! Having retold the story, *Enola Gay* ends with a typical Hollywood homily,

> To the leaders of the Western Allies and the people of a war-torn world, the bomb was a miracle of deliverance. But it was clear that the bomb was also a warning to a world that would never be the same again. The bomb brought peace – but only man can keep that peace.

More recently, Roland Joffe's *Shadow Makers* (1989) has explored the subject from the perspective of General Leslie Groves, military commander of the Manhattan Project. Joffe's claustrophibic film is an interesting study of Groves' fanatical anti-communism and the manner in which he saw the project as a means of enhancing his own career. The scientists of *Shadow*

Makers, particularly the arrogant, ambitious and manipulative Oppenheimer, make an interesting comparison with the gentle, absent-minded and eccentric 'Boffins' so familiar from British productions.

Aviation films dealing with the Second World War not only reinforced popular ideas about the heroism and dedication of the fliers andthe destructive power of the bomber, they also demonstrated the scientific, technical and industrial potential of the nation. The sleek, powerful aeroplane became an important symbol of national achievement. But, by 1945, scientific progress had resulted in the creation of a destructive force of such unimaginable power that, wedded to the aeroplane, it resulted in an atomic nightmare that would haunt the post-war world.

NOTES

1 Harold Nicolson, 24 Sep. 1939, *Diaries and Letters, 1939–1945*, ed. Nigel Nicolson (London, 1967), 36.
2 Harry Watt, *Don't Look At the Camera*, (London, 1978), 129–34.
3 Air Ministry, *The Battle of Britain, August-October 1940* (London, 1941).
4 Clive Coultass, *Images For Battle* (London, 1989), 43.
5 Stephen Pendo, *Aviation in Cinema* (New York, 1985), 175.
6 See Leonard Mosley, *'Battle of Britain', The Making of a Film* (London, 1969).
7 This conclusion is based upon the author's conversations with veterans of the Battle of Britain in 1990–91.
8 For a short history of the AVG see, Ron Heiferman, *Flying Tigers: Chennault in China* (London, 1971).
9 See James Farmer, *Celluloid Wings* (Blue Ridge Summit, Pa., 1984), 219–26, for the film's complex production history.
10 *New York Times*, 20 Nov. 1948.
11 The same misguided belief was applied to the Japanese until Americans met the Imperial Japanese Air Force in combat.
12 On the Tuskegee Airmen, see Stanley Sandler, *Segregated Skies* (Washington, 1992).
13 Thomas Cripps, *Making Movies Black* (New York, 1993).
14 For audience reaction to *The Lion Has Wings*, see Jeffrey Richards, *Mass Observation at the Movies* (London, 1989), ch. 15.
15 Quoted in John Terraine, *The Right of the Line* (London, 1985), 260.
16 Dilys Powell, *Films Since 1939* (London, 1947), 17.
17 Watt, *Don't Look at the Camera*, 152.
18 On the bomber offensive, see Terraine, *The Right of the Line*, and Max Hastings, *Bomber Command* (London, 1979).
19 Coultass, *Images for Battle*, 144.
20 For other interesting aspects of the film, see *ibid.*, 179–82.
21 Nicholas Pronay, 'British Post-bellum Cinema: A Survey of Films Relating to World War 11 made in Britain Between 1945 and 1960', *Historical Journal of Film, Radio and Television*, 8:1 (1988).
22 David Stewart Hull, Film in the Third Reich (Berkeley, 1969), 198.
23 Quoted in *ibid.*, 188.
24 Joseph McBride, *Hawks on Hawks* (Berkeley, 1982), 90–2.
25 Robin Wood, *Howard Hawks* (London, 1969) 99.
26 Richard Schickel, *The Disney Version: The Life, Times and Commerce of Walt Disney* (NY, 1968), 274.

27 James Agee, *The Nation*, 3 July, 1943.
28 *New York Times*, 14 Apr. 1944.
29 Ibid., 18 May 1979.
30 Jeffrey Richards, 'Wartime British Cinema Audiences and the Class System: the case of *Ships With Wings*', *Historical Journal of Film, Radio and Television*, 7:2 (1987), 130.
31 *New York Times*, 16 Nov. 1944.
32 Basil Liddell Hart, *History of the Second World War* (London, 1970), 353.
33 Quoted in Bruce Orris, *When Hollywood Ruled the Skies* (Hawthorne, Calif. 1984), 90.
34 Ibid.
35 *New York Times*, 31 Aug. 1944.
36 Ibid., 18 Jan. 1945.
37 Nimitz was quoted in *New York Times*, 21 Jan. and 10 Feb. 1945.
38 Joseph Anderson and D. Richie, *Japanese Film* (New York, 1960), 267.
39 William Green, *Famous Fighters of the Second World War* (London, 1974), 64.
40 On the 'Zero' films see the interesting article by John C. Fredriksen, 'Teaching History With Video: Japanese Perspectives on the Second World War', *Film and History* 18:4 (Dec. 1988), 85–93.
41 Michael Sherry, *The Rise of the American Air Power* (New Haven, 1987), 301.

7 Post-war, cold war

The year 1945 saw an end to the Second World War but not to international rivalries. Economic competition increased as nations struggled to recover from the war's destructive effects, and the ideological tensions of the cold war added a new dimension to those rivalries. The development of aviation technology was vital in both the civil and military spheres as mankind moved into the age of supersonic flight and nations invested huge sums in order to fly faster, further and higher. In Britain, for example, as David Edgerton has pointed out, 'in the 1950's and early 1960's aircraft were much more than an important element in national and Western defence. They were also a powerful symbol of a new, post-austerity, manufacturing England'.[1] Britain supported technological development on a more lavish scale than any other European nation, yet this fact has frequently been overlooked by those who argue that the nation's story is one of unremitting decline. British aeronautical achievements after 1945 were never sufficiently publicised. Cinema, of course, was only one channel through which an appreciation of these achievements could be disseminated, but until television became commonplace, it was probably the most effective means of mass communication, and a vital element in national propaganda. The aviation film could have been a powerful agent in this respect, yet while the Americans produced some ten major features in the 1950s demonstrating their achievements (and a great many more focusing on aviation and national defence), Britain produced just three! Clearly, then, from the late 1940s Hollywood ruled the cinematic skies.

Why British studios failed to produce features promoting national progress and achievement is not difficult to explain. Lack of investment in the film industry made expensive aviation films almost impossible to produce and when finance was available film makers invariably returned to the wartime exploits of the RAF: the legend of the 'Dam Busters', the exploits of Douglas Bader and so on, pandering to the national obsession with the Second World War – the last great innings of a nation now perceived to be in decline. *The Sound Barrier* (1952) was a notable exception to this pattern and while not the

first film to deal seriously with the consequences of the development of the jet engine (a distinction that goes to the American feature *Chain Lightning* two years earlier), it ably demonstrates what might have been achieved by film makers had its example been followed.

Written by Terence Rattigan and directed by David Lean and starring Ralph Richardson, Nigel Patrick and Ann Todd, *The Sound Barrier* was a story of test pilots set against the struggle to move into supersonic flight. According to Pendo, the origins of the film lay in Lean's fascination with the idea of a 'sound barrier' (the point at which an aircraft flies faster than the speed of sound, 750 m.p.h. at sea level) in the mid-1940s. The director talked to pilots and manufacturers and kept several notebooks of details. He then turned his notes over to Rattigan to be turned into a screenplay.[2] The story opens in the last months of World War Two when RAF fighter pilot Tony Garthwaite (Patrick) marries Susan, daughter of John Ridgefield (Richardson), a pioneer of the early days of flight and now one of England's largest aircraft manufacturers. While visiting Ridgefield, Tony is shown the new jet engine the company are developing: 'It'll do more than win the war,' claims Ridgefield's chief designer Will Sparks (Joseph Tomelty), implying that the engine will open a whole new dimension in the development of aviation. Ridgefield himself calls it the 'engine of the future' and tells Tony that it was invented by an Englishman named Whittle.

When the war ends, Tony becomes chief test pilot for the company and all energies are directed at breaking the sound barrier in the new aircraft the Ridgefield '901'. However, because of the limitations of the machine, that speed can only be attained in a dive, but as the aircraft approaches mach one it is subjected to severe buffeting and the controls stick, making it difficult to pull out of the dive. Tony's wife, Susan (Todd) becomes increasingly concerned at her husband's dangerous job and when she becomes pregnant, Tony takes her to Cairo in a De Havilland 'Vampire' he is delivering to the RAF in order to show her something of the magic of flight – an opportunity for Lean to include a lyrical sequence as the jet flies over Europe at a height of eight miles. In Cairo they meet an old wartime friend, Philip Peel (John Justin), and Tony persuades him to join Ridgefield's as a test pilot. Tony and Sue return to England in the De Havilland 'Comet', then being tested by John Cunningham. This whole sequence demonstrates the romantic aspects of flying and the technical achievements of the British aero industry – the high-speed flight in the 'Vampire' and the 'Comet', the world's first jet airliner. However, landing in England they are greeted by the news that Geoffrey De Havilland, son of the manufacturer, has been killed attempting to cross the sound barrier. This clearly establishes the action of the film as

September 1946. Shaken by De Havilland's death, Tony asks Sparks exactly what happens to an aircraft at he speed of sound. 'I don't know,' the designer replies, 'and no one else does either.' Ridgefield reinforces the point, telling the test pilot that he will be taking a 'voyage into the unknown' that will open up a whole new world. Undaunted, Tony is determined to continue with the test programme and 'beat the Americans' in the new aircraft, the 902 'Prometheus'. However, on his next test flight he is killed – unable to pull out of a dive. Philip takes over the tests and using another 'Prometheus' prototype succeeds in breaking the barrier by playing his hunch that at mach one he can reverse the controls to stabilise the aircraft.

The Sound Barrier explores many of the themes common in the aviation film: the camaraderie and heroism of pilots – Tony's determination to continue the tests after the death of De Havilland, Philip taking over after Tony's death, and the almost ruthless dedication of designer and manufacturer to push back the frontiers of flight. Ridgefield believes himself a man with a vision, determined to conquer the sky and ensure that Britain remains at the forefront of aviation technology. His daughter bitterly complains that this vision has cost the lives of the two men she loved most, her brother learning to fly and Tony in the 'Prometheus'. 'What's the purpose in breaking this barrier?' she asks. 'It's just got to be done,' is the reply. Ridgefield is not insensitive to the human cost of progress but he is realistic enough that it can only be achieved through sacrifice, and thus he shares the vision of Riviere in Night Flight and Geoff Carter in Only Angels Have Wings. Indeed, the final scene, one of reconciliation between father and daughter, takes place in Ridgefield's observatory. The camera pans to the night sky overhead while in the foreground is a model of a futuristic aircraft, its nose pointing to the stars. The film offers a remarkably positive view of British aviation in the late 1940s and early 1950s which Lean creates through a interesting blend of reality and invention. The 'Prometheus' is actually the Supermarine 'Swift', believed at the time to be the state of the art fighter. However, the machine saw only limited service with the RAF because of design problems. But its powerful, streamlined shape made it an ideal visual symbol for the future of aviation. The use of the 'Comet', however, is curious. The aircraft made its first flight in 1949, yet Lean uses it in a scene which he establishes, through De Havilland's death, as 1946. Certainly, the 'Comet' was being tested during the film's production and one can only assume that the director included it to promote national interests. It is also interesting that the impression given in the film is that it was indeed a British aircraft that first broke the sound barrier, yet in reality it was the American pilot Chuck Yeager who first achieved this in October 1947.

The film, however, reinforces the idea that in the age of supersonic flight a pilot needs both skill and intellectual ability to fly. Tony is a 'seat of the pants' pilot; 'he hasn't got it up here,' says Sparks to Ridgefield tapping his forehead. 'That's what a pilot needs nowadays, brains and imagination.' Philip has those qualities. Thus, in the final test, he is able to draw upon his wartime experiences diving a 'spitfire' at high speed and 'feeling' that he could reverse the controls to pull out. *The Sound Barrier* is an interesting mixture of technical explanation, patriotism and drama; popular with audiences it drew a mixed response from reviewers who criticised the lack of human emotion: 'the flying sequences, above all the effective introduction before the credits, convey a genuine fascination with the material . . . This is a machine age film, remote in its human fictions, released and free only in some striking aerial images'.[3]

The following year Two Cities released *The Net*, directed by Anthony Asquith and starring James Donald, Herbert Lom and Robert Beatty. Set in a top secret government research station, 'Port Amberley', a team of scientists led by the arrogant Michael Heathly (Donald) have developed a delta-winged jet aircraft capable of supersonic flight. The 'M7' and the centre are subject to tight security that irks Heathly; 'it's like living in a nice safe net,' he complains to the director. The "M7" has been developed to explore the upper atmosphre and pave the way for the 'M8' which will be used for the exploration of space. The 'M7' is more than just a machine', Heathly tells his wife, repeating the old utopian vision of aviation, three times faster than the fastest supersonic aircraft, it will shrink the world, bring nations closer together and persuade people to trust each other. But such optimism is misplaced, for a foreign agent has already infiltrated Port Amberley and lmost succeeds in hijacking the aircraft on a test flight. His nationality is not revealed but we are given a clue when he orders Heathly at the point of a gun to 'steer due east'. *The Net* is essentially a thriller owing a great deal to contemporary cold war tensions, but interestingly it still pays homage to the notion of progress and utopianism through aviation and suggests that Britain is in the forefront of space research.

The international tensions of the 1950s were also reflected in the 1954 production *Conflict of Wings*. In this comedy-drama, the Air Ministry attempt to take over a marshland bird sanctuary as a firing range for an RAF fighter squadron converting to a ground attack role. The film concentrates on the struggle of the local villagers to frustrate Ministry plans and save the sanctuary. *Conflict of Wings* does, however, raise some interesting issues. The squadron commander (Kieron Moore), defending the Ministry's decision, tells the villagers that the RAF is not commandeering land for fun, that

'men and aircraft must always be prepared' if they are to defend the nation and commonwealth. If cat, the squadron have only four weeks to retrain before being sent to Malaya for operations against communist guerrillas. The villagers eventually win their battle but the film does highlight the issue that national defence has its price – the RAF have to train somewhere if it is to be prepared for a national emergency. *Conflict of Wings* is one of those rare occasions where the central character is an NCO-mechanic and not a flying officer. Films about the RAF, when they did feature ground crew invariably showed them as bumbling incompetents spreading mayhem (George Formby in *It's in the Air* (1938) or Kenneth Connor in the 1961 feature *Nearly a Nasty Accident*) or as silent but loyal underlings preparing the aircraft for a warrior elite (perhaps best exemplified by the character Flight-Sergeant Smythe (Ewan Solon) in *The Dam Busters*). By contrast, *Conflict of Wings* presents us with a fully developed characters.

High Flight (1957), directed by John Gilling and featuring Ray Milland and Kenneth Haigh, deals with the training of pilots at the RAF academy at Cranwell. While the film is an interesting portrait of the RAF in peacetime, the writers revert to the well-used story of the cadet who is a talented pilot but who lacks discipline. Almost washed out of the training programme, the cadet (Haigh) redeems himself by saving the life of his senior officer (Milland). Having leaned the need for teamwork and discipline in the air, haigh goes on to become a member of an RAF aerobatic team. *High Flight* provides a showcase for Britain's air defence capability in the cold war era and aviation technology using footage shot at the 1956 Farnborough Air Show.

There was also an attempt to revive the civil aviation documentary promoting aviation and its importance within the Commonwealth. In 1947 John Eldridge produced *Three Dawns to Sydney* for British Overseas Airways Corporation, a celebration of their new direct UK–Australia route. This was followed by *They Travel By Air*, a BOAC documentary extolling the comfort and speed of air travel. *Sky Traders* (1952) was the last British documentary film to feature civil aviation. Concentrating on a day at a busy international airport, it shows something of the variety of goods being transported by British air services – a revealing and nostalgic picture of the last days of piston-engine civil aircraft.

The first Soviet film to deal with jet flight was made as early as 1946: *Our Heart*, directed by Alexander Stolper, was a fictionalised account of a Russian engineer who, during the war, determined to revolutionise Russian aviation by developing a new, and more powerful engine. So successful is his work that the climax of the film is a non-stop, round the world flight by a Soviet jet aircraft. In 1963, Tatiana Lioznova's *Masters of the Skies* suggested that the

invention of the jet engine really began in Russia in the mid-1930s developed by engineers preparing for the coming war with the forces of Fascism. However, the main focus of this film was the dedication of the test pilots who flew the first protoypes. Test pilots also provided the subject matter for *His Aim in Life* (1957) and *The Sky and I* (1974). While these films suggested that Soviet jet research pre-dated the Second World War, the truth was that the authorities only instigated research into jet propulsion at the beginning of 1945 and the first Russian jet plane did not fly until April 1946.

In the post-war years, film makers also looked back to glorify the early years of Russian aviation. In 1950, Pudovkin produced a film biography of Nikolai Zukovsky, the academic who defined the laws of aerodynamics. Called simply *Zukovsky*, the film was a mere glorification of Russian achievement in the air. Zukovsky was also the subject of the 1972 documentary by G. Chubakova, *The Father of Russian Aviation*. Alexander Gendelstein's *First Wings* (1950) told the story of the first Russian aviator Alexander Mozhaisky, while the feature film *Death Loop* (1962) was a fictionalised account of the lives of Sergei Utochkin and Pyotr Nestorov. The 1979 epic *Poem of Wings* was a co-production with East Germany and France and told of the celebrated aircraft builders Igor Sikorski and Andrei Tupolev. *Flight Over the Atlantic Ocean* (1983) from the Lithuanian Film Studio, reconstructed the 1933 flight by Daris Styapone and Stasis Trenas from the United States to Lithuania. Following the successful launching in 1957 of 'Sputnik' One, the first satellite, Soviet film makers produced a number of films about the 'Father of the Space Age', Constantine Tsoilkovski. The 1958 feature film *The Man From Planet Earth* is perhaps the most well-known. The 1975 documentary by Lev Kulidzanov, *Minute of Glory*, told the story of Russian aviation from the early days of flight to the dawn of the space age. Few Soviet films after 1945 dealt with military aviation and when they did, the focus was usually on events of the Great Patriotic War. Only one feature about contemporary military flying appears to have been made, *Rough Landing* (1985), a story of the training of Naval pilots.

Few other European nations made aviation films, but Sweden has produced three, the first in 1945, *Three Sons Joined the Air Force* told the story of the Hallman brothers, all of whom became Air Force test pilots. The actor Stig Olin, who played the youngest Hallman, went on to direct *The Yellow Squadron* in 1954. The film was really a promotion for the SAAB J29 jet fighter, the first swept-wing jet to enter service in Europe, and of the Swedish Air Force's determination to defend their air space aginst foreign intrusions. Given Sweden's geographical position, on the front line of the Iron Curtain, it is not surprising that film makers should produce features which demonstrated the nation's resolve to defend herself. *We Head for Rio* (1949)

was a Norwegian-Swedish co-production which examined the stress on flight crews operating the newly instigated passenger routes from Scandinavia to South America. While it was a well-made feature, *We Head for Rio* included all the usual ingredients of the airline drama. However, in the post–1945 world, it was the American film industry which continued to dominate the aviation movie genre.

<div align="center">II</div>

The attempt to move into supersonic flight, the prelude to the exploration of space, has often been interpreted as an American epic – the determination of man to cross the 'final frontier' and free himself from earthly ties: the ultimate chapter in the story of America's 'manifest destiny'. Like most American epics, the achievement of supersonic flight in the years after 1945 has been shown in film as the quest of the individual, the heroic test pilot, the dedicated engineer, taking up the challenge on behalf of the nation. Yet, in America, the 1950s and 1960s were the decades of the 'organisation man' – the drab conformist in the Brook Brothers suit, in pursuit of material betterment and desperately afraid to show individualist tendencies. Against this background, the hero of the jet age, the last individualist, had an obvious appeal – the nostalgic reminder of a glorious individualistic past. If this is accepted, it helps to explain why aviation features continued to enjoy such commercial success. Another factor for their popularity was, of course, that these films demonstrated American technological advance in an increasingly dangerous world, where failure to progress was perceived as allowing the 'enemy' to become dominant.

Warner Brothers produced the first major production about jet flight, *Chain Lightning*, in 1950, with Humphrey Bogart and Raymond Massey. Like the later British feature *Sound Barrier*, *Chain Lightning* also opens in the last year of World War Two. Matt Brennan (Bogart), a B17 pilot, takes part in the strategic bombing of Germany. During one mission, we catch a glimpse of the future of aviation when the formation of bombers are attacked by a German Me 163 rocket-propelled aircraft – a scene which uses USAAF combat footage. After the war, Brennan is hired by Leland Willis (Massey), an aircraft manufacturer producing a new generation of military aircraft. Brennan's job is to test the new jet fighters and convince the authorities that they are the machines of the future. After an epic flight to the North Pole, which breaks all existing records, the air force orders the aeroplane. Bailing out of a high-speed jet was a dangerous undertaking and the company are also developing an ejector-seat. When the designer is killed testing this, Brennan unofficially takes up a second prototype and successfully operates

the escape pod. Brennan, having been at the sharp end of war, wants to ensure that military pilots have the best possible chance if forced to bail out. *Chain Lightning* skillfully resolves the contradiction between the need for team effort and individualism. The new fighter is designed by a team but it can only be flown by one man – thus even in a conformist society the individualist is still needed, especially when those skills serve the air force and the nation. The screenplay for this patriotic saga, advertised as the 'Screen's Biggest Bolt of Bogart', was Lester Cole, one of the 'Hollywood Ten' who had been accused of anti-Americanism by the House of Un-American Activities Committee. *Chain Lightning*, however, was not the first feature to deal with jet testing. That distinction belongs to the little-known 1946 film, *Johnny Comes Flying Home* – the story of an air force veteran who, in order to finance his own air freight line, takes a job testing jet fighters. However, it was *Chain Lightning*, an expensive production with major stars, that established the pattern for future films.

Edwards Air Force Base and thew Bell X2 provided the setting for the next Warner Brothers feature, *Towards the Unknown* (1956). The X2, flown by Colonel Everest, established a world speed record of 1,900 m.p.h. in September 1956, and paved the way for exploration of the stratosphere. In the film, the test programme is flown by William Holden playing the fictional pilot Lincoln Bond. The film, competently directed by Mervyn Le Roy and making use of considerable documentary footage, tells the story of the X2 from original design to its record-breaking flight. *Towards the Unknown* can be seen as an introduction to United Artists 1961 semi-documentary *X15*. The X15 was built by North American Aviation as a hypersonic recket-propelled research vehicle which would lead to the development of an orbital aircraft. Operated by the newly created National Aeronautical and Space Administration, the X15 first flew in 1959 from Edwards AFB. The aircraft reached speeds in excess of mach six at a height of over 200,000 feet.[4] Narrated by James Stewart, *X15* focuses on the training of the test pilots who flew the record-breaking missions (Charles Bronson and Ralph Teager). Despite superb aerial photography and the co-operation of NASA and the USAF, *X15* was not the commercial success Universal expected. As the Russians had put a man into space just months before the film's release, *X15* was perhaps something of an anticlimax. American rocket technology owed a great deal to the work of German scientists recruited at the end of World War Two. The most well-known was Wernher von Braun, creator of the V2. His story was told in a dreary and highly sanitised film biography from Monogram, *I Aim At the Stars* (1960), with Curt Jurgens playing the scientist.

The story of the development of supersonic flight, from Chuck Yeager's

breaking of the sound barrier to the last Mercury 7 flight in 1963, formed the basis for United Artists' *The Right Stuff* in 1983 and adapted from Tom Wolfe's best-selling book. In 1979 William Goldman was approached to produce a screenplay from the Wolfe book. As he later noted, 'I wanted to say some-thing positive about America. Not patriotic in the John Wayne sense, but patriotic none the less'.[5] Wolfe begins his book with the Yeager flight of 1947 but then moves on to the selection and training and eventual flights of the astronauts. Goldman's original script used only the material about the second phase. Having completed his script, Goldman found that director Phil Kaufman disagreed about what should be the main focus and wanted to include the Yeager material. As Goldman pointed out, by using the story of the astronauts, 'I wanted to say, using them as a vehicle, that America was still a great place . . . What Phil wanted to say was that America was going down the tubes. That it had been great once, but those days were gone'.[6]

Kaufman believed that Yeager was a great flier, the last outstanding individual. He saw the astronauts as 'mechanical men' with little real ability and their machines controlled for them by ground technicians. Faced with these major differences, Goldman withdrew from the project and the script was completed by Kaufman. The final version includes both the Yeager material and the Mercury missions which, in sense, actually createstwo films artificially welded together. Originally Kaufman may have wanted to comment negatively on America, but the completed film comes across as a glorification of the space programme and the bravery and dedication of the early astronauts – men who had the 'right stuff'. This tone was identified by Curtis Hutchinson's review,

> According to Tom Wolfe . . . test pilots need a special indefinable quality called the 'right stuff' to push themselves and their machines to the limit. America's first astronauts, recruited from the ranks of test pilots, risked their lives as a matter of course. This film is quite unashamedly about their courage.[7]

But alongside these major productions, the studios also made a number of lesser features which dealt with the subject of jet aviation. *Jet Job* (1952) was a routine story of test pilot Stanley Clements refusing to follow orders when testing a new jet. After various complications, Clements is vindicated and the air force gets its new fighter. Universal had Jeff Chandler play a test pilot in *Stranger In My Arms* (1958) – a slight tale of a pilot involved with his best friend's wife. *Here Come the Jets* (1959) starred Steve Brodie as an alcoholic Korean veteran given a second chance as a test pilot by kindly aircraft manufacturer John Doucette. The television series *Steve Canyon* (1958–59),

based on the comic strip by Milton Caniff, had Dean Fredericks as Canyon, an air force troubleshooter solving problems, catching spies and testing new aircraft. The military provided considerable assistance with the filming and saw the show as an aid to recruitment. Other areas of research covered in aviation films included the more serious *On the Threshold of Space* (1956), a documentary-style feature which explored the problems of high-altitude flight. Starring Guy Madison and John Hodiak, the film was based on the career of Colonel Frank Stapp, a USAF medical researcher. The Air Force's Research and Development Command was the subject for *Bailout at 43,000 Feet* (1957). Based on a CBS documentary entitled *Climax* of the same year, the film dealt with the development and testing of ejector seats for the B47 jet bomber. *Top of the World* (1955) focused on the establishment of Air Force weather stations in the Arctic, and *Slattery's Hurricane* (1949) had Richard Widmark as a navy weather pilot tracking a hurricane and reminiscing about his life in aviation. Widmark also starred in *Flight From Ashiya* (1964), an American-Japanese co-production about the USAF Air Rescue Corps.

The training of air force jet pilots was dealt with in *Air Cadets* (1951) from Universal. The film follows the careers of three cadets (Alex Nicol, Richard Long and Robert Arthur) at Randolph AFB from selection to being chosen for the 'Acrojets', an USAF aerobatic team. The feature offered little that was new and, indeed, owed a considerable debt to the earlier *I Wanted Wings*. Rex Reason played a Korean veteran, too old to fly in combat and relegated to a training school in *Thundering Jets* (1958). Bitter at this posting, Reason takes out his resentment on cadets and instructors alike. However, when he saves the life of a young pilot, he realises just how vital his job is. Ingredients from both films were featured in the 1981 television film *Red Flag: The Ultimate Game*, starring William Devane and Barry Bostwick. This details the training of fighter pilots at Nellis AFB, Nevada. The climax is provided by the war games exercise at the end of the course.

A new development in aviation after 1945 was the helicopter – the machine which has enabled the vision of 'air control' to become reality. While the helicopter has become a common image in modern war films only three features have explored the use of these versatile machines as a means of social control. *Blue Thunder* in 1983 was the first. Roy Scheider plays a police pilot, a Vietnam veteran still suffering from the traumas of combat. Given the job of evaluating 'Blue Thunder' – a super helicopter equipped with the latest anti-crime surveillance equipment and heavily armed – he uncovers a plot by the machine's designer to provoke urban riots and use 'Blue Thunder' to put them down, thus proving the effectiveness of his machine. Scheider, of course, reveals the plot and saves the day. The

film's success was due to the visually exciting photography and the novelty of the machine but it also gained exploited fears about crime and paid homage to the veteran 'genre'. ABC ran a television series based on the film with James Farentino in the lead. However, this proved less than successful and was cancelled after only three months.

Nevertheless, it inspired *Airwolf* (1984), a far more successful series. 'Airwolf' was 'Blue Thunder' updated and with even more sophisticated hardware. Flown by Vietnam 'ace' Stringfellow Hawke (Jan-Michael Vincent) the machine took on an impressive array of villains – Vietnames Communists, Libyans, drug dealers and assorted criminals. In the pilot for the series, 'Airwolf's' designer sells it to the Libyans and the CIAhire Hawke to steal it back. Hawke, having recovered the helicopter, decides to keep it until the government locates his brother, a Vietnam MIA (Missing in Action). He does, however, perform selected missions for the 'organisation' which provide the stories for the subsequent episodes. Focusing on pilots rather than machines, *Wings of the Apache* (1990) did nevertheless feature the Army's super helicopter the AH64 'Apache'. The film dealt with military pilots attached to the Drugs Enforcement Agency at war with drug barons in South America. Although this promoted the government's efforts to control the drug problem, the film includes many of the clichés of aviation film genre: Nicholas Cage as the inspired but individualistic pilot; Tommy Lee Jones as the experienced unit commander who teaches him the meaning of discipline; and Sean Young as a woman pilot afraid of emotional entanglements as these might interfere with her flying career.

III

Aviation began to play a significant role in the cold war in July 1948, when the Soviets blocked the road and rail routes into the western sectors of Berlin in an attempt to force the Allies out of the city. To hold on to their sectors, an Anglo-American air supply operation began, the 'Berlin Airlift', which kept West Berliners supplied with food and fuel until the Russians eventually lifted the blockade. A number of feature films were made which used the airlift as background, but only one, *The Big Lift* (1950), dealt with the operation. Directed by George Seaton and starring Montgomery Clift and Paul Douglas, the film was made on location in Berlin in the winter of 1949– 50. The script had to be approved by all four of the occupying powers before filming could commence and although the Russians were initially hostile, they eventually agreed. Even so, the film crew were frequently harassed by the Young Communist League, who resented their presence. The story concerns two airmen, the young Clift, who falls for a German woman,

and the veteran air traffic controller Douglas, who hates Germans but who gradually comes to admire their fortitude under the blockade. The film made use of some interesting documentary footage of the airlift in action, and made its political points – unpleasant Russians, German who are really good democrats at heart – in an understated way. But it was the issue of the air defence of America that really preoccupied film makers in the 1950s.

National defence and security through deterrence became a major issue in America in the period 1950–65. As Joanne Brown has noted, 'when the Soviets detonated an atomic bomb on August 29, 1949, and subsequently demonstrated their ability to deliver such a bomb to the American mainland, Americans lost the illusion of safety'.[8] Such fears were manifested in a number of ways, not least in popular films. *I Want You* (1951), for example, Mark Robson's drama about the effects of the outbreak of the Korean war on a small Midwestern town, begins with an aerial shot of the town and a narration by Dana Andrews explaining, 'Down below is the town I live in. This is the way it would look around seven o clock on a clear evening to a bird, or to a bomber pilot straightening out for his run over the target.' One response to this new threat was a government-initiated civil defence programme under the newly created Federal Civil Defense Administration. But the most effective means to allay public concern was to demonstrate American ability to counter the Soviet air threat with the promise of massive retaliation delivered by the USAF Strategic Air Command (SAC). As one fictional general in the 1957 film *Bombers B52* put it, 'It is the job of a successful general in the nuclear air age to prevent wars; to prevent wars through superior long-range nuclear air power ready to take off at a moment's notice.' As we have seen, popular cinema was the most effective means of mass communication before the widespread use of television and in the period 1947–65, 'the American film industry was actively solicited by the US government to make commercial films that pointed out the dangers of communism'[9] and, we might add, to calm public fears about the danger of aerial attack by demonstrating SAC's massive retaliatory capabilities. It is not surprising, then, that a numer of major feature films were made that focused on the USAF as the first line of national defence.

The cycle began with *Strategic Air Command* in 1955. This film dealt with two major themes: dedication to duty and the introduction of the Boeing B47 'Stratojet' – the air force's first jet bomber. The film had its origins in actor James Stewart's interest in SAC. Having flown twenty-five combat missions as a B24 pilot during the Second World War, Stewart retained an interest in the air force. During a conversation with Curtis LeMay, SAC Commander, the actor became convinced that the Command was the 'biggest single factor

in the security of the world',[10] and persuaded Paramount to make a film that would demonstrate that fact. At that time SAC had just re-equipped with the B47 and the service was more than happy to collaborate on a feature that would promote their work and the new bomber. The story concerns 'Dutch' Holland (Stewart), a World War Two veteran who has returned to major league baseball for his 'last few good years'. However, he is persuaded to return to duty by an old friend, now an SAC general. Initially, Dutch feels he has 'done his share' and resents being asked to return, but an appeal to patriotism persuades him. At Carswell AFB, where the pilot reports for duty, a sign at the entrance to the base sums up the film's message, 'The Nation And Your Security Are At Stake'. When Dutch catches his first glimpse of a B47 he exclaims, 'she's the most beautiful thing I've ever seen in my life'; beautiful but deadly, for as a general later explains, 'A B47 with a crew of three carries the destructive power of the entire B29 forces used in World War Two.' However, all is not well, for Stewart's long-suffering wife (June Allyson) is pregnant and wants a husband with a normal job who stays home in the evenings. When Dutch tells her he is staying on in the air force, she is less than pleased arguing that there isn't even a war on. 'But there is a kind of war on', Dutch replies, 'We've got to stay ready to fight without fighting – and that's harder.' Eventually she becomes reconciled, and Dutch does his duty in preparing his B47 crews for combat readiness. Beautifully filmed using the VistaVision process and tightly directed by Anthony Mann, the film was considered by many critics to be one of the most visually exciting aviation features ever made.[11] In propagandist terms, *Strategic Air Command* must rank as among the most effective films extolling the virtues of the USAF and a revealing example of the corporate-liberal style of 1950s film-making.[12]

In the same year, Warner Brothers made a thirty-minute public service documentary for the USAF, *24 Hour Alert*, narrated by actor Jack Webb. The film was designed to explain to the public why so much jet activity was taking place (the mid-1950s witnessed a dramatic increase in complaints about low-flying aircraft). The film's message was basically that it is better to be disturbed at night by a friendly jet overhead than never to wake up at all because of an enemy air attack. In major cities, *24 Hour Alert* was shown on the same programme as Warners' major feature about military aviation history, *The Court Martial of Billy Mitchell* (see below).

The second major feature dealing with SAC came in 1957, again from Warners, *Bombers B52*, with Karl Malden, Efrem Zimbalist Jr. and Natalie Wood. Again the dual themes were duty and new aviation technology – this time in the shape of the B52 'Stratofortress'. Unusually, the film takes as

its central character an enlisted man, the line-chief Sergeant Chuck Brennan (Malden). Brennan is based at Castle AFB 'Home of the B47'. A new base commander arrives, Colonel Jim Herlihy (Zimbalist); he is an old antagonist of Brennan, a man the sergeant believes is interested only in 'glory and women'. Herlihy's job is to prepare the base for the new B52 bombers and he desperately wants Brennan to stay on. The sergeant, however, under pressure from his wife and daughter (Wood), decides to retire and take a well-paid job in industry. He does agree to stay on and see through the conversion. At training school he is told the B52 is the

> biggest jet bomber in the world: it can reach any target, it can fly at over 600 mph at eight miles high and over 6000 miles without refuelling . . . Just one of these airplanes, just one, can carry greater destructive force than all the bombs dropped by the entire Allied air forces during the whole of World War Two.

The commanding general is less than happy at Brennan's impending retire-ment, 'We stand or fall on maintenance – we need Brennan,' he tells Herlihy, who is virtually ordered to make Brennan stay on. Torn between his desire to please his family and to serve his country, Brennan's life becomes a battle-field, During an argument with his daughter he justifies his job which she has just called 'unimportant':

> I'm a line chief and I'm proud of it . . . Do you know what we have to do every day, every day, to see that they stay up and their crews are safe? We've got to keep our ships and our crews combat ready and when they're ready, no one will dare lay a hand or a bomb on us and maybe some day that'll keep you and your children alive!

During a test flight, the aircraft's radar system catches fire. Brennan and the crew bale out while Herlihy brings the blazing aircraft safely down. Brennan and Herlihy are reconciled when the former realises that Herlihy is a dedicated professional. And Brennan's family realise that he wouldn't be happy anywhere but in the air force and that his job is vital to national defence. The film ends with a massed formation of B52s across a cloudless sky and the dedication to 'Crew chiefs and ground personnel, the indispensable men who contribute so much to our airpower'.

A Gathering of Eagles (1962), from Universal, was the final instalment in what has been called the 'SAC trilogy'. The film lacked the impact of the earlier features, yet it was produced by Sy Bartlett, an air force Reserve pilot and veteran of World War Two, and directed by Delbert Mann, another World War Two aviator. It film deals with the new commander of Carmody AFB

(Rock Hudson), a martinet whose job is to improve efficiency on the base (it has just failed its 'Operational Readiness Inspection') even if it means sacking old friends and ruining his marriage. What the film does show is the state of constant readiness of SAC crews and the high personal cost of being on the front line of national defence. However, in the era of the Cuban Missile Crisis, it was reassuring propaganda. A recurring theme in the film is how it would be impossible for SAC to accidentally trigger a nuclear war – an idea pursued two years later in *Dr Strangelove* and *Fail Safe*. *Gathering of Eagles* lacked the appeal of the earlier SAC features but it did have an effect on its leading man Rock Hudson, who was reported to have said that it was only while filming at Beagle AFB that he realised how important SAC was and not just 'Jimmie Stewart and a big airplane'.[13]

The SAC base at Vandenberg, California, was the setting for the 1971 feature *Lassie: Peace Is Our Profession*, directed by Ezra Stone. This childrens' film has Lassie rescuing a duck from a 'Minuteman' missile launch site, stowing away on a B52 and generally helping out. However, the film does present an interesting picture of the next development of Strategic Air Command – the Aerospace Division. The climax of the film comes when a B52 coming in to land loses power in two engines but the danger is averted by the skill of the crew. The base commander heaves a sigh of relief and the Chaplain, standing next to him says, 'All I know is God is with us, Always.' The final sequence is the base chapel where a stained glass window displays the following prayer,

> Lord guard and guide
> The men who fly
> Through the great
> Spaces of the sky
> Be with them
> Traversing the air in
> Darkening storms or sunshine fair

All this and Lassie too!

Although set in the mid-1920s, *The Court Martial of Billy Mitchell* (1955) should be seen as a part of 1950s concern with air defence. Brigadier-General William Mitchell ranks with Guilio Douhet and Hugh Trenchard as one of the great architects of strategic bombing. As early as 1921 Mitchell demonstrated the potential of air bombardment by sinking the captured German battleship *Ostfriesland* off the Virginia coast. However, his seniors were unimpressed and Mitchell, an outspoken critic of policy, was banished to Texas. It was from here that he battled against the War Department for a big, independent air force, arguing that only air power could really protect the

United States. The crash of the navy airship *Shenandoah* led him to accuse the Navy and War Departments of 'incompetence and criminal negligence and almost treasonable administration'. For this public outburst he was court-martialled and dismissed from the army. The idea of a film biography was first raised in 1942 by RKO but shelved when it was pointed out that airing such a controversy was unwise in wartime. The idea was resurrected in 1955 by Warner Brothers who commissioned Milton Sperling and Emmet Lavery to produce a script and Otto Preminger to direct. Gary Cooper played Mitchell and the film focused mainly on the trial, although flashbacks reveal Mitchell's early struggles to get aviation accepted. Documentary footage of the sinking of the *Ostfriesland* was also included.

At first glance, Mitchell appears to be the archetypal individualistic airman at odds with the organisation – the Army. However, he belongs to a larger team, the nation, and when urged by his commanding officer to play down his criticisms he makes this clear: 'One day, strategic bombing will leave half the world in ruins. I want this country to be in the other half.' And that, of course, was exactly the official SAC view. At the courtmartial, only one senior officer is sympathetic to Mitchell's predictions about the future of airpower – General Douglas MacArthur, but the hierarchy are wrong and the airman's case was vindicated by the events of the Second World War and after. When this film is viewed alongside *Strategic Air Command* and the other SAC features, it becomes obvious that the air force knows best how to defend the nation.

One other curiosity should be discussed here – Howard Hughes' *Jet Pilot* starring John Wayne and Janet Leigh. The film's origins lay in Hughes' love of aviation and his later fervour as an anti-Communist crusader. The story deals with a defecting MIG pilot (Janet Leigh) who flies into Wayne's Alaskan Air Force base. As the American conducts the de-briefing, they fall in love and secretly marry. However, Leigh turns out to be a spy collecting information on the latest American fighters. The government arrange for her to escape and Wayne goes with her, pretending to have become a Communist but really to spy on the Soviets. Back in the USSR, Leigh misses the American way of life and the couple escape in the Russians' latest experimental aircraft. The film was finished in 1951, but Hughes wanted to 'improve it' and consequently 'tinkered' with it until 1956, cutting and and re-editing. In 1957 he persuaded Universal to release it after further editing and the addition of some new aerial footage, including shots of Chuck Yeager stunting an F86 'Sabre'. Poorly received, *Jet Pilot* is nevertheless a fascinating example of Hughes' dual interests and a revealing portrait of American cold war politics.[14]

The Korean War began in June 1950 and provided film makers with new opportunities for profits and patriotism through air war adventures. The USAF was committed to action almost immediately, along with units of the British Fleet Air Arm and Royal Australian Air Force. However, the air war was really conducted by the Americans. During the initial stages of the war, the United Nations had almost complete command of the air but the arrival, in November 1950, of North Korean MIG 15s flown by Soviet and Chinese volunteers added a new dimension.

Hollywood began to reconstruct the air war from 1953 and this resulted in some fifteen feature films made between then and 1958, when public interest began to wane. In some ways, RKO's colour epic *Flying Leathernecks* (1951), the story of a Marine fighter squadron in World War Two, should be seen as the first Korean feature. The film made use of colour combat footage shot in 1950 over Korea and was made partly as a result of Howard Hughes' anti-Communist fervour. However, the first film specifically located in Korea was the 1953 feature *Mission Over Korea* with John Hodiak and John Derek. This dealt with the artillery spotters who flew at low level in unarmed aircraft. *Sabre Jet*, made the same year by United Artists, had only little more interest. Filmed in co-operation with the USAF, the picture was built around the F86 'Sabre', the standard American fighter during the conflict. One element of the weak screenplay dealt with the missions flown by a squadron commanded by Robert Stack. The second focused on his ambitious career-minded wife (Coleen Grey), a newspaperwoman writing about the war. However, when her husband runs into trouble on a mission, she realises it is more important to be a 'wife' than a career woman. *Hell's Horizons* (1955), a cheaply made feature with John Ireland, told the story of the crew of a B29 sent to bomb a Communist-held bridge on the Yalu river. *Jet Attack* (1958) dealt with two fighter pilots shot down behind enemy lines who escape by stealing a Russian jet. On the way, they just happen to rescue a kidnapped American scientist! These features had little to say that was new; most simply reprised situations common from earlier films and were a blatant attempt to profit from public interest in the war.

Somewhat better were *The McConnell Story* (1955) and *The Hunters* (1958). The first was a biographical account of 'triple ace' Joseph McConnell (Alan Ladd) who shot down sixteen enemy aircraft over Korea. McConnell had served as a navigator in World War Two but was so desperate to be a pilot he learned to fly privately. In the late 1940s he qualified as a fighter pilot and served throughout the war. He was killed in 1954 test-flying the F86H. The film, dedicated to the USAF as 'Guardians of the Peace', was premiered in New York and preceded by a parade honouring the Air Force Wives Association.

Made in documentary style, the film is a realistic account of air combat over Korea. *The Hunters* was taken from a novel by James Horowitz, a pilot who had served in a fighter squadron during the Korean War, and based on his experiences. The film deals with antagonism between two pilots, the World War Two veteran Cleve Saville, a cold, remote 'hunter' interested only in building up his score, and the young Abbott (Lee Phillips), a pilot terrified every time he goes into combat. Saville is the old-school individualist, but when Abbott is shot down, it is Saville who belly-lands in enemy territory and helps the younger man home – the loner becomes a team player after all. Directed by the veteran actor Dick Powell, *The Hunters* was a cut above most Korean aviation films. Interestingly, high-tech, jet-age war had little effect on the romantic image of the fighter pilot, for in 1957 when United Artists wanted to explore the problem of miscegenation between American soldiers and Asian women, the studio cast Marlon Brando as a Korean War fighter ace on leave in Japan in the film *Sayonara*.

Features dealing with Naval aviation ranged from the serious and well-made *Bridges at Toko-Ri* (1954) to the studio-bound heroics of *Air Strike* and the overly sentimental *An Annapolis Story* (both 1955), a film about the training of pilots who will finish up in Korea. Holding the middle ground were *Men of the Fighting Lady* (1954) and *Eternal Sea* (1955). The former, owing a great deal to the World War Two documentary *Fighting Lady*, was based on short stories by James Michener and Commander Frank Burns which were welded into a script by Art Cohn. The films deals with the experiences of Grumman Panther pilots serving aboard the carrier USS *Princeton* and flying against targets in North Korea. The film used considerable documentary material and did provide some idea of the scale of naval air operations. *Eternal Sea* from Republic had Sterling Hayden as the captain of a carrier in action off Korea musing about his experiences in World War Two.

However, the most interesting naval aviation feature about the conflict was Paramount's *The Bridges at Toko-Ri* from the novella by James Michener. Directed by Mark Robson, the studio intended the film as a tribute to the United States Navy and particularly the Pacific Fleet. Set in November 1952, it concerns Harry Brubaker, a Panther pilot recalled for service in Korea. Having fought in World War Two, Brubaker resents having to give up his law practice and leave his family to fight another war: 'Why me, again?' he asks the admiral (Frederick March). 'Because you're here,' is the reply, and that is really the film's message. No one wants to fight a war, leave their family and face sudden death far from home. But some men are called and they do the job the best they can. The war is justified by the Admiral's recitation of the 'Domino theory' – that Communist aggression has to be

stopped now or else all Asia will fall – and so Brubaker goes on flying his missions, because if he does not someone else will have to. His squadron are eventually sent against the communist-held bridges at Toko-Ri, key targets on the North Korean supply route to the south, but a heavily defended site. As Brubaker tells his wife when on leave in Japan, the bridges are

> one of the most important targets in Korea and fortified accordingly. Although we're only over the target about 30 seconds, it's a lifetime.
>
> Every gun imaginable is hidden in those mountainsides. The men behind those guns know where we're coming from and where we're headed. We're coming in low and straight, no room to duck or twist

Sitting targets, in fact, for the ground defences.

Ironically, when the squadron carry out the attack they destroy the bridges without casualties, it is only when they attack their secondary targets that Brubaker's machine is hit by shrapnel. Out of fuel, he is forced down behind enemy lines. A rescue helicopter attempts to get him out but is shot down trying to land. Brubaker and the rescue pilot (Mickey Rooney) take cover in a ditch as the Communists close in. Just before the last attack, Brubaker remembers the Admiral's words and says aloud, 'I can see how he's right. You fight simply because you're here.' And so Brubaker, the reluctant warrior, is killed: shot down in a ditch in Korea. Back on the carrier, the Admiral muses on the quality of fliers like Brubaker, 'Where do we get such men? They leave this ship and they do the job. Then they must find us lost somewhere on the sea, and when they find it they must land on its pitching deck. Where do we get such men?' *Toko-Ri* provides an interesting picture of the contribution of naval aviation to the war and of the dedication and sacrifice of the men who fly the missions. These are not 'hot-shot' heroes in love with adventure, but ordinary family men who do the job simply because it is their job. The film also highlights the work of the helicopter rescue pilots. There is little glamour in their work, but it is essential just the same. When Brubaker has to ditch in the China Sea at the beginning of the film, he is rescued by Mickey Rooney's helicopter. Rooney insists on wearing a green top hat when he is flying – a comforting sight as Brubaker later tells the Admiral: 'You're scared, freezing. Then you see an opera hat coming at you out of nowhere and you relax.' *Toko-Ri* is probably the best aviation feature of the Korean War; understated and totally without false heroics and artificial melodrama.

Korea was the first war that made extensive use of the helicopter, primarily in order to pick up downed pilots and evacuate battlefield casualties. Those duties were featured in two films: *Flight Nurse* (1953), a romantic

entanglement between an Army nurse and a helicopter rescue pilot, and more seriously in *Battle Taxi* (1954) from United Artists. In this last film Stirling Hayden played the commander of an air rescue squadron and Arthur Franz an ex-fighter pilot transferred to the squadron. Resentful at being given a less exciting role, Franz continually disobeys orders and compromises his missions. However, when he rescues a friend from his old squadron, he gradually comes to realise the importance of his job.

In 1950, just before the outbreak of the war, the USAF took responsibility for equipping and training the South Korean Air Force. The subject was dealt with in two features – *Dragonfly Squadron* (1953), with John Hodiak as an American major in charge of the training programme, and the more interesting Universal's *Battle Hymn* the following year. Directed by Douglas Sirk, the film tells the story of the war experiences of Colonel Dean Hess (Rock Hudson) a World War Two pilot who volunteered for duty in Korea. The film was introduced by General Earle E. Partridge, Commander of the Fifth Air Force in Korea. Standing, rather uncomfortably, in front of the Mustang fighter flown by Hess (bearing the legend 'I fly by faith'), the General explains,

> This plane was just one of the many in our operations. Its pilot, I will never forget. I'm pleased to have been asked to introduce this motion picture which is based on the actual experiences of this pilot, Colonel Dean Hess, his poignant and often secret struggle with a problem peculiarly his own, his courage, resourcefulness and sacrifice have long been a source of inspiration to me and to the fighting men who have known him . . .

Hess's 'problem' is that during the Second World War, he accidentally bombed an orphanage and killed thirty-seven children. Driven by guilt, he retired from the service and became an ordained minister. However, still troubled and doubtful about his calling, he volunteers for duty in Korea in the summer of 1950. Reluctant to take life he is given command of a training squadron for Korean pilots. The film really tells two stories: the difficulties he encountered preparing his pilots for combat, and his unofficial work for refugee children and the founding of Cheju-Do orphange.

The training squadron is ordered to avoid combat, but as the Communists advance south, it is obviously only a matter of time before they become involved. There is considerable speculation among the other pilots as to how Hess will behave when faced by enemy aircraft, and indeed Hess himself is in a quandary. Resolution comes when one of his pilots, Lieutenant Maples, an African-American, attacks a group of refugees by mistake. Hess attempts to

comfort the distraught flier but Maples tells him that he believes whatever happens is all part of God's plan, that nothing can happen without He gives his nod, 'we have to trust Him . . . How can we live without that'. Hess realises that God will tell him what to do when the time comes. This advice is reinforced by an old Buddhist who tells Hess that 'in order to save we must sometimes destroy'. When North Korean aircraft attack his airfield, Hess scrambles the squadron and, saving Maples, shoots down two enemy 'Yaks'. God has presumably told him that it is alright to destroy enemy aircraft if they are flown by Communists! When the base is evacuated, Hess persuades the air force to airlift the orphan children to Cheju-Do island (Operation 'Kitty Cart') where he establishes the 'Childrens' Home of Korea'. Hess went on to fly 250 missions and became the pride of the Fifth Air Force. After the war, he sold his story to Universal to raise money for the orphange.

Battle Hymn is an interesting film for a number of reasons. At one level it is a well-made and exciting action feature, the aerial sequences are well filmed and convincing. But it is also a film of considerable propaganda value. Hess is a reluctant warrior, an effective fighter pilot but not one who takes life lightly. His humanity is demonstrated by his work for the refugee children and his concern for the wounded and dispossessed. The portrayal of the flier, then, reinforces ideas about the chivalry and nobility of the pilot: Hess is clearly a true 'knight of the air'. The air force share his concerns and thus Operation 'Kitty Cart'. It is also, as far as I am aware, the only feature film until the late 1980s to include an African-American pilot, Lieutenant Maples (James Edwards).

Korea has become the 'forgotten war', completely overshadowed by American involvement in Vietnam. Yet despite the vast employment of air power in that later conflict, only two aviation features have so far been made. Of course, most missions were flown in support of ground operations and would make dull cinema – there were few air-to-air combats in the style of earlier wars. Helicopters, the ubiquitous 'Huey' (Bell UH–1 'Iroquois') and 'Cobra' gunships, have become an essential ingredient of the Vietnam war film, but most features about airmen have dealt with those shot down and enduring imprisonment – *When Hell Was In Session* (1977), *In Love and War* (1986) and *Hanoi Hilton* (1988) – or evading capture – *Bat 21* (1989).

Flight of the Intruder (1990), however, was different for two reasons: it is the only film to deal with naval air operations over Vietnam, and secondly, it is an essentially patriotic vehicle about a war most film makers have shown as immoral and futile. Based on the best-selling novel by ex-Navy aviator Stephen Coonts (interestingly, the novel was first published by the Naval Institution Press), it is set in 1972 and tells the story of carrier pilot Jake

Grafton (callsign 'Cool Hand'), played by Brad Johnson. Grafton's squadron fly the A6 Intruder, the Navy's medium attack bomber. However, Grafton and his fellow pilots are sick of hitting targets that turn out to be 'empty jungle' and long for a real mission against Hanoi or Haiphong harbour. But these targets are out of bounds while peace talks are in progress. On one raid, Grafton's bombardier is killed and the young pilot becomes even more resentful at being asked to risk his life for nothing. His new bombardier is Cole (Willem Dafoe), a three-tour veteran. Cole is an expert at flying 'Iron Hand' missions, a decoy operation to lure out enemy SAM missiles so that the firing sites can be located and 'killed'. But even taking out SAM sites isn't enough for Grafton. When another friend is killed, Grafton and Cole decide to go for a real target. A chance discovery reveals that the North Vietnamese are storing their SAMs in the Peoples' Park in Hanoi. On their next mission, Grafton and Cole head for Hanoi and wipe out the SAMs. Called before a Board of Inquiry for attacking 'illegal' targets, Grafton tries to explain why:

> We bomb worthless targets night after night . . . My first bombardier and 50,000 Americans are dead, can anyone tell me why? This War has become very confusing. Nobody wants to fight in it, nobody seems to want to win it. Maybe it should never have happened but people do die in it. Maybe for me it got personal because I do know the difference between dying for something and dying for nothing . . .

Just as it appears his career is finished, the President orders Operation Linebacker ll, the unrestricted bombing of all targets in North Vietnam. The navy can hardly court-martial Grafton for his action just a few hours before the Presidential order.

The film is seemingly a critique of the government's policy in South-East Asia; as Grafton says, perhaps America should never have become involved, but having made that decision, the government made it impossible for the military to win and wasted the lives of young Americans for nothing. Grafton's raid on Hanoi is, on one level, personal revenge, but it is also a blow for all those who suffered because of a faulty strategy. Ironically, Grafton is the undisciplined individualist common in so many aviation films but here he goes unpunished for his actions. In an epilogue, when his commander is shot down in enemy territory, Grafton again disobeys orders and helps rescue him – which earns the pilot the admiration of his comrades. With its splendid photography, exciting aerial sequences and rock and roll soundtrack, *Flight of the Intruder* owes a great deal to the earlier *Top Gun*, for here again we are immersed in the mystique of the naval aviator.

The only other feature film to deal with aviation during the Vietnam War

was Roger Spottiswoode's anarchic comedy *Air America* (1990). Here we have Mel Gibson as a pilot working for the CIA-controlled air line and undertaking a variety of sinister covert operations. *Air America* takes a totally oppositional view of the war and reveals just how far the CIA was prepared to work with bandits, drug dealers and other unsavoury characters in carrying out its clandestine operations.

IV

Aviation films located in the events of the cold war and glorifying patriotic endeavour and technical achievement, formed an important element of American cinema from 1953 through to the mid-1960s. After that date, aviation tended to be confined to a handful of films dealing with the Second World War or concentrated on the popular airline disaster sub-genre. However, the 1980s witnessed a revival of interest in the aviation movie – films which appear to be pure adventure but which nevertheless contain significant nationalist propaganda.

The first of these features was Clint Eastwood's *Firefox* in 1982. The Firefox is the ultimate jet fighter, an aeroplane operated by the pilot's thoughts, which are transmitted directly into the flight computer. All he needs to do is think about destroying a target and Firefox does the rest. Unfortunately, the aircraft has been developed in Russia by a group of dissident Jewish scientists forced to work for the regime. American intelligence persuades Vietnam veteran Mitchell Gaunt (Eastwood) to penetrate the Soviet base, steal the Firefox and fly it 3,000 miles back to the USA. With the help of the dissidents, Gaunt succeeds but he is pursued by a second machine flown by a Russian ace. This provides the opportunity for a climactic dog fight as the two pilots attempt to 'out-think'. The aircraft may have been designed by Russians, but it needs an American to fly it as it should be flown. The film raises the interesting idea that supersonic aircraft are becoming so fast that they may well soon outpace a pilot's physical and intellectual ability to fly them. The cold war rhetoric of the film and the very poor special effects make *Firefox* appear strangely old-fashioned. As Sally Hibbin pointed out in her review, '*Firefox*, with its jumble of techniques and ideas culled from recent blockbusters, remains to the end, banal'.[15]

The film that really set the tone for the revival of the aviation adventure was, without doubt, the enormously successful *Top Gun* (1986), Tony Scott's saga of Navy fighter pilots. In many ways *Top Gun* is a very traditional film, dealing as it does with a young pilot's rites of passage, learning the real meaning of duty and the importance of teamwork. Pete 'Maverick' Mitchell (Tom Cruise) is the talented but reckless pilot, a flier with the potential to be

a 'top gun' (ace). Maverick and his radar operator, Goose (Anthony Edwards), are selected for a course at 'Top Gun', the navy's elite school for fighter pilots at Miramar, California – 'Fighter Town, USA'. Maverick's main rival on the course is Iceman (Val Kilmer) a fine pilot and one who knows that success in combat depends upon teamwork. Maverick breaks the rules, has an affair with a female instructor (Kelly McGillis) and finally gets into an accident that kills his best friend Goose. Deciding to resign from the navy, he is talked around by the school's commandant (Tom Skerritt). However, the class graduation celebration is interrupted by an international crisis and Iceman and Maverick are dispatched to a carrier in the Indian Ocean. An American ship has been disabled in 'enemy' waters and the two pilots must fly cover for the rescue operation. Iceman is not overjoyed at the prospect of being covered by Maverick, but when they are attacked by enemy MIGs, the latter flies close support for his fellow pilot and still manages to shoot down several enemy aircraft. Back on the carrier Iceman and Maverick are reconciled – Mitchell, the individualist, has joined the team.

Top Gun's plot may well be familiar from a host of 1930s aviation features but it is a film with everything: exciting, well-filmed aerial sequences, an impressive array of the navy's latest jet aircraft, attractive cast, a powerful rock and roll soundtrack and all the glamour of the world of the elite fighter pilot. It is also an intensely patriotic film which celebrates the skill and devotion of navy fliers and American technology. It revived the cult of the air fighter and restyled him as a hero for the 1980s. The success of *Top Gun* inspired a number of obvious imitations. The most blatant being *Supercarrier* (1988), a television film about the rivalries and romances of jet pilots.

Released the same year as *Top Gun*, Sidney Furie's *Iron Eagle* focused on the air force and reflected America's current concern with Middle Eastern politics. An American pilot on a routine patrol is forced down over an anonymous North African state (inhabited by Colonel Gaddafi look-alikes) and held as spy. His son (Jason Kedrick), angry at the government's failure to mount a rescue operation, steals an air force jet with the help of his father's friend, Colonel Chappie Sinclair (Lou Gossett Jr.), and flies off to the rescue. The sequel, *Iron Eagles 11* (1988), has the same anonymous state develop a nuclear missile. As this clearly threatens world peace, Sinclair, leading a team of American and Russian aviators, is sent in to destroy the missile complex. A third instalment came in 1991, *The Aces: Iron Eagles 111*. This has Sinclair leading a team of World War Two fighter aces against a South American drug baron who turns out to be a Nazi war criminal. Totally unbelievable, *Iron Eagles 111* is an entertaining blend of high-camp nostalgia and contemporary concern at the drugs problem: as Sinclair says at one point, 'cocaine is killing

our country'. Perhaps the most interesting of *Top Gun's* successors was the 1991 feature *Into the Sun*. Set in the USAF base at Palermo, Sicily, the story concerns the air patrols aimed at containing Libyan aggression (but again the 'enemy' remain unnamed). Into the base comes a film crew intending to make a *Top Gun* type film with actor Tom Slade (Anthony Michael Hall). Air Force pilot Paul 'Shotgun' Watkins is assigned to coach the actor to give a convincing performance as a hot-shot jet pilot. What starts out as a delightful parody of the genre, however, suddenly becomes serious when, on what should have been a routine flight, Shotgun and Slade are shot down over enemy territory. The film then degenerates into a standard adventure in which pilot and actor outwit the 'enemy'.

Disguised as pure adventure, these successful films clearly reflect the 1980s phenomenon of Reaganism: sabre-rattling, new wave patriotism and increased defence expenditure. They extol the qualities of the hi-tech air-man and airwoman (*Supercarrier*, *Iron Eagles 11* and *Into the Sun* all feature women jet pilots), focus attention on the technology of the defence establishment and demonstrate America's ability (and willingness) to hit back. Finally, they provide constant negative reinforcement of the nation's new enemies – Libyans, terrorists and South American drug cartels.

NOTES

1 David Edgerton, *England and the Aeroplane* (London, 1991) 90.
2 Stephen Pendo, *Aviation in Cinema* (New York, 1985), 133–135.
3 *Sight and Sound*, 22:2 (Oct.–Nov. 1952).
4 The story of the X15 research programme is discussed in Richard Hallion, *Test Pilots: The Frontiersmen of Flight* (Washington, 1981), 250–61.
5 William Goldman, *Adventures in the Screen Trade* (London, 1984), 255.
6 Ibid., 258.
7 *Films and Filming*, 335 (Apr. 1984).
8 Joanne Brown, '"A is for Atom, B is for Bomb": Civil Defense in American Public Education, 1948–1963', *Journal of American History*, 75:1 (June 1988), 69.
9 Garth S. Jowett, 'Hollywood, Propaganda and the the Bomb: Nuclear Images in Post World War 11 Films', *Film and History*, 18:2 (May 1988), 31.
10 *Newsweek*, 9 May 1955.
11 See, for example, Bevtil Skogsberg, *Wings on the Screen* (San Diego, 1984), 136.
12 See the revealing comments by Peter Biskind, *Seeing is Believing* (London, 1983), 64–9.
13 *New York Times*, 26 Aug. 1962.
14 For a critical view see Pendo, *Aviation in Cinema*, 260. However, Mark Spratt gave the film a very positive review when a 16mm print was reissued by the BFI in 1982. See *Films and Filming*, 331 (Apr. 1982).
15 *Films and Filming*, 335 (Aug. 1982).

8 Crisis in mid-air

Most commentators on film appear to suggest that it was the 1970s that saw the emergence of what came to be known as the 'disaster movie' – films such as *The Poseidon Adventure* (1972), *Towering Inferno* , *Earthquake* (both 1974) and *Airport* (1975) – reflecting, claims Steven Earley, a 'contemporary fascination with apocalyptic horror and doom'.[1] But even a cursory examination of the history of the aviation movie reveals that disaster – the spectacular crash or the tragedy just averted – has always been a staple ingredient of that genre. Many of the earliest films dealing with the flying machine included scenes of crash-landings, fire on board, even hijacking. *Thirteen Hours By Air* (1936), *Non-Stop, New York* (1937) or *Central Airport* (1933) were typical of the many films that featured these dramatic events. However, the disaster or the danger averted constituted only one element in a film where the main focus was the growth of an airline, a record-breaking flight or the development of a new machine. The engine failure, crash or whatever, was an incidental, an element of added tension for the audience; a device by which the final achievement of the aviator could be heightened. Yet in the period after 1945, the air disaster took on a life of its own. As air travel became commonplace, film makers increasingly exploited the anxiety experienced by many a passenger. The difference between these new 'disaster' features and the earlier films is that in the former the entire story is constructed around a crash, engine failure, hijacking or death of a pilot. The danger is no longer just one exciting incident in the story, it is the whole *raison d'être* for the film. Nevertheless, the disaster feature did appropriate much from the earlier films: the stereotyped collection of passengers, essential in the air disaster movie, were first created in the 1930s in films such as *Thirteen Hours By Air* and *Death Flies East*, and pilots, cabin crew and airport staff were frequently cast from the same heroic mould as the air fighters of World War One. But just why these films with their repetitious plots and stereotypical characters remained so popular with audiences is difficult to determine.

Certainly, flying has always been invested with an element of danger. Crowds watched the attempts of the early pioneers or flocked to the air

circus to witness the spectacle of a crash or the drama of sudden death, just as much as to see a successful flight or thrilling stunt. Now that air travel is common, and despite modern technology reducing risks to the minimum, accidents still occur, and most passengers probably experience a moment of anxiety at take-off or landing. But while technical problems have been almost eliminated, new dangers in flying have emerged: hijacking for profit or political motive, sabotage by the terrorist or the risk of collision in overcrowded air lanes, all constitute a new menace for the air traveller. Perhaps the air disaster movie is a means of exorcising these fears? Certainly the disaster film enables an audience to indulge its fascination for horror, destruction and spectacle without personal risk. And the spectacle is, because of the increasing sophistication of film making, ever more realistic. The 1960s and 1970s were probably the peak decades for the air disaster feature but the first real example was released as early as 1939.

Five Came Back from RKO, starring Lucille Ball and Chester Morris, established a model which was later ruthlessly exploited by film makers. 'A rousing salute to melodrama, as suspenseful as a slow-burning fuse, exciting as a pin-wheel, explosive as a bomb' were the extravagant comments of one reviewer.[2] But *Five Came Back* is indeed a thoroughly entertaining feature. Twelve passengers board the airliner *Silver Queen* for a routine flight from Mexico City to Panama. They include secretary Lucille Ball and her executive employer, two elderly anthropologists (C. Aubrey Smith and Elizabeth Ridson), detective John Carradine and his political prisoner Joseph Calleia. Over the jungle, 'the territory of the headhunters' the anthropologist informs them, the plane develops engine trouble and the pilot (Chester Morris) just manages to land safely without damaging the aircraft. For twenty-three days they work to repair the engine and cut a runway through the jungle while the headhunters get closer. Finally the plane is ready, but so low on fuel that only five passengers can be taken. The elderly professor and his wife nobly offer to stay and so does the political prisoner. As the aircraft successfully takes off, the headhunters close in. Tautly directed by John Farrow, the film is a classic of the sub-genre. The outbreak of war rapidly focused the attention of film makers on military aviation but, after 1945, interest in the air disaster feature re-emerged and *Five Came Back* provided the model.

Miraculous Journey (1948) had an airliner forced down in South America. Short of food and medical supplies, the pilot (Rory Calhoun) treks into the jungle to find help. Just when the passengers are ready to give up all hope he returns with a rescue party. *Daughter of the Jungle* (1949) told of the passengers of a downed airliner rescued by a female Tarzan. Tarzan himself rescued the

passengers of yet another aircrash in *Tarzan and the Lost Safari* (1957). John Farrow even remade *Five Came Back* in 1956. Retitled *Back From Eternity*, the film had little of the sparkle of the original. *Valley of Mystery* (1967) dealt with a Boeing 707, damaged in a hurricane, and again forced down in South America. (By now the jungle was presumably so littered with wrecked aeroplanes it must have beeen difficult for a pilot to find space to crash.) The story concentrates on the tensions among the passengers while they await rescue. *Sullivan's Empire*, of the same year, had businessman John Sullivan (Arch Johnson) down in the jungle while his three sons conduct a search and squabble about their inheritance. *Terror in the Jungle* (1968) dealt with the sole survivor of a crash, a young boy found by descendents of the Incas and believed by them to be a god! As an alternative to the jungles of South America, *Desperate Search* (1960) used the Canadian wilderness, as did *Wings of Chance* (1961).

An interesting variation, and a far better film, was *Riddle of the Stinson* (1988) from Australian director Chris Noonan. Based on a real incident of 1937, it told of a Stinson aircraft carrying five passengers that disappeared on a regular flight from Brisbane to Sydney. A massive search fails to reveal any trace of the wreck, but Bernard O'Reilly (Jack Thompson), a bush farmer, believes the aircraft was off course and crashed in the mountains. His determination to play his hunch succeeds and he finds the two survivors. The Florida everglades provided the setting for *Crash* (1978), based on a real disaster of 1972, while *And I Alone Survived* (1979) was the story of Lauren Elder who survived a crash in the Sierra Nevada Mountains in 1976. The Arctic provided the setting for the John Wayne feature *Island in the Sky* (1952) and the Alps for the British film *Broken Journey* (1948). The latter is interesting for its portrayal of the brave stewardess (Phyllis Calvert) who holds the passengers together while they wait to be rescued. It also boasts a passenger in an Iron Lung who allows the batteries to be used for the radio even though it means his death! The plot was allegedly based on the crash of an American Army Dakota in the Swiss Alps in 1946. *Flight 90: Disaster on the Potomac* (1984) retold the story of the Air Florida aircraft that crashed into Washington's 114th Street Bridge in January 1982.

A crash-landing in the sea and the subsequent survival of a handful of passengers were also used in a number of films. The 1947 feature, *Seven Were Saved*, appears to have been the first. The theme was given a wartime setting in *The Sea Shall Not Have Them* (1954). Here, an RAF machine is forced down in the North Sea while carrying an important officer who has vital documents which must not fall into enemy hands. The film divides its attention between the rescue attempts to locate them and the crew's struggle to survive in their

frail dinghy. *Crash Landing* (1958) and *Last Flight* (1969) also deal with survivors adrift, as does the Swedish feature *Missing Aircraft* (1965). *SOS Pacific*, a British film of 1959, offered the variation of the survivors washed ashore on a Pacific atoll which is the site of an atomic test. With five hours before detonation, one of the survivors manages to disarm the bomb. Even sillier (if that is possible) was the third instalment of the Airport series – *Airport '77*. This has a privately chartered airliner, packed with art treasures and wealthy passengers, crash into the Caribbean. The plane sinks immediately but remains watertight for some hours, allowing a rescue operation to be mounted. The only surprise about the film is how Jack Lemmon and James Stewart were persuaded to star in it.

A crash in the desert featured in *Sands of the Kalahari* (1965), *Family Flight* (1972) and *Flight to Holocaust* (1977). But unquestionably the most interesting of this group was the 1966 production *Flight of the Phoenix*, based on the novel by Elleston Trevor, and starring James Stewart, Richard Attenborough, Peter Finch and Hardy Kruger. Stewart plays an ageing pilot working for a Middle Eastern oil company. On a routine flight taking field workers on leave, his C82 Skytruck is forced down in the desert. After a British Army officer (Finch) fails in his attempt to get help, one of the passengers (Kruger) tells the survivors that he is an aeronautical engineer and that he believes the aircraft can be 'cannabalised' and a new aeroplane built from the parts. Only when the 'Phoenix' is almost complete do they discover he designs model aeroplanes. But with nothing to lose, they finish the plane and with the survivors strapped to the wings, the veteran pilot manages to fly it to a drilling station and subsequent rescue. The studio commissioned Paul Mantz and Otto Timm to build a flyable Phoenix from spare parts. The machine was passed by the Federal Aviation Administration (FAA) and Mantz flew it for the cameras. After filming was complete, director Robert Aldrich wanted one more take of the Phoenix as insurance. Unfortunately, on a low pass, the undercarriage caught the ground, the plane flipped onto its back and Mantz, the veteran of so many aviation films, was killed. But the strangest location for a crash was in *Land Unknown* (1957), where the airliner is forced down in a mysterious valley where dinosaurs still live!

The Night My Number Came Up (1955) offered an interesting variation. The story was based on an experience that happened to Air Marshall Victor Goddard of the New Zealand RAF in 1946. Goddard (Michael Redgrave), intending to travel from Singapore to Tokyo, was told by a naval officer of a dream in which he saw a Dakota carrying eight passengers crash in a storm. As Goddard was to travel in a Liberator and only four passengers were to fly with him, he paid little attention. However, just before take-off another

three passengers were added and the flight was transferred to a Dakota. The film skilfully deals with Goddard's attempt to rationalise this experience. But when the aircraft runs into a severe storm, it appears to be a premonition of his own death. Yet, when the plane is forced down, the skill of the pilot saves the passengers' lives. Investigation into the cause of a crash has also provided the subject matter for a number of films. *Fate is the Hunter* (1964) deals with a jet crash in which fifty-three passengers were killed and the subsequent technical investigation. *Crisis in Mid-Air* (1979) told the story of an air traffic controller blamed for a major disaster, and *Crash: The Mystery of Flight 501* (1990) focuses on Cheryl Ladd as the wife of a dead airline pilot held responsible for the crash. The most interesting of these, however, was the 1961 feature, *Cone of Silence*. The story involves an airline's attempts to discover the cause of a number of near disasters with their new high-speed aircraft. The evidence at first points to pilot error, but the subsequent investigations reveal that the machine is underpowered and suffers loss of control when taking off fully loaded.

II

Disaster averted has provided the theme for a second group of feature films. Of these the most interesting is probably *No Highway* (1951), with James Stewart and Marlene Dietrich. Based on the novel by Nevil Shute (himself an aircraft designer), the film deals with the very real problem of metal fatigue. Stewart plays Theodore Honey, an eccentric but gifted research engineer employed by the Royal Aircraft Establishment at Farnborough. Honey discovers that the tail section of a new airliner, the 'Reindeer', suffers metal fatigue after 1,400 hours flying time. This causes the tail surfaces to disintegrate. No one, of course, wants to believe him — too much has been invested in the development of the Reindeer. However, when one of the airliner's does crash in Labrador, Honey is sent to investigate. On route over the Atlantic, flying in a Reindeer, he calculates that the aircraft on which he is travelling has flown over 1,400 hours and is due to crash. His announcement to turn back panics the passengers, but when nothing happens they begin to believe him mad. Only Dietrich shows sympathy and begins to believe in him. Back in England he is vindicated when a Reindeer tail section he has had on test does indeed crack. Despite the contrived story, *No Highway* works well; the RAE background is interesting and there is no excessive melodrama. An engine failure in mid-flight is the cause of near disaster in *Decision Against Time* (1957), *Jet Over the Atlantic* (1960) and the Russian-made *The Crew* (1979), while the loss of a propellor creates difficulties for John Wayne in *The High and the Mighty* (1954)

The Crowded Sky (1960) offered two aircraft on a collision course – an airliner and a Navy jet. Only the audience is aware of the danger, but when the crash does occur, the airliner manages to land safely. Airport (1970) deals with a series of problems at 'Lincoln International Airport' – a blizzard, a jet that has blocked the only usable runway and an airliner damaged by a bomb coming in for an emergency problem. It is also Christmas Eve and almost every character has 'marital' problems. Starring Burt Lancaster and Dean Martin, Airport proved to be one of the top money-making features of all time and spawned several sequels. A bomb on board was the subject of Jet Storm, a British feature of 1959, and of the American Doomsday Flight (1966). A terrorist bomb was just one of the many dangers faced by the long-suffering crew in The Concorde: Airport '79. The killing of a passenger and the crew's attempts to overpower the murderer were dealt with in Sky Dragon and Sky Liner (both 1949), The Great Plane Robbery (1950), Mayday at 40,000 Feet (1959) and the West German feature Farewell To the Clouds made the same year.

But the most entertaining (and outrageous) stories were those which dealt with the death or disabling of the pilot. The idea was first used in a 1936 feature, Flying Hostess, where the stewardess has to land the aircraft after the pilot is shot. It was resurrected for Julie (1956), where Doris Day brings the aircraft safely down, and most spectacularly in Airport '75, when a collision kills the flight crew and stewardess Karen Black has to fly the 747 until a helicopter can lower a new pilot aboard. Airport '75 is justifiably famous for its wonderful collection of passengers, including a singing nun and a young girl on route to San Francisco for a heart transplant operation. Zero Hour (1957) had the crew disabled with severe food poisoning and passenger Dana Andrews (a former Battle of Britain pilot who has lost his nerve) taking over the airliner's controls. The film was remade in 1971 as Terror in the Sky, with Doug McClure in the Dana Andrews role. A note of topicality was introduced by making McClure an ex-Vietnam helicopter pilot suffering delayed trauma. Airplane (1980) was a third retelling of the story but made to send up the whole air disaster genre. Of this type of film only the Pilot (1979), with Cliff Robertson, had anything interesting to say. Robertson plays a veteran commercial pilot with a drink problem, who thus risks the lives of his passengers every time he flies.

The hijacking of an airliner for profit or political reasons provided the theme for a number of features. The first was the 1937 film Fugitive in the Sky, when escaped convicts take over an airliner. The idea was again used by Czechoslovak film maker Jan Kadar in 1952 for The Hi-Jacking (Unos). This concerned a group of dissidents taking over a Czech airliner and flying to West Germany. But the theme was widely exploited in the 1970s when world

airlines suffered a spate of such attacks. *Wild in the Sky* (1972) was virtually a remake of the 1937 feature, while The *Pursuit of J. D. Cooper* (1981) recreated the story of the take-over of a 727 in 1971 when the hijacker bailed out over Washington State with $200,000 and was never found, and *Sky Jacked* (1972) had an American 707 taken over by political activists for a flight to Moscow. However, the event which really captured the imagination of the film maker was the hijacking of an airliner from Tel Aviv by Palestinian terrorists. The plane was flown to Entebbe in Uganda and the passengers held hostage. Israel, however, refused to negotiate and mounted a commando raid by Israeli Special Forces to rescue the passengers. No less than three films were made about the incident – *Victory at Entebbe* (1976) and *Raid on Entebbe* (1977) were American productions featuring a number of well-known stars in cameo roles, while *Operation Thunderbolt* was a modest but more realistic version made by Israeli film makers and released in 1977.

The disaster story is, as Stephen Pendo has pointed out, the easiest form of aviation feature to make. Often, all that is required is a cabin interior mock-up and a few stock shots of an airliner in flight,[3] while screenplays merely offer a recycled version of the two or three standardised plots. But, despite their frequently poor production values and repetitious stories, these films hold continual fascination for an audience and continue to be made. As I write, my local video rental store has just placed on its shelves *Passenger 57* (1993), yet another thriller set aboard an airliner. The variation here is that the detective is played by African-American actor Wesley Snipes.

Air travel today is remarkably safe: statistically probably safer than driving on a motorway. But an accident in the air is invariably fatal – passengers have little chance of surviving a crash. Perhaps it is the constant repetition of disaster overcome in these films which audiences find reassuring and which explains their continuing popularity.

NOTES

1 Steven Earley, *An Introduction to American Movies* (London, 1978), 114; see also, James Monaco, *American Film Now* (New York, 1979), 14.
2 *New York Times*, 5 July 1939.
3 Stephen Pendo, *Aviation in Cinema* (New York, 1985), 296

Conclusion

For over eighty years, aviation has provided subject matter for the film maker. Judged by aesthetic criteria, aviation films have all too often been dismissed by the critics as 'just another adventure', or 'another war film'. But this is to ignore their real significance. As Furhammar and Isaksson wrote over twenty years ago,

> The old idea that films can be thought of purely as entertainment or art, or occasionally both, is today regarded with growing scepticism. It's widely realised that films also reflect the currents and attitudes in a society, its politics. The cinema does not exist in a sublime state of innocence, untouched by the world; it also has a political content, whether conscious or unconscious, hidden or overt.[1]

The aviation film, then, at one level, has reflected popular fascination with the flying machine and with the perceived heroism of the aviator. It has charted the transition of the aeroplane in the popular mind from a utopian symbol of progress to a terrifying engine of destruction. More importantly, the aeroplane has been used, 'consciously or unconsciously', by the film maker as a metaphor for national achievement – a subject through which scientific, technical and industrial advance can be measured.

The aviation film came of age during the inter-war years, at a time when, a number of former aviators were employed in the American film industry. They gave shape to the genre and created the seminal features which influenced the aviation film for decades. It was thus the airmen themselves who, in large measure, created their own cinematic image.

NOTE

1 Leif Furhammar and Folke Isaksson, *Politics and Film* (London, 1971), 6.

Select bibliography

BOOKS

Note: place of publication is London unless otherwise stated.

Agee, James, *Agee On Film: Reiews and Comments by James Agee*, New York, 1958.

Aldgate, Anthony, *Cinema and History*, 1979.

Aldgate Anthony, and Jeffrey Richards, *Britain Can Take It*, Oxford, 1986.

Anderson Joseph, and D. Richie, *Japanese Film*, New York, 1960.

Bardeche Maurice, and Robert Brasillach, *History of the Film*, 1938.

Biskind, Peter, *Seeing is Believing*, 1983.

Brown, Karl, *Adventures with D. W. Griffith*, 1973.

Butler, Ivan, *The War Film*, 1974.

Cadogan, Mary, *Women With Wings*, 1992.

Clarke, I.F., *Voices Prophesying War, 1789–1984*, Oxford, 1966.

Corn, Joseph, *The Winged Gospel: America's Romance With Aviation, 1900–1950*, New York, 1983.

Coultass, Clive, *Images for Battle*, 1989.

Dwiggins, Don, *Hollywood Pilot: A Biography of Paul Mantz*, New York, 1967.

Edgerton, David, *England and the Aeroplane*, 1991.

Farmer, James, *Celluloid Wings*, Blue Ridge Summit, Pa., 1984.

Franklin, H. Bruce, *War Stars: The Superweapon and the American Imagination*, New York, 1988.

Fritzsche, Peter, *A Nation of Fliers: German Aviation and the Popular Imagination*, Cambridge, Mass., 1990.

Furhammar Leif, and Folke Isaksson, *Politics and Film*, 1971.

Goldman, William, *Adventures in the Screen Trade*, 1984.

Goldstein, Laurence, *The Flying Machine and Modern Literature*, New York, 1986.

Hallion, Richard, *Test Pilots: The Frontiersmen of Flight*, Washington, 1981.

Halliwell, Leslie, *Seats In All Parts*, 1986.

Hardy, Phil, *Encyclopedia of Science Fiction Movies*, 1984.

Hull, David Stewart, *Film in the Third Reich*, Berkeley, 1969.

Jarrett, Vernon, *Italian Cinema*, 1951.

Jeavons, Clyde, *A Pictorial History of War Films*, 1974.

Peter, Kenez, *Cinema and Soviet Society, 1917–1953*, Cambridge, 1992.

Koppes, Clayton, and Gregory Black, *Hollywood Goes to War*, New York, 1987.

Kracauer, Siegfried, *From Caligari to Hitler*, 1947.

Kulik, Karol, *Alexander Korda: The Man Who Could Work Miracles*, 1975.

Landy, Marcia, *Fascism in Film: The Italian Commercial Cinema, 1931–1943*, Princeton, 1986.

Leiser, Erwin, *Nazi Cinema*, 1975.

Leyda, Jay, *Kino*, 1960.

Low, Rachael, *History of the British Film, 1906–1914*, 1948.

Low, Rachael, *History of the British Film, 1918–1929*, 1971.

Low, Rachael, *Documentary and Educational Films of the 1930s*, 1979.

Low, Rachael, and Roger Manvell, *History of the British Film, 1896–1906*, 1948.

McBride, Joseph, *Hawks on Hawks*, Berkeley, 1982.

Manvell, Roger, *Films and the Second World War*, 1974.

Martin, John W., *The Golden Age of French Cinema, 1929–1939*, 1987.

Mosse, George L., *Fallen Soldiers: Reshaping the Memory of the World Wars*, New York, 1990.

Orris, Bruce, *When Hollywood Ruled the Skies*, Hawthorne, Calif., 1984.

Overy, Richard, *The Air War, 1939–1945*, 1980.

Pendo, Stephen, *Aviation in Cinema*, New York, 1985.

Pisano, Dominick (ed.), *Memory and the Great War in the Air*, Washington, 1992.

Richards, Jeffrey, *Visions of Yesterday*, 1973.

Sherry, Michael, *The Rise of American Air Power*, New Haven, 1987.

Skogsberg, Bertil, *Wings on the Screen*, San Diego, 1984.

Solomon, Stanley, *Beyond Formula: American Film Genres*, New York, 1977.

Tallents, S. G., *The Projection of England*, 1932.

Watt, Harry, *Don't Look at the Camera*, 1979.

Welch, David, *Propaganda and the German Cinema, 1933–1945*, Oxford, 1983.

Wood, Robin, *Howard Hawks*, 1968.

Wright, Basil, *The Long View: An International History of Cinema*, 1974.

Zelinsky, Wilbur, *The Cultural Geography of the United States*, New Jersey, 1973.

ARTICLES

Aldgate, Anthony, Guernica and Gaumont British Newsreel, *Film and History*, 6:2 (1976), 37–43.

Bailes, R.E., Technology and Legitimacy: Soviet Aviation and Stalinism in the 1930s, *Technology and Culture*, 5:17 (1976), 55–81.

Behlmer, Rudy, World War 1 Aviation Films, *Films in Review*, (Aug.–Oct. 1967), 413–33.

Brown, JoAnne, 'A is for Atom, B is for Bomb': Civil Defense in American Public Education, 1948–1963, *Journal of American History*, 75:1 (June 1988), 68–90.

Culbert David, and Martin Loiperdinger, Leni Riefenstahl's 'Tag der Freiheit': the 1935 Nazi Part Rally Film, *Historical Journal of Film, Radio and Television*, 12:1 (1992), 3–40.

Emme, Eugene M., The Emergence of Nazi Luftpolitik as a Weapon in International Affairs, *Air Power Historian*, 12 (1965), 92–105.

Fredriksen, John C., Teaching History with Video: Japanese Perspectives on the Second World War, *Film and History*, 18:4 (1988), 85–93.

Jowett, Garth S., Hollywood, Propaganda and the Bomb: Nuclear Images in Post-World War 11 Films, *Film and History*, 18:2 (May 1988), 26–38.

Legg, Stuart, Shell Film Unit: Twenty One Years, *Sight and Sound*, 23:4 (Apr.–June 1954), 209–12.

Mould David H., and Charles Berg, Fact and Fantasy in the Films of World War One, *Film and History*, 14:3 (Sept. 1984), 50–60.

Neufeld, Michael J., Weimar Culture and Futuristic Technology: the Rocketry and Spaceflight Fad in Germany, 1923–1933), *Technology Culture*, 31:4 (Oct. 1990), 725–53.

Pronay, Nicholas, The British Post-bellum Cinema: a survey of the films relating to World War 11 made in Britain between 1945 and 1960, *Historical Journal of Film, Radio and Television*, 8:1 (1988), 39–54.

From the Wright Brothers to *Top Gun*

Rhode, Bill, The History of Hollywood in Aviation, *American Aviation Historical Society Journal*, 11 (1957), 260–3.

Richards, Jeffrey, Wartime British Cinema Audiences and the Class System: the Case of 'Ships With Wings', *Historical Journal of Film, Radio and Television*, 7:2 (1987), 129–41.

Seton, Marie, War, *Sight and Sound*, 6:24 (1937), 182–5.

Spears, Jack, World War One on the Screen, *Films in Review*, 17 (1966), 274–92.

Strand, Frank, Additional Aviation Movies, *American Aviation Historical Society Journal*, 111 (1958), 152–7.

Travers, Tim, The Shape of Things to Come: H. G. Wells and Radical Culture in The 1930's, *Film and History*, 6:2 (1976), 31–6.

Ward, John W., The Meaning of Lindbergh's Flight, *American Quarterly*, 10 (1958), 3–16.

Index

INDEX OF FILM TITLES

Index

Index

212

Index

INDEX OF NAMES

Index

Index